# Tough Enough

# Tough Enough

## Arbus, Arendt, Didion, McCarthy, Sontag, Weil

DEBORAH NELSON

The University of Chicago Press
Chicago and London

The University of Chicago Press, Chicago 60637
The University of Chicago Press, Ltd., London
© 2017 by The University of Chicago
Published 2017
Printed in the United States of America

26 25 24 23 22 21 20 19 18 17    1 2 3 4 5

ISBN-13: 978-0-226-45777-2 (cloth)
ISBN-13: 978-0-226-45780-2 (paper)
ISBN-13: 978-0-226-45794-9 (e-book)
DOI: 10.7208/chicago/9780226457949.001.0001

The University of Chicago Press gratefully acknowledges the generous support of the
Humanities Visiting Committee at the University of Chicago toward the publication
of this book.

Library of Congress Cataloging-in-Publication Data

Names: Nelson, Deborah, 1962– author.
Title: Tough enough : Arbus, Arendt, Didion, McCarthy, Sontag, Weil / Deborah
 Nelson.
Description: Chicago : The University of Chicago Press, 2017. | Includes
 bibliographical references and index.
Identifiers: LCCN 2016054300 | ISBN 9780226457772 (cloth : alk. paper) |
 ISBN 9780226457802 (pbk. : alk. paper) | ISBN 9780226457949 (e-book)
Subjects: LCSH: Weil, Simone, 1909–1943. | Arendt, Hannah, 1906–1975. | Sontag,
 Susan, 1933–2004. | MacCarthy, Mary, 1882–1953. | Arbus, Diane, 1923–1971. |
 Didion, Joan. | Toughness (Personality trait) | Aesthetics—Psychological aspects. |
 Suffering in literature. | Suffering in art.
Classification: LCC PS151 .N45 2017 | DDC 810.9/9287—dc23 LC record available at
 https://lccn.loc.gov/2016054300

♾ This paper meets the requirements of ANSI/NISO Z39.48-1992 (Permanence of
Paper).

*For Judy Nelson*
*In Memoriam*

# Contents

# Abbreviations

A I : Susan Sontag, *Against Interpretation and Other Essays*
C S K : Mary McCarthy, *The Company She Keeps*
D A A : *Diane Arbus: An Aperture Monograph*
E J : Hannah Arendt, *Eichmann in Jerusalem: A Report on the Banality of Evil*
G G : Simone Weil, *Gravity and Grace*
I A M : Susan Sontag, *Illness as Metaphor*
J P : Hannah Arendt, *The Jew as Pariah*
L O T M : Hannah Arendt, *The Life of the Mind*
O P : Mary McCarthy, *Occasional Prose*
O P S : Susan Sontag, *On Photography*
O R : Hannah Arendt, *On Revolution*
O T : Hannah Arendt, *Totalitarianism: Part Three of "The Origins of Totalitarianism"*
O T C : Mary McCarthy, *On the Contrary: Articles of Belief, 1946–1961*
O V : Hannah Arendt, *On Violence*
P H A : *The Portable Hannah Arendt*
R : Diane Arbus, *Revelations*
R J : Hannah Arendt, *Responsibility and Judgment*
S O F : Mary McCarthy, *Stones of Florence*
S R W : Susan Sontag, *Styles of Radical Will*
S T B : Joan Didion, *Slouching towards Bethlehem*
S W R : *The Simone Weil Reader*
W A : Joan Didion, *The White Album*
Y M T : Joan Didion, *The Year of Magical Thinking*

# Introduction

# Tough Enough

> To name a sensibility, to draw its contours and to recount its history, requires a deep sympathy modified by revulsion.
> SUSAN SONTAG, "Notes on 'Camp'"

This is a book on women writers, intellectuals, and artists who argued passionately for the aesthetic, political, and moral obligation to face painful reality unsentimentally. These may seem like a strange cast of characters to call to your aid during a crisis, but here they are: Simone Weil, while less well known than the others, achieved a cultlike status in the early postwar religious revival for her austere and unconventional mystic Christianity; Hannah Arendt was one of the most important political philosophers of the twentieth century, and her star has risen only higher the further we get from her own moment; Mary McCarthy, well known in her own day as a novelist and a critic, remains a figure of note in American literary history primarily for her autobiographies and her best-selling novel *The Group*; Susan Sontag was the most famous public intellectual of the late twentieth century, an icon in popular culture, and a controversial but highly regarded critic of the arts and politics, although less well regarded for her own artistic practice; Diane Arbus was one of the postwar era's most influential photographers and artists; and Joan Didion, after a long and successful career as a journalist, novelist, and screenwriter, became a celebrity upon the publication of her memoir *The Year of Magical Thinking* and its Broadway adaptation with Vanessa Redgrave. Though these women are hardly unfamiliar to contemporary readers or scholars of the late twentieth century, they do not constitute a recognizable group, and it is likely that few readers will be familiar with all of them. Moreover, they would not have appreciated being classed by their gender, however much they might have found the adjective "tough" accurate.

For years I called this book "Tough Broads," which conveyed something of the aggressiveness I will talk about in the following chapters. Unfortunately, "tough broads" suggested the self-possessed, witty, and flirtatious Mae West

rather than the dour Simone Weil or the cool, remote Joan Didion. However sexually charismatic some of these women were in their personal lives—Sontag and McCarthy notoriously so—none of them wrote prose that could be considered flirtatious or seductive. They are grouped together here in this book for the similarities of style and outlook they shared on the questions of suffering and of emotional expressivity that preoccupied the late twentieth-century United States and, in many ways, continue to do so now. What makes them tough is their self-imposed task of looking at painful reality with directness and clarity and without consolation or compensation. All of them have been called "unsentimental" by some reviewer for their practice of "facing facts or difficulties realistically and with determination," the definition of "unsentimental" according to *Webster's Online Dictionary* (which also lists "tough" as a synonym). However, had I called this book "Unsentimental Women," the term would automatically have conferred praise. This default admiration for unsentimentality (it's always "clear-eyed!" and "refreshing!" or, more soberly, "unflinching") derives from our failure, paradoxically, to take it very seriously. Unsentimentality has no critical history, certainly not the volumes that sentimentality does, even while it has been the default style of serious and important aesthetic work since the advent of modernism in the early twentieth century. Moreover, in the ways that "unsentimental" is reflexively applied in reviews or criticism, it appears to derive more from character than from philosophy, more from temperament than from strategy. After all, most writers would prefer their writing to be refreshing rather than stale, clear-eyed rather than myopic. But the connotations of "unsentimental" go further to suggest probity, bravery, even heroism, as if writing with an abundance of feeling displayed a writer's moral laxity or psychological and intellectual weakness. Under the banner of a heroic engagement with painful reality, unsentimental writing would appear immune from failure.

Except when it fails. And it does fail, only rarely and in very particular circumstances. The scandals around unsentimentality—writing that is *too* unsentimental rather than not unsentimental enough—drew me to the women in this book. Most conspicuously, Arendt's *Eichmann in Jerusalem* sparked a worldwide debate over both her judgment and her character—that is, her heartlessness—but all these women have been called to account for failures of feeling. Mary McCarthy was "pitiless"; Simone Weil, "icy"; Diane Arbus, "clinical"; Joan Didion, "cold"; Susan Sontag, "impersonal." It is difficult to find—for me, impossible—a similar roster of male writers and intellectuals or artists who lived through and beyond their characterization as unfeeling. And while these six are not the only women to raise the issue of heartlessness (other figures from the period do as well—Flannery O'Connor, for instance),

the six in this book made their approach to suffering a deep subject of their work. Their internal debates on representing painful reality and the function of pain more broadly provide an opportunity to follow their thought and their practice closely so that we can learn something about what unsentimentality is and what it can and cannot do. Because unsentimentality is a subject of their work, its aesthetic, moral, and political dimensions will become clearer to us, which will activate unsentimentality as a choice, not mystify it as a character trait.

These controversies arise not simply because the conventions of emotional expression differ between women and men or because the demands for female warmth and sympathy are more insistent. That we know from decades of feminist scholarship. More specifically, the sentimental tradition crafted the eighteenth-century "man of feeling" (who disappeared from public life when sympathy and sentiment were assigned to the domestic sphere in the nineteenth century) in a stoic mode.[1] From Eve Sedgwick in the 1980s to Julie Ellison in the 1990s to Tania Modelski more recently, we have seen how emotional response is deflected onto the viewers of the male sufferer or sympathizer. Whether we are talking about a bewigged Adam Smith or a squint-eyed Clint Eastwood, the traditions of male reserve in the face of suffering—their own and others—go back to the Roman and the Greek Stoics. Julie Ellison describes Adam Smith as such: "For Smith, the ideal manifestation of moral sensibility involves a dignified upper-class sufferer whose very self-control provokes his friends to vicarious tears."[2] This tableau closely resembles Tania Modelski's male weepie, or melodrama: "Real men do not cry, or at best they shed only a few hard-wrung tears; others do the crying for them—usually women or people of color."[3] If Adam Potkay is correct that stoicism is always being remodeled, emotional expression has been solidified at the bottom of the social hierarchy, which means that adopting a stoic mode might appear not just unnatural but presumptuous.[4] In short, if sentimentality can contain stoicism, "too unsentimental" might register two things: the absence of admiring onlookers whose job it is to express intense emotion or the presence of the wrong protagonist whose stoicism is not admirable but alarming. The unsentimentality that is the subject of this book is not "silent and majestic sorrow,"[5] however, but a concerted attempt to manage feelings so that no one tears up: not the writers, not their subjects, and not their readers.

One consequence of this gendering of emotional style is that these women had to be unusually thoughtful about the choice to be unsentimental, compelled to think it through, test it out, explain it as a choice with specific ends. Indeed, far from a mere absence of improperly calibrated or insincere emotional expression, unsentimentality for these writers and artists is a lifelong

project, one that gets worked out with a great deal of self-consciousness. Certainly, temperament plays into this for all these women, as does their life experience. But biography is only the point of departure. What they wrote, how they wrote it, and how they imagined, defended, and advocated their practice make unsentimentality and its ethics available for use.

When Susan Sontag set out to define "camp" in her career-making essay "Notes on 'Camp,'" she began by defining "sensibility," using the word no fewer than fifteen times in the first three paragraphs. If Raymond Williams is correct in *Keywords* that "sensibility" fell out of use in the early 1960s because a consensus about even having taste at all had dissipated, Sontag's 1964 essay constitutes the term's last hurrah and its bold reassertion as a marker of specialization, not generality. Having taste, her opening remarks suggest, whether camp taste or any other, required explanation and definition. What makes this essay so characteristic of Sontag's own sensibility, which she claims it is, is the camp relationship to feeling. Exaggerated feeling is one of camp's prized objects, and therefore, sentimentality is itself always available for camp appropriation. She quotes Oscar Wilde—"one must have a heart of stone to read the death of Little Nell without laughing"—to note camp's delighted, ironic consumption of sentimentality.

Unsentimentalism, too, is a sensibility, a particular taste in emotion with its own aesthetic practices, though the history of the term would not predict it. To summarize Williams, "sensibility" emerged in the eighteenth century as a term of approval for a person's susceptibility to tender emotions. In the nineteenth century, "sensibility" and "sentimental" parted ways; approval shifted to an aesthetic notion of sensibility, the capacity for perception and judgment in matters of taste. "Sentimental" increasingly became the disapproving term for the indulgence in emotion or the clichéd rendering of feeling, though its valence was not yet securely negative. Importantly, in the nineteenth century, the word "unsentimental" still carried with it an idea of coarseness, which played off the earlier association of sensibility and refined capacity for tender feeling. That notion of coarseness disappeared in the twentieth century when "unsentimental" became exclusively a term of approval. By the modernist moment and running back through the Romantic, according to James Chandler's *Archaeology of Sympathy*, "sentimental" had become permanently and irrevocably associated with bad taste and moral simplicity and "unsentimental" with good taste and moral acuity. I have not been able to determine a precise date when "unsentimental" began to stand as *self-evidently* approving in matters of style, and in fact, *Keywords* does not mention the term. By Sontag's moment, the camp delight in exaggerated emotions shows how far

the capacity for tender feeling and the aesthetic capacity for perception and judgment had diverged. It is precisely camp's hardheartedness, its ironic consumption of painful feeling, that constitutes aesthetic refinement. The camp aesthete can determine under which circumstances excessive emotional sensitivity couples with aesthetic failure to turn the awful into the great.

But what does "unsentimental" actually denote? By way of contrast, a nonsentimental work will still treat feelings, but in a way judged fresh, properly scaled, and free of cliché. But "nonsentimental" is a term of exclusion that draws a boundary around that thing we call sentimentality, as does "antisentimental," which identifies a criticism of sentimentality. Neither constitutes a style in itself. "Nonsentimental," the most neutral term, is also the least used because it does not specify a set of properties, merely the absence of properties. "Antisentimental" is the most closely tied to "sentimental" because as several scholars have shown, it is difficult to engage sentimentality critically without reproducing some of its logic.[6] "Unsentimental," as opposed to "nonsentimental" or "antisentimental," I want to argue, does define something specific. And while we might know it when we see it, it does not always look the same. For instance, no one would mistake the prose of Joan Didion for anyone else's, much less that of Simone Weil or Susan Sontag.

What they share first is their attention to the same terrain as sentimental literature—painful reality, suffering, sufferers—but without emotional display. The novelist Thomas Pynchon, for instance, has been accused of being a cold writer because his novels do not offer rounded characters with whom readers might identify; he is not called an unsentimental writer, because while there might be painful reality, there is little that we can identify as suffering because there is little that we can identify as interiority, which is the place of suffering, however publicly displayed. Second, painful reality must be treated concretely, directly, and realistically. When unsentimentality succeeds, its descriptors are "lucid," "clear-eyed," "precise," "restrained," and "penetrating," to name a few. When it fails, unsentimentality veers into coldness, tactlessness, aggression, and even cruelty. Painful reality, it seems, must not be treated too directly, concretely, and realistically without conveying some of the writer's relationship to the suffering, or she—and it is always she—is perceived as cold, tactless, or heartless. Like sentimentality, unsentimentality is also, therefore, implicitly a matter of scale—that is, of the perceived balance between a cause and its emotional effect. To be affectless in the face of extreme suffering can be terrifying, as Arendt argued in *On Violence*.

Because unsentimental work prizes the object of reflection over feelings about that object, its syntax tends to be simpler, shorn of qualification and subordinating clauses, which often work to fold in the feeling perspectives of

both subject and writer. Didion argues in her essay "Why I Write" that quali-
fication and subordination were attempts to soften the blow, so to speak, and
outlawed them for herself accordingly. It seems all these unsentimental writ-
ers did the same and for much the same reason. Causing pain to the reader
was not only acceptable but, at times, necessary. Weil, Sontag, and Didion, for
example, are wary of the satisfactions of sympathy, whether these satisfactions
are narcissistic (the heightened self-regard of displaying how compassion-
ate one's feelings are), moral (the displacement of guilt in that if I feel bad,
I must be good even if I'm not doing anything), or sensual (the pleasures of
intensity, the excitement of sharing feelings). Arendt worries that feelings of
horror aroused by the death camps obliterate thought. Sontag, McCarthy, and
Didion suggest that feelings are anesthetic in that one form of more tolerable
pain works to mask another, deeper injury. Arbus confesses that it hurts to be
photographed but believes that empathy masks human reality.

One of the late twentieth century's great dilemmas has been how to confront
the scale of painful reality or "to regard the pain of too many others," to para-
phrase Sontag. World War II unleashed an enormity of suffering that defied
anyone's attempts, then or now, to describe or comprehend its totality. The
few numbers that quantify it—six million murdered Jews, sixty million war
dead, twelve million dead of starvation in the Pacific Rim, the quarter mil-
lion Japanese incinerated in one day by two bombs, to name just some—can
measure but not convey the horror, the loss, and the reach of destruction at
midcentury. The United States, which was comparatively unscathed, still suf-
fered over four hundred thousand military casualties. While this number is
dwarfed by the USSR's twenty-three million (almost 14 percent of its popu-
lation), a rank order of suffering does nothing to console the statistically most
bereaved, nor the statistically least. John Hersey, who meticulously measured
the atom bomb's impact in seconds and in distance from the center, scatter-
ing data throughout his account of the bombing of Hiroshima, ultimately
reduced his story to that of six survivors to provide some human measure to
the new atomic reality. Scale itself, the sheer imponderability of the size of the
problem, became one of the psychic, social, aesthetic, and political challenges
of the postwar era. "To do the atom bomb justice," Mary McCarthy reckoned,
"Mr. Hersey would have had to interview the dead."[7]

In the face of the midcentury's disasters, artists and writers of all kinds
and from around the globe decried the inadequacy of the formal tools they
had inherited. Theodor Adorno famously claimed that "to write poetry after
Auschwitz is barbaric."[8] However, as we well know, the perceived impossibil-
ity of the task did not render suffering and trauma invisible. On the contrary.

Despite the anguish of many thoughtful commentators, there has been no shortage of attempts to depict suffering across every medium in all ranges of culture from the highbrow to the middlebrow to the mass market. Poets did not stop writing poetry "after Auschwitz," nor did they shrink from attesting to horror; neither did novelists, painters, filmmakers, memoirists, comic-book writers, documentarians, journalists, television writers, dancers, choreographers, even musicians. If the twentieth century is a century of traumas and a century of theories of trauma, as Shoshana Felman puts it, it is also a century of traumatic representation, which encompasses the attempts to do justice to suffering as well as to capitalize on its eager consumption.[9] An expression that leapt into the American public domain after the publication of Art Spiegelman's *Maus* was "There's no business like shoah business."

By examining the work of Arbus, Arendt, Didion, McCarthy, Sontag, and Weil, this book's broadest aim is to contribute a chapter to the story we have been telling ourselves about our relationship to suffering—our own and others—in the decades following World War II. We are told, for instance, that the late twentieth century was a period that prized, often demanded, emotional expressivity and that exhibited a drive toward authenticity and empathy that required the public sharing of feelings. We are also told that the late twentieth century was a period defined by its coolness, its irony, and its affectlessness. This bifurcated story directs us toward a broader question. Naturally, coolness and affectlessness can produce a longing for their opposites in warmth and emotional fullness, whereas authentic self-disclosure of intense personal emotion can result in an equally powerful desire for distance and detachment. Moreover, any cultural moment offers myriad tones and styles, but it is the habits of thought about this period that allow observers to claim both authenticity and irony as dominant or characteristic. We ought to ask what in the larger historical impulses, including the war but also beyond it, threw emotions to the extremes of the emotional scale, or why emotional display—full or empty—became so fraught that emotions would be constantly remarked on in various divisions of the public sphere (I'm thinking primarily of arts and politics) and subjected to constant debate, which itself is marked by emotional charge (elation or disgust, for instance).[10]

The women in this book constitute a countertradition to these two poles, not a happy medium—one in which the display of feeling is minimized if not outright excluded, but which also insists on an encounter with suffering that is serious, engaged, and often painful. It is on this narrow ground between saturation and denial that these women appear so out of step with their times. They neither sacralized pain nor remained indifferent to it, and in this way, they constitute a countertradition that has been mistaken for heartlessness

and coldness. But it is, in fact, something else altogether, something I want to call toughness. They were drawn to suffering as a problem to be explored and yet remained deeply suspicious of its attractions. It is easy to confuse their toughness with indifference or callousness, but that would be to misconstrue their project. They sought not relief from pain but heightened sensitivity to what they called "reality." Perversely or not, they imagined the consolations for pain in intimacy, empathy, and solidarity as *anesthetic*. Their toleration of pain, indeed their insistence on its ordinariness, is a part of their eccentricity. In discourses where pain is a serious ethical and political question, as it was for them, the explanatory authority of trauma has rendered unintelligible both ordinary suffering and the *ordinariness* of suffering.

Their refusal of empathy and solidarity was taken by many to be unpardonable. It was, furthermore, quite literally *unthinkable* because it landed squarely in the heart of postwar America's incoherent relationship to psychic pain and its remedies. As Lauren Berlant and Wendy Brown have argued, intimacy, empathy, and solidarity derived their conceptual and social power from their imagined capacity to heal a deep and often traumatic psychic wound.[11] This relief from pain through empathy resonated widely with other discourses of recovery in late twentieth-century America. It is essential, however, to cast the dilemma of pain more broadly still by remembering that it is not peculiar to areas that we identify with woundedness—identity politics, therapy and confessional culture, and trauma studies—to take pain as self-evident and, in a very complicated sense, satisfying. On the one hand, as Mark Seltzer has explained, late twentieth-century America is a "wound culture" marked by "the public fascination with torn and open bodies and torn and opened persons, a collective gathering around shock, trauma, and the wound."[12] On the other, postmodern culture has exhibited the well-known "waning of affect" described by Fredric Jameson. We are left, then, with two extremes, one where pain supplies an overabundance of meaning or stimulation and one where it fails to produce any affective response at all.

In an important way, their acceptance of and insistence on pain for themselves and their readers constitute a critique of Enlightenment secular modernity with its master narrative of human perfectibility. In the drama of human perfectibility, every source of pain is subject not merely to remediation; it is already located somewhere on the path to elimination. As modernity's fantasy of itself as an increasingly pain-free world imploded in the first half of the twentieth century, these women were willing to admit pain into the sphere of aesthetics and politics. They demanded that feeling pain, a result of considering in detail and with accuracy the conditions of pain and suffering, was a legitimate, even necessary, enterprise. This pain was to be both

the reader's and the writer's. Yet—and here is where they depart, or tried to, from the prevailing ethics of the period—they were not to share that pain. The pain should never be *between* the writer and the reader, though both may experience it.

As Talal Asad's *Formations of the Secular* explains, pain is a peculiarly modern problem and one conceived in terms of scale.[13] Excess became the marker by which cruelty was identified, though where the baseline of acceptability lies is always historically contingent. As cruelty in punishment was outlawed, pain became incompatible with what it meant to be human. To inflict it and to experience it were both dehumanizing. Of course, that did not render cruelty obsolete, he argues; it merely made it secret and subject to denial. But the remaking of the penal code and the notion of rights changed the place of pain in modern societies and rendered it unitary—that is, one thing rather than many. By "many" Asad does not mean that pain varies by intensity (though it does in his account), but that the functions of pain—not its meaning—for the individual and for the community were made invisible and unthinkable. That pain was merely an ordinary part of human life, that it had spiritual and other uses, began to seem inhuman, uncivilized, barbaric. To consider its value or use seemed reactionary.

If we take heartlessness and coldness as mere quirks of personality, we deprive ourselves of alternatives to intimacy and empathy even as their limitations appear more striking and, at the same time, more fixed and naturalized. Because it is difficult to imagine ethics without empathy, however, these women have been perceived as psychologically cold rather than engaged in an ethical project with different assumptions. The ethical models of relation that have been ascendant since the eighteenth century's invention of moral sentiment, and that have been rendered inadequate by the tragedies of the midcentury, tried to bring the self face-to-face with the Other. Because unsentimentality refuses to attend to the emotional suffering of the protagonists of whatever situation confronts the writer, the work of the authors and artists I discuss provides an alternative to an ethical system that rests on empathy, whether that is found in the philosophy of Levinas or the debates over sentimentality; the work of trauma studies or the efforts to understand emotional flow in affect studies; or the work on identity and identification across forms of subaltern studies. These systems fundamentally presuppose a face-to-face encounter with the Other. These women, however, dispute the efficacy of that ethical mode for a variety of reasons: its consolatory distraction, its moral vanity, its tendency to overwhelm and saturate both actors, its unreliability, its impossibility. More importantly, beyond criticizing or discarding empathy, they attempt to mount another ethical mode that requires, to borrow Arendt's

terms, sharing the world with others but without their face-to-face encounter. This is a painful mode, one that deprives the reader of consolation, certainty, predictability, gratitude, company. It is deliberately, sometimes vehemently, anti-utopian. If it promises nothing more than unpredictability, helplessness, sadness, and self-alteration, it also attempts nothing less than an active, expansive, and transformative relationship to reality.

Toughness means difficult, however, not insensate. It paradoxically demanded a heightened sensitivity to reality, just not to other people's emotions. The women I write about here insisted on the duty to face reality; they advocated for the necessity to contain emotions, both those that prevented one from confronting painful reality and those that arose in the process of doing so. They argued for the psychological and political value of toughness. They formulated an aesthetic practice for facing painful reality, which they demonstrated in their own work. They insisted on facing suffering with clarity, alone but in the company of others. Finally, they believed this practice to be crucial to the fate of the postwar public sphere—particularly the US public sphere—and even human civilization itself. But however much they shared, they had different ways of formulating their projects: Simone Weil espoused a tragic formulation of justice in her embrace of a form of suffering so extreme its only analogy is the Crucifixion; Hannah Arendt described herself as heartless so as to elaborate an alternative to a politics of compassion; Mary McCarthy provided an aesthetic theory of facing facts across the many literary modes in which she wrote; Susan Sontag, in her anxiety about cultural anesthetics, explored the problems of emotional self-regulation under late capitalism; Diane Arbus viewed failure as an ordinary part of self-fashioning, providing a pedagogy of helplessness; Joan Didion pitched a battle with self-pity and self-delusion, which ground to a halt when she came to understand the grandiosity of hardness.

"Regarding the pain of others" has been a motivation for extended and brilliant reflection and a source of theoretical, historiographic, and methodological creativity for dealing with the ongoing witness of atrocity and oppression across the globe and even across historical periods. Several fields, often overlapping, have fashioned conceptual tools for thinking about and witnessing suffering in its various scales and registers. With its roots in psychoanalysis, trauma studies have produced ways of attending to the incommunicable, the stuttering, fugitive, oblique ways of speaking of or representing trauma. Feminist studies, race studies, ethnic studies, postcolonial studies, disability studies, gay/lesbian/queer studies, studies of the working class, using methods from a variety of disciplines, all have made visible and intelligible the suffering and oppression of individuals and communities of people

across cultures and across time. Affect studies, which has roots in (without superseding) these fields, is increasingly a nexus in which painful emotion is studied. It has the conceptual advantage of producing rich psychological and social accounts of suffering and responses to it because it takes affects to exist between mind and body, between people, between a person and an abstraction (like the nation or the good life), and between a body and its environment. This in-betweenness is where affect can be generative and motivate action; it is also where it can be unpredictable, which is where it becomes a source of anxiety. Affects are a source of optimism in a great deal of contemporary work on the subject, just as they were a source of dread in studies of crowds, masses, and fascism in the first half of the twentieth century. This book, in making a space for coldness and heartlessness, reserve and containment, marks a border territory of affect studies.

The detachment of these women—their preference for solitude over solidarity—seeks to eliminate the in-betweenness of affect, or feelings and emotions (though these are technically different from affects), for a variety of reasons that will be spelled out in each chapter. This resistance to emotion while in the domain of painful reality also sets them apart from the type of political affiliation favored by the progressive social movements that emerged in the mid-twentieth century, all of which advocated bonds of feeling and group identification. Indeed, their repudiation of both in theory, to say nothing of their refusal in practice, marked these women as pariahs within groups that expected to win their support. For instance, Hannah Arendt's major work of the early 1960s, *On Revolution*, published at the height of the civil rights movement, carefully dissected the "devastating" effects of compassion in political life.[14] Joan Didion's breakout collection of essays, *Slouching towards Bethlehem*, satirized the feeling politics of the New Left and the feeling culture of the fringe Left as the antiwar movement and the hippies intermingled and often collided in Northern California in 1968. And when the social movements of the late twentieth century recommended the healing power of empathy as the glue of solidarity and the aim of progressive politics, they recoiled—not from the goal of social justice but from the path to it. It was not always easy for their readers to make this distinction.

These women have many overlapping biographical, artistic, and philosophical connections, though this is not an argument for influence or a description of anything like an artistic or intellectual collective. As it turns out, collectivity is something none of the women could abide, for various and significant reasons. They were also, not coincidentally, ambivalent or outright hostile to the feminist movements of their days, principally second-wave feminism. I will explore the reasons for their hostility and ambivalence less as a

product of internalized misogyny or even the practical realities of succeeding in an intellectual culture that was often explicitly misogynist than as a specific set of ideas about the foundations of feminist thought, not least its relationship to emotional expressivity, its foregrounding of psychic pain, its emphasis on collectivity, and its advocacy of utopian projects. Their unsentimentality in part lies in their willingness to endure or deflect certain kinds of psychic pain, indeed in their insistence on the morality of doing so. They might, in fact, recognize these claims of oppression, but they cannot philosophically tolerate a relationship to them that permits any shared feeling about them.

Most of these women were associated in some way with the New York Intellectuals, that group of mostly male writers and intellectuals who wrote and edited the influential little magazines of the midcentury such as *Partisan Review*, *politics*, *Commentary*, and *Dissent*. McCarthy, who worked to restart *Partisan Review* after its editors broke with the Communist Party USA, and Arendt, who quickly began to publish in these magazines when she arrived in New York from Paris during the war, were card-carrying members of the New York Intellectuals and among the very few women whose work consistently saw print. McCarthy and Arendt also enjoyed a great and productive friendship, which is why their chapters here overlap in ways the others do not. Simone Weil, who died before the end of the war, was first published in the United States in *politics*, having been translated by McCarthy. Weil was a "patron saint" for certain of the New York Intellectuals, in particular Dwight Macdonald, and she is in many ways a presiding spirit, and a limit case, in this book. Sontag was a second-generation New York Intellectual whose tastes and objects of study were so foreign to the older generation that her time there was limited, and she rarely socialized among them. Didion falls into the orbit of this group by way of her work for the *New York Review of Books* and the patronage of Elizabeth Hardwick, a friend of McCarthy's and Arendt's and a New York Intellectual herself. Hardwick edited the *New York Review of Books*, which absorbed and slowly took the place of the little magazines after the sixties. Diane Arbus, a much more solitary figure, came to renown posthumously and not least because of Sontag's review of her one-woman show at the Metropolitan Museum of Art and the book that it inspired, *On Photography*.

Their paths cross, sometimes run parallel, and they are connected by degrees of personal relationship. For my purposes, they are affiliated more closely by style and shared sensibility than they are by biography, though biography is nonetheless part of it. This is not, however, a book about the New York Intellectuals. The New York Intellectuals produced the intellectual magazines of record, so to speak, of the US midcentury; these magazines,

read across a spectrum of political belief and investment, provided a forum for serious cultural, aesthetic, and political work for the professional thinker, to use Arendt's term, and the nonprofessional alike. There were few places an intellectual could find an audience and engage with other intellectuals and hope to have an influence outside this circle except in academia. Most of these women criticized, sometimes mocked, academic style and specialization even though several of them—McCarthy, Sontag, and Arendt—needed to teach to support themselves. The point is, for most intellectuals of the period, these magazines were the place to publish, even more so for women intellectuals if they did not want to or could not hold academic appointments, which were hardly plentiful for women before the 1980s. They also did not want to specialize. Scholars today do not generally prize the insight of the nonspecialists of their own era.

Of course, their style and sensibility also made them successful in this milieu. That they were not overtly feminist or distanced themselves from feminism certainly did not hurt their careers and probably helped them, though Sontag published "The Third World of Women," her most polemical essay on the condition of women, in *Partisan Review*.[15] McCarthy and Arendt fell afoul of their male colleagues for their toughness, not their sentimentality or softheartedness. McCarthy's graphic (for the time) sexual farces offended her male friends and colleagues, and she wounded several of them seriously in her autobiographical fiction by drawing their all-too-recognizable and all-too-unpleasant caricatures. Arendt was roundly and sometimes viciously attacked by the New York Intellectual cohort for *Eichmann in Jerusalem*.

Their embrace of painful reality does not mean that these women were pessimists. Indeed, as bleak as their message often was, most of them were neither pessimists nor optimists. They fancied themselves realists of a certain kind. Moreover, their own experiences of utopian optimism had a profoundly chilling effect on them. If they were not pessimists, they were robustly anti-utopian. Utopianism, very simply, violated two rules of their creed: that reality must be faced in all its complexity and pain; and that the outcome of any action is unpredictable. One simply cannot know the results, especially of complex political and social actions, and so the moral judgment about that action has to stand on its own, not be wagered against an outcome. Nonetheless, with several of these women, there is a surprising *amor mundi* that subtends their ethics and discipline of accuracy, a love of the world in all its complications, ambiguities, ambivalences. This *amor mundi* helps explain why they were able to sustain their projects over long periods and in the face of dispiriting changes in public life.

With the exception of Sontag, none of these women are known as aes-

thetic theorists, but they all, under the pressure of circumstance, had to for-
mulate an aesthetic theory that comes to grips with the ethical dilemmas of
representing painful reality. This theory is often (but not always) explicit, and
the demonstrations of it in action make up the work of the following chapters.
The methodology of this book takes its cue from a small reference to Theodor
Adorno in Michael Taussig's book *The Nervous System*. Taussig calls for un-
derstanding "contiguous" with representation—that is, "giving oneself over
to a phenomenon rather than thinking about it from above."[16] I'm trying to
think about the literal meaning and the patterns across their work that help
to excavate what is not always explicit but often embedded in their thought
and practice. We might call this what Sharon Marcus and Stephen Best have
termed "surface reading," with all its commitment to the verbal structure of
literary language; the embrace of surface as an affective (or, in this case, not
very affective) and ethical posture; surface as a practical description; surface
as patterns within and across texts; surface as literal meaning—what Marcus
called simply "reading."[17] Surface alone, however, cannot bring us closer to the
model of engagement the texts offer. Because I focus primarily on essays and,
in one case, photographs and photographic essays, the contexts that spurred
their reflection have to be taken into consideration.

The book doesn't follow an overarching theory of unsentimentality. It
instead attempts to inhabit the thought and practice of these expert practi-
tioners of that sensibility in the hope that the intimate public sphere—or the
compassionate public sphere, as Lauren Berlant names it—will have alterna-
tives, since this public sphere (as she shows) seems to be neither genuinely
intimate nor effectively compassionate.[18] A corollary hope is that we will know
the costs and benefits of these alternatives. For these women, unsentimen-
tality is not a cure or even a palliative to the suffering that consumes our
headlines and newsfeeds. Its offers a troubled and troubling encounter with
the shared world that produces such suffering. Facing facts in the terms laid
out here does not mean simply knowing them, which is why the aesthetic
component of this project is so important. If facts alone could lead us to the
promised land—facts about climate change, gun violence, terrorism, war,
racial prejudice, economic inequality—then we already live in a paradise of
facts. The problem is not that we do not know what is happening but that we
cannot bear to be changed by that knowledge. The women I discuss in the
following pages all insist that we should be changed, however much we give
up in the process.

# Simone Weil: Thinking Tragically in the Age of Trauma

> I should not love my suffering because it is useful;
> I should love my suffering because it is.
> SIMONE WEIL, *Gravity and Grace*

## The Mysterious Appeal of Simone Weil

In 1951 and 1952 three books by a French woman—a writer, teacher, philosopher, labor activist, and Jew turned Christian mystic—were translated into English. Obscure to the English-speaking world and only recently well known in France, Simone Weil had died at thirty-four in London of tuberculosis and self-starvation, having published around fifty essays in small leftist and factory journals over the eleven years preceding her death in 1943.[1] Several years before this more dramatic and well-publicized arrival in the United States, Weil's work had been translated for the first time into English by then little-known novelist and critic Mary McCarthy. In the summer of 1945, as US forces dropped atomic bombs on Hiroshima and Nagasaki, McCarthy brought her typewriter to the beach on Cape Cod to work on her translation of Weil's "The *Iliad*, a Poem of Force," a meditation on violence and its inexorable logic of inclusion: everyone, conqueror and conquered, is its victim, alternately and simultaneously. The essay, which was published in the little magazine *politics*, remains in print in several editions today.[2] McCarthy would later recall that her prolonged encounter with Weil's essay marked the end of her "thinking in opposites." Dwight Macdonald, the editor of *politics*, once remarked that "The *Iliad*, a Poem of Force" was the best thing the magazine had ever published.[3]

Weil might have been unknown to a mainstream audience of readers before her death, but she enjoyed an enthusiastic, if coterie, readership among European leftists, many of whom fled to the United States during the war. Her leap from obscurity to renown could hardly have been predicted, but the admiration she inspired among readers of the French literary magazine *Les cahiers du Sud* certainly makes sense of her appeal to US intellectuals, though it in no way forecasts the surprising scope of her impact nor its in-

ternational, aesthetic, and political range. Elizabeth Hardwick, reflecting on
Simone Pétrement's biography of Weil published in the early 1970s, noted
the profound effect Weil had on Hardwick's circle of friends, the so-called
New York Intellectuals and *Partisan Review* crowd.[4] Some have called Weil
the "patron saint" of *politics*.[5] The appreciation of what Hardwick calls her
"spectacular and in many ways exemplary abnormality" was hardly confined
to this group.[6] A short list of those who counted her as an influence includes
five winners of the Nobel Prize in Literature (André Gide, T. S. Eliot, Albert
Camus, Czesław Miłosz, and Seamus Heaney); philosophers Georges Bataille,
Michel Serres, and Iris Murdoch; theologians Reinhold Niebuhr and Paul Til-
lich; Catholic writers Flannery O'Connor and Thomas Merton; two popes
(John XXIII and Paul VI); political activists and writers Dorothy Day, Ignazio
Silone, and Adam Michnik; and poets of diverse styles, including George
Oppen, Geoffrey Hill, Anne Carson, Stephanie Strickland, Fanny Howe, and
Jorie Graham, several of whom (Carson, Strickland, and Graham) have writ-
ten full-length books of poetry devoted to her.[7]

Although all Weil's work would appear in print over the next forty years,
these first books, like the *Iliad* essay, derived from Weil's postconversion writ-
ing. *Waiting for God* and *Gravity and Grace*, published by La Colombe and
Plon respectively,[8] were both assembled and edited by Catholic friends who
admired her saintliness. Their appearance and that of her *Need for Roots*, pub-
lished under the Gallimard imprint and in the series Espoir, represented the
editorial decision of her literary executor, Albert Camus, whose moral stat-
ure and literary fame were at their peak in the early 1950s.[9] Weil had quickly
won an impassioned following in France, and her translation into English
generated a similar response in the United States. The nature of these three
works does not immediately suggest their potential for wide demand, how-
ever. Though Thomas Merton's *Seven Storey Mountain*, a spiritual autobiog-
raphy that culminated in his vow of silence and entrance into a Trappist mon-
astery, claimed the number 3 spot on the nonfiction list of 1949, the list for
1952 contained a sampling more representative of the era: at number 1 was the
Holy Bible: Revised Standard Version, an adaptation of the King James Bible
that critics and scholars derided;[10] at number 2 was a memoir written by the
wife of Rev. Peter Marshall, who rose from humble origins to become chap-
lain of the US Senate only to die at forty-six; at number 6, with a bullet, was
Norman Vincent Peale's *Power of Positive Thinking*, a religious self-help book
that went on to sell twenty million copies. *Waiting for God*, by contrast, was a
collection of letters and short essays written by Weil to her spiritual adviser,
Father Perrin, on subjects like her refusal of baptism, the faculty of attention,
and the love of God and affliction. *Gravity and Grace* was a selection from her

notebooks of aphoristic, even gnomic entries on concepts key to her evolving theology. *The Need for Roots*, the last thing she wrote before her death, was commissioned by the Free French movement in London to provide a plan for the renewal of France after the war.

As David McLellan has argued, Weil was introduced to a broader public as a religious mystic, not a political radical, though she was both.[11] While there is a different focus in the early and the late Weil (if one can say "late" about a writer who died at thirty-four), many of her most important ideas germinated in her experience as a laborer and activist on behalf of France's factory workers.[12] Working in factories outside Paris "gave [her] the mark of a slave," as she says of herself and as all her biographers note, permanently changing her outlook on suffering and fueling her conversion. Her physical frailty and nearly incessant migraines, which made factory work all the more excruciating for her, contributed to her obsession with and clarity on the subject of suffering, but physical pain was only one component—and considered by her the least important—of the myriad forms of suffering to which she attended.

The turn in her later work toward suffering has been mostly taken up by her Christian explicators, no matter how eccentric her thoughts on the subject are to Christian doctrine. Readers interested in her politics have largely avoided this aspect of her work, leaving it untouched (and untouchable) as a symptom of psychological imbalance, her mystic Christianity, or her pessimism in the years following the Nazi occupation of France. The Christian accounts tend to think of Weil's suffering and her sacrifice on behalf of others as evidence of her saintliness; the political accounts, while usually admiring, tend to set these aspects aside as evidence of her masochism. In other words, Weil's embrace of and attention to suffering has been something not to explain but to explain away. Taking an agnostic view of her saintliness and her masochism, this chapter will examine Weil's emphasis on suffering as her infusion of tragedy into both the religious and the political traditions in which she worked. I want to argue that it is not suffering per se, but the tragic view of suffering that scandalizes both Christianity and the leftist political movements in which Weil worked. The bifurcation of her reception over the last sixty years has essentially treated the two passions of Weil's life—politics and religion—as separable, perhaps at times even opposed. Tragedy puts them back into a mutually illuminating dialogue. Weil's signature and most scandalous essay, "L'amour de Dieu et le Malheur," which has always been translated into English as "The Love of God and Affliction," might also have been translated as the "The Love of God and of Tragedy." Thinking about the love of tragedy synthesizes Weil's peculiar theology and politics and elucidates her critique of secular modernity.

It's worth speculating against her contemporary critics that it was not de-
spite but because of Weil's tragic outlook that she found an audience in the
postwar United States and Europe in the early 1950s. If the publication of
her religious writing fed the appetite whetted in both France and the United
States by the religious revival of the postwar era, US reviewers were, nonethe-
less, unanimously baffled by her popularity. No one seemed able to imagine,
especially given the religious climate of the time, why a writer who embraced
suffering like Simone Weil should find any kind of popular readership. Think-
ing about Weil's reception in the context of the religious revival of the late
forties and early fifties provides some outline of what was both threatening
and mystifying about her and her tragic outlook. Postwar American culture
is thought by some historians to exhibit something like post-traumatic stress
disorder.[13] As one version of this story goes, Americans turned inward toward
domesticity in its most conventional form, in what Elaine Tyler May persua-
sively describes as a bomb shelter mentality.[14] The embrace of normalcy—
often under coercively normalizing terms—was a post-traumatic effect, the
outcome of decades of dislocation, deprivation, and loss during the depres-
sion of the 1930s and the mobilization of World War II. Accounts of the reli-
gious revival that followed World War II also detect the traumatized inward
turn that explained domestic patterns of the fifties. Robert Wuthnow echoes
May when describing the surge in church membership in the 1950s. Instead of
the bomb shelter, Wuthnow calls the church a "fortress," but he makes of it the
same analogy in order to draw the same conclusions.[15] Americans retreated
into the fortress of institutional religion in which the house of worship offered
the same virtues as the idealized fifties home—strong father (clergy), com-
forting mothers (welcoming congregations)—to keep at bay dangerous out-
siders and protect themselves from a hostile and unfamiliar postwar world.
The immediate postwar religious revival, it should be remembered, arose
primarily within organized religion (as opposed to the revival of the sixties,
which largely eschewed traditional worship for more syncretic and idiosyn-
cratic forms of devotion). Buttressing this fortress was popular religious writ-
ing, which sold comforting images of the afterlife, uplifting stories of "positive
thinking," and bromides on the peace engendered by religious practice.

However, as Robert Ellwood suggests, the fifties religious revival was bi-
furcated into "highbrow" and "lowbrow" (or more accurately middlebrow)
forms, with popular religion offering a more saccharine version of religious
devotion than more scholarly theologians like Reinhold Niebuhr, Paul Tillich,
Thomas Merton, and, of course, Simone Weil. They, too, enjoyed large audi-
ences of readers, though not the many millions of Norman Vincent Peale.[16]
The emphasis on personal happiness and success in mainstream religious

culture was openly disdained by the leaders of this parallel religious revival.[17] When *Waiting for God* was first published in English, Weil was immediately hailed by intellectuals, most importantly by literary critic Leslie Fiedler, as "our kind of saint": "the Outsider . . . Saint in an age of alienation." Encompassed in this "our" were "Catholic and Protestant, Christian and Jew, agnostic and devout," and especially those who remained at the threshold of belief—the "unchurched."[18]

Weil's theology was perfectly *un*suited to the times if we understand organized religion to offer consolation and comfort. Her personal austerity, her insistence on suffering and the limits of human agency, her embrace of affliction, her uncompromising vision of the obligation of justice, her refusal of compensation and consolation in any form, all remove her from the mainstream of religious thought. Fiedler marked her "Un-Americanness" in his essay on Weil in *Commentary*, which became the basis of his introduction to *Waiting for God*. Excerpted heavily in *Time* magazine and elsewhere in 1951, Fiedler's essay suggested precisely why Weil would *not* find an appreciative audience in the United States: "This is a difficult doctrine in all times and places, and it is especially alien and abhorrent in present-day America where anguish is regarded as vaguely un-American, something to be grown out of, or analyzed away, even expunged by censorship; and where certainly we do not look to our churches to preach the uses of affliction. It is consolation, 'peace of mind,' 'peace of soul,' that our religions offer on the competitive market place."[19] Invariably, reviewers commented on the harshness of her vision, often contrasting it to the "stale smell of sweets" emanating from other religious writing of the day.[20] In the *New York Times*, John Cogley observed that "the notion that religion holds the key to peace of mind . . . would have revolted her,"[21] while Anne Fremantle noted that "there is nothing kind or comfortable about her encounters with God."[22] And yet, despite the warning labels that every review carried about Weil's austerity and extremity, her work *did* find an audience. While public intellectuals believed that they understood the implications of Weil's thought, they assumed that mainstream readers did not. This is in part good old-fashioned elitism and in part genuine puzzlement that popular audiences could accept Weil's message or the form in which it was conveyed.

Unable to account for her appeal, reviewers turned to biography, a far-from-surprising impulse when it comes to women writers of the last century. Pointing to the moments when she demonstrated her radical empathy with some affective intensity, reviewers argued that it was her compassion and her life story that accounted for her "vogue" beyond the more limited circle of professional intellectuals. But this kind of sentimental identification would have

been difficult to sustain upon even the briefest encounter with Weil's work. The coldness of her style and the unwavering hardness of her theology do not nourish expectations of warmth and sympathy. Moreover, Weil's relationship to suffering, sometimes in its most extreme forms, lies so far outside the conventions of sentiment and sympathy bequeathed by eighteenth-century moral philosophy and brought to life in the American sentimental tradition that contemporary readers, midcentury and now, would have found it utterly alien. Weil's treatment of suffering is radical and strange to the extent that it systematically eradicates feeling—feelings for oneself or the suffering other—and replaces it with something impersonal, antisentimental, and self-negating.

Whether a reader met Weil for the first time in a mass-market vehicle like *Time* magazine or the *New York Times Book Review*, a little magazine like *Commentary* or the *Partisan Review*, or a Catholic journal like *Commonweal* or *Catholic Worker*, she would have been introduced first to Weil's biography, second her style, and third her theology. All three seem to me crucial to understanding what Weil represents: the fact of her gender seen in the context of her style and her message; the particular aesthetic choices she made and the philosophy that grounded them; and the embrace of suffering that formed the foundation of her thought. *Time*'s weekly religion column of January 15, 1951, begins as follows: "By most standards, Simone Weil was an absurd and unattractive woman. Almost constantly ailing, painfully humorless and so intense she was either irritating or ridiculous, she agonized through a short life of 34 years and died in 1943 in a gesture that seemed to typify her gift for fruitless heroics" (48). As mean-spirited as this selection is, it represents only a slightly more contemptuous version of the descriptions found in more serious media, which sometimes also traffic in the stereotypes they pretend to abjure ("features almost like a Goebbels's caricature of a Jew" or "almost a caricature of the low-heeled high-brow").[23] Nonetheless, the reviews never fail to mention her possible sainthood, her sudden fame and its mystery, and the reverence the reviewer feels upon an encounter with her work. In the general-reader magazines in particular, some of the hostility directed at Weil's person spun out toward her admirers, including college students who had claimed her for their own, a great many of whom, it should be noted, were not callow late adolescents but veterans of World War II. *Time*'s phrase "by most standards" suggests that the reviewer's skepticism and antipathy speak for the magazine's target audience, who are presumed to be immune from the "fashion" or "rage" for spiritual pessimism.[24]

That such an ugly woman should be so compelling seemed preposterous, to say the least. Moreover, that this unattractive and physically fragile woman should have expressed herself with such tremendous authority seems to have

produced some confusion and irritation. William Barret, the associate editor of *Partisan Review* writing for the *New York Times Book Review*, suggests the source of this force. "Brilliant though she was, Mlle. Weil thought like a woman, and a woman intellectual, notoriously, can be more stubbornly opinionated than any man."[25] Isaac Rosenfeld in *Partisan Review* suggests that Weil's "stubbornness" was probably as much a form of coquetry as it was of conviction. He surmises that in her exchange with Father Perrin over baptism, "she wanted to be courted and come after" and that she was "careful not to terminate the courtship." Ultimately, he concludes, "This may have been the woman in her, but God knows she was lonely enough."[26] It seems almost unsporting to revisit the misogynist reactions to a woman intellectual in the 1950s, so obvious are they and so unsurprising. However, it is important to remember this context when we think of Weil's appeal because it sets up the terms of reception for the women in this book and, for that matter, women writers in general, though not always with such dramatic flair. Without exception, Weil's dogmatically and self-consciously unsentimental project had to be weighed against the fact of her gender, which carried with it expectations of sympathy. Few of her reviewers could square the intellectual force of her writing with the biographical legend of a fragile, ugly, clumsy "girl" given to excessive identification with the suffering masses. Fiedler even suggested that her writing "betrayed her into charm," which she resolutely refused in her personal life.[27] Nonetheless, "charming" is not the characterization anyone else would make of Weil's writing. Reviewers instead commented on the mathematical beauty of her prose; its clarity, balance, simplicity, transparency, and purity, and they frequently used water as an image to invoke its pleasing qualities (clear, cool, and refreshing) as well as its less inviting (icy and cold). Confronting their image of an irrationally empathic, lonely girl was her writing, with its severe, classical beauty, as well as its emotional coldness.

When a twenty-nine-year-old Susan Sontag reviewed a collection of Weil's essays in the first issue of the *New York Review of Books* in 1963, the early Cold War religious revival was at an end. Weil's commitment to suffering was so deeply eccentric to Sontag that she could account for Weil's power as a thinker only by referencing her style. Like Weil's 1950s reviewers, Sontag wrote her essay to address the question of audience, trying her hand at unraveling the mystery of Weil's appeal to her own generation, one shadowed but not scarred by the catastrophes of the midcentury. Unlike Weil's first reviewers, Sontag did not admire Weil's placement of suffering at the center of human life; she instead admired her seriousness. This essay on Weil, later collected in *Against Interpretation* (which marked Sontag's own arrival as a woman of intellectual seriousness), announced one of the important dimensions of the postwar

sensibility as Sontag understood it. Extremity and suffering were signatures of contemporary style, not because we approved the thinkers' positions, but because we respected the tenacity with which they held them. She says that she cannot believe Weil's tens of thousands of readers actually shared her "fanatical asceticism," "her contempt for pleasure and for happiness, her noble and ridiculous political gestures, her elaborate self-denials, her tireless courting of affliction." Instead, she argued, while we do not admit it, we appreciate her "rudeness." The "culture-heroes of liberal bourgeois civilization" are the "writers who bear witness to the fearful polite time in which we live" by being "repetitive, obsessive, impolite." It is, she says, "mostly . . . a matter of tone" that marks these heroes, because their ideas are so unpalatable and untenable. In a society where sanity has become "compromise, evasion, a lie," the rude eruptions of extremity sound like truthfulness, even if what they say bears no relation to truth itself.[28] In short, Sontag does away with the warning label by itemizing Weil's difficult subject matter in order to discard it. Style alone accounts for Weil's appeal, and it is neither charming nor beautiful but rude, intemperate, and fanatical. Gone is the sentimental empathic girl, and in her place is the virago.

If no American reviewers could locate the source of Weil's appeal, Italian anarchist and intellectual Nicola Chiaromonte believed he understood what made her ideas—not her lived example or beautiful prose—so arresting, at least to intellectuals.[29] Chiaromonte first discovered "The Iliad, a Poem of Force" in Cahiers du Sud during the winter of 1941 while he was a refugee in the South of France awaiting transport to North Africa and where he began his friendship with Camus. This small, literary essay by an unknown writer, Emile Novis (Weil's pseudonym), stunned him, and it was Chiaromonte who later introduced her to politics editor Dwight Macdonald and convinced Mary McCarthy to translate the essay. In Il Mondo in 1953, Chiaromonte noted that he was "happy to see how profoundly [the essay] could affect a readership of New York radicals, people not especially concerned with ancient Greece and, to all appearances, interested exclusively in ideological controversy." He had thought few American readers would find the essay relevant, since he assumed they were more interested in putting "force" to "theoretically 'good'" uses after the bombing of Hiroshima and Nagasaki. Instead, in his terms, Weil had produced a "geometry of force" that "is necessarily the study of human destiny, of what it is in the world . . . that defies man's desires, will, and audacity."[30] Chiaromonte understood the essay as a confrontation with the limits of human agency seen "without any comforting fiction, without any consoling prospect of immortality."[31] Without using the term, Chiaromonte was pointing to Weil's tragic sensibility.

Weil's insistence on the limits of human "desires, will, and audacity" could be seen as the exact opposite of popular religious literature with its emphasis on control and mastery. *The Power of Positive Thinking*, to take the most obvious example, offers a midcentury installment in a long tradition of American religious appeals to spiritual self-making. Norman Vincent Peale promises that by using his techniques, like "'imagineering' . . . the use of mental images to build factual results," one could "modify or change the circumstances in which you now live, assuming control over them rather than continuing to be directed by them."[32] For Weil, who distrusted the imagination, suffering imposed reality on the mind, which was all too given to avoiding reality altogether. "We must prefer real hell to an imaginary paradise," she said in *Gravity and Grace*.[33] The bomb shelter or fortress mentality of the period likewise does not readily admit the risks of chance and unpredictability, much less blind necessity. The desire to retreat into a private and sheltered sphere protected by impenetrable boundaries is a fantasy of control and of agency. Properly guarded, no unexpected or dangerous element can disturb the equilibrium of the inhabitants. However, because the borders can never be sealed perfectly, this fantasy of agency and control is inherently anxious.[34] Everywhere in the cultural landscape of the postwar period there are metaphors of leaky membranes containing, or failing to contain, the nation, the mind, and the body, which allowed the first scholars grappling with the late twentieth century to borrow the term "containment" from Cold War foreign policy to describe the arts and mass culture.[35]

If we consider the crisis in agency of the citizens of the most affluent and powerful nation on earth, Weil's critique of agency becomes both harder and easier to understand. On the face of it, Weil's insistence on the extreme helplessness of human beings seems strikingly inapt for sovereign and self-creating liberal subjects of the newly preeminent United States (or their anxious alter egos who seemed to seek everywhere some reassurance of their own potential mastery). And while Weil's emphasis on limits pairs her neatly with the era's realists—moral, theological, political, and literary—and with their existentialist counterparts, her tragic sensibility goes beyond their notions of the limit, however stark and pessimistic they might seem.[36] However, we might speculate that her insistence on agency's inevitable failure removes its stigma. We might even imagine a kind of paradoxical comfort—cold comfort, perhaps—that might be derived from contemplating the ordinariness of human vulnerability. The way to understanding Weil's refusal of mastery, which is the foundation of her tragic sensibility, depends upon her notion of suffering and its related terms—fate, affliction, blind necessity—all of them taken from ancient Greece or at least from what she perceives to be the Greek

tradition's bequest to posterity. In order to understand this, we need to understand what it meant to think tragically in an age of trauma.

## Thinking Tragically in an Age of Trauma

After the war, questions about limits and mastery, human perfectibility, and social utopianism could be found everywhere in aesthetic, intellectual, and political life. The turn toward various "realisms" and their emphasis on limit rather than transformation, modification rather than revolution, represented a chastening of the progressivism of the 1930s and a revulsion against what Hannah Arendt defined as the utopian projects that subtended totalitarianism in Nazi Germany and the Stalinist Soviet Union. One way to understand this new modesty of aim is to view it as resulting from a tragic mentality. For any number of thinkers from the existentialists to the Christian realists, to political and moral theorists, in the arts, in literature, and on the stage, limit and the tragic realization of human failure stamped the moment into which Weil's work appeared.

Questions more specifically about the dramatic form of tragedy—whether it was appropriate to the twentieth century or whether and how it could be adapted to the conditions of modernity—preoccupied writers and critics from the late 1940s to the 1970s. From essays like Arthur Miller's "Tragedy and the Common Man" (1949) to Camus's "On the Future of Tragedy" (1955) to full-length treatments like George Steiner's *The Death of Tragedy* (1961) and Raymond Williams's *Modern Tragedy* (1966), not excluding less influential works like Lionel Abel's *Metatheater: A New View of Dramatic Form* (1963) and scholarly treatments of the form, what was at stake in thinking about tragedy was not just the form's history but the capacity of twentieth-century dramatists and audiences to accept its bitter terms.[37] What makes the question of tragedy's death difficult to plumb is the understanding shared or invoked by a great many writing on the subject: dramatic tragedy was exceedingly rare, appearing in Western culture only twice, once with the Greeks in the fifth century BCE and once during the sixteenth and seventeenth centuries in England and France with Shakespeare and Racine. Moreover, there was an ongoing debate as to whether Shakespeare ever wrote, or wrote more than one, genuine tragedy.[38] So if twenty-five centuries of Western civilization had produced two eras when tragedy flourished spaced two thousand years apart, how could anyone determine whether tragedy was dead or was merely enduring one of its prolonged periods of dormancy? What spelled the end of the *possibility* of tragedy? This question was posed not in aesthetic but in moral terms: Was modernity with its notions of human perfectibility able to accept the limits of

human agency? Was the modern world doomed if it could not? Could modern societies accept that suffering was not entirely remediable or escapable without concluding that they could brutalize their enemies or even their own citizens? Tragic drama was implicitly both a reflection of the superior moral capacities of an earlier age and a source of those capacities, a place where they were honed and fortified by the contemplation of limit and suffering.

Weil's late work can be considered another of these meditations on tragedy, one that spelled out the moral and spiritual requirements of its embrace. Indeed, she tried her hand at writing a dramatic tragedy—*Venice Saved*—the most ambitious of her creative work, which also includes a small number of not-very-successful poems. She began writing this play shortly after she and her parents had fled Paris, and she continued to work on it during her exile in Marseille, New York, and London up to the final weeks of her life.[39] It was never finished. Nonetheless, Weil interleaved her work on this dramatic tragedy with much of her best-known writing: her notebooks and the essays derived from them, such as "The Love of God and Affliction," *The Need for Roots*, and "The *Iliad*, a Poem of Force."

In *French Studies* in 1977, J. P. Little (who would go on to write several books on Weil) compared *Venice Saved* with Camus's *Les justes* to determine whether either writer had achieved a real tragedy. He concluded: "Tragedy needs the sort of complete abandonment in affliction which Simone Weil has given Jaffier. Death alone is insufficient; affliction needs the total destruction of the individual, including his ideals and his self-esteem. This kind of fate cannot be chosen."[40] Despite noting that much had been written on the subject of tragedy in the late twentieth century, citing Steiner and Williams as well as Jean-Marie Domenach (*Le retour du tragique*, 1963), Little eschews the traditional and generic definitions that were then being tested and instead substitutes Weil's term, "affliction," as tragedy's essence. I want to use Little's observation to define Weil's late work as a tragic mode (as opposed to genre), to borrow a term from Rita Felski, one that unifies Weil's late work within an aesthetic rooted in tragedy.[41] Her turn toward the tragic mode, which followed her year of factory labor and the mystical experiences that came shortly thereafter, redefined her politics and her idiosyncratic Catholicism. Over the six years from "Factory Work" (1936) through *The Need for Roots*, it is not suffering alone but its limit case, affliction, that clarified Weil's Christianity and her political engagement.

Weil takes from the tradition of tragedy almost exclusively the Greek notion of necessity and the capacity (or lack thereof) to recognize oneself as vulnerable to its blind mechanism. She has little interest in other aspects of the genre: catharsis, the self-division of the protagonist, or the competition

between morally equal values, for instance. However, according to nearly all the writers on tragedy at the midcentury, the Judeo-Christian traditions were not amenable to the irrationality and meaninglessness of blind necessity. Christianity's redemption narrative explained, made meaningful, and ultimately compensated suffering, which supplies the optimism ultimately destructive of tragedy as a form. Reinhold Niebuhr, the foremost theologian of Christian realism in the postwar era, takes this for granted when he begins his chapter "Christianity and Tragedy" in *Beyond Tragedy: Essays on the Christian Interpretation of History*, written before the war (1937): "Jesus is, superficially considered, a tragic figure; yet not really so. Christianity is a religion which transcends tragedy. Tears, with death, are swallowed up in victory."[42] It is a contradiction, then, to say that Simone Weil espoused a tragic view of Christianity since it would appear that this is a logical and theological impossibility.[43]

While it is difficult to read any few pages of her work and not be reminded of her reverence for the ancient Greeks (especially Homer, Plato, and Pythagoras) or her violent and irrational hatred of Roman and Hebrew civilization, which she considered the precursors to modern totalitarianism, Weil's devotion to ancient Greek culture does not in any way predict her absorption in its tragic sensibility.[44] Toward the end of the essay "The *Iliad*, a Poem of Force," Weil draws a genealogy of Greek literature that begins with Homer's epic, for her the only true epic, and ends with the Gospels. Its middle term is Attic tragedy, especially that of Aeschylus and Sophocles. Homer bequeathed to the tragedians and they to the writers of the Gospels the tragic notion of blind necessity that is the kernel of Greek culture she wants to nourish. What was, then, the "good news" of the Gospels? How can blind necessity, not redemption, be good news?

Camus, who was Weil's literary executor, might have learned from her work when he made an exception to the impossibility of Christian tragedy: "Perhaps there has been only one Christian tragedy in history. It was celebrated on Golgotha during one imperceptible instant, at the moment of: 'My God, My God, why hast thou forsaken me?'"[45] This tragedy, Christ's moment of despair on the cross, is the subject of "The Love of God and Affliction," the first half of which was published posthumously in *Waiting for God*; the second half, found among her papers long after her death, was published in *Pensées sans ordre concernant l'amour de Dieu* in 1962. In this essay, Weil is, of course, discussing, not theater or questions of genre, but theological imperatives derived from the experience of extreme suffering, whose best example is the Crucifixion. Nonetheless, the terms she uses derive from Greek tragedy.

Synthesizing the thought experiments in her notebooks, Weil creates a careful taxonomy to distinguish suffering from affliction/tragedy: "Christian-

ity is not concerned with suffering and grief, for they are sensations, psychological states, in which a perverse indulgence is always possible; its concern is with something quite different, which is affliction. Affliction is not a psychological state; it is a pulverization of the soul by the *mechanical brutality of circumstances*" (*SWR*, 462, emphasis mine).[46] The suffering from which affliction must be distinguished is that which is ordinary—in her phrase, "not surprising":

> It is not surprising that the innocent are killed, tortured, driven from their country, made destitute, or reduced to slavery, imprisoned in camps or cells, since there are criminals to perform such actions. It is not surprising either that disease is the cause of long sufferings, which paralyze life and make it into an image of death, since nature is at the mercy of the blind play of mechanical necessities. But it *is* surprising that God should have given affliction the power to seize the very souls of the innocent and to take possession of them as their sovereign lord. At the very best, he who is branded by affliction will keep only half his soul. (*SWR*, 441)

Instead of extreme pain, grief, loss, poverty, or terror, affliction/tragedy must be composed of three things: "There is no real affliction, unless the event which has gripped and uprooted a life attacks it, directly or indirectly, in all its parts, social, psychological, and physical" (*SWR*, 440–41). And there is no exemplary state of affliction, save Christ on the cross, because individuals can experience the same things and not be "pulverized" or turned into a "half-crushed worm" (*SWR*, 441). Affliction can be seen only in its effects: it leaves its victims wordless; it plunges them into disgust and self-hatred; it makes them incapable of attending to others, either those afflicted like themselves or those who offer help; it makes them complicit in their suffering by poisoning them with inertia; it renders them repulsive to themselves and others. And yet, she concludes that affliction is "the surest sign that God wishes to be loved by us; it is the most precious evidence of his *tenderness*" (*SWR*, 463, emphasis mine). It is easy to see how Weil won a reputation for masochism.

Arguing that affliction is "the center of Christianity" (*SWR*, 471), Weil maintains that it is Christ's agony on the cross that is God's love, not the salvation Christ's sacrifice made possible, which is for her a compensation that makes affliction bearable, which it should not be. Affliction thus allows her to address her great quarrel with the Catholic Church, which is *anathema sit* (which is a denunciation, a declaration of evil, and a banishment from not only the church but from the community of the faithful). Weil remains "unchurched" in solidarity with all the excluded, living and dead, who had been banished or who had never been saved by Christ, whether because they lived

before his birth, outside the range of church evangelism, or practiced other religions, especially in Europe's colonies. Her heresy was to claim that instead of redemption, tragedy was proof of God's divine love: "Any man, whatever his beliefs may be, has his part in the cross of Christ if he loves truth to the point of facing affliction rather than escape into the depths of falsehood" (*SWR*, 463). Since tragedy was universal, so too was Christianity even if its core precepts might take different forms in different times and cultures.[47] Affliction then becomes the truly "catholic" part of Catholicism. This universalizing gesture might look very similar to Adam Smith's system of moral sentiment and sympathy: all humans feel pain. But two things should give us pause. First, as Weil has defined it, affliction is not pain but pulverization, since she put aside the "not surprising" pain of war or illness. Second, affliction must be endured, not redressed. It most specifically does not secure the sympathy of others but, without supernatural grace, elicits their revulsion. Affliction imposes not a duty to relieve pain but a system of obligations, as she would spell out in *The Need for Roots*, to prevent human or social *complicity* in affliction. Affliction is the mark of *God's* "tenderness"; it does not draw forth our own.

## Living with Tragedy

Tragic Christianity reshaped, but it did nothing to fundamentally alter, Weil's politics. A leftist writer and activist for her entire adult life, Weil did not abandon the causes to which she had devoted her life before her conversion, but of necessity her efforts in this regard were redirected during the war. Tragedy, however, determined the parameters of her thinking, her methods of writing and action, and the horizon of her expectations. George Steiner, in his introduction to *The Death of Tragedy*, argued that Marx, with his Jewish faith in reason and justice, "repudiated tragedy," attributing to Marx the statement "Necessity is only blind in so far as it is not understood" (although the phrase comes from Hegel).[48] Weil herself amended another of Marx's famous axioms to "Revolution, not religion, is the opiate of the people."[49] Revolution is a painkiller because it promises a world free of blind necessity, one in which suffering will somehow be excluded or, at the very least, be preventable and curable. Weil ardently believed that modernity only deepened the failure to acknowledge necessity, which proved the universal helplessness of men as mortal beings, and that modernity obscured the human inability to control force, which inevitably resulted in the domination of others. Believing that the world could be perfectible was a mistake with grave implications. It led to hubris, the tragic flaw par excellence, which many Christian realists proclaimed after World War II. More importantly and specifically to Weil, losing

a tragic sensibility produced disdain for the powerless, which permitted the powerful to treat people like things, as she argues in "Factory Work," or to make them into things, corpses, as she says in her essay on the *Iliad*. Marx's belief that the working class could hold the monopoly on power, and with it force, and not be subject to its delusions was for Weil a dangerous fantasy to hold out to suffering people.

She did not lack faith, however, that oppression was subject to human intervention. Eliminating or curtailing oppression was necessary so that tragedy could serve its *theological* purpose, decreation, which Sharon Cameron defines as "losing all personal being . . . to produce a void that could receive supernatural grace."[50] In the last year of Weil's life, she brought this tragic sensibility to politics in *The Need for Roots*, the only full-length book of her career, and the essay "Human Personality," which runs closely parallel to it. *The Need for Roots* infuses her tragic theology into her political analysis of France's capitulation to the Nazis and the set of concrete, sometimes-minute suggestions for reestablishing a just society after the war. Having come to her theology of blind necessity, which claims the moment of extreme helplessness, agony, and humiliation as a person's moment of grace, Weil returned to the political realm to devise a plan for living tragically.

In the opening of *The Need for Roots*, Weil discarded the very term that would come to symbolize justice and social progress by the end of the 1940s: human rights. Instead, she insisted on the "obligations" of human beings, and of their social and political institutions, to other human beings. Rights, she argued much in the way Arendt later would, always required someone to recognize them; obligations, in contrast, were nonnegotiable and therefore applied universally (to fail in one's obligation was to commit a crime). Moreover, a system of rights recognizes and values the sovereignty of the individual, which Weil's sense of tragedy drastically compromises. It is a person's fundamental lack of sovereignty, by which I mean her subjection to mechanical necessity and theological obligation to decreate, that precedes obligation. In Weil's rigorously logical way, she was composing a binding obligation, having established human nonsovereignty; sovereignty could only be an object of self-delusion. Obligations put the onus on the community, which must not be complicit in affliction, though affliction will always and must necessarily exist. Decreation is a theology of nonsovereignty; for Weil, the sovereign individual can only ever be a fantasy, one that is maintained with all the forms of self-delusion, self-aggrandizement, and hubris that create oppression. To be obligated is to acknowledge one's own and others' nonsovereignty, to create the conditions of its theological work, not to speed it along or contribute additional pain and suffering.

For Weil, there is no way to abolish the fantasy of human perfectibility that produces the modern dreams of individual agency and social utopia if pain is feared, hated, shunned, and avoided. This aspect of Weil's work has always been difficult for her critics to assess. As Talal Asad has argued in his anthropology of secularism, "in the sense of suffering, [pain] is thought of as a human condition that secular agency must eliminate universally."[51] For Weil, pain is the ground on which fantasies of human agency and human sovereignty are smashed. Pain is where the world in its brute materiality, its not-me, enters the person. Even the body is the not-me. To paraphrase Weil, pain is how we know we are not everything, that we are therefore limited. Paradoxically, living with pain—that is, not welcoming it (she claims she does not believe in martyrdom) but understanding oneself as vulnerable to it— engenders a more just world. But what does it mean to live with pain, not just our own, but that of others?

In Weil's "Human Personality," which similarly attacks rights, she turns to *Antigone* to make her case. The afflicted need language to make their oppression visible and knowable, and their best models are Homer, Aeschylus, Sophocles, the Shakespeare of *King Lear*, and the Racine of *Phèdre*. In other words, the afflicted need the tradition of tragic literature (for her, Homer is a tragedian) to formulate a response to their condition in a political world, not so their listeners can sympathize or enjoy the catharsis of theatricalized pain. Weil had come to believe that suffering was extremely difficult to see and to communicate in something of the terms Elaine Scarry has made familiar: "to have pain is to have certainty; to hear about pain is to have doubt."[52] Indeed, a preoccupying question of the late essays and journals is the communicability of suffering. But given her recourse to the literary tradition of tragedy, Weil is less concerned than Scarry is with pain's shattering of language. It's crucial, therefore, to understand how Weil's sense of language contributes to the elaboration of her tragic mode in both theological and political contexts and how the language of and the attention to suffering necessitate painful clarity. In her elaboration of the tragic mode, she questions what we call empathy or sympathy.

There are several ways to understand Weil's aesthetic and its ethical foundation: through her commitment to democratic inclusiveness; through her understanding of the relationship between power and language; through her notions of the decreation of the self; and finally, through her portrayal of suffering and its tragic limit case, affliction. I'm going to call this "clarity," which served her political ends, and "painful clarity," which served her goal of reviving the tragic sensibility for the twentieth century.

Given the importance of style to the reception of Weil—whether it is

mathematical beauty or the unreasonable tenaciousness that Sontag finds compelling—it is not surprising that Weil herself had very carefully considered her aesthetic goals. Gustave Thibon, with whom Weil lived in the South of France while awaiting transport to the United States, wrote a frank introduction to *Gravity and Grace* in which he addressed Weil's personal communicative style. Having come to some intimacy with her—arduously, as he says—he had unique insights into her style of expression that he wanted to share. In personal conversation, "she always used to say everything she thought to everybody and in all circumstances. This sincerity, which was due chiefly to her deep respect for souls, caused her many misadventures" (*GG*, 7). Her sincerity, which might also be called her tactlessness, closely resembles her writing style, where concreteness and clarity take precedence over the writer's relationship to the reader or the reader's relationship to the thing described. Weil did not coax her readers to contemplate death but demanded that they do it. She did not cloud or obscure the sacrifice of self that decreation required. Painful clarity hurt; she welcomed that for herself. And while Thibon excuses her tactlessness as a form of respect, Weil was not above hurting her interlocutors. Presumably, it was good for them.

She also viewed writing as another component of decreation because she imagined it as a form of self-disappearing, self-erasure. As Thibon explains, she believed "that it was impossible to attain perfect expression without having passed through severe inner purgation" (*GG*, 8). Her insistence on purity made her "pitiless" on all authors in whom she could detect the slightest inclination to draw attention to the writing itself. "For her the only thing that counted was a style stripped bare of all adornment, the perfect expression of the naked truth of the soul" (*GG*, 8). In a letter to Thibon quoted in his introduction, Weil explained:

> The effort of expression has a bearing not only on the form but on the thought and on the whole inner being. So long as bare simplicity of expression is not attained, the thought has not touched or even come near to true greatness. . . . The real way of writing is to write as we translate. When we translate a text written in some foreign language, we do not seek to add anything to it; on the contrary, we are scrupulously careful not to add anything to it. That is how we have to translate a text which is not written down. (*GG*, 8)

In this notion of writing as translation, it is easy to see how Weil intends to remove the "I" of the writer as either a person to admire or a person to identify with. The effect of this decreation is a highly impersonal style, as Sharon Cameron argues. Weil's overwhelming preference for the French pronoun *on* avoids the personal pronoun (expressions with *on* are often translated into

English with an infinitive construction).[53] The strict impersonality of address relieves the speaker of contingency and point of view, creating a voice without context or personal investment. This mode of address enhances the authority of the prose and the detachment, or "iciness," of Weil's arguments, even her most impassioned ones.

The qualities that made Weil's prose aesthetically compelling, however, also produced its psychic discomfort. In "The Love of God and Affliction," for instance, Weil strives to achieve intellectual honesty and to force it on her reader by making the unthinkable—affliction—brutally concrete. She takes the *Iliad* as her model: "Herein lies the last secret of war, a secret revealed by *The Iliad* in its similes, which liken the warriors either to fire, flood, wind, wild beasts, or God knows what blind cause of disaster, or else to frightened animals, trees, water, sand, to anything in nature that is set into motion by the violence of external forces."[54] Not only is Weil's imagery in "The Love of God and Affliction" drawn largely from the natural world, but few of the similes in the essay could not have been drawn from Homer's world. Mechanical necessity is personified as a tradesman with his forges, brands, and nails, and human beings are reduced to slaves and criminals. The most humanlike figure, the tradesman, works; conversely, slaves—who are branded, stamped, and whipped—figure the vulnerability of the flesh, its softness, and its plasticity; and the figure of the criminal, for which Weil primarily conjures punishment, represents the body's paralysis, immobility, and physical restriction rather than guilt or evil. More frequently, human beings subjected to affliction are not human at all but likened to animals or plants, living things without consciousness or conscience (which in French is the same word). Examples are almost too numerous to list: "a half-crushed worm," "a butterfly pinned alive to a tray," "an . . . animal, almost paralyzed and altogether repulsive."

Likewise, in the whole of *Gravity and Grace*, there are only these few nouns that might count as deriving from or pointing to the modern world: "anarchists," "socialism," "totalitarianism," "Europe," and "class." Their extreme scarcity makes their appearance conspicuous, even startling. This is not to assert that Weil self-styled as antimodern. She stated that "to escape" our civilization "by a return to a primitive state is a lazy solution" (*GG*, 210). Instead, decreation or writing-as-translation demanded that she void her prose (even in her own personal journal) of location, history, and cultural specificity, contributing both to its impersonality and its translatability. Among her most common metaphors or nouns of exemplification are "slave," "conqueror," "animal," "bread," "pencil," "iron," "stick," and "food," and these are never modified. Moreover, they are concrete but also general—not a particular kind of food (much less French cuisine) but food; not a dog or a cat or a goat but an

animal. There is something so basic and elemental in her prose that she creates a world that is familiar, perhaps universal, but at the same time remote. This lack of specificity makes the essay easy to translate because that lack of particularity produces, not a sense of cultural or historical difference, but merely temporal distance. And the simplicity of the nouns and their heavy use in simile and metaphor move the concreteness of her terms to the realm of generality, while their insistent bluntness keeps them from becoming abstract.

She explained her horror of abstraction in "The Power of Words," an essay that she wrote in 1937 upon returning from the Spanish Civil War and in which she compared the war in Spain and the warmongering in Europe to the Trojan War. Weil argued that abstraction created the illusion that war had any objectives whatsoever except the slaughter of those massed under a banner identified with a different abstraction. "For our contemporaries the role of Helen is played by words with capital letters. If we grasp one of these words, all swollen with blood and tears, and squeeze it, we find it is empty. Words with content and meaning are not empty."[55] Those words that were swollen with blood—and soon to swell beyond her imagination—were "nation, security, capitalism, communism, fascism, order, authority, property, democracy." To replace abstraction, which she called "murderous," she described a process of clarification that bends an abstraction toward concreteness: "But when a word is properly defined it loses its capital letter and can no longer serve either as a banner or a hostile slogan; it becomes simply a sign, helping us to grasp some concrete reality or concrete objective, or method of activity. To clarify thought, to discredit intrinsically meaningless words, and to define the use of others by precise analysis—to do this, strange though it may appear, might be a way of saving human lives."[56] This process of definition entails the relentless circling back and examination of paradox—the thing and its opposite—that so mark the notebooks. Weil works through her touchstone concepts over and over again—detachment, suffering, evil and good, beauty, affliction, decreation, death—to give them something of the feel of concreteness. Only the necessary process of clarification separates these "concrete realities" from stick, animal, and pencil. But terms such as "evil" or "decreation" are hardly concrete in the sense that "bread" and "stick" are. Attempting to make them so produces what has been characterized as Weil's assertiveness: each side of the paradox is announced definitively, only to be later revised by an equally unqualified assertion of its opposite. Nothing about this process of the repetition, redefinition, concentration, distillation, and exemplification feels speculative or tentative, which is why excerpting Weil can be so misleading. To treat theological abstractions as if they were concrete realities—that is, knowable and shareable—requires the "rudeness" that Sontag finds so compelling.

This emphasis on definition lent to her writing an impression of authority. She herself addressed this aspect of her prose in *Letter to a Priest*: "The opinions which follow have for me various degrees of probability or certainty, but all go accompanied in my mind by a question mark. If I express them in the indicative mood it is only because of the poverty of language; my needs would require that the conjugation should contain a supplementary tense. In the domain of holy things I affirm nothing categorically. But such of my opinions as are in conformity with the teaching of the Church also go accompanied in my mind by the same question mark."[57] It is not difficult to imagine, then, how her gesture toward intellectual humility could have been taken for evidence of its opposite, intellectual authority. She also wanted the same mark of respect in his answer to her letter. Her questions about the heresy of her beliefs caused in her "a painful spiritual state." But she asked, "I would like to make it, not less painful, only clearer. Any pain whatsoever is acceptable where there is clarity."[58] Painful clarity is also Weil's own aesthetic, as we saw in Thibon's remarks about her personal conversational style and as we see in the essays and notebooks she left at her death.

But there is also a political goal behind her simplicity and clarity, one that is not meant to be painful but democratic. To her essay on *Antigone*, published in a small factory journal in 1936, she appended a letter in which she stated the goals of her short essay: "If I have succeeded in my intention for this work . . . it ought to provide them all [factory director down to the humblest employee] with complete access without the least impression of condescension or of any arrangements having been made to bring the work within their reach. It is thus that I understand popularization. But I don't know whether I have succeeded."[59] The directness and clarity of this essay, and of all Weil's work, derives from its characteristic syntax: the use of declarative sentences, the grammatical preference for coordination over subordination, the emphasis on syntactic parallelism, and the frequent use of analogy (A is to B as C is to D). While this syntax pattern generates the balance and simplicity of her writing as well as its impression of mathematical rigor, it also creates a tone at once authoritative and relentless. In necessarily speculative domains like the nature of the soul or of God's love, Weil's directness and declarative assertiveness convey certainty. Rarely qualifying a thought, Weil displays an authority that demands submission rather than interlocution, as Joan Dargan argues.[60] Moreover, Weil's habit of repetition, fashioned in this declarative and impersonal mode, produces a relentless style of argumentation. Michael Ferber calls it "drumming into our minds . . . the reality of violence."[61] Weil's prose style—her austerity of word choice, simplicity and directness of syntax, impersonality of address, and repetition and redefinition—confronts its

reader with its difficult subject matter without attempting to console, coax, or persuade or to minimize or euphemize. She has fashioned a clear and confrontational style that is as much an ethics and a politics of painful clarity as it is an aesthetics specifically developed to represent suffering.

We can now return to the question of making suffering visible and communicable. If language can be made to serve, why does suffering remain so elusive? Weil first reflected on the difficulty of communicating suffering in a political essay written on behalf of factory laborers shortly before her conversion. In "Factory Work," suffering is both impossible to attend to and impossible to communicate, except, as she later notes in *Gravity and Grace*, by "ill-treating someone or calling forth his pity" (*GG*, 49). In other words, we are able to communicate suffering only by extending its reach to someone else, not through speech but through action. To actually know it and understand it requires language, but more importantly the mental capacity and the tenacity of will to use it.

Weil calls the realities of industrial labor a "mystery," and not simply because she believed members of the Popular Front lacked firsthand experience of the workers' daily lives. "Workingmen themselves do not find it easy to write, speak, or even reflect on such a subject, for the first effect of suffering is the attempt of thought to *escape*. It refuses to confront the adversity that wounds it" (*SWR*, 54).[62] Weil has a very elaborate set of metaphors for "thought," which is severed from the thinking of human beings—the workingmen—and given its own, surprisingly animal properties. Thought does not just "escape," it "flees," "draws back," "slinks back trembling to its lair," and "is obliged to remain in constant readiness." Thought is like a frightened animal, animate but not human, reactive but not active. Indeed, that is her point. It is only when "one's wits are exercised" by the work at hand—when attention and action are synchronized and coextensive—that she uses the term "one's mind." In the essay, Weil attempts to reconnect thought to the suffering body and suffering psyche. For the sufferer, thought has none of the human properties of attention or reflection because it cannot remain either still or purposeful.

Weil almost, but with a difference, employs the two most common modern analogies for the human: the animal and the machine. Weil's thought-animal is distinguished not by its desires and appetite but simply by its response to painful stimuli. It can flee but not pursue. Thought retains the mobility of the human in only its most limited animal attribute: its ability to respond to painful stimuli. The workingman is at the same time something less than a machine; he is a tool or even a useless tool—that is, a piece of junk. The workingman when subjected to the automation of the factory lacks the machine's capacity for motion. The human tool can be used by others and by

the machine or it can be discarded, but it cannot make a mark of its own. Weil had a greater distaste for automation than so many intellectuals of her period did because she saw humans as mere adjuncts to machines, not machines themselves. This rejection of automation as liberation from toil, or from alienated labor, marks a significant difference from Marx, according to Robert Sparling.[63] Unlike the workingman in the popular Charlie Chaplin film *Modern Times* (also in 1936), the human actor does not begin to take on the automaticity of the machine but lies broken beside it. Moreover, neither tools nor junk require the acknowledgment of human actors; without this acknowledgment (which she will describe in more detail in her essay on the *Iliad*), workers see themselves as things too.

Thought, then, is a suffering animal lodged in a thing, the body, which is also under duress from cutting, bruising, burning, heat, fatigue, and noise. However, Weil pays only modest attention to the physical suffering imposed on factory workers and limns instead their existential misery, itemizing the indignities and humiliations of factory work that in the aggregate produce oppression: the loss of autonomy, the subjection to the machine and the clock, monotony coupled with a constant state of alertness, to name a few. All these deprivations—of the ability to make decisions, to possess one's time and one's body, to plan the future—divorce thought from the thinker by making the mental possession of experience impossible. It is these conditions that send thought fleeing, not merely the impact of a blow.

She then interrupts herself midway through to repeat her warning about the impenetrability of suffering. Here she speaks more generally about suffering and thought, and not just in the context of factory work:

> Nothing is more difficult to know than the nature of unhappiness; a residue of mystery will always cling to it. For, following the Greek proverb, it is dumb. To seize its exact shadings and causes presupposes an aptitude for inward analysis which is not characteristic of the unhappy. Even if that aptitude existed in this or that individual, unhappiness itself would balk such an activity of thought. Humiliation always has for its effect the creation of forbidden zones where thought may not venture and which are shrouded by silence or illusion. When the unhappy complain, they almost always complain in superficial terms, without voicing the nature of their true discontent; moreover, in cases of profound and permanent unhappiness, a strongly developed sense of shame arrests all lamentation. Thus, every unhappy condition among men creates the silent zone alluded to, in which each is isolated as though on an island. Those who do escape from the island will not look back. (*SWR*, 64)

Weil places herself in an impossible position between the ignorant observer and the mute sufferer. By her own logic, she speaks from nowhere. This warn-

ing is then followed by a poetic catalog of "impressions of misery": "the profound weariness ... in the set of the mouth," "the pitiful boasts bandied about by the crowds at the hiring halls, etc." (*SWR*, 65). What is the purpose of claiming that no report can emerge from suffering? Weil's political motive in the essay is clearly stated: no meaningful reform can take place without accurate knowledge of the workers' experience of the factory. But such knowledge in the essay is scarcely possible. "*Every* unhappy condition among men creates the silent zone alluded to, in which each is isolated as though on an island. Those who do escape from the island will not look back" (*SWR*, 64). If unhappiness "would balk such an activity of thought" and thought "flees" and humiliation and unhappy conditions create zones of silence, there seems to be no avenue left for attending to or communicating one's own or another's suffering. Only the last line of the passage rescues human agency with regard to suffering. After asserting the fugitive nature of thought and misery both, she inserts choice: "*will* not look back." This willful attention to suffering becomes the task of the rest of her life: how to attend to, explain, and make human suffering visible by forcing herself to look back to the island. She has made herself into something like the Orpheus (or Lot's wife) of misery.

It is, therefore, surprising to see no reference to the "I," no personal reflection or use of anecdote, in the essay. Suffering is conveyed from the outside, scientifically, poetically, and sometimes clinically, without personalization. Dargan criticizes Weil for eliminating her own perspective, but this impersonality introduces another of Weil's complications: the greatest form of compassion is attention, which is not precisely sympathetic or empathic.[64] There is no reciprocal gaze, no possibility of creating a shared feeling of suffering, which radically isolates its victims from others and from themselves. Suffering human beings whose thought has fled are not precisely human in Weil's terms, so they cannot even empathize with themselves or each other because they are cut off from mentally possessing their own experience or their pain. Things are not sentient enough for empathy.

The detachment of "Factory Work" should not suggest that the essay lacks compassion; rather, it attempts something like unsentimental compassion. Like Arendt, Weil is demanding thoughtfulness (thinking), not sympathy (feeling), for her task. Moreover, knowledge of conditions cannot be mistaken for the knowledge of suffering people, which would relegate individual sufferers to a species of victim. She explains this quite directly in an essay from *Waiting for God* called "Reflections on the Right Use of School Studies with a View to the Love of God": "Those who are unhappy have no need for anything in this world but people capable of giving them their attention. The capacity to give one's attention to a sufferer is a very rare and difficult thing; it is almost

a miracle; it *is* a miracle. Nearly all those who think they have this capacity do not possess it. Warmth of heart, impulsiveness, pity are not enough." She continues, "Love of neighbor is simply this one question: 'what are you going through?' It is a recognition that the sufferer exists, not only as a unit in a collection, or a specimen from the social category labeled 'unfortunate,' but as a man, exactly like us, who was one day stamped with a special mark by affliction."[65] Being able to answer this question, not what do you feel or how do you feel, restores to the living thing his or her humanity. This question elicits narrative, which in the telling allows the sufferer to integrate thinking and action, to take possession of his or her experience, which humanizes the sufferer by producing the mind that Weil alludes to in "Factory Work"; one possesses a mind when thought and action are synthesized.

*Gravity and Grace* has much the same impersonal quality as "Factory Work," and advances the latter's imperative to will actively the attention to suffering. That the "I," while rare, functions as a general or a representative "I" is most obvious in those few moments when the personal "I" inserts itself. There are at most eight such entries, several of which border on the general "I," all about the length of a paragraph, no longer than any other entries. Of these eight, most of which point to a personal failing or her experience of physical suffering, one stands out for its length and vehemence. This is the entry on friendship, where Weil chastises herself for her sentimentality. She keeps circling back to her self-admonishment to "learn to thrust friendship aside" because "to desire friendship is a great fault," concluding "we must have done with all this impure and turbid border of sentiment. *Schluss!*" (*SWR*, 116). Then, advising herself not to "prune too severely," she allows herself the beauty of friendship as an inspiration. This moment, when her feelings override her thoughtfulness, admitting to the energy of her own desire for affection and reciprocity, is when she inserts herself into the text and then "prunes" herself back. But this entry is so unlike any other that it is memorable both for its unusual display of feeling—"*Schluss!*"—and for its sharp rebuke to feeling. The insertion and deletion of the "I" is not merely a personal preference, a reticence, for example, on her part. Instead, it is part of her strategy for the decreation of the self, in which the personal "I" is eliminated and the impersonal self given back to God.

*Gravity and Grace*, which is taken from the much longer notebooks, tests her ideas about God and the nature of suffering in thought experiments that carefully refine the paradoxes of her theology. At the same time, it announces a series of binding obligations that combine the compulsion of logic with the exhortation to obedience. Nearly every entry, or set of parallel entries, begins with an indicative, often drawn from the natural laws of the spirit (gravity, for

instance), then explores the logical inferences from the law or fact or observation, and includes somewhere the imperatives "I must" or, more often, "we must" drawn from these facts and deductions. Given $x$, then $y$, therefore $z$. What follows is a representative example from the opening series.

Indicatives:

> All the *natural* movements of the soul are controlled by laws analogous to those of physical gravity. Grace is the only exception.
>
> Lear, a tragedy of gravity. Everything we call base is a phenomenon due to gravity. Moreover the word baseness is an indication of this fact. (*GG*, 45)

Deduction:

> If it be true that the same suffering is much harder to bear for a high motive than for a base one. . . . Hence the use of cruelty in order to sustain or raise the morale of soldiers. Something not to be forgotten in connection with moral weakness. This is a particular example of the law which puts force on the side of baseness. Gravity, as it were, symbol of it. (*GG*, 46)

Imperatives:

> I must not forget that at certain times when my headaches were raging I had an intense longing to make another human being suffer by hitting him in exactly the same part of the forehead. (*GG*, 47)
>
> Not to judge. All faults are the same. There is only one fault: incapacity to feed upon light, for where capacity to do this has been lost all faults are possible. (*GG*, 48)

Compelling her own attention through logic and obedience, Weil is implicitly more concerned with the refusal to face affliction and suffering than she is with the inability to do so. The notebooks, both formally and substantively, prop up and fortify the will by repetitively building a scaffold of logic and duty to contain and compel it. For Weil's evolving theology and politics, attending to and experiencing suffering, especially in its most extreme forms, must be at least partly subject to the will, and the will alone is not enough.

## Suffering and Self-Delusion

Weil is as concerned with the mechanisms of avoidance as she is with the mechanics of seeing suffering. The helplessness, fragility, and mortality of human creatures are the facts of existence that modern men and women most wish to

avoid knowing, but more importantly, she argues, the strategies they adopt to shield themselves from this knowledge—cloaking themselves in prestige and retreating from reality to the imagination—have dire political consequences. Refusing to acknowledge tragedy, one's vulnerability to chance and necessity, licenses and often necessitates the oppression of others. When she trains her eye on the powerful, as she does in the *Iliad* essay, Weil begins with something like a physics of human interaction that makes it nearly impossible to notice the suffering others. This natural law of indifference is presented much like the fleeing of thought and the zones of silence she describes in "Factory Work": she provides observable facts of human behavior that elude the will but can be overcome with either grace or discipline, which is preparation to experience grace when and if it comes. Alongside these forms of refusal, she also explores the mechanics of self-delusion, which is always a willed, though not always a chosen, action. That is, there are two forms of self-delusion: the one that comes from fear and lack of fortitude, which creates automatic, self-protective mechanisms of avoidance, and the one that comes from grandiosity and the intoxication of power, which produces willed acts of cruelty and indifference.

The *Iliad* is for her the greatest poem in the Western tradition, a tradition that has been largely lost to the West, she argues, because it is infused with tragedy. The need for tragedy comes from the great imbalance between the powerful and the powerless, whom "mere chance separates as if across an abyss." The essay famously begins with the proposition that force is "that *x* that turns anybody who is subjected to it into a *thing*. Exercised to the limit, it turns man into a thing in the most literal sense: it makes a corpse out of him." While the literal corpse lies in the background of the essay, it is the "force that does *not* kill, i.e., that does not kill just yet" (*SWR*, 165), that most interests her. She describes how conquered warriors, suppliants, slaves, and soldiers become things in an instant out of fear and helplessness. But being a thing also endures across time, whether for the moments of supplication, the days and years of war, or the lifetime of slavery. Because human beings are things—regarded as such by themselves and by the ones who have power over them—they do not generate even the slightest form of attention. The perception of the victor is not produced by "insensibility," however. She observes of Achilles, for instance, that it is "merely a question of his being as free in his attitudes and movements as if, clasping his knees, there were not a suppliant but an inert object" (*SWR*, 167), stressing that his behavior results not from some incapacity of feeling in him but merely from his ordinary, human reaction to a thing. She makes the analogy of a person moving around a room

that contains only objects. The psychic pressure of human presence always modifies our actions and movements to some extent.

The automatic indifference of the victor has devastating political consequences in war; only the human person "has the power to interpose, between the impulse and the act, the tiny interval that is reflection. Where there is no room for reflection, there is none either for justice or prudence" (*SWR*, 173). As individuals and then whole masses of human beings are turned into things in war, there is nothing to check the slaughter. In this case, she speaks of a mere hesitation, a space for thought—again not feeling and not even the more rigorous and mindful attention. The human reaction to utter helplessness—to not being dead *just yet*—is also to become thinglike. Both victim and victor collaborate: nothing prevents this behavior, which is produced by terror, and nothing stays the victor's hand save the knowledge that he, too, will become a thing in turn. All men, even the best of men in the poem, are turned into things out of fear, and all men, even the best, remain indifferent to others when they are reduced to objects. No warrior in the poem retains the tragic knowledge that he, too, is vulnerable; as a consequence, all will suffer. This small stay against wholesale slaughter derives entirely and precisely from the tragic sensibility—to have in mind *always* that mere chance separates us from disaster. "Perhaps all men, by the very act of being born, are destined to suffer violence; yet this is a truth to which circumstance shuts men's eyes" (*SWR*, 173). When we are not fearful, when we are not in pain, when we are not suffering humiliation, there is always an abyss between us and the afflicted. They are as unrecognizable to us as we are to them.

What Weil most appreciates about the *Iliad* is the universality of blind necessity, that fate is the great equalizer and therefore the wellspring of justice. Homer exemplifies the "geometrical rigor" of Greek ideas of retribution and chance, which he passes down to the great tragic dramatists, Sophocles and Aeschylus, and finally to the Gospels. "The sense of human misery gives the Gospels that accent of simplicity that is the mark of the Greek genius, and that endows Greek tragedy and the *Iliad* with all their value" (*SWR*, 192). "And the sense of misery is the pre-condition of justice and love" (*SWR*, 192). Christianity lost the sense of Greek tragedy when it insisted that suffering could be joyful. She argues that it is simply impossible that grace could do more for men than it could for Christ on the cross. In essence, she is seeking to restore to Christianity its tragic sensibility. As she draws to the end of her essay, she laments this loss of tragedy and reserves her greatest ire for our capacities for self-delusion, which she claims the Greeks could do without. The Greeks were heroic to her because they had the capacity to "avoid self-deception" in

confronting "the extent to which each soul creates its own destiny." She argues that "this whole question is fraught with temptation to falsehood, temptations that are positively enhanced by pride, by shame, by hatred, contempt, indifference, by the will to oblivion or to ignorance. Moreover, nothing is so rare as to see misfortune fairly portrayed; the tendency is either to treat the unfortunate person as though catastrophe were his natural vocation, or to ignore the effects of misfortune on the soul" (SWR, 192–93). Unlike "Factory Work," where suffering remained mute and mysterious because "thought fled," Weil now sees human agency, the only recoverable human agency in her late work, to reside in attention and intellectual honesty. Although Weil is attempting to produce in her own essay the neutrality and compassion she finds in Homer's *Iliad*, failing to avoid self-deception elicits her sharpest condemnation: "the only people who can give the impression of having risen to a higher plane, who seem superior to ordinary human misery, are the people who resort to the aids of illusion, exaltation, fanaticism, to conceal the harshness of destiny from their own eyes" (SWR, 194). A lack of self-delusion is conveyed in Homer's style. Homer is a great epic/tragic poet because he delivers "the bitterness of such spectacle undiluted," offering "no comforting," "no consoling," "no washed out halo of patriotism" (SWR, 164). "The cold brutality of the deeds of war is left undisguised" (SWR, 190) and the shame of the "coerced spirit" is "neither disguised, nor enveloped in facile pity, nor held up to scorn" (SWR, 192). Homer's neutrality and realism make his treatment of suffering naked and blunt, but not without compassion. She thought the poem was a miracle of compassion because everyone, no matter on which side, was treated to a fair portrayal and caught in the same dilemmas of blind necessity. The style that places the accent on human misery contributes to the poem's evocation of justice.

The problem of self-delusion is a preoccupation of the notebooks as well, but in her essay on the *Iliad*, Weil is concerned with the temptation to ignore or avoid suffering. Again, Weil begins with tragedy as the test of reality. Suffering imposes reality on human beings because it marks a space where reality cannot be denied. Affliction is the limit case of reality entering the body through suffering. Beauty solicits the viewer on behalf of the world, but it doesn't demand its acknowledgment the way that suffering does. So suffering tests the individual's capacity to acknowledge and ultimately love reality. In *Gravity and Grace*, she comes at the incapacity to deal with reality in two ways (at least): through the difficulty of apprehending reality and through the fear of being exposed to its painful qualities. In both cases, it is the imagination that either blocks access to reality or eases suffering by substituting something unreal for the pain that cannot be tolerated. Weil is consistently suspicious

of the imagination, not because she has no interest in aesthetic creation, but because she thinks the imagination's primary purpose is to insulate us from the real. "Necessity is a stranger to the imaginary" (*GG*, 101), for instance. Or "What is real in perception and distinguishes it from dreams is not sensations, but the *necessity* enshrined in these sensations. 'Why these things and not others?' 'Because that is how it is'" (*GG*, 101). This is a key point in Weil's argument. Necessity unlocks us from our own subjectivity, what she calls a dream world. This is in part a chastening of human illusions about control and mastery of the world; it is in part a liberation from the self. We have to love creation because God made it, and we can love this best when we are subject to necessity, which is always painful. We turn our heads toward God at the moment of acute affliction because we fear death; turning toward God, empty of everything but impersonal humanity, means dying or being willing to die. Dying is for her both physical death and the psychic death of our attachment to our own qualities and the things of this world. She demands, "We must continually suspend the work of the imagination in filling the void within ourselves. If we accept no matter what void, what stroke of fate can prevent us from loving the universe? We have the assurance that come what may, *the universe is full*" (*GG*, 64). In a sense, the only way we know things are real is because they are beautiful or they hurt. And hurt is the only way to helplessly, therefore obediently, assent to the universe.

In *Gravity and Grace*, the imagination creates alternatives to reality that have no substance in themselves. It is not a creative organ but a destructive organ because it blinds us to reality—both its beauty and its terror—which we fear. The imagination is therefore one of the chief consolations for suffering, all of which she excludes from the experience of reality. In order for reality to penetrate, the sufferer must not be consoled. Ultimately, she asks the reader to acknowledge the horror of affliction and the ordinariness of suffering without the traditional Christian compensations for it.[66] She is not redeeming or relieving human helplessness; she is finding its theological use, which is to expose the fragility and limitation of human life. The only thing that remains in affliction is the capacity to love, to turn one's head toward an absent God. In the "use of suffering," we might infer its transformation and transcendence, for instance, transforming suffering into knowledge or into virtue. But we would be missing the idiosyncrasy of her thought and of her belief, which one critic called her "surprising, shocking insight": "the paradoxes of Christianity . . . are constantly being stripped of camouflaging platitude and shown for all their divine absurdity."[67] A careful look at her work will not permit even the limited consolations or compensations for suffering. As she argues elsewhere, "There is no answer to the why of affliction

just like there is no answer to the why of beauty or joy. There is never any earning, any expectation, any striving. Therefore martyrdom is not something to be sought."[68] This unreasonable, unjust devastation of human life cannot be chosen; what can be chosen is our clear-sighted facing up to it and our unconsoled experience of it. We can *reasonably* choose tragedy—and Weil has tried to reason us there rather than persuade us through our feelings of pity and compassion—because logically we should want to choose a more just world and a more direct experience of God.

# Hannah Arendt: Irony and Atrocity

The German text of the taped police examination . . . , each page corrected by Eich-
mann, constitutes a veritable gold mine for a psychologist—provided he is wise enough
to understand that the horrible can be not only ludicrous but outright funny.
HANNAH ARENDT, *Eichmann in Jerusalem*

Eichmann really figured, you know, "The Jews—the most liberal people in the world—
they'll give me a fair shake." Fair? *Certainly.* "Rabbi" means lawyer. He'll get the best trial
in the world, Eichmann. *Ha!* They were shaving his leg while he was giving his appeal!
That's the last bit of insanity, man.
LENNY BRUCE, "The Jews"

## The Scandal of Tone

By the end of the 1940s, after the Nuremburg Trials and the founding of Israel,
discussions of the Nazi genocide, much less its mechanics, all but disappeared
from public view. In the United States, the 1955 stage version of *The Diary of
Anne Frank*, which won both multiple Tony Awards and the Pulitzer Prize,
excised references to Anne's Jewishness to the protest of no one and converted
her story into a timeless and universal example of the triumph of the human
spirit under trying conditions. Ending with the line "I still believe, in spite of
everything, that people are really good at heart," the play might reasonably
have left the impression that it was about a girl trapped in an attic, not one
gassed in Auschwitz. In France in the late 1950s, Elie Wiesel struggled to find a
publisher for his memoir, *Night*; in 1960 he accepted a hundred-dollar advance
from an American publisher, and his book was published in a first print run of
three thousand copies, which took three years to sell out. Primo Levi's *If This Is
a Man* sold only 1,500 copies when it was first published in Italy in 1947. It was
issued in both English and German translations in 1958 and had its biggest suc-
cess in 1963, when it was published along with Levi's second novel, *The Truce*.
Though all three of these works now have been read by many millions of read-
ers and have become a part of a canon of Holocaust literature, neither survivors
nor the public at large were, to borrow a phrase from Hannah Arendt, will-
ing to "face the reality" of the extermination camps in the early postwar era.[1]

By many accounts, the 1961 trial of Adolf Eichmann in Jerusalem marks
a turning point in the public acknowledgment of Jewish suffering under the

Nazi regime. Eichmann's trial did not alone cause but rather coincided with and accelerated the insertion of the Holocaust into the collective memory of the twentieth century. In addition to the unprecedented testimony of Auschwitz survivors during the trial, the word "Holocaust" was then coming into popular use; its historians, most notably Raul Hilberg with his *The Destruction of the European Jews* (1961), were publishing in noticeably greater numbers with the benefit of broader archival and ethnographic research; personal testimony about the Holocaust was losing its stigma, significantly as an effect of the trial itself; and a new generation, particularly in Israel, was stirring up controversy by asking difficult questions of survivors, who had been reluctant to discuss in public the atrocity that had defined their lives. Because we have grown so accustomed to the Holocaust as a fixture of the public imagination and because testimony to trauma per se became so prominent a feature of late twentieth-century culture, particularly in the United States, we may need to remind ourselves of the emotional intensity and intellectual uncertainty that attended these changes in public discourse. Along with the question of whether one should talk about the Holocaust in public came the even less clearly formulated question of how one should go about it.

Into this very sensitive moment came the often ironic and, for many, scandalously *in*sensitive *Eichmann in Jerusalem: A Report on the Banality of Evil* by Hannah Arendt. The reputation of this esteemed political philosopher, a German Jew who had herself fled the Nazis, assured readers of the book's seriousness; serialization in the *New Yorker* and publication by Viking Press shortly thereafter guaranteed exposure of the story to a wide audience. It is hard to imagine conditions under which a book would receive more notice, and indeed, it enjoyed extraordinarily broad coverage and criticism: scores of reviews, radio programs, interviews, mentions in gossip columns, extended essays, private book club discussions, public symposia, and hundreds of letters to the editors of the *New York Times*, the *New Yorker*, and newspapers and magazines around the world. No one, neither contemporary reviewers nor recent critics, discusses Hannah Arendt's report on the trial of Adolf Eichmann without first touching on the intense and protracted controversy that it generated. In fact, as Dan Diner has argued, the controversy became as much a subject for commentators as the book itself, giving to the debates around Arendt's work an iconic status apart from the report itself.[2]

There have been many attempts to understand precisely why *Eichmann in Jerusalem* was and for many remains so disturbing, but it has yet to be fully examined how Arendt's treatment of suffering depended upon assumptions about the display of sympathy in relation to the Holocaust. While *Eichmann in Jerusalem* engendered a great deal of acclaim for Arendt, its reception was

more profoundly marked by the bitterness, anger, hurt, and disappointment, primarily but not only among her Jewish readers. The outrage over the book arose largely around two questions: the first was Arendt's sensitivity; the second, her factual accuracy. Scholars have scrutinized Arendt's presentation of the facts and have deemed it a notable but less troubling issue than the initial accusations of pervasive error and distortion predicted.[3] Instead, I want to concentrate on the problem of Arendt's tone because the debates over her book suggest that among the many controversial ideas that she expounded, *Eichmann in Jerusalem* violated conventions of sympathy that, although still incoherent, were deeply felt. The book continued to irritate readers, because the late twentieth century was a period when psychic pain became one of the most prominent features of political and aesthetic discourse.

Her critics were much more inclined to interrogate her rhetoric than her supporters were, though the problem was often cast as one of personality or psychology. According to this argument, Arendt was simply herself unsympathetic, cold, even brutal; she hated herself for being a Jew and therefore accused the Jews of their own murder; she identified with the German persecutors. Her supporters, however, never presented a very satisfying case for the virtues of Arendt's writing style.[4] By only sometimes acknowledging the caustic comments or seeming harshness of tone, her defenders brushed aside her style's potential to injure; by praising her cool impartiality, wry pleasure, and wit, they failed to recognize the possible insult in the very qualities they admired. Only in recent years have critics wondered at the rhetorical strategy of *Eichmann in Jerusalem*.[5] Arendt was certainly aware of the terrible history of those who would find her arguments most urgent and certainly knew that to be deliberately, or even carelessly, tactless would have been cruel. It is not that I want to rescue Arendt from this charge so much as I want to restate the question in order to derive a meaningful philosophical and political answer from it. I prefer, that is, to pose this question to Arendt's ideas rather than to her personality.

To restate the question: does the rhetoric of *Eichmann in Jerusalem* derive from Arendt's political philosophy? And does this political philosophy presuppose a relationship to suffering? The issues that *Eichmann* addresses are central to Arendt's work as a whole, though she does not explore them systematically; she was, after all, acting as a journalist, providing a report on a trial by telling a story. Too often *Eichmann* is taken out of the context of Arendt's other work, but it would be a mistake to imagine that her recourse to irony was made without calculation. Arendt had reflected on how to think about extremity for more than a decade, and her views on it were typically idiosyncratic. In fact, published only a month before *Eichmann in Jerusalem* was *On Revolution*, which contains her most sustained discussion of sympa-

thy and the politics of misery. The writing of *On Revolution* was temporarily interrupted by Arendt's attendance at the trial and the manuscript was completed just before she began to work on her report. Naturally then, her ideas about emotion—specifically compassion, love, pity, and sympathy—and, as she put it, their "disastrous" effects on politics and public discourse would have been very much present to her as she arrived at her analysis of the Eichmann trial, and the Eichmann trial very much on her mind in the revising of *On Revolution*. In particular, the chapter "The Social Question" in *On Revolution* is noteworthy because she gestures toward it in her famous post-*Eichmann* exchange with Gershom Scholem, the scholar of Jewish mysticism who had been her longtime friend. Equally important, the last work of her life—the posthumously published *The Life of the Mind*—attempted to resolve the question that she declared her consuming topic after witnessing the display of what she called Eichmann's *thoughtlessness*. Once we see Eichmann as posing a problem of thinking, however, it also becomes clear that this investigation did not begin after *Eichmann* but considerably earlier in *Rahel Varnhagen* and *The Origins of Totalitarianism*. What remained for Arendt to develop was a conception of thinking that would avoid the traps and delusions she dissected in those two earlier works.

Therefore, though they have taken their own paths in the reception of Arendt's work, the questions of sympathy and thinking cannot be entirely separated, as *Eichmann in Jerusalem* demonstrates. In this work, we see the relationship between sympathy and thinking rendered incoherent when Arendt attempts what she calls "the unpremeditated, attentive facing up to, and resisting of, reality—whatever it may be" in *The Origins of Totalitarianism*.[6] "Facing up to reality" appears countless times in slightly different phrasing throughout Arendt's entire body of writing in terms that recognize only occasionally how painful this might be. "Unpremeditated," however, as opposed to another crucial word in Arendt's lexicon, "spontaneous," implies openness and defenselessness, a refusal to assemble in advance the tools or the categories to apprehend a set of facts that may defy both. Unpremeditated attention holds still, unarmed, whereas spontaneous attention might suggest an active entering into contact. This posture resembles to a remarkable degree the form of attention Simone Weil advocates with respect to affliction or tragic reality, as discussed in the previous chapter. Where Weil's attention derives from a relationship between individual persons, which will be the foundation of a more just political world, Arendt's defenselessness in the face of often brutal reality is more directly political; she will insist on facing painful reality as the price not only of sharing the world with others in their plurality but of having any world at all left to share.

Thinking and suffering, the motivation for sympathy, come together in Arendt's figure of the pariah. Not only a figure for the Jew, the pariah is the thinker who refuses the myriad safeguards against reality and dares to share reality in its painful concreteness, as well as the thinker who insists on the shallowness of the things of this world at the considerable penalty of world-lessness, a fate Arendt holds in particular horror. The foundation of individual conscience and political common ground, Arendt's notion of thinking seems to require suffering the painfulness of reality without consolation, compensation, or communion with others. Arendt's employment of irony in *Eichmann*, I want to suggest, is less a product of her character (though no doubt it was enabled by her psychological makeup) than part of an implied philosophy of suffering, one that violated the assumptions and expectations of many post-war readers, both the "professional thinkers" and the nonprofessional alike.

### Sympathy and Heartlessness

Sorting through the reception of *Eichmann in Jerusalem* is a massive under-taking. Nevertheless, two sets of reviews and responses point in the general direction of the sympathy discussion and begin to suggest its contours. The first exchange, now the most widely read of any, consisted of letters written between Arendt and Scholem, which were initially published in *Mitteilungs-blatt* in 1963, then translated for publication in *Encounter*, and finally col-lected in Arendt's *The Jew as Pariah* in 1972.[7] Though she was one of the rare individuals whom he had addressed with the informal *Du* in his correspon-dence (i.e., until her writing on Eichmann),[8] Scholem was deeply wounded by *Eichmann in Jerusalem* and his response to it was fiercely critical. The second exchange, arguably the most influential in the US popular press in the 1960s, began with Michael Musmanno, Pennsylvania Supreme Court justice, Nu-remberg prosecutor, and witness for the prosecution in the Eichmann trial, whose indignant review on the front page of the *New York Times Book Review* was followed little more than a month later by almost three pages of letters from readers (roughly 10 percent of the issue)[9] and an exchange between au-thor and reviewer.[10] William Shawn, the *New Yorker* editor, also weighed in, defending Arendt in his magazine after corresponding at length with Mus-manno.[11] Both sets of exchanges take issue primarily with Arendt's tone and her treatment of suffering, Scholem explicitly so and Musmanno less directly by offering a counterexample.

Scholem begins by suggesting that her work is "not free of error and dis-tortion" but turns directly to the heart of the matter—her tone—especially with regard to the role of the Jews in the catastrophe. "At each decisive junc-

ture . . . your book speaks only of the *weakness* of the Jewish stance in the world. I am ready enough to admit that weakness; but you put such emphasis upon it that, in my view, your account ceases to be objective and acquires overtones of malice."[12] The depth of Scholem's anger becomes evident in his conclusion: "Insofar as I have an answer, it is one which, precisely out of my deep respect for you, I dare not suppress; and it is an answer that goes to the root of our disagreement. It is that heartless, frequently almost sneering and malicious tone with which these matters, touching the very quick of our life, are treated in your book to which I take exception" (*JP*, 241). Accusing Arendt of "heartlessness," especially given the evidence of personal friendship in the letters (they address one another by first name and exhibit a somewhat strained and formal intimacy), might appear to the reader as a severe but perhaps merely ad hominem attack. His insistence on heart, however, can be seen as a protocol-in-the-making for the treatment of the Holocaust, a "way to approach the scene of that tragedy." Scholem has in mind two specific definitions of "heartlessness": for one he uses the Hebrew *Ahabath Israel*, "the love of the Jewish people," and for the other, the German *Herzenstakt*, the "tact of the heart."[13] Taken in tandem, these two definitions of heart compose a relationship to sufferers and suffering that is both general (it extends to the Jews as a people) and generalizable (it is decorum motivated by sympathy for anyone else's pain). He concludes that to discuss "the suffering of our people and the 'questionable figures who deserve, or have received their just punishment'" "in so wholly inappropriate a tone—to the benefit of those Germans in condemning whom your book rises to greater eloquence than in mourning the fate of your own people—this is not the way to approach the scene of that tragedy" (*JP*, 242). Scholem is instructing Arendt in the emotions her writing should have conveyed—her love of the Jews and her sympathy for the Jews as suffering creatures—and the place that sympathy should take in relation to other possibly competing moral priorities, like the condemnation of the German perpetrators. By this argument, Scholem would also be offended by something like dispassion or neutrality, though not perhaps as outraged as he is by what he perceives as Arendt's malice.

Arendt responds by decisively embracing the first form of heartlessness as Scholem defines it. While she claims that she had never denied her own Jewishness, she asserts in a much-quoted passage that she does not have a "love of the Jewish people." She answers: "You are quite right—I am not moved by any 'love' of this sort, and for two reasons: I have never in my life 'loved' any people or collective—neither the German people, nor the French, nor the American, nor the working class or anything of that sort. I indeed love 'only' my friends and the only kind of love I know of and believe in is the love of persons" (*JP*,

246).[14] She concludes, "I do not 'love' the Jews, nor do I 'believe' in them; I merely belong to them as a matter of course, beyond dispute or argument" (*JP*, 247). She then dismisses "the tact of the heart" as politically dubious and intellectually fraudulent: "Generally speaking, the role of the 'heart' in politics seems to me altogether questionable. You know as well as I how often those who merely report certain unpleasant facts are accused of lack of soul, lack of heart, or lack of what you call *Herzenstakt*. We both know, in other words, how often these emotions are used in order to conceal factual truth" (*JP*, 247). At issue in heartlessness for Arendt is the devotion to the concrete, whether person or fact, which stands in for reality as such. Because it embraces a category, the love of a people can only be an idea and a willed emotional relationship to that idea, and so not an emotion at all;[15] the love of a person, like all concrete matters, derives from particular qualities that are apprehended through contact. Emotional tact, she seems to suggest, submits reality to the jurisdiction of feeling because it requires one to attend first to the imagined feelings of a listener and only second to the reality at hand, forfeiting the latter in service to the former. Heartlessness would therefore be a necessary component of Arendt's most fundamental charge to her readers: face reality.

Like Scholem, for whom suffering must remain in the foreground out of an ethics of attention, Musmanno obligates Arendt to attend to suffering because its sheer enormity makes it impossible to ignore. While Musmanno never makes broad claims about Arendt's tone with respect to the suffering of the victims, his own rhetoric is an implicit rebuke to her lack of sympathy because it supplies the emotion he evidently did not find in her account.[16] For example, at one moment he speculates: "If, in recalling the period, one could shut one's eyes to the scenes of brutal massacre and stop one's ears to the screams of horror-stricken women and terrorized children as they saw the tornado of death sweeping toward them, one could almost assume that in some parts of the book the author is being whimsical."[17] Musmanno's rhetoric dramatizes the engulfment in misery that Arendt finds "disastrous" in *On Revolution*. So overwhelming is the horror, recollection literally reproduces suffering and compels even the witness to participate in it: scenes and sounds become so real that only by becoming insensate (shutting eyes, stopping ears) can one avoid confronting them. Nevertheless, his sentimental invocation of "women and children" in his censure of Arendt's whimsy suggests some mistrust of the fact of suffering, some fear that the "tornado of death" will be insufficiently horrifying on its own. His apparent need to amplify the suffering that, in his own terms, is beyond intensification refers us not to the victims' distress but to his own at witnessing the scene. Moreover, it suggests that there is an inherent problem of scale in matching the witnesses' emotional

response to the sufferers' terror or grief. Musmanno seems to think that ethi-
cally he—and Arendt—need to suffer too, but of course, his own suffering
pales in comparison, and so the rhetoric of his response looks melodramatic
and inauthentic. The problem with the available conventions of sympathy—
the attempt to stand with and to share the feelings of the victim—is that with
a disaster of such unprecedented magnitude, such conventions can only fail.

Arendt's refusal of the obligation to attend to suffering rests precisely on
its power to blind and deafen and to shift emphasis from an event to feelings
about the event. The suffering of the Jews, Arendt argued in *Eichmann in
Jerusalem*, had no place in the trial because it was not in dispute; rather, Eich-
mann's responsibility for it was. But in *On Revolution*, Arendt banishes suf-
fering from the public realm in more general terms, not because one can be
indifferent to it, but because one cannot. Precisely for this reason, *On Revolu-
tion* is an extended defense of coldness and heartlessness. Drawing her meta-
phors almost always from bodies of water, Arendt repeatedly describes suffer-
ing and the emotion it stimulates as "boundless." As she says of Robespierre's
sympathy for the destitute masses of Paris, "He lost the capacity to establish
and hold fast to rapports with persons in their singularity; the ocean of suffer-
ing around him and the turbulent sea of emotion within him, the latter geared
to receive and respond to the former, drown all specific considerations, the
considerations of friendship no less than considerations of statecraft and
principle."[18] In the context of this loss of boundaries, Arendt's heartlessness
refuses the generalizing tendency upon which Scholem's definition rests and
which Musmanno's review attempts to demonstrate. Moreover, the ocean of
sympathy pulls into the public realm the necessities of life, which are the most
immediate and urgent concerns there are: the reproduction and maintenance
of life. "Where the breakdown of traditional authority set the poor of the
earth on the march, where they left the obscurity of their misfortunes and
streamed upon the market-place, their *furor* seemed as irresistible as the mo-
tion of the stars, a torrent rushing forward with elemental force and engulfing
the whole world" (*OR*, 113). Once having entered the public sphere, necessity
and the rage that accompanies its frustration will swamp all other concerns,
just as suffering in Musmanno's description threatens to do. Because misery
is as irresistible as a force of nature, because it is impossible to look beyond it
once it has shown itself, it must not be revealed in public.

In the writing of her own account, Arendt sought to hold back the tide of
suffering that she felt threatened to overwhelm the trial. Her most character-
istic rhetorical technique, especially in her report of Eichmann's testimony,
is abrupt understatement. For instance, when Eichmann defended himself
from the charge of "base motives" by arguing he "remembered perfectly well

that he would have had a bad conscience only if he had not done what he had been ordered to do—to ship millions of men, women, and children to their death with great zeal and the most meticulous care," Arendt concedes that "this, admittedly, was hard to take" and moves on with her analysis.[19] By explicitly naming Eichmann's duties, which certainly he did not, Arendt pauses to make his crime concrete and visible, but in tersely confessing the pain his defense inflicts, she hurries past the emotional reaction while also minimizing it. When she retells Eichmann's anecdote of his "normal human encounter" in Auschwitz with a man named Storfer, one of the representatives of the Jewish community with whom he had worked for years, she concludes: "Six weeks after this normal human encounter, Storfer was dead—not gassed, apparently, but shot" (*EJ*, 51). It is not that Arendt denies this story its horror, but rather that she attempts to suggest its horror by *not* dwelling on it, instead letting the rhythm of her prose convey the weight of the evidence. This lengthy story told in complex, concatenated sentences ends here almost literally with a bang.

Arendt's chapter "Evidence and Witnesses," about fourteen pages (as long as most other chapters), spends only about half of those pages on survivor testimony, though such testimony, she notes, occupied twice as much court time as Eichmann's own. And yet, she is not able to resist completely the power of the victims' stories, and she has her own criteria for their proper appearance in public. Of the several she recounts, mostly critically (for irrelevance, propaganda, self-aggrandizement), Zindel Grynszpan's[20] testimony of his expulsion from Germany to Poland produces an uncharacteristic moment of engagement:[21] "This story took no more than perhaps ten minutes to tell, and when it was over—the senseless, needless destruction of twenty-seven years in less than twenty-four hours—one thought foolishly: Everyone, everyone should have his day in court. Only to find out, in the endless sessions that followed, how difficult it was to tell that story, that—at least outside the transforming realm of poetry—it needed a purity of soul, an unmirrored, unreflected innocence of heart and mind that only the righteous possess" (*EJ*, 229). Everything in these two sentences, even the self-mocking "foolishly," refuses momentum. Arendt's awkwardly placed dashes interrupt the flow of the first sentence and return us to the story she has just recounted. Her references to time intervals between the dashes—twenty-seven years, twenty-four hours—belie the brevity of the ten minutes the witness spent on the stand. Moreover, the two repetitions—the repetition "senseless, needless" and the doubling of "everyone, everyone"—not only halt the progress of the sentence but also mark perhaps the only eruption of sympathy in the prose of *Eichmann in Jerusalem*. This passage is noteworthy, not only for its rarity, but for its style. If one eliminated these repetitions, the line would be voided of affect,

transformed into a statement rather than an expression of anguish. (Edited, the sentence would read: The story took no more than ten minutes to tell, and when it was over one thought: everyone should have his day in court.) Sympathy is conveyed in the micropauses of the dashes and commas, which produce a hitch between the repeated words. There is a momentary refusal to move on or pass over, a dwelling on suffering and a sharing of emotion if only for the space of a breath.

Nonetheless, Arendt takes back the sympathetic identification (though not the hitching syntax) immediately in the next sentence with her depiction of the tedium (the "endless sessions") of survivor testimony when it is neither aesthetically satisfying nor pure of heart, by which she means un-[self]-reflecting (unconscious of one's effect on others). Indeed, what most impresses Arendt about Zindel Grynszpan's testimony is its refusal of emotional rhetoric: "He spoke clearly and firmly, without embroidery, using a minimum of words" (*EJ*, 228). It is his economy, even more than his "shining honesty" (*EJ*, 230), that tempts Arendt to abandon her strict refusal of sympathetic witnessing, if only momentarily and "foolishly." Combining the purity of heart with an aesthetic of the concrete, Grynszpan allows the facts to speak for themselves; it is as if he disappears behind or into them, which allows the listener to confront, not the emotion produced by suffering, but the reality of suffering itself. The boundlessness of emotion in the sufferer and the witness is contained by an implied agreement not to share it, either the pain of suffering or the sympathy of witnessing.[22] Arendt clearly does have in mind an aesthetic for sharing the reality that produced the suffering (but not the suffering itself): concrete, rhetorically minimalist, matter-of-fact (neutral, not affectless), and unself-conscious. As she argues in *On Revolution*, the exposure of the heart carries its own dangers:

> Whatever the passions and emotions may be, and whatever their true connection with thought and reason, they certainly are located in the human heart. And not only is the human heart a place of darkness which, with certainty, no human eye can penetrate; the qualities of the heart need darkness and protection against the light of the public to grow and to remain what they are meant to be, innermost motives which are not for public display. However deeply heartfelt a motive may be, once it is brought out and exposed for public inspection it becomes an object of suspicion rather than insight; when the light of the public falls upon it, it appears and even shines, but, unlike deeds and words which are meant to appear, whose very existence hinges on appearance, the motives behind such deeds and words are destroyed in their essence through appearance; when they appear they become "mere appearances" behind which again other, ulterior motives may lurk, such as hypocrisy and deceit. (*OR*, 96)

In this "place of darkness," a phrase that colors emotion more ominously, Arendt tightens the clamp on emotion one more time, suggesting both the necessarily unreliable nature of testimony to emotion or motivation and the necessarily corrupting effect of its appearance in public. Zindel Grynszpan's righteousness was preserved in public because he did not seem to be aware that he was making it appear.

With Jewish suffering in the Holocaust making its appearance in public in the early 1960s, Arendt's defense of heartlessness in On Revolution looks both defensive and prescient. I think it is worth speculating that in addition to developing her analysis of totalitarianism in On Revolution, this time with respect to the political Left, Arendt might have been moved to ponder the vicissitudes of compassion for the very reason that the extreme suffering of the camps was beginning to be explored in public, particularly in the Eichmann trial.[23] Her admonition, "History tells us that it is by no means a matter of course for the spectacle of misery to move men to pity" (OR, 70), suggests also some concern that miseries are asymmetrically compelling. The American revolutionary leaders were not moved by the spectacle of black misery in the institution of slavery, seeing nothing of the possibilities of solidarity in suffering that the French revolutionaries did with the sans-culottes of Paris. So the possibility that misery does not provide a direct line to compassion, that it can indeed be overlooked no matter how visible it is, sits adjacent to its overwhelming power to sustain interest and obliterate all other considerations of justice and reality. For these combinations of reasons—the capacity to be either mesmerized by suffering or indifferent to it, the willed obscuring of facts by emotional tact, the corruption of motivation in the witness/reporter—Arendt pushes both the heart and suffering out of the light of public display. She could not have been more out of step with the times.

### The Grammar of Pluralism

If Arendt's sympathy (or lack thereof) for the Jews constituted one pole of the debate over her heartlessness, the other would be that she extended whatever sympathy she had to Eichmann himself. In her portrayal of Eichmann, Arendt's irony came into play, and it is this feature of her work as much as any that contributed to the confusion as to where her sympathies lay. William Shawn, for instance, attributes Musmanno's misreading of her sympathy to his misunderstanding of her irony: "He accused Miss Arendt of an excess of sympathy for Eichmann (her condemnation of the Nazi leaders was far more withering than any that had been made before) and of a lack of sympathy for the Jews (her sorrow over their suffering was far more eloquent

than the Justice's own). He ignored all Miss Arendt's ironies (referring to her 'Alas, nobody believed him,' unmistakably ironic in context, as a 'lament' for Eichmann)."[24] Shawn is clearly correct in this case: this "alas" was meant not for Eichmann but for the court—prosecutors, counsel for the defense, and the judges—who "missed the greatest moral and even legal challenge of the whole case," which was that "an average, 'normal' person, neither feeble-minded nor indoctrinated nor cynical, could be perfectly incapable of telling right from wrong" (*EJ*, 26). Another example shows a greater degree of subtlety on Arendt's part but will make the point more broadly and suggest the value she might have found in irony. Musmanno states: "She says that Eichmann was a Zionist and helped the Jews get to Palestine."[25] Arendt's version is considerably less straightforward. In her account, when Eichmann began working for Himmler's security service, he was required to read "*Der Judenstaat*, the famous Zionist classic, which converted Eichmann promptly and forever to Zionism. This seems to have been the first serious book he ever read and it made a lasting impression on him. From then on, as he repeated over and over, he thought of hardly anything but a 'political solution' (as opposed to the later 'physical solution,' the first meaning expulsion and the second extermination)" (*EJ*, 40–41). As ambivalent as Arendt's own relationship to Zionism was, she is not equating Zionism with Eichmann's "idealism," nor his belief with anything a Zionist would espouse.[26] Zionism was, on the one hand, simpler. Eichmann's and the Zionists' goals overlapped: Eichmann was ordered to rid Europe of the Jews; the Zionists wanted a homeland. On the other, it was much more complicated. Eichmann's conversion to Zionism demonstrates the extent to which he understood himself as an "idealist":

> The reason he became so fascinated by the "Jewish question," *he explains*, was his own "idealism." . . . An "idealist," *according to Eichmann's notions*, was not merely a man who believed in an "idea" or someone who did not steal or accept bribes, though these qualifications were indispensable. An "idealist" was a man who *lived* for his idea—hence he could not be a businessman—and who was prepared to sacrifice for his idea everything and, especially, everybody. *When he said* in the police examination that he would have sent his own father to death if that had been required, *he did not mean* merely to stress the extent to which he was under orders, and ready to obey them; *he also meant to show* what an "idealist" he had always been. (*EJ*, 41–42, emphasis mine)

As we can see in the passage, Arendt is not, as Musmanno claims, defending Eichmann "against his own words" but conversely, maybe even perversely, attempting to take Eichmann *at* his word. Moreover, for many reasons, taking Eichmann at his word was an enormously difficult task: he lied, boasted

outrageously, and, worst for Arendt, demonstrated a staggering incompetence in the use of language (his utter dependence on his own stock phrases and clichés, "winged words" as he called them; his "heroic fight with the German language, which invariably defeats him"; and his inability to speak anything but "officialese" [*EJ*, 48]). Nonetheless, her attempt to take him at his word, which produces the irony so characteristic of her depiction of him, is crucial to both her sense of his moral failing and her own attempt to do what Eichmann so conspicuously failed to do: view the world through the eyes of others.

"It was all irony," Arendt said, and while many have commented on her choice to characterize Eichmann primarily through irony, it has remained an open question as to why she did so. One of the consistent elements of the reception of *Eichmann in Jerusalem* is the extent to which this irony backfired. As one commentator noted in *Dissent*, "*If this is irony, at whom is it directed? One does not have to be a Zionist to be shocked, or to 'misunderstand' the author's intent.*"[27] Shawn, too, argues that both the *New York Times* and Justice Musmanno were "insensitive" to her irony, though Shawn insists that Musmanno "chose" to misread. Whether deliberate or inadvertent, the misreading of Arendt's irony seems to have derived from her attempt to communicate, mostly ironically, Eichmann's view of himself, which suggests the extent to which the grammar of reported speech can itself convey sympathy. No matter how often Arendt lampooned Eichmann in the pages of her narrative, when she reported his speech she was perceived to share his perspective—that is, to empathize with him, not to ironize him. Arendt's taking Eichmann at his word struck her readers as an act of solidarity rather than a testing of reality.

Why would Arendt take such a risk? Arendt's commitment to her idea of "plurality," which Seyla Benhabib called her "political principle par excellence,"[28] outweighs the risk she took in using irony. Instead of evil, hatred, or sadism, Arendt identifies Eichmann's most "decisive flaw" as the "almost total inability ever to look at anything from the other fellow's point of view" (*EJ*, 47–48). This solipsism is a failure to "merely [make] present to oneself what the perspectives of others involved are or could be," which pointedly is "not empathy . . . for it does not mean assuming, accepting the point of view of the other."[29] It is not, in Arendt's terms, that Eichmann could not feel for others (though nothing in his testimony suggested that he could). What disabled his conscience and permitted him to transport the Jews to their death was that he could not imagine their having a perspective on this enterprise other than his own. Therefore, her irony can be viewed as an attempt at plurality, as mocking as it was. By taking him at his word, Arendt displayed his self-understanding on the assumption that its ludicrousness was always visible at the same time.

That irony is an affectless rhetoric suggests the distance between plurality and empathy. It was a distance, however, that many of her detractors could not travel, not because they were poor readers necessarily but because their habits of reading and their preference for an emotional explanation for Nazi evil overrode her intervention.

Just as the concept of "the banality of evil" offended many of her readers, shifting the Nazi moral breakdown into the register of cognition rather than emotion was perceived as a banalization of their crimes and an exoneration of Eichmann. Arendt's term seemed to reduce the gravity of the crimes by changing their motivation: by assuming a motivation, no matter how odious, radical evil had the effect of sustaining the enormity of the crimes; in contrast, by assuming motivelessness (or incommensurate motivation, like Eichmann's desire for a promotion), the crimes, not the criminal, seemed banalized, as if mass murder would be more tolerable, not less, when done for no reason rather than for a repellent one.[30] As Ernest Pisko was to claim in a *Christian Science Monitor* article on May 23, 1963: "Using rationality where only experience and compassionate imagination could have been proper guides she has pushed herself into a position where she appears to adopt a thesis proclaimed by Franz Werfel that not the murderers but the murdered are guilty."[31] *Newsweek*'s reviewer, while calling her a "profound and brilliant political philosopher," nonetheless wonders whether thinking itself had gone too far in her attempt to understand the trial:

> Miss Arendt has the kind of courage which only first-rate intelligences have—the courage not only of her convictions, but also of the power of her thinking processes. It is here that she runs tragically afoul of her fellow Jews, who like most of mankind, have merely the courage of their convictions. They *know* what has happened to the Jews in recent history; Miss Arendt is constantly struggling to find out, to break through what appears to be the congealed surface of events to the life below. On her side, the difficulty is that she sometimes dives too deep and not only loses contact with the surface, but also with the human oxygen that makes common-sense breathing and thinking possible.[32]

And yet, it is precisely losing "common-sense" and "contact with the surface" that Arendt finds so morally suspect in *Eichmann*. Eichmann's thoughtlessness ensures his failure to remain in contact with reality and to share and dispute it with others, which is her definition of common sense: "The longer one listened to him, the more obvious it became that his inability to speak was closely connected with an inability to *think*, namely, to think from the standpoint of somebody else. No communication was possible with him, not

because he lied but because he was surrounded by the most reliable of all safe-guards against the words and the presence of others, and hence against reality as such" (*EJ*, 49). Eichmann demonstrates the moral collapse of Germany be-cause he resists the kind of thought that would force him to face reality, which is the criminality of the regime on whose behalf he acts. Arendt's efforts to distinguish between Eichmann's thoughtlessness and his lack of intelligence or education make thoughtlessness a product of will rather than of nature or socialization. (This distinction will become crucial to Arendt in *The Life of the Mind* because thinking becomes the bulwark of morality and so necessarily a property of all men rather than just the trained or the talented.) Plurality and concreteness in language work together as the safeguards *of* rather than *against* reality—plurality because it will not mirror a person back to himself; concreteness because it, as she sees in Zindel Grynszpan's testimony, brings one face-to-face with reality without distortion or evasion.

Arendt sees plurality at risk in two opposing but equally devastating ways in *Eichmann in Jerusalem* and *On Revolution*. Eichmann's radical remoteness from the reality of anyone else's perspective on the world destroys plurality as surely as does the overwhelming sympathy of the revolutionary tempera-ment as described in *On Revolution*. Instead of too much distance, the bound-lessness of emotion and sympathy dissolves otherness by collapsing distance, the distance that maintains the distinction between self and the other and that sustains plurality. Between these two poles of "idealism," the right and left incarnations of totalitarianism, stands the realist whose foremost obliga-tion is to reality as such, which must always be guaranteed with plurality and common sense—that is, that we share the world with others. Since Arendt believes that the most important political question of the late twentieth cen-tury is whether or not something leads to totalitarianism, her prescription for political action and political deliberation could not be clearer: face reality together, not the emotions that reality inspires. The reality that she insists on sharing is itself painful, but perhaps more importantly, facing reality with "unpremeditated attention" requires suffering forms of discomfort that can bring that engagement to a halt. Testing reality against the views of others, while it may corroborate and enlarge our own, also may not, which is both its value and its risk. The thinker who would value plurality must also embrace its unpredictability and uncertainty. And concreteness may make reality per-ceptible and shareable, but the very facts of reality may be extremely painful to bear. The safeguards of reality (plurality and concreteness), then, deserve more scrutiny because they are the pressure points in Arendt's philosophy of thinking and emotion. What allows one to confront reality without safe-

guards, to take the essential moral, political, and psychological risks that this entails, and what are the risks of failing to do so? Arendt is far more explicit about the risks of failing to confront reality than she is about the capacities that must be nurtured in order to do so.

## Reality Bites

Her decision to banish painful feelings from public life, theorized in *On Revolution* and put into practice in *Eichmann in Jerusalem*, needs to be understood in relation to her conclusions about suffering and thinking in the work that preceded these. Coming to terms with Eichmann crystallized something in her own thought that had been latent or undertheorized, and this led her to questions about thinking and thoughtlessness that preoccupied her for the rest of her life.

Her biographer Elizabeth Young-Bruehl argues that Arendt felt herself to be "cured" of an intense emotional relationship to painful reality in the writing of *Eichmann in Jerusalem*.[33] While Arendt survived the malaise brought on by the rise of totalitarianism and of the reports of the Holocaust, her work preceding *Eichmann* wrestled continually with the painfulness of reality and with forms of thinking. In particular, *Rahel Varnhagen* and *The Origins of Totalitarianism* revolve around the terrible costs of failing to face reality and the forms of thinking that permit its evasion. In distilling the compensations provided by these forms of thinking, which shelter individuals and even whole societies from reality, we can approach her philosophy of political heartlessness.

Arendt's thinking about the relationship between painful reality and forms of thinking begins in her biography of the early nineteenth-century Jewish socialite Rahel Varnhagen, which like *Eichmann in Jerusalem*, is frequently characterized as unsympathetic, harsh, or pitiless.[34] In this biography, Arendt places a very different value on Lessing's "self-thinking" that she referred to in her letter to Gershom Scholem. There she defined self-thinking as characteristic of the "conscious pariah":[35]

What confuses you is that my arguments and my approach are different from what you are used to; in other words, the trouble is that I am independent. By this I mean, on the one hand, that I do not belong to any organization and always speak only for myself, and on the other hand, that I have great confidence in Lessing's *selbstdenken*, for which, I think, no ideology, no public opinion, and no "convictions" can ever be a substitute. Whatever objections you may have to the results, you won't understand them unless you realize that they are really my own and nobody else's. (*JP*, 250)

In her post-*Eichmann* reconciliation with reality,[36] Arendt viewed self-thinking as a part of the public exchange of ideas, one that guaranteed a plurality of thought by ensuring the independence of individuals from what was often called "group-think" in the sixties. In contrast, in *Rahel Varnhagen*, "self-thinking" is a form of Enlightenment reason peculiarly susceptible to the distortions of introspection and, therefore, particularly appealing to Rahel, who wished to avoid acknowledging to herself her status as a pariah. Cut off from the world, "'self-thinking,' which anyone can engage in alone and of his own accord," was not a way of entering into public debate, secure enough in one's perceptions to share and thereby amend them, but a way of closing oneself off from plurality and the facts of experience.[37] "Self-thinking" for Rahel, as Arendt gleans from her letters, "brings liberation from objects and their reality, creates a sphere of pure ideas and a world which is accessible to any rational being without benefit of knowledge or experience" (*PHA*, 54). This abandonment of the world in Arendt's account of Rahel's self-thinking, a "foundation for cultivated ignoramuses" (*PHA*, 54) as Arendt bluntly puts it, liberates but only for "isolated individuals." Preferring to imagine past prejudices as mere relics, the isolated individual is not required to acknowledge "a nasty present reality," which is the lingering of prejudice in the minds of others.

The trajectory of Rahel Varnhagen's life arcs toward her acceptance of her pariah status, as the words she spoke on her deathbed attest: "The thing which all my life seemed to me the greatest shame, which was the misery and misfortune of my life—having been born a Jewess—this I should on no account now wish to have missed" (*PHA*, 49). This shift entailed learning to think with reality rather than using her mind to distract, obscure, and cushion the reality that was too painful for her to bear: her status as a Jew. Arendt does not underestimate the agony of Rahel's dilemma; if anything there is an astonishingly visceral pain in Arendt's description of Rahel's exclusion. Arendt asks how introspection can "be so isolated that the thinking individual no longer need *smash his head against the wall* of 'irrational' reality?" (*PHA*, 55, emphasis mine), and "how can you . . . transform reality back into its potentialities and so *escape the 'murderous axe'*?" (*PHA*, 55, emphasis mine), a metaphor Rahel used for acknowledging herself a "Schlemihl and Jewess" (*PHA*, 54). Arendt argues that "bound by this inferiority," Rahel "must avoid everything that might give rise to further confirmation, must not act, not love, not become involved in the world. Given such absolute renunciation, all that seemed left was *thought*" (*PHA*, 53). Introspection in *Rahel Varnhagen* is principally a form of compensation for this worldlessness and a consoling method of consolidating self-image by refusing to subject it to contradiction.

Rousseau is here (and elsewhere in *On Revolution*) Arendt's prime tar-

get for the "mania for introspection" as a form of self-delusion (*PHA*, 55). Freed from the conflict and contradiction of plurality, the individual is more guarded against reality than ever before. For Arendt, these various forms of avoiding reality in introspection have their temptations, which she names as the power and the autonomy of the soul. However, she argues that these are "secured at the price of truth, it must be recognized, for without reality shared with other human beings, truth loses all meaning. Introspection and its hybrids engender *mendacity*" (*PHA*, 55). This avoidance of the facts leads inevitably to disaster for the world's pariahs. Not only is the painful condition left unchanged by the retreat from reality, but also the self is obliterated in the process. Rahel's choice to avoid her reality "requires an inhuman alertness not to betray oneself, to conceal everything and yet have no definitive secret to cling to" (*PHA*, 57). Finally, her own refusal to confront reality created a vagueness that confused the object of her oppression. Not "blocked by individual and therefore removable obstacles, but by everything, by *the* world" (*PHA*, 59), no sort of action seemed either useful or possible.

The political worldlessness of Rahel and her generation is given much greater amplification in *The Origins of Totalitarianism*, which is itself about the distortions of thinking that permitted the rise of National Socialism. Moreover, Arendt defines totalitarianism as an attempt to obliterate the capacity to think, which had become increasingly difficult under the conditions of modern alienation and loneliness: "As terror is needed lest with the birth of each new human being a new beginning arise and raise its voice in the world, so the self-coercive force of logicality is mobilized *lest anybody ever start thinking*—which as the freest and purest of all human activities is the very opposite of the compulsory process of deduction" (*OT*, 171). The two distinctive features of totalitarianism—terror and the "self-coercive force of logicality," which she calls "supersense"[38]—are thus brought together as problems of thinking. Everyone in the totalitarian system is implicated in the problem of thinking and facing of reality: the perpetrators, both the masses and the elites in different ways; the outside observers in the international community; and the victims of domination. The strategies of the perpetrators and outside observers represent solutions to the anxieties of thought (unpredictability, uncertainty, and doubt) that make totalitarianism attractive and plausible. The last category, the camp victims, represents the abyss of thought that makes thinking during one's incarceration or about it after the fact nearly impossible.

In Arendt's terms, the masses' submission to logical supersense, the non-thinking that looks like thought, is a consolation and one for which she exhibits a certain sympathy: "Before the alternative of facing the anarchic growth

and total arbitrariness of decay or bowing down before the most rigid, fantastically fictitious consistency of an ideology, the masses will probably always choose the latter and be ready to pay for it with individual sacrifices—and this not because they are stupid or wicked, but because in the general disaster this escape grants them a minimum of self-respect" (*OT*, 50). In Arendt's calculation, the ultimately murderous self-sacrifice of the Nazis wins adherents because it provides something of value, not only meaning and a place in history, which creates self-respect, but also predictability in a time of helplessness and chaos. In adopting this logicality, however, the masses will inevitably develop contempt for their own individual realities. For supersense and logicality to proceed, any reality that contradicts them must be wished away, ignored, or destroyed, even when that process works to the detriment of the individual's self-interest or even survival. The promise of meaningfulness and predictability is therefore a compensation and consolation for a reality that is unbearable. We can conclude, then, that logic is itself a consoling form of thought when divorced from experience and that consolation as much as logic is to be regarded with suspicion, for the cost of predictability in this case is one's own superfluity—that is, one's own expendability.

Like the masses, the Nazi elite also banished reality, but in this case by regarding it as mere inconvenience, something utterly plastic and subject to the will. Given enough power and the time to use it, these men would remake reality into the fantasy of the leader. In this sense, thinking has stopped altogether. There is *a* thought married to power, and reality is transformed in order to conform to the idea. As Arendt explains, description becomes prediction: the "Jews are a dying race" means "kill the Jews." The elites, she says, "instinctively" understand this. Thought married to power means the destruction of plurality, something that the masses have already lost in their isolated loneliness. "It is chiefly for the sake of this supersense, for the sake of complete consistency, that it is necessary for totalitarianism to destroy every trace of what we commonly call human dignity. For respect for human dignity implies recognition of my fellow-men or our fellow-nations as subjects, as builders of worlds or co-builders of a common world" (*OT*, 139). Other human beings' perspectives on the world become not only a matter of inconvenience to the elite but an obstacle to remaking reality. To the extent that the inconsistency, disruption, and the discomfort of opposition inherent in plurality seem to endanger the grand thought, plurality will be compromised, if not destroyed.

The international community was unable to grasp the reality of totalitarianism because assumptions about human nature remained unexamined in light of new evidence about it issuing from Germany. The unexamined

"common sense" (in the ordinary, not Arendtian, sense of the words) that self-interest governs human motivation undermined the apprehension of the danger of totalitarianism, which is always potentially *self*-destructive (in Arendt's argument, all men, not just the victims of the camps, were equally superfluous):

> There is a great temptation to explain away the intrinsically incredible by means of liberal rationalization. In each one of us, there lurks such a liberal, wheedling us with the voice of common sense. . . . But wherever these new forms of domination assume their authentically totalitarian structure they transcend this principle, which is still tied to the utilitarian motives and self-interest of the rulers, and try their hand in a realm that up to now has been completely unknown to us: the realm where "everything is possible. . . ." What runs counter to common sense is not the nihilistic principle that "everything is permitted," which was already contained in the 19th-century utilitarian conception of common sense. What common sense and "normal people" refuse to believe is that everything is possible. (*OT*, 137–38)

Thinking has forgotten its obligation to the world and the necessity of self-doubt and questioning. This is not a failure of feeling or empathy but a failure of nerve, a preference for the comfort of certainty to the anxiety of self-doubt. The harshness of her characterization of the "wheedling" of the "liberal" that "lurks" in us all suggests the contempt Arendt had for this avoidance of self-interrogation, because she believed that such a way of thinking had indeed occurred in the comparative safety of the rest of Europe.

We come finally to those terrorized into abandoning thought: the inmates of the concentration camp. Once again, Arendt poses for her reader a question about the relationship between thinking and reality, though in this case she argues that the individual *must* flee reality because it is unbearable. Reducing a human being to a set of physiological reactions makes thought impossible, as we have seen in Weil's "Factory Work."[39] More interesting in terms of Arendt's own insistence on facing reality is the problem of thinking *about* total domination in light of the suffering of the Jews. Richard Bernstein suggests "it is by 'dwelling on horrors' of the concentration camps . . . that Arendt can provide a brilliant analysis of these institutions."[40] A closer examination of her analysis in *The Origins of Totalitarianism* reveals that the camps were the only reality that could not properly be faced in the sense that she had elaborated elsewhere. The death camps, which are in her terms the most significant feature of totalitarianism, its laboratory for "everything is possible," produce something like an abyss in thought. It is essential to think *of* them—that is, of the fact of their existence—because totalitarianism presents the single great-

est threat to the future of human beings, but it is literally impossible to think *about* them:

> If it is true that the concentration camps are the most consequential institu-
> tion of totalitarian rule, "dwelling on horrors" would seem to be indispens-
> able for the understanding of totalitarianism. But recollection can no more do
> this than can the uncommunicative eyewitness report. In both these genres,
> there is an inherent tendency to run away from the experience; instinctively
> or rationally, both types of writer are so much aware of the terrible abyss that
> separates the world of the living from that of the living dead, that they can-
> not supply anything more than a series of remembered occurrences that must
> seem just as incredible to those who relate them as to their audience. (*OT*, 139)

The experience, not the fact, of the concentration camps violates the prerequi-
sites of common sense. Testimony to the experience of the camps cannot be
shared, because it is unbelievable both to the one experiencing it and to the
one listening. Because it is "as though he had a story to tell of another planet"
(*OT*, 139), the horror also attains the status of the surreal, if not the unreal.
Unthinkable, unshareable, and unreal, the memory of the camps is trans-
formed into physical pain: the memory is "smitten in the flesh," a wound that
the sufferer cannot dwell on. Arendt also bars the contemplation of this suf-
fering by others, much as she does in *Eichmann in Jerusalem*: "Suffering, of
which there has been always too much on earth, is not the issue, nor is the
number of victims. Human nature as such is at stake" (*OT*, 139). Using the
problem of boundary violation that she uses in *On Revolution*, Arendt argues
that pity only augments suffering: "In times of growing misery and individual
helplessness, it seems as difficult to resist pity when it grows into an all-
devouring passion as it is not to resent its very boundlessness, which seems
to kill human dignity with a more deadly certainty than misery itself" (*OT*,
27). It is left to the "fearful imagination" of those "aroused by such reports"
to speculate on the future reappearance of totalitarianism. In this sense, pain,
suffering, and the wound of history are relegated to the private realm. They
are neither the grounds of politics nor a subject of knowledge.

Arendt even denies that facing this reality has any value by suggesting,
incredibly, that the experience of the camps has no future consequences for
survivors. She makes the startling claim that horror changes no one and noth-
ing: "A change of personality of any sort whatever can no more be induced
by thinking about horror than by the real experience of horror. The reduc-
tion of a man to a bundle of reactions separates him as radically as mental
disease from everything within him that is personality or character. When,
like Lazarus, he rises from the dead, he finds his personality or character un-

changed, just as he had left it" (*OT*, 139). By limiting the power of terror to the moment of its infliction, Arendt eliminates the need to revisit it after the fact. Because it changes nothing and no one, because it cannot be thought or shared, it exists simply as a motivation, as a question, *the* question, that unites all political thinking. Erasing horror from the domain of thought leads us back to *Eichmann in Jerusalem*. Declaring the suffering of the Jews in the camps beyond thought in *The Origins of Totalitarianism* and the heart's motivations beyond scrutiny in *On Revolution*, what could she have examined but Eichmann's thoughtlessness when she arrived in Jerusalem for the trial?

## After Eichmann

Arendt made no secret of the effect of Eichmann's trial on her life's work, dedicating herself to an inquiry into thoughtlessness and ultimately the philosophical history (or lack thereof) of the activities of thinking, willing, and judging, the three sections of *The Life of the Mind*. She repeatedly announced that it was the "fact" of Eichmann's thoughtlessness and what she came to understand as its role in the moral collapse of Germany that fueled the urgency behind this inquiry. Throughout all her essays, lectures, and books in the 1960s and early 1970s, Arendt's thinking about thinking colored her inquiries into contemporary political and moral dilemmas like the atom bomb, the Vietnam War, and the global student movements. As in her, albeit less systematic, attention to thinking that marked *Rahel Varnhagen* and *The Origins of Totalitarianism*, Arendt continued to point out the aversion to thinking and the situations, events, or conditions under which people became thoughtless. While she always uses the term "emotion" as she slows down to isolate that moment when a person abdicates his responsibility to think, it would be more accurate in our own terms to call thoughtlessness a response to affective distress, those moods or states that combine somatic, emotional, cognitive, and behavioral elements that do not yet rise to a nameable emotion. Thoughtlessness, or the forms of thinking that take the place of thought (logical supersense, for instance), ease the affective turmoil brought on by the unpredictability, uncertainty, doubt, and sheer painfulness of contemporary life and, in the end, by thinking itself.

In one of her first efforts to explore thinking after *Eichmann in Jerusalem*, a series of lectures given at the New School and the University of Chicago in 1965 and 1966 and published as "Some Questions of Moral Philosophy," Arendt argued that emotions were impeding the ability to think about the moral questions raised by the genocide of the Jews.[41] In these lectures, Arendt reacts to the dramatic reversal in the public discussion of the Holo-

caust, which had moved from one that could not admit the horrors into visibility to one that could not stop looking at them in the two to three years since she published her report. Arendt believed that the question she wished to investigate—how ordinary people could completely lose their moral compasses—"was concealed by something about which it is indeed much more difficult to speak . . .—the horror in its naked monstrosity" (*RJ*, 55). Arendt is adamant that it is the "*speechless* horror" and the speechlessness produced by horror that make thinking impossible and trivialize other considerations of judgment and analysis:

> Since people find it difficult, and rightly so, to live with something that takes their breath away and renders them speechless, they have all too frequently *yielded to the obvious temptation to translate their speechlessness into whatever expressions for emotions were close at hand, all of them inadequate.* As a result, today the whole story is usually told in terms of *sentiments which need not even be cheap in themselves to cheapen and sentimentalize the story.* The whole atmosphere in which things are discussed today is overcharged with emotions, often of a not very high caliber, and whoever raises these questions must expect to be dragged down, if at all possible, to a level on which nothing serious can be discussed at all. (*RJ*, 56, emphasis mine)

One cannot help but hear Arendt responding to the reproaches of heartlessness in this complaint. Emotions, and not just sentimentality, in this passage are always dangerous to public debate; emotions "need not even be cheap in themselves to cheapen"; therefore, any emotions whatever will spoil the public sphere. The answer for her is to refuse to "translate" the horrors into emotion rather than into language. As in *On Revolution*, the appearance of misery elicits a collective emotional outpouring that swamps the public sphere and blocks thinking.

Arendt's collapse of legitimate emotions, which nonetheless "sentimentalize," with those of "a not very high caliber" places her squarely in the modernist tradition and in the company of the Frankfurt school refugees/émigrés, like Theodor Adorno, who had such influence on American intellectuals in the postwar era. Certainly she shares with them a distrust of emotions in public life and a deep distaste for sentimentality; her treatment of the testimony of Zindel Grynszpan demonstrates her own modernist preferences for concreteness and lack of emotional expressivity. However, Arendt goes a step further. Misery and horror do not provoke an insipid response from either French revolutionary leaders or contemporary witnesses to atrocity; but although they elicit a powerful and genuine one, that response nevertheless ends in disaster. Given the familiarity with the antisentimentalism of her

contemporaries and the long-standing aversion to sentiment among modernist writers and thinkers, the outcry elicited by her irony and her refusal to treat Jewish suffering directly should be far more surprising than it has been, especially from within the circle of intellectuals who championed modernist aesthetics at the *Partisan Review* and elsewhere.[42] In thinking about the Holocaust, modernist antisentimentalism seemed to be just as spectacular a failure for many readers as the more easily disparaged sentimentalism of *The Diary of Anne Frank* a decade before. No representational solution seemed adequate. The almost-universal chorus among writers and intellectuals after the war lamented the unbridgeable gap between language and modern life, the inability to express either the gravity or the enormity of the midcentury atrocities, the unprecedented and therefore unmanageable crisis of the atom bomb's capacity to wipe out human life, and the inadequacy of traditional literary forms and practices to cope with these new crises of representation. Nevertheless, some responses seemed more ethically repellent than others. Arendt's heartlessness, as she defined it, rather than the more broadly shared antisentimentalism of her peers, carved out areas of reflection and practices of representation that she assumed would be painful—not merely clarifying or invigorating—but not so emotionally wrenching as to render the translation of experience into language pointless.

Arendt would continue to defend and to elaborate heartlessness in *On Violence* and then *The Life of the Mind*. First, she wants to distinguish heartlessness from sociopathy, which is the inability to feel. She says, relying on Noam Chomsky, whom she quotes approvingly throughout *On Violence*: "Absence of emotions neither causes nor promotes rationality. 'Detachment and equanimity' in view of 'unbearable tragedy' can indeed be 'terrifying,' namely, when they are not the result of control but an evident manifestation of incomprehension. In order to respond reasonably one must first of all be 'moved,' and the opposite of emotional is not 'rational,' whatever that may mean, but either the inability to be moved, usually a pathological phenomenon, or sentimentality, which is a perversion of feeling."[43] More concerned with emotions in general than with sentimentality in particular and with control rather than neutrality, Arendt creates a division that she will spell out clearly in *The Life of the Mind*, where she goes to some lengths to inoculate thinking from the contamination of feeling. The mental activities of thinking, willing, and judging, defined by their autonomy from one another, all depend on the quieting of the "soul's passions."[44] She creates a firm distinction, even partition, between mind, which is defined by its self-chosen activity, and the soul, which is "where our passions, our feelings and emotions arise, . . . a more or less chaotic welter of happenings which we do not enact but suffer and which in

cases of great intensity may overwhelm us as pain or pleasure does" (*LOTM*, 72). A principal difference is that emotions and feelings are "suffered," that is, endured passively, whereas the mind is "sheer activity." However, Arendt has no answer to the problem of being "overwhelmed" by emotion and the degree to which one is passive in the face of it; she argues that emotions "are not liable to be changed by deliberate intervention" (*LOTM*, 73), and she scoffs at the Stoics, who succumbed to the philosophical "fallacy" of equating soul and mind (because they are both internal and therefore invisible) rather than understanding them to be distinct. "That you can *feel* happy when roasted in the Phalarian Bull" seems to her obviously ridiculous. The point is not that the mind can control feeling—it cannot—but it can control the display of those feelings. And "we need a considerable training in self-control in order to prevent the passions from showing" (*LOTM*, 72). The alternative to infecting public life with emotion or resorting to the morally perilous thoughtlessness seems to be the sheer endurance of pain, even overwhelming pain. Implicitly, only time will quiet the passions and allow the feelings of being overwhelmed to subside. This wait for quiet, however, must not be understood as thoughtlessness, which is for her willed nonthinking; it is, rather, not thinking *just yet*. Thoughtlessness constitutes the active avoidance of painful feeling and offers a substitute form of thinking that consoles and soothes.

Arendt is perhaps clearest on how thoughtlessness acts as a mechanism to avoid pain in her lectures, both "Some Questions of Moral Philosophy" and its later iteration as "Thinking and Moral Considerations." Both of these lectures, more political and more polemical than the magisterial *The Life of the Mind*, begin with Eichmann to address the quandary he posed and conclude by linking the issues brought forward in the trial with her theory of thinking as a moral preservative. Her first move is to democratize thinking as an activity of all human beings and to assert that thinking can arise out of any occurrence and among all walks of life. Something happens and we retell it as a story, preparing it for communication or for reviewing it later with oneself. She then claims the best way for a criminal to escape detection and punishment is to "forget what he did" (*RJ*, 94) by not preparing the event for retelling: "No one can remember what he has not thought through in talking about it with himself" (*RJ*, 94). Thoughtlessness begins with a deliberate choice not to represent actions in language, not to create memory: "If I *refuse* to remember, I am actually ready to do anything—just as *my courage would be reckless if pain, for instance, were immediately forgotten*" (*RJ*, 94, emphasis mine). Thus, the motivation to thoughtlessness is not generated by feeling, much less by overwhelming feeling, but by the avoidance of painful feeling (guilt, remorse, discomfort, confusion). Having done wrong—and thus knowing it or perhaps

sensing it, though she doesn't say so—we *choose* thoughtlessness. She goes on to assert that evildoers may very well exist, but the real danger is "those who don't remember because they have never given thought to the matter, and without remembrance, nothing can hold them back" (*RJ*, 95). In refusing to remember, evil is not radical—it has no roots to stabilize itself—but rootless and therefore limitless (the "everything is possible" innovation of National Socialism). We cannot forgive such a person because, in Arendt's terms, there is no person there to forgive, having willingly abandoned the human capacity for thinking, using language, and remembering.

To sustain this avoidance of pain over time rather than in the moment, we turn to forms of consolatory thinking. In *On Violence*, the potential for painful feeling generates a form of thoughtlessness that looks very much like logical supersense. She draws her example from the US government and its efforts to strategize nuclear conflict. Contemporary warfare, utterly transformed by the destructive capacity of atomic weaponry, was the epitome of unpredictability, which is a characteristic of all violence and warfare intrinsically. She argues: "Under these circumstances, there are, indeed, few things that are more frightening than the steadily increasing prestige of scientifically minded brain trusters in the councils of government during the last decades. The trouble is not that they are cold-blooded enough to 'think the unthinkable,' but that they do not *think*" (*OV*, 6). What leads to disaster is not emotion or its lack but consolatory thinking that preempts the emotional volatility of unpredictability. Creating "facts" by forgetting the assumptive nature of their hypotheses, the "brain trusters" or war-gamers enjoy their fantasy of predicting the future, "hypnotized" into losing touch with "reality and factuality" because they are so mesmerized by the "inner consistency" of their games (*OV*, 7–8). The games provide the illusion of predictability because "random events" are excluded by the rules of the game. Arendt reminds her readers that events are called such only because they arise without warning, because they are by definition unexpected. Thus, the brilliant strategists do not *think* because they do not want to *feel* their own distress. Arendt's respect for the worldwide student movements derived from her perception of their greater tolerance for painful feeling: young people alone had "greater awareness of the possibility of doomsday than those 'over thirty'" (*OV*, 17). She says: "To the oft-heard question: Who are they, this new generation? one is tempted to answer, Those who hear the ticking. And to the other question, Who are they who utterly deny them? the answer may well be, Those who do not know, or refuse to face, things as they really are" (*OV*, 18). In one of the last lectures she gave, "Home to Roost," on mendacity in the conduct of the Vietnam War, she ended her scathing remarks, delivered at a bicentennial celebration, with a

call for facing reality and enduring the painful feelings that arrive in that act. "When the facts come home to roost, let us try to make them welcome. Let us try not to escape into some utopias—images, theories, or sheer follies. It was the greatness of this Republic to give due account for the sake of freedom to the best in men and to the worst" (RJ, 275).

If writing *Eichmann in Jerusalem* allowed Arendt to recover the *amor mundi* that grounded her political philosophy, it has been less obvious the extent to which this recovery depended on developing a relationship to suffering that was distinctly unconsoling and austere. Two intellectual biographies, Julia Kristeva's *Hannah Arendt* and Sylvie Courtine-Denamy's *Three Women in Dark Times: Edith Stein, Hannah Arendt, Simone Weil*, celebrate Arendt's love of the world, much as did Young-Bruehl. Kristeva focuses on the importance of love in Arendt's thinking, and Courtine-Denamy, on Arendt's efforts to reconcile herself with reality. Both see her thought as motivated by what we might call a will to joy, and both find Arendt's tough-mindedness with regard to painful feeling and public life scintillating. Nevertheless, in their optimistic appraisal of Arendt's love of the world, they have not calculated the tolerance of suffering that was a part of her newfound equilibrium. The realist who stands between the twin poles of totalitarian idealism—the solipsism of thoughtlessness and the boundarylessness of revolutionary sympathy—must tolerate, even embrace, what might be considered forms of psychological distress. The realist accepts the pain of reality, no matter how extreme; endures doubt; welcomes conflict; consents to unpredictability; takes up the isolation of the conscious pariah; and concedes control over the future. The only way to become a realist, and for Arendt we all must do so for our mutual survival, is to cultivate a suspicion of intellectual and psychological comfort in whatever forms we find them. Arendt hated illusions about the terrible facets of human existence and wished for herself and her "co-builders" of the world to accept willingly a wounding by them. Suffering is so much a part of her notion of thinking that only by feeling pain can one know that one loves the world properly.

3

# Mary McCarthy: The Aesthetic of the Fact

What often seemed to be at stake in Mary's writing and in her way of looking at things
was a somewhat obsessional concern for the integrity of sheer fact in matters both
trivial and striking.

ELIZABETH HARDWICK, foreword to *Intellectual Memoirs*

## Alone on the Same Side

One evening in the late 1940s, Hannah Arendt and Mary McCarthy found themselves standing together on a subway platform in uncomfortable silence. Though both were returning home from an editorial meeting for the magazine *politics*, on which they had served for some time, neither had spoken to the other since their disastrous first encounter at a party six years earlier. Arendt approached McCarthy and said in her typically blunt manner, "Let's end this nonsense. We think too much alike."[1] Each then apologized and so began one of the most vital intellectual friendships of the last century. Brock Brower aptly surmises why they were able to make peace: over the years at *politics*, "they found that on any number of public questions they always ended up on the same side, and 'usually alone.'"[2] Carol Brightman, McCarthy's biographer and the editor of their letters, suggests that they formed a "party of two,"[3] but it is more accurate to make use of Brower's felicitous turn of phrase: on the same side and alone. Being "alone" "on the same side" seems to me an unusually precise characterization of the detached quality of relation they sought in each other and in their political affiliations.

Their preference for going it alone has made them difficult to categorize politically. McCarthy could have been referring to herself or Arendt when she described her other close friend, the Italian drama critic and political anarchist Nicola Chiaromonte: "His ideas did not fit into any established category; he was neither on the left nor on the right. Nor did it follow that he was in the middle—he was alone."[4] If this characterization sounds familiar, it was the credo published in the first issue of the relaunched little magazine *Partisan Review*, which McCarthy, Philip Rahv (her then lover), William Phillips, Dwight Macdonald, Fred Dupee, and George Morris revived in 1937:

"*Partisan Review* is aware of its responsibility to the revolutionary movement in general, but we disclaim obligation to any of its organized political expressions. Indeed we think that the cause of revolutionary literature is best served by a policy of no commitments to any political party." The new *Partisan Review* was breaking from its past as the literary organ of the Communist Party USA, its founders having broken with the party after the Moscow Trials. The *Partisan Review* may have been unfixed in its party affiliations, or it may have wanted to believe so, but it was committed to polemic, positions, and ideas. Neutrality meant going after everyone. This unfixed but polemical style suited McCarthy to a T. Although she is typically associated with the anti-Communist Left, she was never systematic in her politics and was considered by some of her friends and most of her enemies as dilettantish in her political commitments. Arendt, on the other hand, appeared to belong among the postwar liberals, but she also seemed to betray them time and again, most conspicuously with her report of the trial of Adolph Eichmann and her "Reflections on Little Rock."[5] Their contrariness, I want to show, was on a deeper level a commitment to being disrupted and self-alienated, to changing and being changed, through their painful encounters with reality.

Their stands on particular issues alienated them from their allies or potential allies, but so too did their mode of relation. Arendt's and McCarthy's detachment, their preference for solitude over solidarity, sets them apart from the type of political affiliation later favored by the progressive social movements that emerged in the Cold War era, all of which advocated bonds of intimacy and group identification, and during which their reputations were forged. Indeed, their repudiation of both in theory, to say nothing of their refusal in practice, marked these women as pariahs within groups that expected to win their support. When the social movements of the late twentieth century recommended the healing power of empathy as the glue of solidarity and the fuel of progressive politics, Arendt and McCarthy recoiled, not from the goal of social justice, but from the path to it. It was not always easy for their readers to make this distinction. Because it is difficult to imagine ethics without empathy, Arendt and McCarthy have been perceived as psychologically cold rather than engaged in an ethical project with different assumptions. The ethical models of relation ascendant since the eighteenth century's advancement of moral sentiment and thrust forward by the tragedies of the midcentury have tried to bring the self face-to-face with the Other. If we return to the image of two women standing side by side, facing the subway, we might imagine a countertradition of ethical relation, one that seeks not to come face-to-face with the Other but to come face-to-face with reality in the pres-

ence of others. Since reality and the Other cannot be faced at the same time, McCarthy and Arendt chose to face reality, however psychically wounding. This chapter will take up each of these issues, facing reality (or facing facts, as McCarthy put it) and being "alone together," to think through the demands that McCarthy, in dialogue with Arendt, made on her readers and on the literary forms through which she addressed them.

The last chapter described Arendt's embrace of heartlessness. Responding to Gershom Scholem's angry, disappointed condemnation of her "heartlessness" in *Eichmann in Jerusalem*, Arendt critiqued the notion of heart, accepting his description but on her own terms, which I will inflect in a slightly different way here: "Generally speaking, the role of the 'heart' in politics seems to me altogether questionable. You know as well as I how often those who merely report certain unpleasant facts are accused of lack of soul, lack of heart, or lack of what you call *Herzenstakt*. We both know, in other words, how often these emotions are used in order to conceal *factual* truth" (emphasis mine).[6] Arendt felt it her duty to report the facts, as "unpleasant" as these might be, and to an even greater degree, so did her friend McCarthy. Indeed, McCarthy offers something like a tutorial on this question, returning to the problems of fact and reality throughout her career, most insistently from the late 1940s to the early 1960s, and in all of the many genres in which she worked: novel, short story, essay, travel writing, autobiography, political journalism, and criticism. Titling a short story collection *Cast a Cold Eye*, McCarthy spent the better part of her long career articulating the demands of this cold eye in the effort to "face facts" and make her readers face them, too. That she spared no one in this endeavor, including herself, made her critical and satirical aggression legendary. Her reviewers unfailingly described her prose with adjectives like "heartless," "cutting," "acid," "pitiless," "detached," and "brutal," and with nouns like "knife," "stiletto," "switchblade," and "scalpel."[7] And no doubt, McCarthy intentionally wounded with her writing for reasons that are personal. Nonetheless, as for all the women in this book, this aggression has been seen primarily as a castrating bitchiness, effectively personalizing, gendering, and otherwise obscuring the more general principles on which she worked and went to great lengths to explain. The "fact" (and what she called "factuality," as opposed to the more familiar term "realism") is the foundation of McCarthy's aesthetics, just as it is a foundation of Arendt's politics.

McCarthy's brutal frankness stemmed from her belief in facts, which she theorized in terms of politics, journalism, intellectual life, literature, and visual art during the midpoint of her career, when she produced her best

work. During the 1950s, McCarthy set about naming her aesthetic principles primarily in her nonfiction writing in the prospectus to *Critic*, the essays from *On the Contrary*, her travel writing about Venice and Florence, and her first autobiography, *Memories of a Catholic Girlhood*. This work, along with her first novel (*The Company She Keeps*), her later autobiographies (*Intellectual Memoirs* and *How I Grew*), and the best-selling novel *The Group*, form the core of what are now the most widely read works of McCarthy's large oeuvre. Her novels are, for the most part, absent from this list. The argument has been that in working so directly with the events, persons, and details of her own life—she wrote only what could be called autobiographical novels or romans á clef—McCarthy's novels lacked imagination. This chapter will argue the opposite: McCarthy's novels are not too close to the facts of her life but are too overdetermined by her ideas. This in turn softened the very things about facts that she held most dear: their inherent properties of unpredictability, unmanageability, and autonomy.

## The Aesthetics of Common Sense

"Facing reality" sounds like a cliché, and indeed it is, if we fail to understand the dynamic terms in which Arendt and McCarthy imagined the process. Arendt's conception of facing reality depends on Kantian common sense, which is not the rational being's possession of self-evident and natural truths but an active and complex sharing of a necessarily partial view of the world. McCarthy's notion of "the facts," as she called them, is not a faith in objective and stable reality but a confrontation with reality's elusive, sensual, and frequently painful qualities. I want to follow a path from Arendt's political philosophy of common sense to McCarthy's aesthetic of the fact to explain why they believed reality had to be faced in a condition of exposure and how this could be achieved. While McCarthy often edited Arendt's prose and Arendt informally tutored McCarthy in political philosophy, they never actually wrote together (though McCarthy frequently "Englished" Arendt's prose and brought her unfinished *The Life of the Mind* to press). Seeing McCarthy as a practitioner of Arendt's ideas about common sense articulates the aesthetic prerequisites of Arendt's political philosophy; likewise, seeing Arendt as a theorist of aesthetic perception demonstrates the ways in which McCarthy's aesthetics originate from a political stance in the world.

Arendt proposed "friendship" of the "sober and cool" classical variety as a way to imagine political relationship, ruling out "friendship . . . as a phenomenon of intimacy, in which friends open their hearts to each other."[8] Elimi-

nated, too, was solidarity of the kinds she and McCarthy knew from their youth: national belonging, ideological partisanship, and party politics. Arendt distinguishes her notion of solidarity from pity and compassion in *On Revolution*, where she says men establish solidarity with the "oppressed and exploited" both "deliberately" and "dispassionately"; indeed, "compared with the sentiment of pity, it may appear cold and abstract, for it remains committed to 'ideas' . . . rather than to any 'love' of men."[9] She said of herself to Scholem during the *Eichmann in Jerusalem* controversy that she had "never in [her] life 'loved' any people or collective."[10] McCarthy's antipathy to ideological solidarity grew out of her experience with Stalinists during the Moscow Trials, a self-defining and career-changing episode she recounts in "My Confession."[11] Having accidentally signed a petition in support of asylum for Leon Trotsky, McCarthy was then subjected to harassment by anonymous midnight callers urging her to withdraw her signature. Admitting to her readers that this support was uninformed and capricious at first, McCarthy was provoked into the first meaningful political act of her life more in outrage against the coerced unity of the united front than in solidarity with the Trotskyists. Like Arendt, McCarthy viewed the question of affiliation and group belonging as a statement of fact, not an expression of feeling. Both agreed that one could not deny belonging when called out as a member of a group; one could not assert a necessarily specious universality no matter how appealing. McCarthy spent much of her late autobiographies—*How I Grew* and *Intellectual Memoirs*—chastising herself by counting up her youthful attempts to disguise the fact of her Jewish grandmother; she did this despite her public acknowledgment of this grandmother on the first page of her 1957 autobiography, *Memories of a Catholic Girlhood*. Neither sought to "love" this affiliation; they aimed merely to own it in Arendt's case and, in a more complicated way, to own up to it in McCarthy's.

Among the dangers they saw in certain kinds of solidarity—along with the potential for mendacity and coercion, the penchant for rituals of purification and exclusion—was its anesthetic quality, which McCarthy and Arendt believed to be one of its most damaging features. Solidarity, as they saw it practiced, deprived individuals of the experience of reality by insulating them against its painful effects. This insulation came in many forms. National belonging protected individuals against the loneliness and isolation of mass society. Ideological solidarity eliminated unpredictability by providing a largely fantastical but soothingly coherent theory of experience and narrative of the future. And the solidarity of pariah groups, as Arendt called them, was perhaps the most seductive of all: it offered an intense sociability found nowhere else in modern society. She says of pariahdom:

This produces a warmth of human relationships which may strike those who have had some experience with such groups as an almost physical phenomenon. Of course I do not mean to imply that the warmth of persecuted peoples is not a great thing. In its full development it can breed a kindliness and sheer goodness of which human beings are otherwise scarcely capable. Frequently it is also the source of a vitality, a joy in the simple fact of being alive, rather suggesting that life comes fully into its own only among those who are, in worldly terms, the insulted and injured.[12]

Nonetheless, this vitality comes at too exorbitant a price: worldlessness. Arendt explains how pariahdom divests the pariah of any ability to share the common world. These capacities are—surprisingly, I think—aesthetic. She argues that "the privilege" of the pariah's exceptional humanity "is often accompanied by so radical a loss of the world, *so fearful an atrophy of all the organs with which we respond to it—starting with the common sense with which we orient ourselves in a world common to ourselves and others and going on to the sense of beauty, or taste, with which we love the world*—that in extreme cases, in which pariahdom has persisted for centuries, we can speak of real worldlessness. And worldlessness, alas, is always a form of *barbarism*"[13] (emphasis mine). To take the full measure of her claim about barbarism, we need to backtrack for a moment to a letter she wrote to McCarthy tutoring her on the sensual and ultimately aesthetic component of common sense. The pariah is not alone in the loss of common sense; this loss she detected at the "root of modernity" in "the distrust of the senses." She points to "the perversion of common sense, or rather the misgivings about it in its *sensual* quality," as a destruction of the common world: "Common sense . . . is a kind of *sixth sense* through which all particular sense data, given by the five senses, are fitted into a common world, a world which we can share with others, having in common with them. Common sense in other words was the control instance for the possible errors of the five other senses" (emphasis mine). The distrust of common sense led to the assumption that what made the world shareable was not the senses but "a faculty we all have in common . . . the logical faculty."[14] But logic, she claims, is unable to "[guide] us through the world," and it is toward a restoration of the sensual, aesthetic component of common sense that Arendt leads.[15] As I will explain, McCarthy was by temperament and training already a student of this school of aesthetic common sense by this time; Arendt was supplying her with a philosophical foundation and clarifying her terms.

"Common sense," in Arendt's use, is activity rather than knowledge; that is, it is something one does, not something one has. Moreover, unlike the ordinary term, Arendtian common sense is not self-evident but *self-altering*.

"Common sense" as the "sixth sense" requires individuals to engage with others in the act of perception, sharing the world in a way that corrects and amends subjective insight. Because one's bodily and social position in the world generates one's perspective of reality, sharing corrects best when these positions overlap least. There is no absolute truth to be achieved in this process—that is, no "correct" way to view reality—but there is, in her words, a "control instance" against "errors." Therefore, the pariah, constrained by law and custom to associate only with those most like him, is deprived of degrees of correction and alteration or, to use the language of taste she invokes, refinement. Encountering difference is the lever of correction. Therefore, any group formed around likeness, whether that be shared ideological commitment or national belonging, risks adopting these same perceptual restrictions by shielding themselves against different perceptions of reality. When Arendt advises the pariah to stand apart from the intimate society of the pariah group, she does not recommend self-sufficiency but plurality—that is, bringing the perceiving self into contact with nonintimate, differently situated others. The politics of plurality and common sense requires, then, something like an aesthetic of the fact, which is a discipline of perception as well as a practice of representation.[16]

Arendt evidently believed that McCarthy had acquired that discipline. In a preface to Chiaromonte's *Paradox of History* (his 1966 Gauss Lectures), McCarthy told the following anecdote, somewhat superfluously to her argument:

> Many years ago my great friend Hannah Arendt and Chiaromonte had agreed to meet in Florence during a trip of hers to Europe, for they had much to talk about (he had greatly admired *The Human Condition* and written her a long letter about it, which she answered, also at length, I believe). In Florence, they spent a couple of days together looking at the city, but when afterward I asked one of them (I forget which) how it had gone, he or she shrugged: "All right, I suppose. She/he is intelligent. But so abstract!" The other reported the same. (*OP*, 260)

McCarthy wanted to make the point, defending Chiaromonte from his English critics, that a writer's or thinker's level of abstraction is a relative thing. In the anecdote, Arendt and Chiaromonte, too, prefer concreteness, which reveals something about McCarthy herself. As the very close friend of both, McCarthy evidently provided to each his or her preferred level of concreteness. To put this another way, McCarthy provided the contact with reality that they so urgently sought. She was the fact to their idea. While McCarthy's emphasis on facts and her unique evaluation of their aesthetic properties preceded her friendships with Chiaromonte and Arendt, their decades-long

conversations enriched and focused McCarthy's understanding of the role of the fact in literature.

## The Aesthetic of the Fact

While McCarthy's use of facts to shock her readers or to satirize herself and others is well known, the extent to which she theorized facts as a component of her own aesthetic and the aesthetic achievement she most admired has hardly registered.[17] The apprehension of facts, as McCarthy understood the term, is necessarily aesthetic in the root meaning of the word, as Arendt explained. Susan Buck-Morss summarizes this efficiently: "The original field of aesthetics is not art but reality—corporeal, material, natural. . . . It is a form of cognition, achieved through taste, touch, hearing, seeing, smell—the whole corporeal sensorium."[18] As both a realist novelist and a novelist of ideas, McCarthy sought to achieve cognition through the senses. However, as she explained in "The Fact in Fiction," the cognition of reality through the senses would prove nearly impossible, and therefore exceptionally urgent, under the conditions that prevailed in the late twentieth century. The traumatic realities of the midcentury—Buchenwald, Auschwitz, and the hydrogen bomb as she enumerates them—were a species of "irreality," which had in their sheer enormity rendered everyday life unreal and insignificant (*OTC*, 267). The contemporary novelist, who should have provided the bridge between the vast traumatic events of history and the local, provincial experiences of everyday life, had retreated from the facts of experience into a "dream world."[19] At the same time, realism as it had developed over the previous hundred years had revealed itself as "unstable," turning systematically into "irreality," thus compounding rather than alleviating the peculiar disease of modern life.

In "The American Realist Playwrights" she explains this instability. Even the greatest realists inevitably find "reality" unsatisfying and so betray the genre with the grandiosity of unearned universality or the sordidness of pornography. However, the instability of "realism" is as much a question of moral character as it is one of aesthetic sensibility: "To find the ideal realist, you would first have to find reality. And if no dramatist today . . . can accept being a realist in its full implications, this is perhaps because of a *lack of courage*" (*OTC*, 311, emphasis mine). She hoped to summon writers who would "be able to believe again in reality, the factuality, of the world" (*OTC*, 270), but in order to demand the necessary courage, she had to dismantle the ingenious defenses against reality that allowed writers to avoid the pain reality inflicted. McCarthy's body of work can be seen as a long meditation on the myriad forms of self-delusion that comforted her generation, not excepting herself.

McCarthy's commitment to the fact is probably most easily recognized in her now best-known work, *Memories of a Catholic Girlhood*. When collecting for the volume the series of autobiographical stories she had published in the *New Yorker*, McCarthy added "inter-sections," all of which meditated on the factuality of her recollections. With the benefit of hindsight, reader comment, and the comments of those depicted in the writing, McCarthy set about fact-checking her work, going to the public record and the records left behind by others who knew her or shared her experiences, searching her own memory and comparing her memories with those who were there. Later when she wrote the last two memoirs, *How I Grew* and *Intellectual Memoirs*, toward the end of her life, she engaged in an ongoing fact-checking throughout the prose, constantly querying her memory, challenging her own interpretation, and then sometimes revising and changing the story as she added a new memory or piece of information. The conversational style of these later works makes fact-checking the compositional framework. In *Memories of a Catholic Girlhood*, however, McCarthy is subjecting the autobiographical project to the pressure of fact that she was at the same time laying out in her essays and in her travel writing in the mid-1950s. In this first autobiographical work, it is less a distrust of her memory than an ongoing interrogation of her courage: a moral inventory, in facing up to the facts. Throughout her autobiographical writing (and some of her novels), the lack of courage always seems to lead to what she conceives of as her most egregious moral failures and thus constitutes the most embarrassing flaw she can name in herself.

Autobiography is only one realm in which factual accuracy matters, however. From the late 1940s, when she began writing fiction, she had worried about the place of the fact in American life. However, what she meant by a "fact" is somewhat complicated. The conventional meaning of the word is misleading for the simple reason that McCarthy used it to describe many different kinds of things, which indicates that a fact is not purely information, though it can be. A fact can also be an occurrence in history, like the death camps; an event in culture, like a new art form or artist; a document, like a novel or a transcript of a hearing; an aesthetic object, like a painting or a useful one like a window; a person, like Richard Nixon, or a character in fiction, like Charles Bovary. However, even though it is difficult to say exactly what a fact is, by looking at the many contexts in which she wrote about facts, it is possible to say what a fact *does*. What makes something a fact seems to be less its informational content than its capacity to alter the observer.

She first began explicitly addressing the absence of fact in American journalism and intellectual life in the prospectus to the magazine *Critic* (1952), which she attempted (and failed) to launch with, among others, Hannah

Arendt. McCarthy argued that the conformity of American journalism was not a breakdown in the critical faculty, as the name of the magazine might imply. There was plenty of opinion, and some of it critical, but there simply was no diversity of opinion or truly dissident ideas. The fault lay instead in the widespread fear of confronting facts. For instance, in the so-called little magazines, writers were more interested in displaying their cleverness than contending with facts, thereby drawing attention away from complications they could not master; she points to one of her own articles as an example of this fear of appearing "pedestrian" or simply "not smart." In liberal magazines like the *Nation* and the *New Republic* anxiety about the "security" of their "beleaguered" position "[drove] them to suppress, like military censors, any facts or ideas that might tend to support the enemy's side."[20] Finally, mass-market publications capitalized on the "absence of true reporting by hiring men of talent to produce clever arrangements of synthetic or plastic 'facts,'" offering a pabulum to the "average" reader, whom they imagined as a "dolt."[21]

Though different in each case, the problem of reporting amounts to the same thing: knowing the story in advance of an encounter with the world, especially an encounter that could alter a narrative already in place. The facts manufactured by the Luce empire suggest this most clearly: the synthetic fact is not precisely a lie—it will be verifiable, of course—but neither is it precisely a fact.[22] "Plastic" or "synthetic" facts do not operate like real "facts," because they are mass-produced out of materials not found in nature—that is, not found *in* the world—and they are malleable. The writer molds the fact to the story rather than the other way around. A true fact, however, can be distinguished from its synthetic double rather easily. Facts resist manipulation: they are "dissident . . . insofar as they support thought, insofar as they are obstinately real . . . that is, positively rebellious to the structures mass-society and its media impose on them."[23] And facts, rather than writers, are socially offensive. As McCarthy acknowledged: "This mere taking of notice [of them] is bound to seem critical—unwarrantably rude, even, like a peremptory question."[24] To face facts, the journalist must risk the social condemnation of rudeness and intransigence (the peremptory question that closes down rather than opens up debate), which is all the more perilous for women writers, in whom the assertion of authority and the failure to exhibit good manners are more ruthlessly punished.

The "courage" she hopes to stimulate in facing facts is, therefore, paradoxical: we are meant to yield to them. Yielding should not be equated with passivity, however. Instead, yielding is being open to alteration, which is genuinely painful. She asks the intellectual and the liberal journalists to relinquish their defenses against facts (she has no real interest in reforming the Luce edi-

tors). In place of cleverness, intellectuals must risk perplexity and lack of mastery in their thought, trading the rhetoric of certainty for one of tentativeness and speculation. Instead of shoring up her own security, the liberal journalist must risk the appearance of disloyalty by admitting the potentially mutinous fact into discussion. McCarthy's seriousness about the need for courage suggests that she appreciated the difficulty of what she proposed. The intellectual, in opening to this strangeness in his own thought, makes of himself a stranger; that is, the encounter with facts may render a person unrecognizable to himself. Likewise, the liberal partisan in exposing his "side" to strangeness opens the possibility of refiguring his own positions. In their defensive postures, both are refusing strangeness and alterability, the intellectual by being too self-enclosed, too unwilling to share the task of understanding the fact with others, and the partisan by binding himself too closely to others like him, using solidarity as a shield against the fact that might erode consensus, however ill-founded. Since encountering facts is a discipline of perception, not a onetime event, she is demanding that the intellectual and the liberal partisan enter a process of self-alienation that is not only genuinely painful but never-ending.

If we turn to a short story written nearly a decade before she drafted the prospectus for *Critic*, we can see McCarthy beginning to test the relationship of facts, alterability, and pain. In *The Company She Keeps*, "The Portrait of the Intellectual as a Yale Man" locates us on the same terrain that the prospectus navigates: the intellectual journalist, Jim Barnett; the liberal magazine where he works; and the Luce-type publication where he winds up. Barnett, the "Average Thinking Man," figures the moral and political self-delusion of the liberal intellectual who does not want to be altered by his beliefs or by the world around him. Graduating from Yale having "just taken a big gulp of *Das Kapital*," Jim finds himself working at the *Liberal*, a weekly magazine very much like the *New Republic* of the 1930s, where he writes articles and serves as something of a "mascot."[25] What makes Jim's espousal of Marxism so appealing to the magazine's veterans lies not with his original ideas about it, because he has none, but with the mere accident that he had them at all. As the "Average Thinking Man," he neutralized the danger of the "out of work or lonely or sexually unsatisfied or foreign-born or queer" who came to socialism "by some all-too-human compulsion" (*CSK*, 170). Jim is careful to preserve his character and temperament, his statistical averageness ("he was a walking Gallup Poll" [*CSK*, 173]), and his iconic normalcy (he looks like "the young man who is worried about his life insurance" or his "dandruff" [*CSK*, 167]). Fancying himself a realist and someone who can "face facts," Jim is satirized by McCarthy not only for his faux realism but for his faux idealism, his

unwillingness to close the gap between his theory and his practice. Jim marries the "Average Intelligent Woman," and they set about living the Average American middle-class life. As his own experience draws further and further from the political ideas he thinks he believes, he wrestles with his conscience, content to let small irritations—the "insipidity of his domestic life"—prove his moral probity and political commitment. "Unable to renounce money, he had renounced the enjoyment of it" (*CSK*, 187). His suffering is always minor, unearned, and self-justifying, which nonetheless allows him to reconcile the compromises he has made with his beliefs.

Jim's contented self-satisfaction erodes when he meets Meg Sargent, the McCarthy look-alike who is the protagonist of the volume of stories, but a minor character in this one. Meg, McCarthy's self-idealization in this story as she is in no other in the collection, is willing to face facts, criticize the smugness of liberals, and break with the Communists over Leon Trotsky. Jim has a brief affair with her, fancies himself in love with her (mostly because she does not appear to love him back), and finds himself worried about his conscience in relation to her obviously more strenuous one. It "ought to be a little bit harder," Meg says to the staff of the *Liberal*, and Jim knows this to be true (*CSK*, 195). Quitting *Liberal* when Meg is fired for her support of Trotsky, a movement he himself belatedly joins, he finds himself unemployed and temporarily euphoric because he has taken a stand, however easy it was to do so. Because he has no capacity to sacrifice and no capacity to know that he has not, Jim is convinced of his virtue by the discomfort of his bad faith. He is able to quickly find employment at a Luce-type publication, devolve into a middle-class dullard, and come to scorn the beliefs of his younger self.

Throughout the story, Jim's calculation of his own emotional pain regulates his belief and his assessment of the facts. Always the triviality of his pain, which he mistakes for suffering, marks the failure of his principles. His outstanding characteristic as the "Average Thinking Man" is that he himself comprises his only measure of reality. Anything that falls outside his experience is unverifiable at best and someone else's illusion at worst, so nothing can touch him or change him because it cannot penetrate him. Through Jim's inalterability, McCarthy also satirizes a glib and self-deluding form of toughness. Jim believes that in feeling pain, he is facing facts and suffering for his beliefs, but he mistakes mild discomfort for real suffering. For instance, when he finds himself "comfortably on the horns of a dilemma," he falls asleep (*CSK*, 181). When he finds himself "pinched" by the monotony of domestic life, he counts this pain as the mark of principle. But because neither pain alters him, we know that he has not indeed faced facts.

For McCarthy herself, fiction—properly factualist—provides a moral cor-

rective to the writer by incorporating fact into the self, the proof of which is finding one's self painfully unrecognizable. In "Artists in Uniform" and "Settling the Colonel's Hash," both written shortly after McCarthy drafted the proposal for *Critic*, McCarthy recounts a mortifying experience of arguing with an anti-Semite and then what happens to her when she writes about that encounter. "Artists in Uniform" begins when McCarthy, the only woman in the company of an Air Force colonel, a reptilian and possibly insane young accountant, and assorted fat, greasy middle managers, tries to intercede in a conversation about Communists in universities. It was, of course, the height of (Joe) McCarthyism when she wrote this story, but its subject is not anti-Communism but anti-Semitism. Her intervention quickly elicits a coded anti-Semitic remark from the colonel—"I can tell you one thing, [the Communists] weren't named Ryan or Murphy!" (*OTC*, 55)—and McCarthy begins both to argue against and to collaborate with the anti-Semitism of her interlocutors by trying to avoid designating her own relationship to Communists, Jews, and artists. In short, she realizes queasily as she goes on that she is attempting to have no particularity at all for fear that being part of any group will destroy the loftiness of her tolerance. (She's less explicit about what else it might destroy, though she is conscious that she too has been cowed by the political demagoguery of the moment.)[26] This never-successful pose is compromised before she begins speaking of her green dress and pink earrings, her "uniform," which conveys to her audience that she is an artist and therefore assumed to have particular opinions and particular allegiances, among which is solidarity with Jews and Communists. She ends up in the club car of a train with the colonel, attempting to show him the error of his ways, trying to hide the fact of her Jewish grandmother from him. He keeps insisting that she has partisan motives; she keeps trying to assert the universality of her position. The story ends as the colonel sees her off on the train and asks what her married name is. Broadwater, she answers, and the colonel, assuming Broadwater to be a Jewish name, smiles as if he has won the argument.

In "Settling the Colonel's Hash," McCarthy explains that she discovered her own complicity with the anti-Semite by writing about the facts of her experience in the short story: "I put in the green dress and my mortification over it because they were part of the truth, just as it had occurred, but I did not see how they were related to the general question of anti-Semitism and my grandmother until they *showed* me their relation in the course of writing" (*OTC*, 240). She claims that she wrote the story to embarrass herself, showing herself to be the "mutually repellant twin" (*OTC*, 239) of the odious colonel, and in the hope of embarrassing the reader as well. The moral failure

in the short story—trying to rise above particularity—is clarified to her and amended by applying the aesthetic discipline of the fact.

She writes the essay, she says, to defend this literary method against institutionalized forms of reading that discount factuality. College students were looking for a more "recondite significance" in the green dress and the hash, some "literary or artificial symbolism" (*OTC*, 231). "In this dream-forest, symbols become arbitrary; all counters are interchangeable; anything can stand for anything else. The colonel's hash can be a Eucharist or a cannibal feast or the banquet of Atreus, or all three, so long as the actual dish set before the actual man is disparaged" (*OTC*, 232). McCarthy counters that "[t]here were no symbols in this story; there was no deeper level. . . . The sandwich and the hash were our provisional *ad hoc* symbols of ourselves" (*OTC*, 229–30). Instead, there were the art of selection, where the "details that are not eliminated have to stand as symbols of the whole, like stenographic signs" (*OTC*, 231), and "natural symbolism, which is at the basis of all speech and all representation" (*OTC*, 232). In this comparison of the natural versus manufactured symbolism, we can hear again McCarthy's distinctions between the natural and the artificial fact, the latter of which is plastic. Natural symbolism is "centripetal" and "hovers over an object, an event, or a series of events and tries to declare what it is"; by contrast, literary symbolism is "centrifugal and flees from the object, the event, into the incorporeal distance, where concepts are taken for substance and floating ideas and archetypes assume a hieratic authority" (*OTC*, 232). The problem with this centrifugal force is that it "reaches very finite limits" and leads to "a single, monotonous story." Natural symbolism, therefore, provides the foundation of Arendtian common sense by conveying both the common world, which is the object or event made more identifiable and shareable in writing, and plurality, which is the multiplication of stories, of change, and of difference. Moreover, the aesthetic of the fact rests on the same kind of openness and, again, passivity in relation to facts as explained in McCarthy's exhortation to journalists: "It means only that the writer must be, first of all, a listener and observer, who can pay attention to reality, like an obedient pupil, and who is willing, always, to be surprised by the messages reality is sending through to him" (*OTC*, 240). This "obedience," this taking of dictation from the facts of experience (the "stenographic sign") aligns journalism and prose fiction, making the two forms nearly indistinguishable, but only nearly.

Nearly a decade later, in the early 1960s, McCarthy would draw journalism and two of its aesthetic cousins, the novel and realist drama, closer together in order to differentiate them, giving to the arts generally the more rigorous relationship to facts and to their properties of unpredictability and alteration.

The novel, like the newspaper, "carried the news—of crime, high society, politics, industry, finance, and low life" (OTC, 260) and only ceased to function as an integrating social art form when it no longer "[stooped] for gossip" (OTC, 265). Realist drama, too (like all realist modes), drew its sources from the newspapers. Nonetheless, this is where the similarity between journalism and art ends. Without an intense formal pressure on the particular details of the everyday, the realist novelist or playwright can do no more than reproduce a generic fate. She explored the problem of newspapers in the following passage from a BBC broadcast, which was excised from the later essay that was based on these comments: "Newspapers, which appear every day, seemed to be the repositories of 'everydayness.' . . . This, in fact, is not true; neither a tabloid like the Daily News nor a dignified paper like the New York Times gives a faithful picture of the life of the average person in New York (still less, the Parisian newspapers of Paris), and the reliance on the newspapers imparted to realism, very early, a curiously sensational flavor, slightly canned-tasting misery, a flavor of crime and low life and disease."[27] Like her ridicule of the "plastic" and "synthetic" facts in mass-market news journals, McCarthy sees prefabricated and inauthentic reality in the mass circulation of stories. In this passage she objects more to the "canned-taste" of misery than its tawdry origins (crime, etc.). (McCarthy, known among her friends as an excellent cook, devoted a whole chapter in her novel Birds of America to satirizing mass-produced foods. There is hardly a worse adjective in her personal lexicon than "canned.") In its uniformity and blandness, canned misery indicates not the necessary disruptiveness of the fact but the reassuring predictability of statistical reality.

Like the artificial fact, statistical reality also defends against unpredictability. She faults American realist playwrights because "the individual in the realist drama is regarded as a cog or a statistic; he commits the uniform crime that sociologically he might be expected to commit" (OTC, 297). Their preference for the statistically real gives to the drama its necessary verisimilitude, but only at the most superficial level: the audience is familiar enough with statistical norms to find them plausible. At the same time, however, since statistics is a science of prediction and aggregation, statistical reality cannot represent the anomalous, which resides in the particular. Therefore, even while displaying the ugliness of modern life, the statistically realist play cannot be a force of social change because it submits to determinism and pessimism. Her essay on Madame Bovary suggests why: "Anyone could have prophesied what would become of Emma. . . . Where destiny is no more than average probability, it appears inescapable in a peculiarly depressing way. This is because any element in it can be replaced by a substitute without changing the

outcome."[28] While Flaubert remains one of her heroes of the realist genre, his greatness lies not in his portrait of Emma but in the underappreciated character Charles Bovary, precisely because Charles remains outside the predictions of statistical reality. Through Charles, who retains the "concreteness" of his peasant origins, we can see the link between the accident and social change. "No program for human development could be predicated on Charles' mute revolt against organized society. He is a sheer accident, nothing less than a placid miracle."[29] The accident preserves this sense of possibility. "All that can be said is that Charles Bovary . . . was cherished by his creator as a stubborn possibility that cannot be ruled out even from a pessimistic view of the march of events."[30] The element of chance is, therefore, a component of her optimism, rescuing the possibility of change in even the most "realistic" view of history. In her view, like Arendt's, one had to tolerate—even embrace—the pain of unpredictability in order to preserve one's optimism.

The fact seems to be a rather ordinary and perhaps neutral place to rest one's moral, political, and aesthetic foundations; after all, while illusion has many enthusiasts in the realm of aesthetics, no one publicly advocates a politics of illusion, however many practice it. Moreover, the reverence for the facts of the world can seem naïve, simplistic, conservative, or merely obstinate when they are taken to be a kind of self-evidence requiring no further interpretation, deliberation, or action. For McCarthy, a fact does not resolve argument or close off political and aesthetic engagement but initiates them; facts begin conversation, exploration, and contestation. The fact's dissidence, as she calls it, lies in its revelation of the accident, the unexpected, the surprise, or the "miracle" in everyday experience, which explains how McCarthy's factualism unifies her taste. While her favorite novelists were the nineteenth-century giants of literary realism like Flaubert, Tolstoy, Austen, and Eliot, she also respected the "realism" of Beckett and Ionesco, championed the "factuality" of William Burroughs, and identified Pirandello's genius in his "explosion" of a "fact" upon the stage (OP, 26). She named Brunelleschi the great Florentine master because he yielded to the factuality of the world; she disparaged Michelangelo because he did not. These examples, and there are many more, suggest that art shares with facts two indispensable qualities: the ability to alter the observer and the capacity to reveal the unexpected and the unmasterable. Art works best when it is most like a fact—that is, not realist but, to use her term, factualist.

As a number of critics have noticed, McCarthy was devoted to the role of chance in her writing and in politics. This taste for the accident she shared with Arendt, whose terms for unpredictability—spontaneity and natality—constituted the essence of human nature in *The Origins of Totalitarianism*.

Though it can be crushed through terror, spontaneity—which is, very simply, the human capacity to start over—is renewed with the birth of a new individual. To preserve the element of chance and spontaneity, McCarthy and Arendt wanted thinking and writing to be relieved of the burden of consistency, not to resist commitment but to protect the capacity for alteration. As Arendt said of Lessing, "Criticism, in Lessing's sense, is always taking sides for the world's sake, understanding and judging everything in terms of its position in the world at a given time. Such a mentality can never give rise to a definite world view which, once adopted, is immune to further experiences in the world because it has hitched itself firmly to one possible perspective."[31] This continual self-alteration by contact with the world could be secured and enhanced by the cultivation of the organs of perception—that is, in the realm of the aesthetic.

However important this alteration was to McCarthy's aesthetics and politics, she was careful to narrow the scope of injury. Looking at various essays and fiction, McCarthy formulates a scale of suffering where the exposure to fact is painful enough to induce change but not exceptional enough to shatter (rather than alter) the observer. The ordinariness of suffering creates a set of expectations for the perceiver, allowing the pain of openness to mark an authentic encounter with a fact. Significant pain does not suggest that openness is to be refused; it is the sign that openness has been achieved. However, trauma and extremity are beyond the scope of her contact with painful facts. Traumatic facts, like "lampshades made of human skin," turn into "irreality," facts that cannot be "imagined," and therefore shared. This argument follows almost directly from *Origins of Totalitarianism*, where Arendt remarked on "the terrible abyss that separates the world of the living from that of the living dead," arguing "that [writers] cannot supply anything more than a series of remembered occurrences that must seem just as incredible to those who relate them as to their audience" (*OT*, 139). In "Fact and the Novel" and elsewhere, McCarthy seeks not to try to rescue the unimaginable fact for common sense but to reclaim for the realm of shared experience the ordinary, even routine facts and events of daily life that have been rendered insubstantial by midcentury horrors. McCarthy would leave traumatic reality silent even while requiring the most forthright confrontation with painful reality.

Nonetheless, the novel of everyday social reality with its own pains and rigors can powerfully intervene in contemporary morality and politics. Defining the novel in one of her late essays, "Novel, Tale, Romance," McCarthy describes it in terms almost verbatim from Arendt's letter to her with one significant change:

The novel, after all, is the literary form dedicated to the representation of our common world, i.e., not merely the common ordinary world but the world we have in common. The faculty for apprehending it—this world conterminous with each of our separate life experiences and independent sensibilities, this world that lies between us—is, of course, common sense, the faculty we need to serve on juries, assess job offers, judge the characters of strangers. . . . Common sense, also known as the reality principle, rules the novel, commanding the reader to recognize only events and personalities that do not defy it. (OTC, 143)[32]

"The faculty for apprehending [the world]" is no longer the aesthetic, as it was for Arendt in her letter to McCarthy. That aesthetic of the fact is already embedded in the novel form itself. McCarthy instead, either revising Arendt years later or misremembering her lesson, gives this faculty to common sense in the ordinary way we speak of it as a precondition of judgment. As the "reality principle," common sense demands that the novel deal with the factuality of the world, which does not govern the tale or romance. She continues: "[Common sense] was greatly valued by Tolstoy as a moral dowsing rod within everybody's reach. . . . Common sense tells you the way things *are*, rather than the way your covetous ego or prehensile will would like them to be. And the sparsity of novels [in the German literary tradition], the great carriers of the reality principle, may help to explain German defenselessness in the face of National Socialism" (OTC, 144). The failure to develop an art form that dealt with "the way things *are*" hobbled the Germans when National Socialism told them a tale or a romance about who they were or would like to be. McCarthy in the essay is creating not a hierarchy of forms but a taxonomy: novels are novels and tales are tales, and we should be able to recognize the difference. However, while the stuff of newspapers and local scandals, as she argues, provides the "news" of the novel, the form's relationship to the factuality of the world is not soothing and self-gratifying. The painfulness of ordinary reality in the novel prepares the citizen to enter the public world of common sense—that is, of moral and political judgment. In the realm of the fact, McCarthy makes no distinction between the aesthetic and the political realm, which gives to art real-world consequences, which is to say responsibility. Taste is a deeply political matter, not because it divided classes of people, as it would for her friend Dwight Macdonald in *Masscult and Midcult*, but because taste governed one's relationship to reality.[33]

Though written near the end of her life, the essay "Novel, Tale, Romance" takes up an argument about facts that McCarthy had made in *The Stones of Florence*, a travel book that she felt best explained her own aesthetic values

and that she wrote with an unusual sense of ease and confidence.[34] She claimed to feel "a great, great congeniality" with the city and "felt that through the medium of writing about . . . this city, its history, its architects and painters . . . it was possible for me to say what I believed in."[35] In its general sensibility, she claims that "the unitary genius of the Florentines" derived from "the small world held in common and full of 'common' referents," a kind of ideal Arendtian polis.[36] More specifically, Florentine art, she argues, "cannot be likened to anything but itself, and in this way it resembles architecture—a solid fact obtruded into the world" (SOF, 76). Of all the Florentines she admired, it was Brunelleschi in whom she discovered the Florentine tradition of factualism at its height.

Her comparison of this master with Florence's more famous Michelangelo finds the origins of fascism in the betrayal of the fact. In Brunelleschi's art, she finds classical beauty ("gravity, purity, simplicity and peacefulness" [SOF, 72]; "just proportion and . . . order" [73]; "perfect balance" [73]; "forms realized in their absolute integrity and essence" [75]) accommodated to human realities (rain gutters, wind ducts, and iron hooks for scaffolding in the Duomo and "the art of essentials, of the bread-and-wine staples of the human construct" [74]) that identifies the character of his work. The facts of the world find expression in Brunelleschi because he yields to them. If a modern traveler encounters Brunelleschi's Duomo arising "like an irreducible fact" (SOF, 69) in the midst of the marketplace and the motor traffic of 1950s Florence, by contrast Michelangelo's David, with his "cold, vain stare . . . in love with his own strength and beauty," provides evidence of the "original crime or error" in the Florentine invention of the modern world, the "terrible mistake" that "had to do with power and megalomania or gigantism of the human ego" (SOF, 64). The Florentines are not only the inventors of the modern world for McCarthy but also the first modernists: everywhere "disturbers, agents of the new" (SOF, 65), "upsetting preconceptions of the mind and eye" (SOF, 66) and injecting a "dynamism into the arts," a process of acceleration, which created obsolescence. It is not this creativity that horrifies her but the "covetous ego" and "prehensile will" (OTC, xx) that she finds in Michelangelo, who rails against anything or anyone that "[shows] its resistance to the tyranny of [his] genius" (SOF, 79). This, she argues, "is why so many of his works . . . are unfinished: no particular work could satisfy the magnitude of his ambition. Perfection can be achieved if a limit is accepted; without such a boundary line, the end is never in sight" (SOF, 80). This disregard of limits, this intolerance for the "whole world of others" and even Nature itself, is the crime of which she speaks. This failure to accommodate to the facts of the world, the things and people outside one's own ego, made rubble out of Europe. And

though she puts the words in the mouth of a sad Florentine in the Michelangelo room of the Bargello, she lays the responsibility for the destruction of Europe at Michelangelo's feet: "*You* were responsible for this" (*SOF*, 65).

## The Unalterability of the Past

In the 1970s, within the span of three years, Mary McCarthy had the unenviable task of eulogizing both Arendt and Chiaromonte, her two closest friends and intellectual companions. She also wrote an obituary of sorts for Philip Rahv, the editor of the *Partisan Review* and her onetime lover, and for Fred (F. W.) Dupee, a friend who was also part of the group to revive the *Partisan Review*. (These are collected in *Occasional Prose*.) McCarthy had a knack for this kind of writing, conveying vividly the singularity of each person and, characteristically, downplaying her own feelings of loss. She then devoted herself to Arendt's and Chiaromonte's writing and brought several major works to publication. She edited and helped translate a collection of essays by Chiaromonte (*The Worm of Consciousness and Other Essays*) and wrote lengthy prefaces for them and for the republication of his Gauss Lectures from 1966, *The Paradox of History*. She took on the difficult charge of completing Arendt's *The Life of the Mind*, the mammoth work on thinking, willing, and judging left unfinished at her death, for which McCarthy also wrote a postface, a second eulogy. Hardwick called this labor nothing less than "sacrificial."[37] In these eulogies, prefaces, and postscripts, McCarthy took the opportunity to reflect on the aesthetic of the fact as it related to the question of being alone together to face reality. Death was both the unalterable fact she had to face and the condition of her aloneness.

For instance, McCarthy's preface for a collection of Chiaromonte's theater essays acknowledges, but understates, their intimacy. In the opening paragraphs she lists Chiaromonte's American friends, including herself but noting her relative distance (she was "less close than"); she then revisits this closeness at the end: "To write about him and his ideas, now that he is dead, has been a hard undertaking. I should have liked him to be able to listen, approve, dissent, modify. Above all, *help*. Yet in reality, as I suddenly recognize, he *has*—on the principle of God-helps-those-who-help-themselves—by being absent, beyond recall or consultation" (*OP*, 33). McCarthy stresses her aloneness and also its benefits, which might be conventional chin-up optimism. Chiaromonte had helped her, however, not by leaving a body of work to reflect on or, put otherwise, by being with her in his writing, but by "being absent." Left to struggle on alone, she concludes that though hard, this had been a happy experience, much like being a student who suddenly sees how every-

thing fits together. This cheery ending to what was a very difficult experience reflects the narrowness of McCarthy's emotional expression and at the same time illustrates the virtues of being alone together to face reality. The preface elaborates this claim by arguing that theater as an aesthetic form offers just this experience of facing facts alone together.

While both McCarthy and Chiaromonte had been drama critics for more than thirty years and each greatly admired the other's work, she begins the preface by addressing the mystery of Chiaromonte's attraction to the theater. He was not someone with a flair for or attraction to costume and posing; they both thought that theater was a dying art form performed for an ever-shrinking audience, "a peculiar species of animal nearly extinct" (*OP*, 13). It's not the love of illusion or magic but theater's strenuous encounter with reality that he admires. In carefully working through his criticism as she translated and edited the essays, McCarthy discovered a theory of drama that was, per-haps not coincidentally, remarkably similar to her own aesthetic theory of the fact. Indeed, it is difficult at moments to distinguish Chiaromonte's ideas from her own, which suggests how closely they had worked together and how like-minded they were. For Chiaromonte, being "in reality"—bounded by and limited to it—was what theater as a form was best able to express and, more importantly, to enact. The value he placed on the theater's reality, a paradox in itself, is even stranger given his pronounced distaste for theatrical realism. Chiaromonte preferred the modernist abstraction of Pirandello, the playwright whose work most shaped and embodied his taste.

The momentousness of Pirandello for Chiaromonte, McCarthy claimed, was not just that "*fact* had exploded on the stage" but, as she restates shortly thereafter, "The *fact* that had exploded among those six people, reducing them to modernist-looking bits and pieces, fragments of their former 'aca-demic,' illusionist personalities, *had already exploded before the start of the play*" (*OP*, 31, emphasis mine). By restating this proposition three times, Mc-Carthy emphasizes the pastness of the explosion. She continues to refine her notion of facts under the shadow of her friend's death: among all the arts, theater "had a special privileged position in that its forms—comedy, farce, tragedy—constitute the means by which reality is met and accepted for what it is, i.e., that which is ineluctable and cannot be altered" (*OP*, 26). Reality had not always had this property of unalterability for McCarthy. But reality is not real enough without the presence of others, as Arendt would argue. McCarthy continues: "It is the discovery of [boundaries], swift or gradual, the knocking up against them, rebounding, attempting to circumvent them, that make up the agon, never a straightforward contest between two individu-als . . . but between the one and a dense plurality" (*OP*, 27). The experience of

limits belonged to everyone in the theater, actors and spectators alike, who feel their limits and their boundaries and share this sense of boundedness and limitation together in the public space of the theater. The spectator meets reality alone and among (and often against) others but not with them—that is, not looking at them but at the stage, aware of the others in proximity but not facing them.

Although this notion of theater as a dramatization of limits generally describes the form of tragedy, McCarthy argues that Chiaromonte found it demonstrated in any form of theater, comedy as well as farce. Moreover, if Chiaromonte thought that reality was above all "sad," "even in its humors and extravagances" (OP, 24), his sense of theater might be imagined as inherently tragic, as we might have guessed from his admiring description of Simone Weil in the first chapter. The realities of "Necessity, the Law, the Divine, or simply Others" as she names them, "ultimate realities," "purge" actors and spectators alike of "faith in norms and outcomes" (OP, 32). Nonetheless, Chiaromonte's notion of reality is suffused with pity: "Don Abbondio is a little piece of reality, and pity, as with Chekov, is the agency that allows us to perceive it. 'Pitiless realism' was detestable, clearly, to Chiaromonte and as remote from his eyes from the real, which would shrink from its touch, as any other form of 'graphic' representation that took itself for the truth" (OP, 25). It is in this notion of pity that McCarthy and Chiaromonte sharply diverge. While McCarthy notes that Pirandello's definition of comedy—"the sentiment of the contrary"—is very close to Chiaromonte's definition of the real, her own relationship to the real, to limits and boundaries, to the explosion of facts into consciousness, is unlike her friend's, pitiless, not tragic but farcical. Her greatest contribution to twentieth-century US literature might be the gift for farce exemplified by the unromantic seductions in her most famous short story, "The Man in the Brooks Brothers Suit," and in The Group and her autobiographies, where her factuality "explodes" on the page, detonating women's fantasies of sexual romance and eroticism at the moment when male writers were turning to obscenity to both deromanticize and reeroticize contemporary literature. Reading "The Man with the Brooks Brothers Suit" against anything but William Burroughs's Naked Lunch, which she much admired, suggests how much more devastating to sexual mores McCarthy's factualism was than obscenity could hope to be. As she says toward the end of that story: "If the seduction (or whatever it was) could be reduced to its lowest common denominator, could be seen in farcical terms, she could accept and even, wryly, enjoy it. The world of farce was a sort of moral underworld, a cheerful, well-lit Hell where a Fall was only a prat-fall after all" (CSK, 111).

Carol Brightman links the narrowing of emotional range to McCarthy's

earliest experience of loss—the sudden deaths of both of her parents in the
flu epidemic of 1918—and the odd, cruel way that her extended family treated
those deaths, never explaining them to the children nor including them in the
rituals of mourning.[38] Brightman's theory accounts for McCarthy's psycho-
logical predisposition toward containing the emotional range of her work, but
it does not account for McCarthy's discovery of the function emotional con-
tainment might have for art, politics, and social life, as developed in conversa-
tion with Arendt and Chiaromonte. Her eulogy for Hannah Arendt explains
this discovery dramatically and, within McCarthy's range, most poignantly.

When Arendt died unexpectedly of a heart attack in 1975, McCarthy de-
livered the eulogy reprinted in her *Occasional Prose* as "Saying Goodbye to
Hannah." Readers have frequently noted the sensuality in her description of
Arendt, who was certainly better known for the power of her mind than the
turn of her ankle. Nonetheless, it is to her ankles McCarthy turned:

> I do not want to discuss Hannah's ideas here but to try to bring her back as
> a person, a physical being, showing herself radiantly in what she called the
> world of appearance. . . . She was a beautiful woman, alluring, seductive, femi-
> nine. . . . She had small, fine hands, charming ankles, elegant feet. She liked
> shoes; in all the years I knew her, I think she only once had a corn. Her legs,
> feet, and ankles expressed quickness, decision. You had only to see her on a
> lecture stage to be struck by those feet, calves, and ankles that seemed to keep
> pace with her thought. (*OP*, 38–39)

The eulogy's intense, even erotic physicality has been interpreted as evidence
of the romantic quality of their friendship, to which their letters and the ob-
servations of their friends also attest. The sensual particularity of this passage
seems fitting, however, when we think of McCarthy practicing her aesthetics
of the fact on her friend. McCarthy's sensual, aesthetic appreciation of Arendt
shares Arendt's concreteness with a common world, the world of friends and
family that is their intimate circle, as well as with the wider public world that
read her work.

But the surprising part of the eulogy is not McCarthy's sharing of Arendt
but her retraction in a final anecdote of the intimacy she develops earlier.
Noting Arendt's "respect for privacy, separateness, one's own and hers" (*OP*,
41), McCarthy then tells a story of her own intrusion into that separateness.
In an effort to please her friend, she had purchased a small tube of anchovy
paste as part of the breakfast supplies she gathered for Arendt's forthcom-
ing visit. When Arendt discovered it, she reacted with consternation and dis-
pleasure, pretending not to recognize what it was, and then saying nothing.
McCarthy explains: "I knew I had done something wrong in my efforts to

please. She did not wish to be *known*, in that curiously finite and, as it were, reductive way. And I had done it to show her I knew her—a sign of love, though not always—thereby proving that in the last analysis I did not know her at all" (*OP*, 42). In concluding the eulogy on this moment of trespass, McCarthy makes her characteristic gesture of self-chastisement, calling attention to the limits of intimacy rather than extolling the very unique closeness she enjoyed with Arendt. The gesture of restraint to the audience is a powerful one, even if McCarthy warns only herself, perhaps rebuking her own desire to draw Arendt closer, possessing her in memory as it were, now that she was no longer present to object. The eulogy enacts the twin impulses of being alone together, drawing us closer to Arendt, who is offered to the audience in her most seductive detail, and creating space around her by admonishing against the presumption of intimacy and familiarity. Telling this story restores to Arendt the aloneness proper to friendship and solidarity.

In some way, Arendt's refusal of McCarthy's gesture of friendship seems unnecessarily cold. The small token of familiarity from a best friend of twenty-five years seems hardly an excessive violation of the invisible line of intimacy, even if McCarthy herself sought to respect and honor that line. And surely McCarthy and Arendt's distancing has been overdramatized because our culture expects warmth and intimacy from women and feels their absence all the more keenly when they are denied. If Philip Rahv had surprised his coeditor William Phillips with some favorite morsel, I think it's safe to say we would have been less surprised by Phillips's reaction than Rahv's thoughtfulness. I'd like to suggest, however, that there is something to be learned from coldness. The delicate balance between Arendt and McCarthy seems all the more compelling because attachment has to be refused *on principle*. Arendt taught McCarthy, who in turn ventured to instruct her listeners, that heartlessness was not only a necessary precondition of public life but also preservative of friendship. The austere rule of heartlessness, which seems to apply equally to friendship, politics, and aesthetics, should not be confused with insensitivity. The aloneness they cultivated does not entail *de*sensitizing but *re*sensitizing, becoming more open and more responsive to the facts of the world. It did, however, forbid being more responsive to others, to one's friends and interlocutors, both public and private. The aesthetic of the fact, practiced in the company of others, but without their intimacy, necessitated a peculiarly severe discipline of representation and of attention that was enabled not by solidarity but by solitude.

# 4

# Susan Sontag: An-aesthetics and Agency

So far as we feel sympathy, we feel we are not accomplices to what caused the suffering. Our sympathy proclaims our innocence as well as our impotence.

SUSAN SONTAG, *Regarding the Pain of Others*

## Things Being What They Are

In *Making It*, Norman Podhoretz's 1967 Horatio Alger story of his climb from immigrant poverty to the pinnacle of the intellectual world, the *Partisan Review*, he takes a jab at Susan Sontag, his younger and much more famous colleague among the New York Intellectuals:

> Her talent explains the rise itself, but the *rapidity* with which it was accomplished must be attributed to the coincidental availability of a vacant position in the culture. That position—for which, by virtue of their unmistakable authority, her early pieces constituted an implicit, though not of course intentional application—was Dark Lady of American Letters, a position that had been carved out by Mary McCarthy in the thirties and forties. But Miss McCarthy no longer occupied it, having recently been promoted to the more dignified status of *Grande Dame* as a reward for her long years of brilliant service. The next Dark Lady would have to be, like her, clever, learned, good-looking, capable of writing family-type criticism as well as fiction with a strong trace of naughtiness.[1]

That same year, Carolyn Heilbrun, a pioneer of feminist literary criticism at Columbia University, echoed Podhoretz's observation in her interview with Susan Sontag for the *New York Times*, though in a very different key: "How short the world is of famous, intelligent women: one per country, per generation."[2] Podhoretz's "position" for which a woman makes an "application" might leave room for more than one woman intellectual, the Dark Lady being only style, perhaps, among others; Heilbrun's lament strips the position down to its barest element: Dark Lady or not, there's only one token woman. When Mary McCarthy supposedly quipped to Sontag at a cocktail party, "So I hear you're the new me," she might have been either buying into the system or jok-

ing with Sontag at Podhoretz's (and everyone else's) expense. Since no one can locate the origin of this story (least of all Sontag), its circulation says more about the eagerness of the *Partisan Review* "boys," as both McCarthy and Sontag called them, to see these two women as interchangeable and to sow the seeds of discord between them.[3] That it continues to circulate long after the principals are dead suggests the enduring appeal of a catfight.

Their similarity has been difficult to process in all but these most superficial terms, and it has been made increasingly implausible by the exaggerated and increasingly narrow generational demarcations of the late twentieth century. Though both were children of wartime—McCarthy the First World War and Sontag the Second—Sontag came of age in the comparatively peaceful and prosperous Cold War 1950s as opposed to the worldwide economic depression of the increasingly fascist 1930s. However, like McCarthy and Arendt as well, Sontag was deeply troubled by the loss of faith in the senses and called for a renewed commitment to aesthetic pedagogy in the most urgent (but, unlike them, ecstatic) terms. As excoriating as it is, her manifesto, "Against Interpretation," is infused with optimism more than dread and colored by the emerging body politics of the 1960s. "Against Interpretation" made two slightly different claims about the distrust of the senses: one, that the hypertrophy of the intellect had made sensual experiences of art irrelevant to criticism; and two, that the overcrowding of objects and sensations and the overstimulation of everyday life in late capitalist society had had an anesthetic effect, dulling to the point of deadness the individual's capacity for sensation. In a spirit of euphoria in the 1960s, surrounded by aesthetic experimentation in all forms, Sontag called for an "erotics of art" rather than a hermeneutics, asking her readers "to *see* more, to *hear* more, to *feel* more," to experience through the senses "the luminousness of things being what they are."[4]

Sontag's fundamental insight differs little from McCarthy's and Arendt's however much more passionately she argued. There is also nothing new in her critique of the anesthetic quality of modernity. The German sociologist Georg Simmel made this argument in "The Metropolis and Mental Life" in 1903; the essay was widely read when it was republished in the 1950s and had a profound impact on the Chicago School of Sociology at the University of Chicago, where Sontag was an undergraduate and where she met her husband, the sociologist Philip Rieff.[5] Sontag ventures into new territory, however, when she takes note not simply of the anesthesia of modern culture and the adaptive coldness and detachment of its inhabitants but also of its opposite: its cultivation of feeling, especially extreme states of feeling, and its wild mood swings between intensity and affectlessness. In her essays collected in *Against Interpretation*, she explored the extremity of painful feeling in the

"Artist as Exemplary Sufferer" and "Simone Weil"; the emotional reserve of Robert Bresson and the "gift of strong emotion" in Michael Leiris; the horror inspired by affectlessness in "The Imagination of Disaster"; and emotional coolness in "One Culture and the New Sensibility." Because she was not a systematic thinker, or at least not a very good one, these moods became a central feature of her taxonomies of art and literature without ever being the subject of her own sustained reflection in an essay. If Raymond Williams introduced the "structure of feeling" to cultural analysis in the 1950s,[6] Sontag supplemented it with the feeling of feelings in the 1960s—that is, her acute rendering of the aesthetics of feeling in art: how it was produced in medium-specific ways in the reader/viewer of literary, visual, theatrical, and cinematic works of art. Emotional style was a symptom to be appreciated, one of her key terms, and then analyzed in her ongoing diagnosis of contemporary culture.

If, like McCarthy and Arendt, Sontag also favored emotional self-regulation, she was less invested in an embargo on emotional display and vastly more concerned with the struggle to retain agency over one's inner state. Moreover, she understood aesthetics as a tool not merely of apprehension and knowledge, as they did, but also of feeling management. The capacity to *feel* more sensually was the antidote to feeling too much or too little emotion. Nowhere is this aspect of Sontag's work more important to note than in her essays from the 1970s when "things being what they are" began to look less "luminous" than ominous. By 1975, with the ignominious end of the Vietnam War and her own diagnosis with breast cancer, Sontag extended and deepened her inquiry into the contemporary culture of emotions, provoked by her retreat from the euphoria and optimism of the 1960s, her increasing discomfort with the body politics and utopianism of the New Left, and her attention to ugliness, both political and aesthetic. The 1974 *New York Review of Books* essay "Fascinating Fascism," on the photographs and films of Leni Riefenstahl, has been thought to mark an abrupt reversal of Sontag's aesthetics. I want to argue instead that she never gave up the aesthetic philosophy articulated in her early work, but that she began to reevaluate it in relation to *painful* reality in *On Photography* and *Illness as Metaphor*, which she called a new version of "Against Interpretation." Both texts plumb the root causes of emotional disregulation in contemporary culture and recalibrate her aesthetic program in the aim of recovering emotional self-management.

Certainly, there is a biographical connection between the two works. Sontag's cancer treatment interrupted the publication of the last two essays in what would become *On Photography*. She edited them into final form for the book while she was researching and then writing the first of the essays for *Illness as Metaphor*. *On Photography* and *Illness as Metaphor* are both taxono-

mies in the pattern of her earlier work, but they are also pathographies in that they attempt to deal with illness and the way that it shapes the social world. Though taken from the German *Pathographie*, whose first citation in the *Oxford English Dictionary* dates to 1848, "pathography" in English is a twentieth-century invention.[7] The first meaning—a description of a disease—is now rare; instead, the second definition—"the study of the life of an individual or the history of a community with regard to the influence of a particular disease or disorder; (as a count noun) a study or biography of this kind"—is Sontag's task. Broadly defined, for Sontag that illness is disregulation: *On Photography* bemoans the surplus of photographs and concludes with a call for an ecology of images; *Illness as Metaphor* understands excess and dearth (energy, consumption, expressivity) as the conditions that tuberculosis and cancer metaphors illustrate. Alongside material surplus and in conjunction with it, there is the troubling disregulation of feeling, which Sontag believes undermines art and politics in similar ways. Feelings get in the way of feeling (seeing, hearing, touching), which is to say they are anesthetic or, when not properly managed, can be. Scholars of the late twentieth century in the United States tend to characterize it as a period marked either by intense authentic feeling or by irony and the erosion of feeling. In more general public debate, there are repeated attempts to regulate feeling, to admonish or celebrate displays of emotion, to admire or rebuke emotional containment. Sontag observed this confusion about the place of feeling in public life in the latter half of the twentieth century and began to link feeling states to problems of agency as she encountered them in the realms of art, politics, and the body. For Sontag, emotions are only problematic insofar as they threaten agency, which they always do.

## On Pathography

I feel like the Vietnam War. . . . My body is invasive, colonizing. They're using chemical weapons on me. I have to cheer.

I feel my body has let me down. . . . And my mind, too. For, somewhere, I believe the Reichian verdict. I'm responsible for my cancer. I lived as a coward, repressing my desire, my rage.[8]

Sontag wrote these words in her journal during her harrowing regimen of chemotherapy for breast cancer in the late fall of 1975, shortly after her radical mastectomy and six months after the end of the Vietnam War.[9] She was then in the grip of the cancer war metaphors that she would deconstruct so deftly in *Illness as Metaphor*, the book that came out of her experience, just as she

was in thrall to the Reichian psychological explanation of cancer, which she also dismantles in that work. The way she knew the effect of the war metaphor and the psychological theories of disease from personal experience is not, however, a part of that book and only recently has become available to her readers via her son David Rieff's memoir of her death. Autobiography and personal experience are important to *Illness as Metaphor* in their absence, but for the moment, I want to consider how densely Sontag's journal signals the historical context of her disease in these two quotations. The Vietnam War and, more obliquely, the sexual revolution shape Sontag's thinking in her two major essays from the 1970s, *On Photography* and *Illness as Metaphor*, and suggest how the problems of feeling exacerbated by both war and sexual freedom would in some ways complicate and in other ways clarify Sontag's response to the feeling culture of the late twentieth century. Suffering and desire, as forms of emotional intensity that compromise agency, get mapped onto one another, and aesthetics becomes the tool by which to regulate their intrinsic excess.

Though *Illness as Metaphor* was published a little more than thirty years ago, the cultural syndrome that she attacks is now so remote or so firmly associated with New Age mind-body therapies that it is difficult to remember how mainstream her reading of cancer was. If Sontag's essay concerned only a discourse of cancer that is now a relic of history, its value as a document of the period might be more circumscribed. It is, however, a pathography of feelings in modern Western societies, particularly the United States, and the norms of feeling she describes are by no means remote. The most important system of tropes in coding disease comes from the domain of emotions and emotional style.[10] Both tuberculosis and cancer in *Illness* are defined by their enactment of a culturally preferred or abhorred relationship to personal emotion—that is, an emotional style that is valued and one that is not. Echoing the bipolarity of emotion that Sontag had been tracking since the early 1960s, tuberculosis represents intense emotional states and fluent personal expressivity; cancer, emotional anesthesia and inarticulacy. As a result of this bifurcation, Sontag argues that while tuberculosis is an erotic and glamorous disease, cancer can be neither aestheticized nor eroticized. Taken together, what Sontag finds pathological (among other things, of course) is the extreme *overvaluation* of feeling, not just as a capacity of the modern individual, but also as a requirement of full cultural citizenship. *Illness as Metaphor* constitutes a pathography in its original, most clinical meaning: a description of a disease. Precisely because of Sontag's distrust of feeling, *Illness* is antipathographic in the contemporary use of the term inaugurated by Joyce Carol Oates in the late 1980s to name a morbid and sensational genre of life writing.[11] By her own logic,

Sontag's personal experience—and, more particularly, her feelings about it—could not be part of her study, however central it was to her motivation for writing.[12]

What would come to be called "the war on cancer" was unveiled by Richard Nixon in his State of the Union address in 1971 as part of a major initiative to make America the "healthiest nation on earth":[13] "I will also ask for an appropriation of an extra $100 million to launch an intensive campaign to find a cure for cancer, and I will ask later for whatever additional funds can effectively be used. The time has come in America when the same kind of concentrated effort that split the atom and took man to the moon should be turned toward conquering this dread disease. Let us make a total national commitment to achieve this goal."[14] Despite popular mythology, his announcement did not employ military terms and he did not use the word "war," which appears only twice elsewhere in the speech. As the Vietnam War dragged on, martial rhetoric was more likely to depress or enrage his listeners than inspire them. Discovering a cure for cancer, then (and now) the second leading cause of death in the United States, was to be the most ambitious scientific project of his presidency, Nixon's equivalent of the Manhattan Project and Project Apollo. The "war on cancer" rhetoric was derived later by implication when the president signed the National Cancer Act of 1971 and housed its new research facilities at Fort Detrick, Maryland, which had been the army's biological warfare research center since 1942. Nixon named two rationales for this decision: one pragmatic, one symbolic. He had shut down research on biological weapons unilaterally in 1969; by executive order, the army's stockpiles of spores and viruses were destroyed in the face of an impending international agreement outlawing biological warfare. Since there were now underutilized (but very advanced) research facilities—biological weapon *defense* remained on-site—Nixon assigned Fort Detrick as the new home for the National Cancer Institute, declaring that the United States had the rare opportunity of "turning swords into plowshares and spears into pruning hooks," "changing the implements of war into instruments of peace."[15] Symbolically, the war on cancer was a beneficiary of the other, nonmetaphorical kind of war, which is not the same thing as a peace dividend. When the war in Vietnam finally and officially ended in 1975, Fort Detrick had been a cancer research center for three years. Sontag's troping of her body as the Vietnam War plays out this symbolic conversion, turning napalm into chemotherapy, which retains the toxicity and aggression of both. Nixon, however, was trying to work the metaphor in the opposite way, applying the medicinal properties of cancer *research* to a war-torn United States.

Every historical account of cancer research marks the 1970s as its water-

shed moment, the before and after of the treatment of the disease. Moreover, as Sontag's essay predicted, greater understanding of cancer, spurred by an additional 1.6-billion-dollar appropriation,[16] was already transforming the culture of the disease. One simple example: cancer became a subject for the movies, one that could be seen and named, not merely implied. If in the 1970 movie *Love Story*, Ali McGraw's character, Jenny, dies of some unspecified but not unrecognizable disease (leukemia), by the end of the decade, cancer was no longer unspeakable in popular culture. In *Promises in the Dark* (1979), the cancer diagnosis, prognosis, and treatment are all spelled out to the patient in the film, and by a woman doctor no less, a similarly remarkable, though not as unprecedented, novelty. By 1983 the Academy Award–winning comic melodrama *Terms of Endearment* spends fully half the movie following its main character's treatment and painful death from cancer. As it was demystified, cancer had rapidly lost its capacity to shame its victims, who were less likely to be understood as psychologically complicit in their physical breakdown.

This putative complicity lies at the heart of *Illness as Metaphor*, where Sontag claims "the source for much of the current fancy that associates cancer with the repression of passion is Wilhelm Reich" and states that Reich "did more than anyone else to disseminate the psychological theory of cancer."[17] Nonetheless, the conspicuous role that Reich plays in *Illness as Metaphor* as the avatar of psychological theories of cancer seems vastly out of proportion to his actual influence. Sontag's own footnotes list an array of contemporary medical research projects linking cancer and the emotions, and she does not exhaust the bibliography. In June 1978 the same year *Illness* came out in both essay and book form, Constance Holden published a substantial review essay in *Science* called "Cancer and the Mind: How Are They Connected?," which tracked research from the 1950s forward linking cancer and emotions.[18] Reich is, unsurprisingly, not mentioned in the article. Moreover, Sontag understands Reich to have described cancer principally as a disease of repressed rage; Holden, too, shows that the majority of research linking cancer and emotion also identifies rage and suppressed rage as possible influences on cancer. Reich, however, according to Sontag, understood cancer as "a disease following emotional resignation—a bio-energetic shrinking, a giving up of hope" (*IAM*, 23).[19] For Reich, a lack of emotional intensity rather than a surplus caused cancer. In fact, he only rarely mentions rage in *The Cancer Biopathy* (four times in four hundred plus pages), though this is Sontag's focus, and she might have attributed that to him by way of Norman Mailer's infamous comment that stabbing his wife saved her from cancer. Sontag is clearly taking her cue from nearly every other study linking repressed emotions and

cancer but Reich, though she will understand the cancer patient as emotion-ally anesthetized in ways that echo Reich's conclusions.

Reich explains his theory of the origins of cancer in *The Cancer Biopathy*, initially published in small release from the Orgone Institute Press in 1948 and reissued by Farrar, Straus, and Giroux in 1973 in the course of repub-lishing much of Reich's out-of-print work. Farrar, Straus, and Giroux, also Sontag's publisher, benefited from (or capitalized on) two things: one, the resurgent interest in Reich among the New Left and sexual revolutionaries of various political stripes; and two, the dramatic increase in attention to cancer after the National Cancer Act. "Wilhelm (The Function of Orgasm) Reich," as *Time* magazine called him in their 1957 obituary,[20] had died in prison, having been sentenced to two years for fraud in distributing the orgone accumulator; only seven years later, in 1964, he was being hailed, if somewhat ironically by *Time*, as the father of the "second" sexual revolution. Reich's cancer theories had probably reached the peak of their influence in 1947 when Mildred Brady wrote her infamous report in the *New Republic* on the dangerous "cult of Reich" and sexually titillating orgone accumulators that were to treat cancer patients.[21] This essay got the attention of the FBI, which already had a file on Reich, and set in motion his eventual conviction for fraud.

To say that Reich's orgone research, which is the basis of his cancer theory, was suspect is to put it mildly. No aspect of his work had been less well re-ceived or less credible than the research he did on orgone energy toward the end of his career. He did, however, exert a great deal of influence on US writers—William Burroughs, Norman Mailer, Saul Bellow, Paul Goodman, J. D. Salinger, Allen Ginsberg, and Jack Kerouac make the short list—and on postwar psychoanalytic innovations like gestalt therapy and primal therapy. Only Burroughs and to a lesser extent Mailer found Reich's experiments with orgone energy compelling, and while these experiments continue to attract followers at the fringes of psychoanalytic and medical research, Reich in 1978 was not a formidable target. And yet, Sontag continually returns to him to expose what she sees as the most noxious form of metaphorical thinking in contemporary cancer discourse.

The pathographic link to Reich is not, I want to argue, *The Cancer Biopa-thy* so much as it is *The Sexual Revolution* and its influence on the culture of the 1960s and 1970s.[22] Reich's prescription for cancer is identical to his prescription for authoritarianism and for individual psychological health: heterosexual genital pleasure culminating in orgasm. Sontag signals Reich's theories in *Illness as Metaphor* when she says, "What is called a liberated sex-ual life is believed by some people today to stave off cancer, for virtually the

same reason that sex was often prescribed to tuberculars as a therapy" (*IAM*, 21). Sontag's popular reputation as a sexual revolutionary, based on some of her essays, the famously alluring photographs by well-known photographers, and her not-very-secret lesbianism, overshadows her lack of commitment to its foundational assumptions. Indeed, in the early 1960s she wrote a glowing review of Norman O. Brown's *Life against Death*, in which she admires his repudiation of the body politics of the United States (referring only once to the "ill-fated Wilhelm Reich").[23] And in 1967 in *Partisan Review*, she published one of her best-known essays, "The Pornographic Imagination" (reprinted in *Styles of Radical Will* in 1969), which defined pornography as a genre of literature, described its generic features, and illustrated the merits of some of its outstanding examples. But Sontag was hardly alone at the vanguard in taking up the topic of pornography, which any number of public intellectuals and academic scholars addressed in the wake of the Supreme Court's dismantling of the category of literary obscenity from 1957 to 1966.[24] In a more important sense, Sontag was a very skeptical fellow traveler, one who embraced the relaxation of sexual hypocrisy while standing well apart from the Reichian optimism about sexuality that guided the sexual revolution. Her trepidation about sexual intensity may offer another explanation for Sontag's unwillingness to disclose her sexual orientation, even in the midst of gay liberation in the 1970s and the AIDS crisis of the 1980s, a fact that has always puzzled and often enraged her queer readers. Given what we now know about Sontag's sexual anxieties from her recently published journals, the social opprobrium heaped on homosexuals, which she feared, may also have provided her with an excuse to contain her sexual adventurousness, which would allay her fear of being overwhelmed by her own desire.

In "The Pornographic Imagination," working primarily from the French pornographic tradition, Sontag opted out of the polarized dichotomy in the United States between advocates of liberalization and those of censorship. She says: "What seems to be decisive in the complex of views held by most educated members of the community is a more questionable assumption—that human sexual appetite is, if untampered with, a natural and pleasant function; and that 'the obscene' is a convention, the fiction imposed upon nature by a society convinced there is something vile about the sexual functions, and by extension, about sexual pleasure" (*SRW*, 56–57). Instead, Sontag argues that sexual appetite is "demonic" and something "like nuclear energy, which may prove amendable to domestication through scruple, but then again may not" (*SRW*, 57). We might explore the extreme realms of sexuality to understand extreme forms of consciousness, she advised, but certainly not because it is good for us. Unlike Reich, Sontag did not believe that sexuality, freed from

what he called "sex-economic regulation," would be health inducing for either the individual or the social body. It would instead have variable effects, not because of neurotic sexual malfunction but because of the unruliness, obsessiveness, and extremity of sexual desire itself. Moreover, sexual feelings were too explosive, to continue her metaphor, too potentially *annihilating*, to be safely handled by everyone. Sontag closed by arguing that "pornography was only one item among many dangerous commodities being circulated in this society," that "perhaps *most people* don't need a 'wider scale of experience,'" and that, without extensive preparation, "any widening of experience and consciousness is destructive for *most people*" (SRW, 71–72, emphasis mine). Confined to aesthetic experimentation and to what she supposes to be the sturdier psyches of an elite or coterie audience, extremity is merely interesting, not dangerous, because it maintains its status as experimental, pedagogic, and even quasi-scientific. The mass participation in extreme states of feeling and of sexual feeling in particular made her increasingly uneasy about its volatility and its increasing saturation of public culture. This concern guides *On Photography* as well, though in the opposite direction, with its apprehension about extremes of suffering and its distaste for the an-aesthetics of the contemporary avant-garde.

## On Photography

Little attention has been paid to the fact that the 1972 retrospective of the photography of Diane Arbus at the Museum of Modern Art produced Sontag's landmark *On Photography*. Certainly, critics always mention Sontag, now mostly in passing, in criticism of Arbus's work, but Arbus's importance to Sontag is rarely noted, if at all. Sontag's unofficial (and only) biography tells us that *On Photography* itself, not just the essay "America, Seen through Photographs, Darkly," grew out of her fascination with Arbus's photographs and the unusually intense popular reaction to her retrospective, mounted the year after Arbus's suicide. Photographed herself by Arbus six years earlier, Sontag was "knocked out" by the work and equally astonished at the crowds visiting the exhibit (some 250,000 people saw this show; the book that accompanied the exhibition sold 100,000 copies).[25] No collection of photography had achieved such mass appeal since Edward Steichen curated the "Family of Man" exhibit at MOMA in 1955. Sontag noted about the analogy: "Instead of people whose appearances please, representative folk doing their human thing, the Arbus show lined up assorted monsters and borderline cases— most of them ugly: wearing grotesque or unflattering clothing; in dismal or barren surroundings—who have paused to pose and, often, to gaze frankly,

confidentially at the viewer."[26] In 1955 unprecedented crowds had congregated
to take pleasure in what Sontag defined as "sentimental humanism," a repre-
sentation of a world without conflict; in 1972 similar numbers assembled to be
confronted by its inverse, a world united by pain. The Arbus show epitomized
for Sontag a disconcerting shift in the art and politics of suffering, one that
she understood to be inescapably "anesthetic."

The problem of anesthetics weighed heavily on Sontag's reflections on
the photographic image. In 1972, the year of Arbus's show, the most famous
photograph in the country was of a naked Vietnamese girl running down a
dirt road, her arms outstretched, her mouth wide open, her face contorted.
Though she was not alone in the photograph (there are other children who
are clothed, a boy whose face betrays his agony, and others who appear more
frightened than injured; there are US soldiers walking nonchalantly down the
side of the road paying no attention to the children), the photograph came to
be called "napalmed girl"; it won a Pulitzer Prize and was named the World
Photograph of the Year. Sontag called these kinds of photographs "novelt[ies]
of misery" and argued in the opening essay of her book that the ubiquity
of such images deprived them of the novelty that was meant to shock. The
images themselves were not anesthetizing, but the volume of images "upped
the ante," creating a vicious cycle that swelled the number and horror of
images while simultaneously diluting their effect. Sontag's criticisms of Ar-
bus are couched in much the same terms as her concerns about war photo-
journalism. In fact, so close are they that in Sontag's miscellany of quotations
at the end of On Photography, Arbus becomes a war photographer, as she
indeed sometimes saw herself. Though Sontag does not explicitly link Ar-
bus's images to the photojournalism of the Vietnam War, she quotes some of
Arbus's lesser-known statements on photography; "I am creeping forward on
my belly like they do in war movies" and "God knows, when the troops start
advancing on you, you do approach that stricken feeling where you perfectly
well can get killed" (OPS, 39). It is the context of the Vietnam War and of
the photographs of atrocity that leads Sontag to condemn Arbus's—and her
peers—an-aesthetics.[27]

Conventional wisdom about the photojournalism of the Vietnam era
takes for granted the force of these photographs in provoking the outrage of
the antiwar movement. However, many, if not most, accounts of post–World
War II photography now consider the Vietnam War to mark a decline in
the power of documentary and photojournalism to incite social protest.[28] The
glory days of documentary dissent, the Depression-era photographs of the
Farm Security Administration, whose most famous practitioners were Walker
Evans and Dorothea Lange, set the aesthetic terms and political standards

for documentary photography in the United States, neither of which seemed intact by the late 1960s for a wide variety of reasons. Moreover, critics of photography in the early 1970s were acutely conscious of the unpredictable effect of images of trauma. The extremity of the photographs did not have the effect, or at least not as directly as many had assumed, of building the movement to end American involvement in Vietnam. This concern, coupled with the transformation of photography in the 1960s from a commercial, journalistic, amateur, scientific, and art project into a museum collectible, spurred a renewed attention to the photographic image, an attempt to theorize it, as well as to display and catalog it. Along with photographers and museum curators like John Szarkowski of MOMA, critics who had no particular training in the medium, like Sontag, Roland Barthes, and Stuart Hall, as well as art critic John Berger, wrote important essays about the photographic image. Berger's and Sontag's shared interest in war photography and their mutual influence in thinking about it will be elaborated later.

Given that Arbus is frequently called "tough," "unsentimental," and "cool," the stylistics of her work seem to correspond to the sensibility that Sontag extols in "One Culture and the New Sensibility," and the emotional content of her work appears to comport with Sontag's own distrust of immoderate feeling. It should therefore strike us as surprising that Sontag exhibited such antipathy to Arbus's portraits. Certainly, Sontag was not alone in her distaste. The response to Arbus's work was volatile, generating tremendous esteem and equally severe censure (curators at MOMA had to clean the spit off her photographs at the end of each day, as some viewers of the exhibit rendered their judgment in a visceral way). But there is a more complex argument at work than disgust for a gallery of freaks. Of course, we cannot know whether the spitters in the MOMA crowds were reacting to what Arbus photographed or how she photographed it. For Sontag, however, it is not merely the subjects of Arbus's interest but the way Arbus photographed them that induced her moral queasiness.

Sontag has many objections to Arbus's work but chief among them is the following: "She seems to have enrolled in one of photography's most vigorous enterprises—concentrating on victims, on the unfortunate—but without the compassionate purpose that such a project is expected to serve" (OPS, 33). Oddly, however, in much of On Photography, Sontag devotes herself to demonstrating how unreliable the document of suffering and its compassionate motive are for engaging conscience. First, photography's aestheticizing of reality renders human misery beautiful. Second, repeated exposure exhausts shock, which defuses the jolt to conscience that mobilizes action. And third, and perhaps most important, the photograph of suffering elicits no predict-

able ethical response. Its ethics are, she says, "fragile" (*OPS*, 20). Sontag argues that a photograph can only intensify or mobilize an ethical sentiment that preexists it. Her example is the Vietnam War. In the Civil War, the photographs of Andersonville that circulated inflamed feelings of hostility toward the South, but not antipathy toward the war. Unlike the Korean War, where no photographs of war atrocity appeared in the mass media, Vietnam produced a documentary protest because an ethical sentiment against the war already existed. The photograph needs the "appropriate context of feeling and attitude" (*OPS*, 17) in order to have a political meaning; it cannot create that context. While Sontag argues that the Vietnam protests provided the "appropriate context of feeling and attitude" for war photography, her essays also demonstrate how *in*appropriate a "context of feeling and attitude" the war photographs had landed in. On the one side, there was the protest movement; on the other, the anesthetics of contemporary visual culture.

To drive her point home, Sontag tells a personal story in the opening essay about her first exposure to a "novelty of misery" before familiarity has set in and weakened the shock of the photograph:

> For me, it was photographs of Bergen-Belsen and Dachau which I came across by chance in a bookstore in Santa Monica in July, 1945. Nothing I have seen—in photographs or in real life—ever cut me as sharply, deeply, instantaneously. Ever since then, it has seemed plausible to me to think of my life as being divided into two parts: before I saw those photographs (I was twelve) and after. My life was changed by them, though not until several years later did I understand what they were about. What good was served by seeing them? They were only photographs—of an event I had scarcely heard of and could do nothing to affect, of suffering I could hardly imagine and could do nothing to relieve. When I looked at those photographs, something was broken. Some limit had been reached, and not only that of horror; I felt irrevocably grieved, wounded, but a part of my feelings started to tighten; something went dead; something is still crying. (*OPS*, 19–20)

As important as the suffering itself, the "limit"—"not only that of horror"— that Sontag experiences remains unnamed. What seems to divide her life in half, leaving her grieved, wounded, and partly dead, is her own lack of agency, her helplessness. She sounds that note twice in describing the photographs: "could do nothing to affect" and "could do nothing to relieve." (With somewhat more equanimity, she will confront this as the "unappeasable past" in *Regarding the Pain of Others*.)

This passage clearly affected John Berger's thinking about photographic images because he quotes it in his well-known essay "The Uses of Photography," his homage to *On Photography*, as he wound up to his conclusion about

the alternatives to current exploitative uses of the camera. But their mutual influence, or maybe confluence, extends backward to 1972, when both began to write about photographs. At the peak of his own cultural influence following the tremendous success of *Ways of Seeing*, the title of both his BBC television series on painting and the book he wrote to accompany the series, Berger turned his attention to war photographs and the feelings of helplessness photographs of extreme suffering inspire. Published just before Sontag began publishing her essays on photography in the *New York Review of Books*, Berger's "The Photographs of Agony" is a short piece on the appearance of horrifying photographs from the Vietnam War in mass-circulation newspapers, and it attends to exactly the problem of helplessness that Sontag describes. Like Sontag, Berger comments on the fact that these photos were recent arrivals in mass media but instead wonders why organizations that supported the war would publish them. In other words, the effect of these photos must be something other than we expect. He argues that these photographs produce a dislocating and disabling sense of moral inadequacy that leaves the viewer with no response of sufficient moral efficacy. What the viewer experiences, then, from the shock produced by the photographs (we are "seized" and "engulfed" by suffering) is yet another shock, the shock of her own moral failure, which overrides—even suppresses—the suffering and violence depicted in the photograph. This produces, he says, either despair or a compensatory penance, like donation to a charity, but it does not produce political will. Instead of confronting the *real* lesson of the photos, he argues, which is our own political helplessness to stop wars fought in our name by our own governments, we are left in a state of moral and political paralysis. We suddenly see ourselves without agency, and this revelation of helplessness allows the photos to be published in the first place.[29]

For Berger, these photos operate like a traumatic event—that is, they take place out of time. When the observer returns to ordinary time, the suffering in the photograph is discontinuous and inassimilable to normal life. The suffering in the photograph in effect vanishes, displaced by the viewer's experience of his moral irrelevancy, which pushes the subject matter of the photo back into the discontinuity in time that it produced. What both Sontag and Berger require when witnessing suffering in the photograph is the possibility of agency on the part of the viewer. This agency is part of a fundamental assumption of a politics of suffering, one in which we know what pain means and we know what to do about it. In Berger's terms (not yet Sontag's), witnessing can become a form of moral trauma when agency is vacated, incomplete, or incommensurate with the viewer's moral dilemma. Without the viewer's agency, suffering drops out of view and perhaps into exile, to borrow

from *Illness as Metaphor*, where Sontag acknowledges that illness changes one's citizenship, deporting the sick to their own kingdom and granting their return only when well. It is not then, the mere presence of the witness, but instead, the agency of the viewer must seem intact to offer the suffering a passport to visibility. This, then, is the power of the viewer: to make suffering visible by being there to witness it in the form of an invitation to action.

This feebler agency, the flip side of paralysis and moral irrelevance, is more familiar to us as sympathy. Whether a viewer derives pleasure from or merely enjoys her own feelings of sympathy or outrage, even of pain, when viewing the suffering of others has preoccupied a great deal of criticism for more than twenty-five years as the effects of the arts of sympathy have been examined and reexamined across genres and historical periods. These feelings are repulsive to Sontag when she returns to them toward the end of her life in *Regarding the Pain of Others*. Sontag revisited *On Photography* to amend her arguments about images of suffering explicitly in terms of agency. *If* feelings are anesthetized, and she now doubts that they are, it is "passivity" rather than the surfeit of images that "dulls feeling." She might very well have learned this from Berger. In resuscitating the capacity to respond emotionally to these images, Sontag nevertheless exhorts the reader to "set aside" sympathy because it "proclaims our innocence and impotence" while masking our complicity in horror.[30]

Not surprisingly then, as indeterminate as the ethical effects of photographs of suffering are, Sontag grounds the ethics of documentary squarely in its solicitation to action. She excoriates Arbus for deploying the visual rhetoric of documentary to display suffering without any of the form's implicit call to action. Arbus's display of pure suffering without an attempt to mobilize conscience becomes an *anesthetic*, a pain that acts as a painkiller. The whole point of Arbus's photographs, she argues, is to teach you "not to flinch," to raise the threshold for feeling anything, much less pain. This erosion of revulsion, she believes, has dangerous consequences. That is, it makes it increasingly difficult to respond to the misery of the world. In this way, Sontag saw Arbus as producing a "self-willed test of hardness" (*OPS*, 40)—a toughness that was for Sontag a project of becoming insensate. Obviously, characterized this way, Arbus produces precisely the opposite of what art should cultivate in a world Sontag describes as so overproduced that it has overwhelmed our senses; instead of stimulating and enlarging our capacity to feel, Arbus had weakened it further still. Moreover, if every additional image of suffering further erodes the capacity to feel, Arbus's work accelerates the Vietnam era's depletion of moral sentiment.

It would be easy to mistake Sontag's criticism of Arbus as a preference

for emotional appeal, which is one component of the gaze of documentary. However, Sontag is no fan of direct emotional address, and throughout her career she ignored the art associated with or produced from within the post-war social movements entirely. The art that she most admires is that which is the most emotionally well regulated. In "One Culture and the New Sensibility," Sontag claims that "today's art, with its insistence on coolness, its refusal of what it considers to be sentimentality, its spirit of exactness, its sense of 'research' and 'problems,' is closer to the spirit of science than of art in the old-fashioned sense" (*AI*, 297). Only a few pages later, she argues that "the interesting art of our time has such a feeling of anguish and crisis about it, however playful and abstract and ostensibly morally neutral it seems" (*AI*, 302). Sontag insists above all that art has a responsibility to shape conscious-ness by providing new sensations, not feelings, and that its importance to us is to provide the education necessary to cope with the rapidly changing sen-sorium of modernity. In "The Spiritual Style of Robert Bresson," she comes closest to articulating this ideal: "Great reflective art is not frigid. It can exalt the spectator, it can present images that appall, it can make him weep. But its emotional power is mediated. The pull toward emotional involvement is counter-balanced by elements in the work that promote distance, disinter-estedness, and impartiality. Emotional involvement is always, to a greater or lesser degree, postponed" (*AI*, 177). Emotional regulation stands in the nar-row middle ground between the threat of affectlessness and the overpowering emotional claims of anguish.

It is important, then, to return to Sontag's notion of erotics, the other stress point in her calibration of art and emotion, in order to perceive the difference between the "distant," "mediated," "disinterested," or "postponed" emotional involvement and what she defines as Arbus's anestheticism. "Erot-ics" is one of Sontag's master terms—also one of her most confusing and counterintuitive—and it is closely linked to capitalism, which is the plane on which feeling, images, and suffering meet through the metaphor of economy. For Sontag, the erotics of art does not seek to cool affect, as it might first seem in her description of Bresson's films; rather, it seeks to manage powerful feel-ing, even while augmenting its force. Put another way, eroticism enhances the capacity to feel intensely while maintaining agency over one's desire. Rather than abandon, it promotes self-control. The ability to experience as much feeling as possible without being overcome or controlled by desire is as neces-sary for the consumption of images as it is for the experience of sexual desire, whose terms are often interchangeable in *On Photography*. For Sontag, the ideal economy—for images, sexual desire, or commodities—is highly regu-lated, dictated less by demand than by fiat because demand always threatens

to be excessive. She famously concludes *On Photography*: "If there can be a better way for the real world to include the one of images, it will require an ecology not only of real things but of images as well" (*OPS*, 180), a fantasy that draws on the burgeoning environmental movement of the 1960s and 1970s to impose limits on consumption and waste. Overproduction and overconsumption make demand, or desire, unreadable, produced as much from the outside as from within. Sontag worries that we can no longer enjoy our own desire because we have lost control over it. Our agency has been compromised.

Buried beneath the explicit anxiety about the erosion of sensation (which is propelled by the overproduction of capitalist economies) and the erosion of feeling (which is speeded up by the overproduction of images of suffering) lies the equally distressing sense that feeling on its own tends to run out of control, to dominate rather than to enrich, to overwhelm agency rather than fuel it. Recall from "The Pornographic Imagination" that sexual feelings are potentially annihilating. Toward the end of the final essay of *On Photography*, Sontag equates images and sexual feeling: "The possession of a camera can inspire something akin to lust. And like all credible forms of lust, it cannot be satisfied: first, because the possibilities of photography are infinite; and, second, because the project is finally self-devouring. The attempts by photographers to bolster up a depleted sense of reality contribute to its depletion" (*OPS*, 179). Both economies—the economy of *eros* and the economy of images and commodities—require a form of discipline and self-control that art can teach, but somehow photographs cannot. To have one's agency vacated by a photograph means to have no capacity to resist its seduction. This suggests that the menace of Arbus's photographs is at the same time the opposite of what Sontag argues, that her photographs, rather than deadening feeling, propel the viewer into feelings that are at once irresistible and impossible to act on.

## The Romance with Powerlessness

Sontag was not immune to the seduction of strong feeling even while her more typically analytic and dispassionate voice warned of its dangers. If the wariness of "The Pornographic Imagination" centered on the potentially annihilating feelings of sexual desire, and if the anxiety of *On Photography* arose in the context of overwhelming feelings of helplessness, the essay that concludes her work of the 1960s, in contrast, enters fully into the culture of feeling of the New Left. "Trip to Hanoi" (1968), one of her most controversial essays, represents a striking anomaly in the body of her work for two reasons:

first, the essay takes a diary form, making it one of the rare pieces of auto-
biography of her career; second, her longing for personal emotional expres-
sivity is neither repeated nor echoed anywhere else in her writing. The first
half of the essay, taken from her journals, recounts her initial discomfort and
alienation from North Vietnam, its people, and its revolutionary project. She
locates this discomfort in the aesthetic and psychological flatness of her ex-
perience: the flatness and simplicity of their language and the moral universe
it describes; the flatness of her personal interactions with her emotionless
and sexless Vietnamese ambassadors. She says that "in Vietnam, everything
seems formal, measured, controlled, planned. I long for someone to be indis-
creet here. To talk about his personal life, his emotions. To be carried away by
'feeling'" (*SRW*, 227). In the face of what she perceives to be affectlessness, she
swings toward the opposite pole. The seemingly unnecessary quotation marks
around "feeling" are the only indication of her internal debate over emotional
expressivity, whether her own or others.

The second half of the essay reads like a conversion narrative, not only
in its change of heart but also in the literal conversion of all the properties
that initially disturbed her. Linguistic and moral simplicity become a kind of
honor; personal and sexual reserve become a commendable "emotional tact"
and "sexual discipline." Converting these properties into things she can (and
generally does) admire, Sontag no longer resists but enters into the "two-
dimensional . . . ethical fairy-tale" she felt she had been offered. Checking
herself against the pastoral and primitivist clichés of Western revolutionary
intellectuals, she nonetheless concludes: "I found, through direct experience,
North Vietnam to be a place which, in many respects, *deserves* to be idealized"
(*SRW*, 258). She claims to have been changed, fundamentally, because she was
experiencing "new feelings" and therefore new consciousness, noting in an
extended footnote that "what brings about revolutionary change is the shared
experience of revolutionary *feelings*—not rhetoric, not the discovery of social
injustice, not even intelligent analysis, and not any action considered in itself"
(*SRW*, 263–64n). This is a rather stunning statement for Sontag's work even
in the sixties, much less for the years that followed. As she wrote to Adrienne
Rich during their heated exchange over Sontag's "Fascinating Fascism" in the
*New York Review of Books* in 1975: "I do dissociate myself from that wing of
feminism that promotes the rancid and dangerous antithesis between mind
('intellectual exercise') and emotion ('felt reality'). For precisely this kind of
banal disparagement of the normative virtues of the intellect (its acknowl-
edgement of the inevitable plurality of moral claims; the rights it accords,
alongside passion, to tentativeness and detachment) is also one of the roots of
fascism."[31] Having been seduced by the suffering but stoic North Vietnamese

into embracing the American enthusiasm for shared feeling, she will spend the 1970s trying to historicize—and politicize—the seductions of sympathy, what might be called the Western romance with powerlessness.

Let's return to Sontag's description of her illness: "I feel like the Vietnam War."[32] Crucially at this moment as the war ends in futility, as she revises *On Photography* for publication in book form, and as she begins writing *Illness as Metaphor*, Sontag imagines herself as the Vietnam *War*, not Vietnam or by extension the Vietnamese people. If she were Vietnam, she could extend to herself the sympathy meant for the invaded, colonized, and brutalized victims of the war with whom she had long expressed solidarity. Instead, reversing all of her actual positions during the war, she is the patriot cheering US military aggression; her body initiates a war with itself as invader and colonizer, emphasizing her identification with the United States, while suppressing her identification with Vietnam as the invaded and colonized body; and "they," her doctors, figure the US military as her deadly but potentially life-sustaining allies. Sontag figures herself primarily not as the victim but as the aggressor and as the helpless bystander who can only root for destruction. It's difficult not to hear that famous Vietnam-era military justification turned paradigmatic irony: We had to destroy the village in order to save the village. But it is important to note, even in Sontag's physical distress, she does not become the object of sympathy, even her own. And while she will figure her own lack of agency ("I have to cheer"), she will not turn herself into an image of suffering whose function, as she understands it in *On Photography*, is to appeal to the agency of others.

While I hesitate to put too much pressure on the journal notes of someone recovering from surgery and undergoing chemotherapy, Sontag's formulation suggests how much the Vietnam War had become emblematic of helplessness itself. That she could so easily imagine herself on the sidelines cheering the war effort might underscore what she came to perceive as the fundamental misguidedness of the antiwar effort, which she argued exhibited an investment in feeling that rendered it powerless to alter US involvement in Vietnam and, worse (to her mind), valued the moral drama of helplessness more than the political efficacy of agency. (That "Trip to Hanoi" celebrated this culture of feeling goes unremarked.) In June 1975 the *New York Review of Books* published a special supplement in which they asked some of their contributors to reflect on the meaning of the war and its ending. Sontag contributed a brief, bitter piece on the futility of the antiwar movement that she organizes around the movement's romance with powerlessness. Her point—"The Vietnamese won *politically*; the antiwar movement lost"—is at the heart of her dismay and

disillusion. She explains: "The reasons why 'we' lost are complicated. While for some Americans the Vietnam War was an extraordinary, decade-long political education in the nature of imperialism, state power, etc., for many more it was an *éducation sentimentale* which quite underestimated the nature and extent of state power. The Movement was never sufficiently political; its understanding was primarily moral; and it took considerable moral vanity to expect that one could defeat the considerations of *Realpolitik* mainly by appealing to considerations of 'right' and 'justice.'"[33] As she turns her back on the antiwar movement with the ambivalent "we," Sontag rebukes the "many" in the movement for finding in it an opportunity to cultivate their feelings, not their understanding of global politics. She finds part of this "sentimental education" to have been both self-deluded and narcissistic, a moral vanity that depended on feeling good about one's capacities for feeling bad. Complaining that the movement was always antipolitical and too invested in its own innocence, she claims that "living with their victory (however devoutly that was to be wished) will not be as edifying or as simple morally as protesting their martyrdom—a matter which is already clear as they busy themselves installing a social order in which few of us who supported the DRV and the PRG would care to live, and under which none of us, as 'us,' would survive." If the sixties had made life "interesting again," as she noted, the task for the 1970s would be to achieve a political moral adulthood, one "with a growing and history-minded distrust of all slogans of historical optimism" and a "lessening affection for our own innocence."

Sontag found the ineffectualness of the antiwar movement to lie in its orientation toward feeling: its vanity in its innocence and virtue, its enjoyment of its capacity for sympathetic identification. She seems to hold in her mind two things: first, that powerlessness, by guaranteeing virtue, was its own reward; second, that sympathetic identification carried with it the grandiosity of agency, which was measured not against effectiveness but against the agencylessness of the suffering Vietnamese. On the one hand, it is easy to see Sontag berating herself for embracing just this dynamic of feeling in "Trip to Hanoi." On the other, her gross oversimplification of the antiwar movement grows out of the ambivalence toward feelings that increasingly marked her work, her sense of their threat as well as their seduction.

*Illness as Metaphor* takes up just this romance with powerlessness by tracing it back into the nineteenth century, providing a longer cultural history for the claims of Sontag's critique of the antiwar movement. One link between *Illness* and the short piece in the *New York Review of Books* special supplement is the word "interesting," a favorite term of approbation for Sontag in

the 1960s and perhaps the most damning word in her lexicon in the 1970s. In an interview with Roger Copeland in *Commonweal* in 1981, Sontag was asked about the term "interesting" and its application to her by Elizabeth Hardwick. Sontag answers: "I was astonished by Elizabeth's remark. She was 100 percent wrong. In fact, for a couple of years now, I've been accumulating notes toward a critique of this notion of 'the interesting.' It started with the sixth essay in *On Photography* where I argued that one of the ways in which photographs are untrue is that they make *everything* interesting. And then, of course, in *Illness as Metaphor*, I talk about this 19th-century notion that tuberculosis makes one more interesting." Responding to Copeland's assertion that at one time she liked the term, she says that in the 1960s John Cage, Merce Cunningham, Jasper Johns, and Marcel Duchamp used the word "interesting" all the time and "it sounded very glamorous and aristocratic."[34]

Therefore, when Sontag says in 1975 that the 1960s made politics "interesting again," she indicates that the sixties both animated politics and reanimated the Romantic drama of individuality, emotional intensity, and powerlessness that she had come to find so disturbing. On the one hand, tuberculosis "is celebrated as the disease of born victims, of sensitive passive people who are not quite life-loving enough to survive" (*IAM*, 25), while on the other, it was a "way of affirming the value of being more conscious, more complex psychologically" (*IAM*, 26). By affirming the value of psychological complexity, "Sickness was a way of making people more 'interesting'" and "perhaps the main gift to sensibility made by the Romantics is . . . the nihilistic and sentimental idea of 'the interesting'" (*IAM*, 30–31). Sontag is at pains to establish the logic equating "interesting" and "powerless": interesting derives from sadness or sickness, which implies refinement and sensitivity, and refinement and sensitivity are the special attributes of the powerless. "For more than a century and a half, tuberculosis provided a metaphoric equivalent for delicacy, sensitivity, sadness, powerlessness; while whatever seemed ruthless, implacable, predatory could be analogized to cancer" (*IAM*, 61). The modern version of Romantic individualism is not the cancer victim, who is too anesthetized emotionally to enjoy his or her powerlessness, but the mentally ill, who like the tubercular "[retires] from the world without having to take responsibility for that decision" (*IAM*, 34). The romance with powerlessness—one's own and others—is then necessarily a political liability, but it turns out to be an aesthetic one as well.

*Illness as Metaphor* has been seen primarily as a departure for Sontag, unique in its goals for direct social impact, which she affirmed many times in interviews around its publication. However, Sontag also described *Illness as Metaphor* to Fritz Raddatz of *Die Zeit* in this way:

But what I was attacking at that time in my essay and what I would continue to attack is interpretation in a much narrower sense—namely interpreting away the facts of a case by means of words. Released by my cancer illness, I have concerned myself in a newer, longer work with how words and concepts cover the reality of sickness (it used to be TB, now it's cancer). Actually, it's been clear to me for only three weeks that *my essay about cancer is a different version of "Against Interpretation."* It is in this way that one has to understand my attack and it is in this way also that my analysis of Leni Riefenstahl is to be seen. What does "beautiful" mean anyway?[35] (emphasis mine)

There are two important steps here: one is Sontag's attack on "interpreting away the facts of a case" with words that "cover the reality of sickness," and the other is aligning *Illness as Metaphor* with her aesthetic manifesto "Against Interpretation." By the logic of *On Photography* and her argument about the representation of suffering, the "reality of sickness" cannot appear in *Illness as Metaphor*. Her illness, anyone's illness, is not a form of suffering that solicits action from the viewer or the reader. It is private, even though Sontag hoped to reach those ill with cancer. By the logic of "Against Interpretation," being "against metaphor" is to dismantle the meaning-making enterprise when it affects the sick. In *Illness*, she wants disease to remain a fact of physical, not metaphysical, distress. In denying meaning to disease, Sontag intends to deflect the burden of responsibility for illness that disease metaphors, particularly of cancer, inflict on the suffering. In other words, Sontag wants to deflect responsibility for being ill and in so doing restore to the sick agency over their diseases. This restoration comes out of an aesthetic strategy or pedagogy of the senses.

As she says in "Against Interpretation," "the function of criticism should be to show *how it is what it is*, even *that it is what it is*, rather than to show *what it means*" (*AI*, 14). This approach treats art like a fact and makes criticism a type of scientific investigation, a Linnaean endeavor in the description of species, which the volume *Against Interpretation* accomplishes so brilliantly in its taxonomies of camp, science fiction films, Happenings, etc. But if we are to take her comments seriously, we have to ask what it means to think of *Illness as Metaphor* as an aesthetic manifesto. At the risk of being too literal, can we imagine telling the readers whom she's most concerned with reaching—those ill with cancer—to see, hear, and feel *more*? If we were to substitute "illness" for "art" in "Against Interpretation" or "art" for "illness" in *Illness as Metaphor*, we would get statements that sound perfectly compatible with both essays. "Real art has the capacity to make us nervous" becomes "real illness has the capacity to make us nervous." "Interpretation makes art manageable, comfortable" becomes "metaphor makes illness manageable, comfortable." How-

ever apt these might be in context, the statements would not displace any of our conventional understanding of disease or language. Illness does make us nervous, particularly if we agree with Sontag (and so many others) that illness and death are nearly invisible in modern life, and euphemism does manage, however unsuccessfully, the distress of uncomfortable reality. But how far do we go with this analogy? Where Sontag states her aesthetic values most clearly ("transparence is the highest, most liberating value in art—and in criticism— today. Transparence means experiencing the luminousness of the thing in itself, of things being what they are" [*AI*, 13]), would she—or we—be able to value transparence with respect to illness? "In place of a hermeneutics" do we really need "an erotics of *illness*" (*AI*, 14)?

That Sontag might indeed wish for something like an awakening of the senses with regard to illness—even grave, depleting illness—does not seem implausible when we think of other exhortations to the senses, to the aesthetic, in times of suffering and distress. We might have to understand that far from ever repudiating "Against Interpretation," Sontag rewrote the essay several times over the course of her career, but in areas we normally do not understand to require an aesthetic pedagogy. One of her most controversial pieces came after the attacks on the World Trade Center. Published together with several other short responses by noted writers in the Talk of the Town section of the *New Yorker* thirteen days after September 11, Sontag blistered the media and national political figures for their "sanctimonious reality-concealing rhetoric . . . unworthy of a mature democracy," which she argued infantilized the US citizenry. Infuriating the political Right, Sontag also questioned whether the attackers could properly be understood to have lacked "courage," in her terms a "morally neutral" term. Whatever they were, she said, they were not "cowards." But most of all, she objected to the failure to *think* about the event, what its causes might be or what it represented in the arena of world politics. "Let's by all means grieve together," she said, "but let's not be stupid together."

If we imagine her implying the root meaning of "stupid"—let us not have our faculties deadened or dulled; let us not be stunned with surprise and grief—we can see Sontag imploring the reader to remain attuned, even sensitive, to reality in this most extreme state of emotional distress. This argument against stupidity is another version of "Against Interpretation": "All the conditions of modern life—its material plenitude, its sheer crowdedness—conjoin to dull our sensory faculties. And it is in the light of the condition of the senses, our capacities (rather than those of another age), that the task of the critic must be assessed" (*AI*, 13–14). Her remarks on the events of September 11 renew this petition to critical, aesthetic intelligence. In fact, this is prob-

ably the most consistent position Sontag ever held. In art and in politics as in illness, the aesthetic—meaning the cultivation of our capacity to sense the world—needed to be reanimated, and to do this cultivation always required the suppression or negation of emotional response.

More than her angry reprimand to the media and to politicians, Sontag was faulted for the absence in that essay of two other things. She made no address to the victims or their families. She expressed no solidarity with the residents of New York, her home for forty years. Should even the victims of this attack, which obviously included readers of the *New Yorker*, like those struck with cancer, be asked to remain alive to sensation, to complexity, to reality, when reality itself was so overwhelming, so unimaginable, so "monstrous"? Obviously, Sontag said yes, and did not demur on this point when challenged aggressively and angrily after the fact. As many readers have noted, *Illness as Metaphor* also says nothing about Sontag's own experience of cancer, and indeed we could go so far as to say it says nothing very much about the physicality or "reality" of the disease. As her son notes along with countless others, the essay was almost "*anti*-autobiographical." One's own pain is simply never a tasteful or ethical subject of contemplation, taste being a form of ethics for Sontag.

In her last collection of essays, *Where the Stress Falls*, she seems to admire most in Elizabeth Hardwick her refusal in *Sleepless Nights* to dwell on wounds to the self: "Not a breath of complaint (and there is much to complain of)."[36] Indeed, disciplined self-transcendence in form is a value extolled in everything from writing to dance (Lucinda Childs, Lincoln Kirstein, and Mikhail Baryshnikov) to painting (Howard Hodgkin). Moreover, speculating on why this might be violates the terms of reading that she lays out in "Singleness," one of the essays in which she describes her relationship to her own writing. She warns strenuously against making assumptions about her person from either what she has chosen to write or what she hasn't: "I write what I can: that is, what's given to me and what seems worth writing, by me. I care passionately about many things that don't get into my fiction and essays. . . . My books aren't me—all of me. And in some ways, I am less than them."[37] While Sontag is more willing to insert herself into some of these essays than one might expect, the entire collection is laced with caveats about autobiography, its capacity to conceal as well as reveal, and her dismay at the indefatigable self-exposure of so much contemporary writing. Autobiography *can* be a "wisdom project" but only when, like Adam Zagajewski's *Another Beauty*, it "purges [one] of vanity," or, like Roland Barthes's late work, it is "artfully anti-confessional."[38]

But Sontag's arguments against self-expression and emotional disbur-

denment are not merely aesthetic, or not aesthetic in a simple notion of that word. While many critics of late twentieth-century culture have bemoaned the expressive turn in the arts, they have done so for several reasons, none of which I think is primary to Sontag. They have argued that this self-expression is simply inartistic: poorly written, boring, excessive, amateurish, and self-indulgent, therapy masquerading as art. Sontag's problem is more complex and more, well, interesting. While she does question the value of some expressivity, her primary complaint is not aesthetic as a question of beauty ("what does 'beautiful' mean anyway?") but aesthetic as a question of knowledge—that is, knowledge through the senses. Feelings are an impediment to feeling—that is, sensation—and thus to knowing what something is and how it is what it is. And in the terms of *Illness as Metaphor*, feelings and expressivity are ways of enjoying one's own powerlessness while also enjoying the moral superiority and the lack of accountability that that powerlessness confers. Her autobiographical absence in *Illness* is a withholding with a mission. Denying the reader access to her experience, her feelings of and about disease, is part of the larger strategy to scale back the importance of feelings altogether. They are not enough, as her son says quite plaintively in his memoir of her death. Worse, they are the very fallacy she's writing against, that tuberculosis and cancer are diseases of feeling—extreme feeling in the case of tuberculosis and affectlessness in cancer. Feelings are, instead, the disease of modern life, not just the terms in which modern people misunderstand and seek to disown their corporeality.

5

# Diane Arbus: A Feeling for the Camera

I think it does, a little, hurt to be photographed.
DIANE ARBUS, letter to Marvin Israel

## Arbus and the Question of Empathy

The photograph is of a skinny blond boy, roughly six years old, in Central Park, New York City. Head slightly tilted, ears a little too large for his head, he has an exaggerated grimace on his face that draws his dirt-smeared mouth into a tight line. His eyes, wild but imploring, gaze directly back into the camera. His clothing accentuates his childishness: a print shirt with a round collar and black shorts with suspenders, the left dangling down to his elbow. Below the shorts, his knobby knees are stained and his shin smudged or bruised. He holds his arms straight and tight against his sides, hands turned out, the right gripping a plastic hand grenade, the empty left in a rigid clutch shaped to grasp a matching grenade. An indistinct female figure stands some yards behind him, maybe thirty, and further behind, approaching from the right-hand edge of the photograph, are a blurry little girl holding a blurry woman's hand and another blurry figure pushing a baby carriage. On the left edge is another pair of figures, probably children, also fuzzy and indistinct. In sharp focus in the immediate foreground, positioned several degrees left of center at the tip of the triangle made by the groups of figures, the boy appears unchaperoned and alone in the otherwise-empty park. He looks very young and slightly deranged.

The photograph is *Child with a toy hand grenade in Central Park, N.Y.C.* (1962), by Diane Arbus, and it is one of her most famous (see fig. 1). The museum catalog for the 2003 *Revelations* retrospective of Arbus's work, by far the largest collection of her photographs and writing ever published, includes the contact sheet from the photo session in which this picture was taken. Of the eleven photographs she took of this child, only this one image has anything remarkable about it. The other ten are conventional shots of a child mugging for the camera. The boy poses stiffly at first, then begins to smile

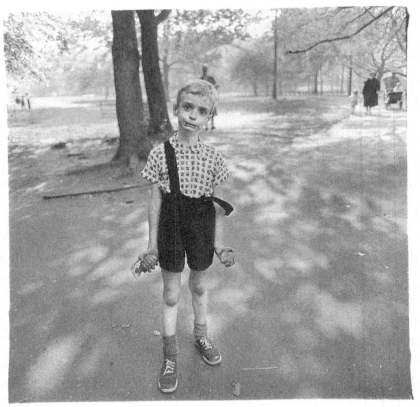

FIGURE 1. Diane Arbus, *Child with a toy hand grenade in Central Park, N.Y.C.* (1962). © The Estate of Diane Arbus. Reprinted with permission.

and flirt, but as the session goes on, he experiences a moment of exasperation. In the seventh shot, just before the striking eighth, he stands with his right leg out, his fists on his hips, his mouth compressed in disapproval, as if he were an adult admonishing a misbehaving child. Obviously frustrated with the game he's playing with the photographer, which has perhaps gone on long enough, he appears aware that he hasn't given Arbus what she wants. The next picture leaps off the contact sheet, an original and startling moment that shows the child so absorbed in the momentary battle of wills that he leaves off posing. The child glowers at her and beseeches her and then just as suddenly resumes hamming it up for the camera in the next shot, though now less stiff and self-conscious, having perhaps gotten what he needed (a word of approval? a smile?) because he had given Arbus what she wanted.

The contact sheet offers a succinct example of Arbus's working method. While this session was shorter than many, her patience and her ability to

establish rapport with strangers come through nonetheless. But the contact sheet provides more than a record of her process. Seeing this photograph in a series reveals just how unremarkable this boy was. The unstated assumption about this photograph has always been that, like the freaks she discovered at Hubert's Museum, Arbus sought out a disturbed-looking child and took his photograph. Instead, the contact sheet demonstrates that what looks like his derangement only erupts in the context of their interaction. Moreover, seeing the child's photograph in this series reminds us of the multiple genres in which Arbus worked, among them the portrait, the fashion photograph, New Journalism, and the family snapshot. Arbus deconstructs the fantasies embedded in these genres not by changing their formats but by waiting for something unexpected—the violence of childhood play, for instance—to erupt into view. So unsettling is the reality of childhood to the genre's conventions that it is easy to forget the forms altogether.

I begin with genre in Arbus's work in order to think about her photographic style and why it has generated what seems to be an irresolvable argument about empathy in the reception of her work. The genre still most associated with Arbus is documentary. This location has predominated despite two important collections of her photographs to appear between the original *Diane Arbus* posthumous exhibition in 1972 and the *Revelations* retrospective in 2003. The first, *Diane Arbus: Magazine Work* (1984), emphasized her commercial career by collecting her photographs and essays from *Harper's*, *Esquire*, and the *London Sunday Times* (among others). It also included a persuasive essay by the curator Thomas Southall positioning Arbus's work within New Journalism.[1] The second, *Family Album* (2003), concentrated on Arbus's keen interest in the family album and the snapshot by collecting her photographs of families and reproducing the contact sheets from a very lengthy session of family portrait making.[2] This collection, too, included substantial essays demonstrating the centrality of the forms of the album and the snapshot to her work.

The positioning of Arbus as a documentary photographer comes out of the two shows that made her reputation, both curated by John Szarkowski, the Museum of Modern Art's enormously influential director of photographs.[3] *New Documents* in 1967 grouped her with Garry Winograd and Lee Friedlander to show documentary photography's new direction, which Szarkowski said aimed "not to reform life, but to know it." The second was *Diane Arbus*, the posthumous one-woman show five years later, which turned her into an icon. Szarkowski described Arbus's relationship to the documentary tradition in the following way in the wall text of the 1972 retrospective: "Diane Arbus's pictures challenge the basic assumptions on which most documentary

photography has been thought to rest, for they deal with private rather than social realities, with psychological rather than historical fact, with the prototypical and mythic rather than the topical and temporal. Her photographs record the outward signs of inner mysteries."[4] Even as Szarkowski identified Arbus's work with the documentary tradition, both the American reformist line and the European taxonomic line represented by August Sanders (who came to be known in the United States in the 1960s), he also indicated the ways in which her work did not fit. If the documentary tradition displayed a consistent style of clarity and directness toward reality, it also displayed in the American tradition a particular emphasis on human suffering and a blend of realism and emotional charge, which was meant, in the words of Roy Stryker, the director of the Farm Security Administration, which sponsored the great documentary photography of the Depression era, to "incite change" by mobilizing sympathy. These two documentary modes—that of "knowing" and that of "reforming"—were tangling and untangling in the 1960s. For instance, Walker Evans, who made his name with the Farm Security Administration in the 1930s, delivered his important lecture on "lyric documentary" at Yale in 1964 in which he eschewed the social reform agenda; in 1966, the year before *New Documents*, the Farm Security Administration spirit had been revived by Cornell Capa's exhibition *The Concerned Photographer*, and its similarly titled catalog, and the documentary practices it celebrated made for some of the most arresting images and photo-essays of the Vietnam War.

That Arbus fulfilled the realist impulse of the documentary tradition could hardly be more obvious, whatever her subject matter. But documentary stuck to Arbus through the powerful intervention not only of Szarkowski but also of Susan Sontag, Arbus's first and still most influential critic. Sontag's essay on the 1972 exhibit, which launched her inquiry into the medium of photography, is still routinely cited in reviews and scholarship on Arbus's work. As I argued in the previous chapter, Sontag framed the problem of Arbus's photographs within the documentary tradition, following Szarkowski, and defined her work as a misappropriation of its form. Sontag claimed that Arbus photographed and collected other people's pain but offered no "compassionate purpose" to the viewer. In these terms, Arbus lacked empathy and the photographs offered a "self-willed test of hardness," one that inured the viewer to ugliness and pain.[5] Sontag attached Arbus to one version of the documentary tradition, the US reformist agenda, and found Arbus's ability to mobilize sentiment not only deficient but also corrosive of sympathetic sensibilities more broadly.

The uneasiness that Arbus's work produced in her viewers and to which

the genre of documentary drew attention was dissipated by the nearly unanimous praise for the *Revelations* exhibit of 2003, which certified Arbus as one of the premier photographers of the late twentieth century. The effect of this canonization was to immunize her work from serious confrontation with the discomfort her photographs continue to generate in her audience. Discomfort continues to be noted in reviews, to be sure, but roughly thirty years after the controversial one-woman show at MOMA, her work had been tamed. For one, its disturbing intensity is taken for granted as part of her genius, the label itself seeming to answer the curiosity her originality might otherwise inspire. In another way, the more expansive and diverse fund of images of the US public that began to be produced in the 1960s has also transformed the work by making her subjects more familiar. Transvestites and the mentally disabled, for instance, have a great deal more visibility than they did forty years ago. Nonetheless, even as Arbus has become familiar to generations of viewers (though not always by name), and even as she exerted a tremendous influence on photographers who followed her, the way her camera looked at her subjects—and the way that they look back—continues to surprise, confront, and trouble her audience.

But what finally tamed Arbus is the attribution to her project of an empathic motive, described also as tenderness, openness, and compassion. Over the last forty years, deciding where Arbus falls in terms of "compassionate purpose" has been the single most important critical judgment. With few exceptions, critics, reviewers, and academic historians of the medium have attempted to assign her to one side of a polarity between detachment and empathy. The results are not, however, as binary as that might imply. Some viewers want her to be empathic and claim that she is; some want her to be empathic and claim that she is not; some want her not to be empathic and claim that she is; some want her not to be empathic and claim that she is not. Curator Sandra Phillips's catalog essay for *Revelations* has her working in the "productive tension between empathy and critical distance" (*R*, 60), which splits the difference. So Arbus wins and loses and loses and wins in an argument that says a great deal more about the public life of empathy in the late twentieth-century United States than it does about the nature of her work.

However, this emphasis on empathy runs counter to Arbus's own philosophy of camera work. That she "adored" her freaks, that she had deep affection for many of her subjects, and that she developed relationships with them is not precisely what I mean. Instead, Arbus had a particular notion of the feeling of the *camera*, and that is where her disturbing toughness lies. She worked hard to detach the feeling of the camera from her own personal feelings; she

conceived this separation as a technical problem, and she claimed that she had to master it in order to produce the photographs she longed to make. Arbus fits more easily into the period's burgeoning suspicion and scrutiny of emotion in photographs and their compassionate purpose. Let us return to the photograph of the child with the toy hand grenade. When this photograph was first displayed, it was thought by many to comment critically on the Vietnam War.[6] While we do not know whether Arbus ever imagined it to be such a statement, and indeed there is good reason to suppose that she did not (Arbus was apolitical in most respects, which has become even clearer on the publication of *Revelations*), we ought to remember that the Vietnam War provoked a serious inquiry into the role of photographs—and, in particular, the photograph of suffering—in public debate. If Susan Sontag and John Berger were attempting to account for what Sontag called the "fragile" ethics of the documentary photograph in 1972, so, too, did Stuart Hall mount his own analysis of photojournalism in the *Manufacture of News* in 1973, in which he relied on Roland Barthes's reissued *Mythologies* (1972; originally written in the mid-1950s).[7] Barthes would take up the photograph in a more sustained way before his death in *Camera Lucida*, which was published posthumously in 1981.[8] Whether the analysis was genre based, form/mediation based, or driven by semiotic analysis, there were a great many questions and suspicions over how photographs spoke and the pain they spoke of. There may be today more consensus about the compassionate purpose of photography—or about the capacity of photographs to elicit compassion—than there was in 1972 when Arbus arrived at MOMA in her one-woman show. That suspicion seems to erode over time, to be resurrected, only to erode again. This past decade or more, in its ethical turn, which takes empathy to be *the* ethical mode, has eroded that suspicion again.

That Arbus might also be seen as a theorist of the photograph has been less clear, in part because of our dependence on the limited archive of Arbus's statements about her work: the fifteen pages assembled by her daughter Doon and Arbus's friend, mentor, and lover, Marvin Israel, that prefaced the first monograph, *Diane Arbus: An Aperture Monograph*. With *Revelations*, it is possible to inquire further into her theory of camera work. Rather than resolve the tension between Arbus's detachment and empathy, it might be more useful to imagine that she, too, theorized a distinction between personal and aesthetic feeling. Like all the women in this book, she understood her refusal of empathy to open the space for attention and reality. And it might have had a compassionate purpose as well, just not one built through the feelings of empathy or constructed, as Sontag insisted, from the possibilities of agency.

## On Not Being Nice

She has the rarity of being, in her work at least, never a "nice person."
ELIZABETH HARDWICK on Sylvia Plath, *Seduction and Betrayal*

But I suppose there is something somewhat cold in me. Although I resent that implication.
DIANE ARBUS to Studs Terkel

The closest thing to an authorized biography of Arbus, the "Chronology" in the exhibit catalog for *Revelations*, is an assemblage: a year-by-year narrative ending with the coroner's report after her death; photographs of and by Arbus, some known, some not; her writing in the form of letters, homework assignments, essays, and grant applications; and assorted ephemera like passports, daily planner lists, and newspaper clippings. While there is more material here than had ever been seen before, the chronology has enhanced and refined but not substantially altered the view of Arbus that the first monograph, *Diane Arbus: An Aperture Monograph*, produced. (Given the presiding role of Arbus's daughter Doon in both, it was unlikely to do so.) Adding to the Arbus corpus, *Revelations*'s contribution lies in the elaboration and contextualization of some of Arbus's most famous statements on photography, thus providing nuance and complexity, and sometimes clarity, to her often orphic pronouncements. Moreover, by displaying more of Arbus's writing, the *Revelations* curators, Elisabeth Sussman and Doon Arbus, allow us to see her as a serious writer, and therefore one whose words can bear up under analytic pressure. Less cryptic than *Diane Arbus: An Aperture Monograph* because it is less fragmentary, *Revelations* makes us see Arbus as a serious, if still idiosyncratic, theorist of photography.

The title *Revelations* not only describes the work the exhibit does for our knowledge and appreciation of Arbus but also springs from the character of her work. Arbus's best-known photographs derived from her encounters with the socially marginal: nudists; freaks like the denizens of Hubert's Museum in Times Square or eccentrics (like Uncle Sam or Prince Robert de Rohan Courtenay, rightful hereditary claimant to the throne of the Byzantine Eastern Roman Empire); genetic anomalies like dwarfs, giants, identical triplets, and hermaphrodites; sexual outcasts like drag queens, sex workers, and homosexuals; and the institutionalized mentally disabled. With those subjects as well as with more ordinary folk—young couples, socialites, suburban families, babies—she liked to capture what she called "the gap," which is the distance between a person's intended and actual self-presentation. To her

contemporaries and to most of her critics, all Arbus's photographs seemed to function in one way or the other as exposure, either bringing into public a hidden social type or revealing a hidden dimension of a common social type. This sense of revelation is perhaps part of what Sontag and Szarkowski meant when they called her photographs "private." Unlike the subjects of street photography, her subjects posed voluntarily, and moreover, a great many of her subjects posed themselves in public, which did not relieve her of accusations of voyeurism and exploitation.

Arbus did not have to go out to Hubert's, to drag balls, or to Coney Island to discover the "gap." This part of her work has received a great deal of commentary, but reviewing in light of *Revelations* helps us to understand how Arbus viewed her own project and the work a camera could do. In *Diane Arbus: An Aperture Monograph*, she said of the gap (also called "the flaw"):

> Everybody has that thing where they need to look one way but they come out looking another way and that's what people observe. You see someone on the street and essentially what you notice about them is the flaw. It's just extraordinary that we should have been given these particularities. And, not content with what we were given, we create a whole other set. Our whole guise is like giving a sign to the world to think of us in a certain way *but there's a point between what you want people to know about you and what you can't help people knowing about you.* And that has to do with what I've always called the gap between intention and effect.[9] (emphasis mine)

The gap seems to be anything *but* private in Arbus's terms. If we believe what she says about the flaw/gap, making it visible in a photograph becomes a different sort of problem, not a revelation of a private, hidden secret but the capture of ordinary human reality or, better, the refusal not to capture ordinary human reality. The photograph makes public in the sense that the "gap" now exists between the viewer and the subject of the photograph so that they can both see it at the same time. That she coaxed this gap into view, that her subjects inadvertently revealed themselves, might be the standard account of Arbus's portraits, but it seems that she was rather less impressed with its hidden quality than with its obviousness.

The ubiquity and ordinariness of this gap/flaw suggests that Arbus could hardly have avoided photographing it, and that the interesting theoretical or technical problem would have involved how to avoid photographing something so obviously there. For two reasons this seems not to have been the case. On the one hand, there was the social dimension of taking photographs, and on the other, there was the technical problem of capturing reality. As *Diane Arbus* makes clear, she had to work against something in herself and against

the fabric of sociability that allows this gap and/or flaw somehow to go unnoticed by the *camera*. Juxtaposed to the above comments on the gap are reflections on the difference between personal feeling and camera feeling. She first says that empathy is *not* something she believes in: "What I'm trying to describe is that it's impossible to get out of your skin and into somebody else's. And that's what all this is a little bit about. That somebody else's tragedy is not the same as your own" (*DAA*, 2). She continued: "There are certain evasions, certain nicenesses that I think you have to get out of" (*DAA*, 2). The camera as a tool does not evade or make nice. It has a "kind of exactitude," a "kind of scrutiny that we're not normally subject to. I mean that we don't subject each other to. We're nicer to each other than the intervention of the camera is going to make us. It's a little bit cold, a little bit harsh" (*DAA*, 2). She admitted in a letter to Marvin Israel: "I think it does, a little, hurt to be photographed" (*R*, 146). Throughout her correspondence with Israel, which was often daily, she constantly took her ethical temperature, debating the kinds of transgressions she felt she was making, but then, of course, making them anyway.

Ultimately, Arbus wagered her desire for reality against the soft focus of sociability. This transgression is something other than "voyeurism," simply because the gap was not, in her terms, an exposure or a revelation of a hidden thing. She admitted her duplicity when interacting with subjects who would be under the exactitude of the camera: "I think I'm kind of two-faced. . . . It really kind of annoys me. I'm just sort of a little too nice. Everything is Ooooo. I hear myself saying, 'How terrific,' and . . . I really *mean* it's terrific. I don't mean I wish I looked like that. I don't mean I wish my children looked like that. I don't mean in my private life I want to kiss you. But I mean that's amazingly, undeniably something" (*DAA*, 1). This willingness to be ingratiating in the service of "something" is her willingness to elicit the reality of her subjects quite against their own desire for a certain kind of self-presentation. As her celebrity subjects frequently protested, they themselves did not find this reality pleasing, or even acceptable, but of course, they were used to being looked at, if not actually seen. Norman Mailer (see fig. 2) famously complained, "Giving a camera to Diane Arbus is like putting a live hand grenade in the hands of a baby." Mae West threatened to file suit against her; Germaine Greer complained vociferously about her portrait and Arbus's in-your-face technique of getting it (even literally in your face since, according to Greer, Arbus posed her on a bed and then hovered inches above her snapping her photographs).

If the human eye learns to unsee the flaw, the camera does not, or so we would expect because we assume cameras capture the realities in front of them, however much we might dispute the perspective imposed by the

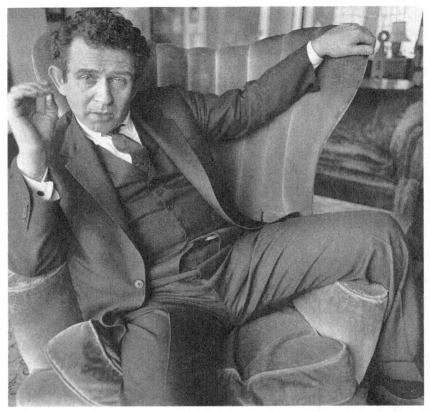

F I G U R E  2 . Diane Arbus, *Norman Mailer* (1963). © The Estate of Diane Arbus. Reprinted with permission.

photographer in pointing the camera or cropping the photo. *Revelations* makes clear that Arbus did not take that capture for granted. As she explained to her students after visiting and revisiting a Walker Evans exhibit:

> Sometimes I can see a photograph or a painting, I see it and I think, that's not the way it is. I don't mean a feeling of, I don't like it. I mean the feeling that this is fantastic, but there's something wrong. *I guess it's my own sense of what a fact is.* Something will come up in me very strongly of No, a terrific No. It's a totally private feeling I get of how different it really is. I'm not saying I get it only from pictures I don't like. I also get it from pictures I like a lot. You come outdoors and all you've got is you and all photographs begin to fall away and you think, My God, it's really totally different. I don't mean you can do it precisely like it is, but you can do it more like it is. (*R*, 342n496, emphasis mine)

Continuing in this vein, calling on the term "fact" in a way that Mary Mc-Carthy did, she reviewed several other photographers with her students, ex-

pressing her dismay at the aestheticizing of everyday reality, which would deprive the image world of "what really is." She said of Ansel Adams: "One quarrel I've got with [him] is that—he's never lied in a photograph or even exaggerated—it's just that his prints are so magnificent, he renders everything so incredibly. . . . I mean I never saw a tree like an Adams tree . . . they're all silver and glowing, and you know, that sky . . . like something you might give for a wedding present, but not like trees. Not that I know trees very well" (*R*, 342n499). Even with Evans and Adams, both known for the clarity and precision of their photographs, Arbus rejects the aestheticizing effect of the camera. In this, she joins Sontag, whose general rule of photography is that it makes everything beautiful. However, for Sontag, Arbus was the one exception. She quipped about Arbus, "In photographing dwarfs, you don't get majesty and beauty. You get dwarfs."[10] Arbus had rendered a fact in the photograph, but capturing reality without beautifying it is not so easily done, even if reality seems to be sitting right there unable to resist.

*Revelations* demonstrates that Arbus's pursuit of reality had an almost-obsessive quality. Her critics and her admirers both have understood her drive to capture reality as a form of therapy, an interpretation that derives from a statement in *Diane Arbus* that she felt deprived of reality as a child and compensated for that sense of unreality with her camera work.[11] Arbus said: "One of the things I felt I suffered from as a kid was I never felt adversity. I was confirmed in a sense of unreality which I could only feel as unreality. And the sense of being immune was, ludicrous as it seems, a painful one. It was as if I didn't inherit my own kingdom for a long time. The world seemed to me to belong to the world. I could learn things but they never seemed to be my own experience" (*DAA*, 5). I hardly want to quarrel with the psychological interpretation except to say that it represents only the beginning of the story, not the end. That Arbus was motivated to escape her isolation and insulation by entering the world, or by having the world enter her, seems inescapable. But we should also note that both reality and unreality produce suffering, either adversity or pain. The real-world adversity that she did not experience is clearly painful, but to not feel it is also painful. Whether her decision to encounter the adversity of the world rather than to suffer from her immunity to it is naïve, as Sontag claimed, Arbus always associated her freaks, "born with their trauma," with "kingdoms" and "aristocracy." She might have been a department store princess, but she had no kingdom—that is, no sense of her own sovereignty, secured by *surviving* a trauma, not merely having one. She chose a different kind of pain, not a therapeutic release from pain, through her photographs.

Why Arbus might have posed the problem of reality to herself is finally

less illuminating than the insights into the nature of photography that its pursuit generated. Arbus claimed that she was always more interested in the thing she photographed than in her technique. "For me the subject of a picture is always more important than the picture. And more complicated. I do have a feeling for the print but I don't have a holy feeling. I really think what it is, is what it's about. I mean it has to be *of* something. And what it's of is always more remarkable than what it is" (*DAA*, 15). This respect for content points us toward her subjects and to the realities she tried to capture there. As Sandra Phillips notes in her essay in *Revelations*, this devotion to content sets Arbus in opposition to the prevailing art historical trends of the period. However, capturing reality proved to be a very stubborn formal problem—surprisingly so, given that the photograph has always been designated as the medium defined by its reproduction of reality. Both André Bazin and Roland Barthes were particularly obsessed with this dimension of the photograph. For Bazin, photography is distinguished as an art form for "this transference of reality from the thing to its reproduction," while for Barthes, "the photograph is a literal emanation of the referent."[12] That Arbus was "hyped on clarity" (*DAA*, 9), a topic of considerable interest to her critics, might be seen as her attempt to get as much of this "emanation" or "transfer" as possible onto the print. Several important essays detail her technical interests.[13] To summarize, Arbus used the resources of her camera, changing them at the crucial points in her development as an artist, to enhance the clarity of her images and move away from the graininess of her earlier work.

However, at the same time, she began to use the flash to exaggerate differences and flatten backgrounds, foregrounding her portrait subjects. Very early in her career she stopped cropping her negatives, a practice that was popular during the period in which she began her work (the mid- to late 1950s) and was associated with spontaneous or street photography. And she developed a printmaking process and a distinctive print look characterized by black borders that ensured that the image qua image was what the viewer experienced. Making the mediation of the photograph unavoidably noticeable by defamiliarizing the look of the print was central to her larger process. This is a kind of realism, one that will not confuse the artifact with the thing it represents because it calls the distinction to the viewer's attention. For Arbus, this kind of realism, which includes the made-ness of the work of art as part of its reality, was a distinctive property of photography itself: "It's always seemed to me that photography tends to deal with facts whereas film tends to deal with fiction. The best example I know is when you go to the movies and you see two people in bed, you're willing to put aside the fact that you perfectly well know that there was a director and a cameraman

and assorted lighting people all in that same room and the two people in bed weren't really alone. But when you look at a photograph, you can never put that aside" (*DAA*, 6). While in matters of presentation and technique, Arbus imposed the artifice of photography as part of its realism, the content of Arbus's photography—the people she photographed—display the very same artificiality or the made-ness of the human subject. In fact, the relationship of *how* she photographed to *what* she photographed is essentially homologous.

Photography, like individual self-presentation, was produced in the failure of agency—that is, in the gap between what one intends and what one achieves. Her technical experimentation should be seen less as an attempt at mastery than as playing with various modes of accommodation to the "recalcitrance" (*DAA*, 5) of the camera. Coming to terms with this unpredictable tool meant forging a peculiarly distanced relationship to the camera. The observation "I never have taken a picture I've intended. They're always better or worse" (*DAA*, 15) is only one of a remarkable number of statements from the *Diane Arbus* monograph that insist on her *lack* of control over the picture-making enterprise. That is, since she could not control the outcome of her photographs and often did not like what emerged when she tried, she devoted considerable energy to sustaining or even inhabiting the gap between intention and effect. She liked the strobe because "you were essentially blind at the moment you took the picture" (*DAA*, 9). She loved the "mystery" of technique, which comes from "deep choices" and even "millions of choices" in "invention"—none of which is really intentional, she argued. It's "luck" or "ill luck" but beyond control. She believed that self-knowledge and self-scrutiny were an impediment to her work. "Very often knowing yourself isn't really going to lead you anywhere. Sometimes it's going to leave you blank" (*DAA*, 7–8). She wrote to Marvin Israel, "I don't press the shutter. The image does. And it's like being clobbered" (*R*, 147).

While the monograph's collection of fragmentary musings made Arbus appear naïve or merely intuitive, the *Revelations* "Chronology" shows the intense labor and reflection that went into her evasion of intention. The *Revelations* exhibit re-created a collage wall where she hung some rough prints of her own photographs, pictures torn out of magazines, newspapers, and books, and quotations to cultivate an unconscious relationship to her work. It should not surprise us that intention would leave her cold or seem inadequate, because she thought that human beings were essentially created by the failure of intention. Giving up conscious control of the artistic process is an idea that had wide currency in the postwar art world. Certainly in her portraits, Arbus draws on the tradition of street photography with which she is associated,

which dates back to the nineteenth century. More broadly we can see Arbus as part of what Daniel Belgrad has called the "culture of spontaneity," which groups abstract expressionism, Beat poetry and prose, bebop, Black Mountain poetics, and much more, for their faith in intersubjectivity and conversation, their antirationalism and anti-intellectualism.[14] The intense, prolonged encounter with her subjects is as much a part of this movement as the openness of chance, when the camera clobbered her. Arbus's effort to reside in the failure of intention, to block it by whatever means necessary, places her squarely within this larger movement. However, her sense of the ordinariness of the failure of intention, its inescapability, denies the process its mystical or oracular function and restores it to the realm of ordinary human endeavor, as ordinary—and as flawed—as human self-fashioning.

The truth or the fact or reality, as she put it in various contexts, was surprisingly difficult to render in the photograph. It was partly luck, the product of millions of invisible or unconscious choices that revealed something to the photographer, and it was partly a refusal of the social niceties that blunted the apprehension of what was really there. She couldn't do it "precisely like it is," only "more like it is." Refusing to interfere with the camera's coldness became a way for her to show what human beings looked like. To end with one last well-known statement of Arbus on Arbus: "I really believe that there are things which nobody would see unless I photographed them" (DAA, 15). Perhaps she meant less the hidden and socially marginal people that she photographed than the reality we normally overlook in an effort to be nice. Empathy for her seems to be a way *not* to see the other—a form of good intentions that collaborates in making the other invisible.

## The Limits of Agency

The chronology in *Revelations* selects from Arbus's early writing some remarkably astute readings of Chaucer and Cervantes for a freshman composition class in high school as evidence that her "mature sensibility" emerged early, perhaps even fully formed. The following is what she had to say about Chaucer in *The Canterbury Tales*: "When he describes the nun's daintiness, it doesn't seem as if he thinks that that is a standard of good conduct . . . rather he turns separately to each one and looks on them as whole miracles not as compounds of abstract qualities, and he seems to know that each one will always be himself and he wants that" (R, 128). Of Cervantes's *Don Quixote*, she observes: "You feel that suddenly and deliberately he threw off his already limited awareness of the conventions of the world, and threw himself

in the world's face defiantly, because he was what he was, and he felt that that was good enough" (R, 128). This juxtaposition of quotations easily pairs the photographer with the writer Chaucer, and the subject/freak with Cervantes's character Don Quixote. Chaucer loved the physical world because "it is unique and because it is here" (R, 128). Quixote's "'madness' is a way of being himself to the limit." This pairing could describe Arbus's form of attention and her subjects, especially in her early photographs, "being themselves to the limit" (R, 128). I want to pause, however, on her phrase "he felt that that was good enough" to ponder the intersection of these grandiose, perhaps mad projects of being oneself, and the question of gap, which we might also call the limit. Arbus possessed Chaucer's capacity for wonder and appreciation of "things being what they are" (to recall Sontag, McCarthy, and Arendt), which is part of her obsessive commitment to reality. For Arbus, the failure of intention, or what we might also understand as a failure of agency, was not a catastrophe, not "pain" as Sontag defined it, but good enough. The point for her, as she says of Quixote, is the commitment to being oneself fully and completely even when it looks like madness to other people. One of her earliest essays attests to the fact of limits and the "delicate art" of working with them.[15] In *Harper's Bazaar* in November 1961, an essay called "The Full Circle" included the photographs of five "singular" people, eccentrics that originally included Stormé DeLarverie, "The Lady Who Appears to Be a Gentleman." (This last figure was eliminated from *Harper's* but showed up in the reprint of the essay in *Infinity* the next year.) DeLarverie gave Arbus a line that appears to have captured something for her: "If you have self-respect and respect for the human race you know that Nature is not a joke" (as quoted in *R*, 55).

In stylizing the failure of human agency, Arbus makes it banal and yet visible, neither traumatic nor especially meaningful. In this way, failure is not identity producing—everyone fails to achieve their intentions—even while it remains particular because each project of self-realization is unique. Arbus's work taken as a whole tells a story about agency and its limitations, beginning with its rupture of a fantasized seamlessness between interior and exterior and concluding with the complete evacuation of intention in *Untitled*, the posthumous collection of photographs from Arbus's last project. In *Magazine Work*, she tends to focus on outlandish kinds of agency; the people she was most attracted to photographing were those individuals with the most impossible projects of self-realization, the Don Quixotes (see fig. 3).

In the *Untitled* series, the photographs are from Arbus's last project: taking pictures in a home for what were then called the mentally retarded. Here

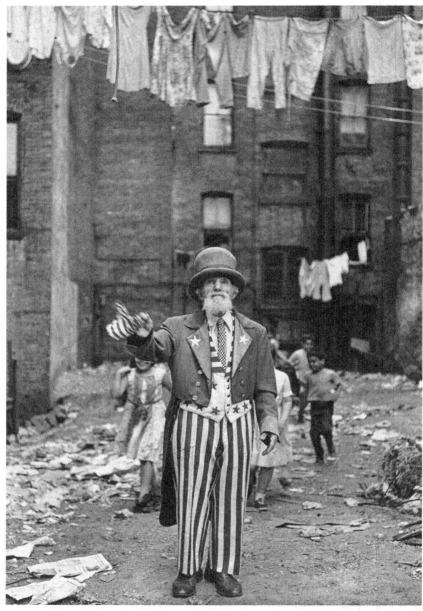

FIGURE 3. Diane Arbus, *Max Maxwell Landar (Uncle Sam)* (1961). © The Estate of Diane Arbus. Reprinted with permission.

FIGURE 4. Diane Arbus, from the *Untitled* series (1969–71). © The Estate of Diane Arbus. Reprinted with permission.

Arbus took a large number of photographs of Halloween celebrations where the costumed figures sometimes seem bewildered by what they are wearing, not projecting a fantasy of self-making (see fig. 4).

So we have more than one play with agency: first, its most grandiose aspirations and, at the end of her career, its bluntest limitations. Arbus clearly delights in the fantasies of agency that her subjects act out, but she also demonstrates no compulsion to enter into them. The limits of agency are not traumatic but inevitable, the human confrontation with the unplastic realm of the body and the world. The repetition of failure might imply futility, but Arbus's endless fascination with these projects suggests otherwise. Arbus, unlike Sontag it would seem, differentiates between the limits of agency and its disappearance.

Self-presentation in all these photographs is "flawed" in the sense that it always represents a shortfall of agency, a discrepancy between the efforts made

to create a self and the failure of those efforts. This is the revelation of the photographs in the Aperture monograph (*Diane Arbus*) that seems to consign them, for many critics, to the private sphere. Again, it is the disappearance of agency, or its failure or limitation, that makes the photograph private, not the particular content of the individual's circumstances. Similarly, in *Untitled*, we have a different sort of gap because we cannot understand the subjects to have very much agency over their self-presentation at all, or at least that is what many of the photographs seem to display. The exaggeration captured in these photographs is what Carol Armstrong called the "unmanaged face," which is accentuated in the collection by the interplay between photographs of the masked and of the unmasked face.[16] The two become different versions of the face that cannot be molded and held in place by conscious will.

Comparing photographs from *Diane Arbus* with those from the *Untitled* series suggests their inverted relationships between masking and agency. Like the *Untitled* series, the Aperture monograph contains a number of instances of the masked face or costumed body. This costuming is perhaps wittiest in her photographs of the members of nudist colonies. For instance, *Nudist Lady with Swan Sunglasses, PA* (1965) shows the woman holding a glamour pose (left knee slightly bent and angled across the right, hand on hip) and decked out in sunglasses and open-toed shoes, with a necklace and bathing cap (see fig. 5). The wit lies in the near eclipse of the nude body by the props and pose. Throughout this series, making and costuming override the body, calling into question the function of nudity for the camp members. In this photo, as in every case in the Aperture monograph, the subjects of the portraits are not so much masked as unmasked by their costume. Their direct gaze into the camera creates an image of self-assertion that, while troubled, is clearly a project of agency. Even in the case where masking is the self-chosen project of the sitter, this will to self-assertion appears in the failed masking. *Diane Arbus* contains a number of photographs of transvestites whose masking projects are always simultaneously successful and flawed. In *A Young Man in Curlers at Home on West 20th Street, N.Y.C.* (1966) the mask of femininity, conveyed by the curlers, the darkly stenciled, thinly plucked eyebrows, and the soft openness of his lips, is belied by the faintly noticeable stubble on his chin and his too-large hand and too-thick fingers, manicured nails and all, stylishly holding his cigarette. The young man's eyes boldly address the camera, defying the gap between the image he wills and the image he creates.

*Untitled*, as Carol Armstrong argues, is full of masked faces and faces that are masks. Many of the photographs were taken during Halloween celebrations, and the contrast between adult-sized bodies and childlike costumes is in itself a part of the uncanniness of the photos. Unlike the Aperture

FIGURE 5. Diane Arbus, *Nudist Lady with Swan Sunglasses, PA* (1965). © The Estate of Diane Arbus. Reprinted with permission.

monograph, the masked faces (see fig. 6) rarely provide access to the eyes of the subject, while the distorted faces, sometimes misshapen by genetic deformity, other times disfigured by an awkward facial expression, very often expose the eyes as blank and unseeing. In both cases, the eyes are unreadable, and therefore, no assertion of selfhood can be determined.

In her last work, the disappearance of consciousness for the sitter correlates with the loss of agency for the viewer. Stylistically, the subjects of these photos are rarely centered. They enter from off frame, stand obliquely to the camera, sit upside down, stare vacantly. Far more rarely do they address the camera, and even when they do, the meaning of the gaze cannot be determined. In addition, these photographs have a far greater depth of field than anything in the Aperture monograph. With much deeper gradations of color, often eerie backgrounds of clouds and shadows, the subjects of the *Untitled* series cavort in a kind of mysterious parallel universe. While her first set of

FIGURE 6. Diane Arbus, from the *Untitled* series (1969–71). © The Estate of Diane Arbus. Reprinted with permission.

freaks can assert their sense of self in relationship to the viewer—a typically confrontational event—the mentally retarded of the second series are almost entirely unself-conscious in their pose. Likewise, they cannot reserve themselves from scrutiny. Without that self-consciousness, as incomplete as it is, a different sort of ethical relationship is established between the viewer and the sitter. Sontag might consider this an agnostic position with regard to scrutiny, one that offers no clear ethical position from which to look or to look away.

In her miscellany of quotations at the end of *On Photography*, Sontag takes from Arbus the following: "If I were just curious, it would be very hard to say to someone, 'I want to come to your house and have you talk to me and tell me the story of your life.' I mean people are going to say, 'You're crazy.' Plus they're going to keep mighty guarded. But the camera is a kind of license. A lot of people, they want to be paid that much attention and that's a reasonable kind of attention to be paid."[17] If we read this passage from the perspective

of Sontag's essays, she means to emphasize "license" and "guarded" and the transgression of privacy through the camera. But what is also evident is the reasonableness of being paid a particular kind of attention. Arbus is not trying simply to ferret out their unguarded moments here—in fact they have no guarded moments—but to pay a weighty kind of attention.

Arbus took these photos in the early 1970s before activism on behalf of the mentally and physically disabled had produced a new fund of images.[18] I do not believe (nor do I think that Arbus believed) that the subjects of her photos were in pain or that they lacked self-consciousness. In fact, many of them in this series look remarkably happy, even joyful (see fig. 7). But the photos have been *received* as painful images and images of pain. This is due to the discomfort in the viewer who has no protocol with which to view them. Arbus puts us into an interesting position here with regard to "paying attention," which is complicated by the taboo against "staring" at the mentally retarded

FIGURE 7. Diane Arbus, from the *Untitled* series (1969–71). © The Estate of Diane Arbus. Reprinted with permission.

or, indeed, anyone with a manifest disability. This taboo against staring, while always couched in terms of decorum ("it's not polite to stare"), is equally a withdrawal of attention.[19] There seems to be no adequate duration of address. The photographs become a possible location of attention because staring at them is not just permitted but encouraged. A thoughtful examination and scrutiny of detail are then activated for a group of people for whom regard is always abbreviated, if not preempted, lest it become a violation of dignity. Two violations of dignity are possible, of course: the indignity conferred by looking and the indignity conferred by refusing to stare.

The photographs, then, seem to ask nothing of the viewer except that they be seen. Passive in the face of unmanaged faces and ungainly bodies, of incongruous self-presentation, of unbridled emotion and vacant stares, the viewer can witness but not intervene or normalize. But this is more than a "self-willed test of hardness," as Sontag describes it. Perhaps Arbus was attracted to pain that has no agency and no meaning in order to demystify or desacralize it. In this view, pain is not supplementary to the human experience but integral to it. Banishing pain, deviance, and deformity is a way for us to experience pain as either anomalous to the human condition or merely temporary, awaiting correction, alleviation, and transformation. Arbus forces her viewers to pay attention to exposure, to lack, to the rigidity of the body and its inability to express the will. Paying attention to the absence and failure of agency remakes this experience of limitation into an ordinary event. In a culture that constantly promotes and idealizes perfectibility, flawed agency can become intolerable and, worse, personal, as if each individual, hiding the failure of agency in private, was alone the victim of necessity. It is possible that the alarm expressed by Sontag about the absence of agency is precipitated in Arbus's work by the deflation of agency. Making failure ordinary might make the complications it posed less intolerable. Arbus's subjects, much to her fascination and admiration, were not defeated by their limitations but continued on, projecting sometimes outlandish and impossible selves even if they never succeeded in transcending their own bodies. And grandiose notions of agency might even squelch the impulse toward small but significant acts of self- and world-making. Stormé DeLarverie, who taught Arbus that nature was not a joke, is thought to have thrown the first punch outside the Stonewall Inn in 1969.

# 6

# Joan Didion: The Question of Self-Pity

Is the ear the ultimate moral judge?
MARY MCCARTHY, review of Didion's *Democracy*

## Composing Herself

Joan Didion's 2005 memoir, *The Year of Magical Thinking*, not only won the National Book Award but was reviewed or excerpted everywhere from the *New York Times* to *Oprah: The Magazine*. There are several reasons the book garnered so much attention. Then seventy years old, Didion had produced an admired body of work that, while not always best-selling, had earned her a wide readership and a place among the elite American writers of the past fifty years. Varied in her output—she had written several successful screenplays with her late husband, John Gregory Dunne, four novels, and eight books of nonfiction (to say nothing of numerous uncollected essays)—Didion can lay claim to being one of her era's best novelists, best journalists, best political and cultural critics, and, not inconsequentially, best prose stylists. Defined early in her career as one of the "New Journalists" for works such as *Slouching Towards Bethlehem* (1968), Didion has also entered the emerging canon of late twentieth-century American literature: she appears regularly on college course syllabi, and in 2004, her current publisher compiled a reader, *Vintage Didion*, a hallmark of canonicity.[1] Finally, she is extremely well connected in the New York and Los Angeles media industries and can easily secure the attention of editors, promoters, and reviewers.

Yet none of these factors, as substantial as they are, ensure the success of any book. (A similarly well-orchestrated media barrage could not persuade readers to care about Tom Wolfe's *I Am Charlotte Simmons*, though he shares with Didion nearly all of the above qualifications.) Other factors, the subject matter of the book and the manner in which it was taken up, help us to understand its popular and critical success. Although it is also the kind of cultural analysis for which Didion is known, *The Year of Magical Thinking* was marketed as a memoir, and the memoir is, if not the most, then certainly

among the most popular genres of prose writing in the contemporary United States. It is, moreover, a memoir about the sudden death by heart attack of her husband of forty years, which occurred while their only child, Quintana, lay critically ill in intensive care. Death, grief, illness, and loss are subjects of particular concern for the aging baby-boom generation for whom Didion has acted as ambivalent commentator and even (against her will) representative. When Quintana herself died shortly before the book's publication, public sympathy swelled an already-keen interest in the book and its author. Didion's reputation as a writer of clear-eyed and unsentimental prose also played a role in the success of the book. With nearly universal agreement, reviewers effused over the (in general, pick three) "lucid," "penetrating," "acerbic," "ironic," "taut," "clear-eyed," "spare," "dramatic," "fierce," "intelligent," "brutal," "compact," "precise," "immediate," "literate," "restrained" approach she took to her experience. Her exploration of grief won the approval of the critical establishment, which had obviously expected Didion to bring her usual "unwavering eye" to a subject ripe for mawkish treatment and, almost just as obviously, breathed a sigh of relief when she did.

Though reviewers characterized the book as stylistically similar to her other nonfiction, Didion invites us to see *The Year of Magical Thinking* as a departure in both its degree of personal revelation and its style. She explains in the first chapter of the book:

> I have been a writer my entire life. As a writer, even as a child, long before what I wrote began to be published, I developed a sense that meaning itself was resident in the rhythms of words and sentences and paragraphs, a technique for *withholding* whatever it was I thought or believed behind an increasingly *impenetrable polish*. *The way I write is who I am, or have become*, yet . . . this is a case in which I need more than words to find the meaning. This is a case in which I need whatever it is I think or believe to be *penetrable*, if only for myself.[2] (emphasis mine)

This passage suggests that Didion had changed her approach to writing in *The Year of Magical Thinking*. Implicitly, the "impenetrable polish" will give way to something rougher and more open; the characteristic "withholding" will yield to expressivity. We should expect, therefore, not the Didion we have known, but the Didion who has been hidden behind the veneer of style. But if we are to take her at her word, we should be as precise as she is herself. However penetrable Didion has promised to make her story of grief and loss, what lies behind the "impenetrable polish" of her elegant sentences are thoughts and beliefs. She does not promise access to her feelings.

It is unclear whether audiences could have found what Didion seemed to

promise to herself and to her reader. The style of *The Year of Magical Thinking* is, after all, quintessential Didion: direct declarative syntax; extensive use of parallel structure; rhythmic repetition; specificity of concrete detail; under-statement; irony; oblique narrative juxtaposition. And it is polished. A close reading of the opening four lines of the memoir, taken from the first lines she wrote after Dunne's death, tell us why Didion failed to transform her style as much as she might have wanted:

> *Life changes fast.*
> *Life changes in the instant.*
> *You sit down to dinner and life as you know it ends.*
> *The question of self-pity.*

The first three lines, which restate the same fact, look like an exercise in com-position (the computer document is called "Notesonchange.doc"). She gives us drafts of a proposition, which move from the general to the specific with nuances of meaning or precision accruing in the details. "Life" acquires the concreteness of domestic routine in "you sit down to dinner"; "fast" acceler-ates to "in the instant"; "change" becomes drastic and permanent in "ends." The general statement of fact also tilts very gently toward particularity—a person ("you") experiences this sudden change—but not so far as to indicate a particular person, like the one writing, the "I." Rather than narrating herself to herself, Didion is carefully working out a better aesthetic solution to con-veying the fact of shock. This is not an emotional calculation but an aesthetic one. She is, in both meanings of the word, composing herself.

Where the first three lines repeat, seemingly unable to move forward, the fourth line leaps forward by looking back, skipping over a reaction to change by turning instead to a judgment about that reaction. "The question of self-pity" draws attention to itself by departing in construction from the first three lines, not a statement like the others but a sentence fragment that does not so much ask as assert the fact of a question. She does not formulate *what* the question of self-pity is, merely brings it to our, and her, attention. And self-pity arrives rather peremptorily. Before any emotional fallout appears in her writing, Didion passes judgment, or sets up the terms of judgment, for the feeling that is as yet unrecorded. A marker of excess, self-pity is at once a feeling and a moral judgment about feeling. The double location of these lines—first in the notes and then in the memoir—has, then, two functions, a private and a public.[3] Only four lines into her notes, Didion has cautioned herself against an immediate threat: that she will be surprised by grief into the aesthetic as well as moral flaw of sentimentality. Only four lines into her memoir, Didion has prepared her reader to monitor sentimentality and given

notice that she can be trusted to excise it in advance. This is both a mark of vigilance and a protective warding off of criticism, her own and that of others, therefore a mark of impermeability or at least anxiety about its opposite.

If this is an unusual moment in the contemporary memoir, which often shows an intense and persistent interest in psychic pain, it is not at all an uncommon one in the body of Didion's writing. Self-pity, which Didion invariably pairs with self-delusion, has been the deep subject of her work whether she is writing about weddings in Las Vegas or presidential campaigns, Cuban exiles or the Central Park Jogger, the Reagan Whitehouse or the Clinton/Lewinsky scandal.[4] Self-pity and self-delusion are the moral flaws that underwrite bad politics and bad writing, which for Didion are one and the same thing. Since she began to develop an aesthetic philosophy in the late 1950s and early 1960s, Didion has advocated "moral toughness" as the antidote to the social and political turmoil of the late twentieth century.[5] This chapter will trace the history of Didion's "hardness" from the early essays of the midsixties to the political journalism of the 1980s and the recent self-reevaluations of the 2000s. I want to track the long history of Didion's relationship to feeling more generally, self-pity being one instance of it, as it follows from and leads to an aesthetic moralism or a moral aestheticism. Because Didion's sense of "the way I write is who I am" has a deeper logic and a more forceful ethics than mere style, style itself is the battleground of Didion's moral and political skepticism.

## The Question of Feeling

In order to approach the "question of self-pity," we have to account first for the more general role that feeling plays in Didion's work, in particular that from her early career when she was reporting on the counterculture and its cultivation of feeling and personal expressivity. The oft-quoted self-description she supplied in "A Preface" to *Slouching Towards Bethlehem* etched into cultural memory an image of Didion as small, neurotic, and pained—painfully sensitive and painfully shy:

> I am bad at interviewing people. I avoid situations in which I have to talk to anyone's press agent. . . . I do not like to make telephone calls, and would not like to count the mornings I have sat on some Best Western motel bed somewhere and tried to force myself to put through the call to the assistant district attorney. My only advantage as a reporter is that I am so physically small, so temperamentally unobtrusive, and so neurotically inarticulate that people tend to forget that my presence runs counter to their best interests. And it always does. That is one last thing to remember: *writers are always selling somebody out.*[6]

This miniportrait sketches Didion as the prose Diane Arbus, to whom she is sometimes compared. Although she is so shy and unobtrusive that her subjects relax and reveal themselves "counter to their best interests," there is nonetheless already a hint here of the two Didions, one that we might associate with the persona of the essays, the other with their style. In the last three lines, we have a long rhythmic (lulling) parallel sentence—so "small," so "unobtrusive," so "inarticulate"—followed by a short declarative sentence, which serves as a punctuating interruption that clears space for the payoff in the last line: "That is one last thing to remember: *writers are always selling somebody out.*" With the abrupt shift in tone and rhythm that goes with the unexpected shift in the message conveyed—from "I am harmless" to "I am dangerous"—we have the style of voice that belies the image of the shy, inarticulate observer.[7] This is not to say that Didion was anything less than truthful about her timidity, only that the style and persona need to be weighed against each other in any calculation of Didion's feeling states. As she declared in *The Year of Magical Thinking,* "The way I write is who I am," not "what I write." The cognitive dissonance created by the contrast between the persona of the essays (fragile and emotionally overwrought) and the voice (controlled and ruthless) suggests that "the world of feeling" in Didion's work is not as transparent as critics and readers have imagined.[8]

The collections that created her reputation—*Slouching towards Bethlehem* and *The White Album*—contained not only personal essays like "On Self-Respect" and "Goodbye to All That," which had been previously published in mass-market magazines like *Vogue,* but also journalism that carefully situated her stories within the optic of her own emotions and anxieties. This attention to her own feelings, which has been categorized as part of the personalism and emotional expressivity of New Journalism, has tended to obscure the idiosyncrasy of Didion's work even though she has largely muted this expression of feeling since the mid-1980s. Her reputation now alternates between two diametrically opposed characterizations: one as an anxious and emotionally fragile sensitive and the other as an unsentimental, ironic, and unsympathetic critic.

New Journalism's heyday, sometimes dated roughly as the 1960s and 1970s, sometimes more specifically as 1965 to 1979, has become synonymous with 1960s counterculture and its values, in particular, antiauthoritarianism, emotional expressivity, and personalism. New Journalists, unlike their more conventional brethren in the news media, understood and mapped the counterculture; its leading figures—Tom Wolfe, Norman Mailer, Truman Capote, Dan Wakefield, Terry Southern, Michael Herr, and Hunter Thompson—often reproduced its anarchic spirit on the page. Like Didion, these men (and they

were virtually all men) were mostly in their thirties when they began to inte-
grate techniques of fiction writing with journalism, and so were technically
beyond the generational horizon of sixties youth culture as their subjects
themselves understood it ("Never trust anyone over thirty"). Nonetheless,
their experimentalism, their willingness to reinvent journalistic forms, their
skepticism toward authority and objectivity, their insistence on authenticity,
their emphasis on their own subjectivity, and their simulation and *stimulation*
of emotional response meshed with the values of the counterculture.

In the formal conventions of New Journalism, Didion was a faithful and
masterful practitioner. She placed herself as observer/reporter into the work;
she paced her essays and integrated detail in the manner of prose fiction;
she spent long days and weeks with her subjects, what is called "saturation
reporting," in order to have access to their interior states and then commu-
nicate them. Nevertheless, in sensibility she was worlds apart from her peers.
Didion's ironic skepticism, sometimes verging on contempt toward the coun-
terculture and brutally displayed in essays like "Slouching towards Bethle-
hem," marked her as an anomaly in the canon. The degree to which she de-
parts tonally and emotionally from her fellow New Journalists has often been
miscalculated in the rush to categorize her work. As Didion would explain
in one of the last essays of *The White Album*, "Morning after the Sixties," she
was a member, *not* of the sixties, but of the fifties' "silent" generation. If the
other New Journalists were not precisely the same generation as the one they
chronicled, Didion was surely exaggerating her own generational displace-
ment in order to explain how poorly matched her own sensibility was to the
one she had described.

To acknowledge the subjectivity of the reporter was, for her, not so much
to write autobiographically as to limit the perspective on the events in ques-
tion. In an uncollected essay, "Alicia and the Underground Press," Didion
staged her preference for "advocacy journalism": "I admire objectivity very
much, but I fail to see how it can be achieved if the reader does not under-
stand the writer's particular bias. For the writer to pretend that he has none
lends the entire venture a mendacity that has never infected the *Wall Street
Journal* and does not yet infect the underground press."[9] If Tom Wolfe was
offended aesthetically by the "beige" prose of conventional journalism, Did-
ion was offended morally by its mendacity.[10] Such narrowing and locating
of point of view was held as a badge of honesty rather than egocentricity, a
rejection of the false claims of omniscient objectivity. When Didion declared,
"Since I am neither a camera eye nor much given to writing pieces which do
not interest me, whatever I do write reflects, *sometimes gratuitously*, how I
feel" (*STB*, xv, emphasis mine), she introduced an autobiographical burden

into her work. Her readers would have to know enough about her feelings to understand how they filtered the observations. These feelings were to act as operating instructions in the interpretation of the stories, telling us how emphasis or attention might have been placed. "Sometimes gratuitously" is not, however, a very reliable guide. Didion's epistemological caution about her own (and others') feelings reveals a deep suspicion about their ability to clarify experience. They provide additional but also potentially misleading data to be examined with the same skepticism Didion brings to other interpretive frameworks.

Wary of the certainty of feeling but unwilling to pretend that personal feeling was remote from the project of writing and interpretation, Didion made her own feelings part of the data. The personal feeling that frames the essays is not, however, simply personal. The piece that perhaps most directly mined the relationship between her feelings and her subject is the first essay, "The White Album," of the collection so named. Not only does Didion weave into her account of Los Angeles in the late 1960s periodic testimony of her own fragile emotional state, but she also includes a transcript from a medical report with a diagnosis of her psychological condition. In this way, she writes from outside herself, as if she were one of her interview subjects, taking her own experience as alien and, at times, even absurd. Including this material in the essay about a jittery historical moment helps Didion to parse out her private experience of anxiety from the more general one and finally to reintegrate it: "An attack of vertigo and nausea does not now seem to me an inappropriate response to the summer of 1968."[11] Didion's feelings in this piece are depersonalized and exteriorized, less her own than a part of the social effluvia, something ambient, shared between and passed from individual to individual, community to community.[12] Her feelings are atmospheric, both in a literary and often in a meteorological sense. Weather patterns frequently begin her essays and almost always set an ominous emotional tone, not as a pathetic fallacy, reflecting the interior states of the characters in the drama, but as exterior triggers of the characters' feelings and the actions that follow from them. A meteorological focus would be less surprising if Didion did not primarily write about California, a state generally understood to have rather pleasing and temperate weather.

If the depersonalizing of feeling centers on environment, both natural and built (Santa Ana winds, the city of Los Angeles), it also tracks with a biological imperative. Feelings can be explained as part of human developmental stages and therefore express more or less a person's age rather than individual psychic makeup. The essays of both early collections display a mocking skepticism toward what she understood as the adolescent feelings that marked

the counterculture. For instance, "Where the Kissing Never Stops," a profile of Joan Baez and her Institute for the Study of Non-violence for the *New York Times Magazine*, lampooned a sixties icon at the height of her popularity.[13] Baez, who was not only a commercial success but a prominent figure of the civil rights and antiwar movements, comes across as a cipher whose ability to induce and relay powerful emotional connection accounts for her popularity and her politics. Carefully constructed as a zeitgeist figure—"the right girl at the right time . . . who sang everything 'sad'" (*STB*, 46)—Baez comes across as paradigmatic of what Didion portrays as the feelings-rich but intellectually vacant radicalism of the 1960s. In Didion's account, Baez's "sad" feelings come prior to her political convictions: in the civil rights movement she "found . . . something upon which she could focus the emotion" (*STB*, 47). Reversing the cause-and-effect structure we typically associate with feeling, emotions find their objective correlative rather than follow from them. Didion's irony dismantles Baez's commitment to civil rights and deflates her presence "where the barricade was, Selma, Montgomery, Birmingham," as if all those occasions merely represented the stages from which she could orchestrate an emotional connection to her audience. Political protest becomes an exercise in feeling sad in communion with others, those "very young and very earnest" followers who project their own adolescent longing onto her. Didion does not question the authenticity of Baez's feelings—they are perfectly authentic—but to Didion, that authenticity has no meaning. "To encourage Joan Baez to be 'political' is really only to encourage Joan Baez to continue 'feeling' things, for her politics are still, as she herself said, 'all vague'" (*STB*, 56). Finally, while Baez is not as vapid as the prose of her concert programs ("My life is a crystal teardrop"), she does "hang on to the innocence and turbulence and capacity for wonder, however ersatz or shallow, of her own or of anyone's adolescence" (*STB*, 58). Feelings that belong to "her own" or "anyone's adolescence" are less personal than categorical or developmental. At no point in the essay does Didion look back into Baez's biography to answer questions about her emotional makeup or political investments.

Didion's skepticism of feeling and, in particular, the uses of feeling continued long past the heyday of emotional politics in the 1960s. Her essay "Sentimental Journeys," from 1991, takes for granted the environmental contagion of feeling and works to demonstrate the paradoxical function of strong feeling: its analgesic effect. The essay explains how one particularly violent story— the rape and beating of the Central Park Jogger—served paradoxically as a painkiller for New York City residents during the recession of the late 1980s and early 1990s. Didion reads New York's fascination with this story and its multiple deployments—in the newspapers and tabloids, in political speeches,

in the everyday conversations among New Yorkers—as a narrative displacement of the real injuries New Yorkers suffered in the culture of "getting and spending" and "having and not having." The Central Park Jogger story acts like "morphine," a "sedative," or a rush of "endorphins" that dulls the injuries of capitalism, pervasive corruption, and official criminality.[14] The intense suffering of all the characters in the drama—whether the white, Ivy League–educated Wall Street woman who was raped and beaten nearly to death or the African American and Latino teenagers who were immediately and inaccurately judged guilty of the crimes—provides relief for pain too deep and, most importantly, too impersonal and structural to be acknowledged.[15] The satisfactions of "sentimental journeys"—indeed of sentimentality itself—lie in the use of emotion to mask emotion, and they work in this case to use virtue as emotional consolation. Those outraged by the jogger's violated body could imagine themselves her avenger; those outraged by the rush to judgment against the teenagers and the racist fantasies that accompanied it could imagine themselves as their defenders. Energized by the powerful emotional charge of the violence and insulated in a cloak of unambiguous virtue, New Yorkers were able to celebrate the vitality of their city—in Didion's account, habitually, frantically, even ritualistically—and obscure their sense of futility about its downward slide. Drawing on a literary critic, Walter Taylor of the State University of New York at Stony Brook, Didion marks out the political liability of sentimentality, defined as "empathy without political compassion."[16] But in her terms it is more, a morally bankrupt system of self-delusion that both soothes and numbs at the same time.

## On Style and Moral Hardness

In neutralizing sentimentality and in exposing the actual wound behind its proxy, "Sentimental Journeys" must be intended to cause pain to its New York readers in two ways: by counteracting the effectiveness of the "morphine" of the Central Park Jogger story; and by injuring the narcissism of her readers. Like all the women in this book, Didion no doubt finds this pain curative, but she offers no apology nor qualification for the wound she inflicts, which might have been reduced by marking her own solidarity with New Yorkers in the corrupt, capitalist frenzy of the 1980s (a refusal much like Sontag's after 9/11). She had announced her willingness to cause her subjects pain in *Slouching towards Bethlehem*, but at the heart of Didion's sense of morality and her sense of style, which cannot be separated, hurting the readers' feelings is also part of the writer's moral obligation. Unlike Mary McCarthy, however, Didion never sets herself up as a target.

Didion developed her aesthetic of moral hardness at William Buckley's *National Review*, where she served as a staff reviewer (in her words, a "utility infielder") from 1959 to 1965. Part early Pauline Kael and part midcareer Mary McCarthy, Didion's essays are biting and witty, censorious and funny, opinionated and direct, though she had yet to develop her own distinctive style or a coherent aesthetic philosophy. Like Kael, Didion associated liberal cant with a certain softhearted, self-congratulatory vagueness; like McCarthy, on whom she models herself in one essay, she admires the literature of fact. It is perhaps not surprising to see Didion aligning herself with these two writers, both of whom came from the West but made their mark on the East Coast literary establishment.[17] None of these early essays have been collected (and they are not her most original work), but in them we can see Didion formulating the relationship between style and moral toughness. In early essays, this relationship appears in passing criticisms of individual writers. For example, she derides Colin Wilson and John Braine, two of England's "angry young men," for their "tender-minded shallowness of perception" while praising Flannery O'Connor for her "merciless style" and "hard intelligence."[18] In 1965 she drew these various observations into a coherent statement about contemporary writing in "Questions about the New Fiction," the last essay she wrote for *National Review*. Through the essay, Didion entered the 1960s debate over realism and whether the contemporary novelist could represent the bizarre and rapidly changing social reality of the late twentieth century. Tom Wolfe's manifesto on the New Journalism from 1972 is the best-known statement on this problem, but the debate began in the early 1960s with Mary McCarthy's essay "The Fact in Fiction" in the *Partisan Review* and Philip Roth's "Writing American Fiction" in *Commentary*.[19] While Roth and Wolfe bemoan the abdication of social reality by the contemporary novelist, they treat the problem as fundamentally aesthetic. Wolfe famously derided novelists and the novel form and claimed for New Journalism the mantle of the new realists, arguing that they had solved the problems in technique that beset contemporary fiction. Like McCarthy, Didion understands the aesthetic problems of realism as fundamentally moral, though moral in a different way. If McCarthy argued that contemporary realists were too cowardly to face the facts—that is, the content of reality—Didion will argue that contemporary realists do not have the balls to use the syntax of realism.

She argues first that the novel has lost its place to film because of its "failure to maintain the excitements of technical discipline, not only so apparent on, but so inflexibly imposed by film."[20] The "skill at contrivance" had been replaced by improvisation, a deliberate forfeiture of technique, which was considered pedantic and empty by the end of the 1950s. "Improvisation is no art

but a stunt," she argues, and spontaneity is mere sloppiness. She mocks Roth's cry of alarm in *Commentary* that novelists cannot "make *credible* much of the American reality."[21] The problem, as she sees it, is that novelists like Joseph Heller, Bruce Jay Friedman, and Thomas Pynchon "improvise themselves into cul-de-sacs where actual moral questions lurk, and then lose their nerve, go soft." The problem is not that they have risked representing the preposterousness of modern life but that they are "[disinclined] to go all the way with anything." In her reading, the hallmark of these writers is their "refusal to follow or think out the consequences, let alone take them. . . . This absence of moral toughness seems to me to determine the style and the structure of the novels, or rather the lack of it." She concludes: "Everyone wants to tell the truth, and everyone recognizes that to juxtapose two sentences is necessarily to tell a lie, to tell less than one knows, to distort the situation, cut off its ambiguities and so its possibilities. To write with style is to fight lying all the way. . . . To tell something, really tell it, takes a certain kind of moral hardness."[22]

The aesthetics of moral hardness rest on a tolerance for pain and a willingness to not only accept but also inflict pain as part of being a writer. Six years later in a lecture in Los Angeles at the University of California, Didion positioned her own work in relation to arguments she had made about the new fiction: "I'm not much interested in spontaneity; I'm not an inspirational writer. What concerns me is total control."[23] She illustrated the problem of "control" in writing with an anecdote about self-pity. In December 1969 Didion had devoted her column in *Life Magazine* to a reflection on Christmas, family, ritual, and work called "In Praise of Unhung Wreaths and Love." In the essay, Didion describes herself crying in an office because she is not at home with her daughter performing the rituals of Christmas that she had observed as a child. However, the essay does not devolve into the sentimentalism it seems to predict. It becomes, instead, a reconciliation with her own ambition:

> I tell myself that I am crying because the baby told me in November that she wanted a necklace for Christmas, and instead of stringing beads by firelight I am watching an AP wire in an empty office. But of course that is not why I am crying at all. Watching an AP wire in an empty office is precisely what I want to be doing: women do not end up in empty offices and Blimpy Burgers by accident, any more than three-year-olds and their mothers need to make pomegranate jelly together to learn about family love. I am crying because I am tired and feeling sorry for myself and because the abstract that is Christmas seems always to heighten the capacity *not only for self-pity but for self-delusion*, seems ever to make me forget that we design our lives as best we can. There is something about Christmas, not the private mystery of it but the coercive public celebration of it, that victimizes us all.[24] (emphasis mine)

While she attributes the intensification of her self-pity to a larger cultural force, the "coercive public celebration" of Christmas, Didion ultimately wants to assure the reader that her pain is self-inflicted and ultimately her own responsibility, the result of her own choices. It turns out that Didion was not being completely honest in this essay, perhaps as a salve to her *Life* readers. In "Chilling Candor of Joan Didion at UCLA," Digby Diehl reports that Didion took this story one step further. To her audience, Didion acknowledged that her "wallowing in self-pity" had less to do with missing her family at Christmas than missing a "watershed event happening in California." The AP wire reports that she was reading in that empty office were the first to come in from Altamont, a rock concert that went famously and violently awry (four deaths, dozens of injuries, extensive property damage). "My self-pity was professional and very selfish, which is the way writers have to be sometimes."[25] The inability to tolerate one's own pain—that is, to "control" one's own self-pity—begins the slippery slide from moral softness to stylistic sloppiness to self-delusion. To "impose" that self-delusion, rooted in self-pity, on others in the act of writing is, for Didion, a violation of the writer's public trust.

Style is the one aspect of Didion's work to have received sustained attention from scholars of the period. Instantly recognizable in both her essays and her fiction, her style has been called "the rhetoric of particularity."[26] How this particularity functions has been the object of some debate, but it is commonly accepted that particularity defines her style and that particularity makes Didion an aesthete. Her own essay from 1976, "Why I Write," confirms this view in part and locates her preference for the well-wrought detail in personal disposition. She realized in college, she reports, that instead of toward ideas, her mind "veered inexorably back to the specific, to the tangible, to what was generally considered by everyone [she] knew then or for that matter [has] known since, the peripheral." In rendering these tangibles in words, Didion was able to discover what she thought. "The picture tells you how to arrange the words and the arrangement of words tells you, or tells me, what's going on in the picture. *Nota Bene*. It tells you. You don't tell it."[27] Writing is therefore a process of induction (the thing speaks for itself), obliquity (the periphery rather than the center comes into focus), and impersonality (even "the arrangement of words" has more cognitive agency than the writer), not unlike McCarthy's notion of stenographic signs. Though Didion will go on to use her most recent novel as an example, the inductive, oblique, and impersonal modes also describe Didion's essays.

If this description of her process seems passive, in interviews she has made it clear that she has a black-and-white sense of right and wrong and that she considers confronting "evil" to be a writer's moral obligation. Didion's

clear sense of writing as aggression is a less-remarked-upon feature of "Why I Write." Didion "stole" the title from George Orwell because she liked the "sound of the words" — "I I I" — but she implicitly aligns herself with Orwell's blending of the aesthetic experience of writing with the partisan motivation for writing. Her declaration of respect for advocacy journalism in "Alicia and the Underground Press" coheres with Orwell's affirmation of partisanship as well as with his insistence that writing is meant to "expose" a lie. Didion takes Orwell one step further by arguing that the writer is fundamentally a "secret bully" who "imposes" her own "sensibility" on "the reader's most private space," however she might mask this hostility by "subordinate clauses and qualifiers and tentative subjunctives, with ellipses and evasions."[28] The truthfulness of style lies not only in the accurate reporting of particularity but in a syntactical candor about its own aggression.

The moral aggression in the act of writing ultimately conflicts with Didion's avowed libertarianism. "On Morality," an essay first published in the *American Scholar* under the title "The Insidious Ethic of Conscience" and later collected in *Slouching towards Bethlehem*, narrows shared moral terrain to two certainties: "You can't just leave a body on the highway" and you can't violate "that one vestigial taboo, the provision that no one should eat his own blood kin" (*STB*, 158), the lessons she gleans from the Donner Party, whose story shaped her upbringing. (The Donner Party crossed the Sierra Nevada in November 1846, too late in the season, attempted a short cut through a new but poorly cleared pass, and fell victim to storms that trapped them through to the spring. Of the eighty-five that began the crossing, only forty-three survived, some of the dead having been eaten by the others.) Taken out of the gloomy context of the essay, it is difficult not to read these prohibitions as doubly ironic, overstating the morbid (wouldn't consuming the flesh of human beings who are not blood kin also constitute a taboo?) in order to understate the breadth of moral consensus. But they are not. Admitting how "primitive" her conception of morality is, Didion spends the greater part of the essay warning against the good intentions of other people's virtue. However, her desire to privatize morality to the greatest possible degree inevitably conflicts with her knowledge that writing violates moral privacy by "imposing" the writer's morality on the reader. This conflict produces, I want to argue, what Didion calls her characteristic style, "inductive irony." I want to call this a res ipsa loquitur style of advocacy or admonition, which can slip perilously close to inscrutability when irony becomes unstable. Perhaps because Didion is classified as a postmodern ironist and moral certitude seems antithetical to postmodern irony, the moral dimension of Didion's style has flown beneath the radar.

The Failure of Inductive Irony; or, *Res Ipsa*
*Loquitur, sed Quid in Infernos Dicet?*

This made-up Latin is a law school joke about the legal argument "res ipsa loquitur"—the thing speaks for itself—commonly used in negligence litigation. The joke—the thing speaks for itself, but what the hell is it saying?— encapsulates the problem for Didion's inductively ironic mode of argumentation (or, as she calls it, description). Evidence for Didion always acts like *self*-evidence. We know this practice from her earliest work in *Slouching towards Bethlehem*. When in the last short paragraph of the long "Slouching" essay, three-year-old Michael is caught chewing on an electric cord, Didion concludes with this observation: "and they didn't notice Sue Ann screaming at Michael because they were in the kitchen trying to retrieve some very good Moroccan hash which had dropped down through a floorboard damaged in the fire" (*STB*, 128). Didion trusts the inductive power of the detail to suggest ironically the misplaced values in Haight-Ashbury and the dangers threatening the generation being raised by drug-addled adults, whom she most often refers to as "children." The additional ironic twist, which is merely the modification of the noun "hash"—"very good Moroccan"—derives from its scarcity in her prose. So rarely does Didion modify nouns at all, much less evaluatively, that this one immediately suggests quotation. We know it is not Didion but her subjects who rate the hash. This is Didion's res ipsa loquitur method of indictment.

The balance between moral hardness, inductive irony, and painful feeling became unmanageable, however, when Didion encountered a scale of feeling that deviated from the range she had explored earlier in her career. Two assignments forced her attention to style and feeling—in particular, excesses of feeling. The later example, *Salvador*, from 1983, began Didion's now thirty-year quarrel with the political Right; her essays in the section "Women" in *The White Album* are part of her earlier twenty-year quarrel with the political Left. *Salvador*, a work of investigative reporting about the US role in El Salvador during the first Reagan administration, suggests how the extremities on either side of a scale of psychic pain—one never defined but taken for granted as self-evident—create difficulties, even obstructions, in Didion's own writing practice. I want to quote a very long passage because it will help us to parse various elements of Didion's style. This is a particularly rich selection and typical, not only because Didion is analyzing her own writing but also because she is *imitating* herself and her characteristic modes of observation, presentation, and interpretation. Her loss of confidence in her own habits of style, she says, arises in the face of a psychic disturbance,

which is terror. The extremity of this feeling of terror (not the pervasive but weaker feeling of dread, which permeates her work from the 1960s and 1970s) throws her customary forms of observation and interpretive reticence into crisis.

This is the passage in which Didion imitates and then comments on her own writing style:

> The place brings everything into question. One afternoon when I had run out of the Halazone tablets I dropped every night in a pitcher of tap water (a demented *gringa* gesture, I knew even then, in a country where everyone not born there was at least mildly ill, including the nurse at the American Embassy), I walked across the street from the Camino Real to the Metrocenter, which is referred to locally as "Central America's Largest Shopping Mall." I found no Halazone at the Metrocenter but became absorbed in making notes about the mall itself, about the Muzak playing "I Left My Heart in San Francisco" and "American Pie" ("... *singing this will be the day that I die*...") although the record store featured a cassette called *Classics of Paraguay*, about the *pâté de foie gras* for sale in the supermarket, about the guard who did the weapons check on everyone who entered the supermarket, about the young matrons in tight Sergio Valente jeans, trailing maids and babies behind them and buying towels, big beach towels printed with maps of Manhattan that featured Bloomingdale's; about the number of things for sale that seemed to suggest a fashion for "smart drinking," to evoke modish cocktail hours. There were bottles of Stolichnaya vodka packaged with glasses and mixer, there were ice buckets, there were bar carts of every conceivable design displayed with sample bottles.
>
> This was a shopping center that embodied the future for which El Salvador was presumably being saved, and I wrote it down dutifully, this being the kind of "color" I knew how to interpret, the kind of inductive irony, the detail that was supposed to illuminate the story. As I wrote it down I realized that I was no longer much interested in this kind of irony, that this was a story that would not be illuminated by such details, that this was a story that would perhaps not be illuminated at all, that this was perhaps even less a "story" than a true *noche obscura*. As I waited to cross back over the Boulevard de los Heroes to the Camino Real I noticed soldiers herding a young civilian into a van, their guns at the boy's back, and I walked straight ahead, not wanting to see anything at all.[29]

In the passage, we see vivid examples of the "inductive irony" that Didion suggests no longer "illuminates" her story. These details—the kitsch American music playing in the mall, including the contextually ominous lyric "this will be the day that I die," the guards, the shopping matrons, the consumer goods—exhibit Didion's characteristic interpretive reticence. She will never

tell us what to make of "I Left My Heart in San Francisco" or beach towels with maps of Manhattan, assuming that the details in themselves contain all the necessary commentary.

The telling detail is only part of the problem, however. Given that Didion has placed a great deal of moral weight on syntax, we must factor in the rhythm of the prose, which Didion has referred to as the residence of meaning. In this passage, we see the dominant stylistic structures in Didion's prose: parallelism and repetition. (Note the "about . . ." parallels in the first paragraph and the "that this was a story" parallels in the second.) Parallelism is part of inductive irony or interpretive reticence because it is the comparison/ contrast structure with the least interpretive pressure. While Dennis Rygiel sees Didion's use of parallelism as a "rhetoric of artifice and formality," which it surely is, its function is more than aesthetic.[30] That is, these details are not organized by coordination, contrast, subordination, or hierarchy. Nor are the items necessarily from the same class of things (e.g., she lists music, people, consumer goods). Didion leaves the reader to make sense of the series and their elements—that is, the parts and their relationships to the whole. Her act of interpretation, and it is by no means a small one, is the creation of the series itself, which aspires to look argumentatively neutral, mere reportorial faithfulness to the detail. The reader's act of interpretation—induction— depends upon the details, but the details and their arrangement do not seem to mandate the conclusions.

So why does inductive irony fail in *Salvador*? And does it, indeed, fail? Didion tells us that terror disables her ordinary writing practice. The "soldiers herding a young civilian into a van, their guns at the boy's back," which is delivered in a very Didion-like style, evidently does not sufficiently convey, to her own reading, the ambient terror of the place. As one detail in the series from the mall, this example of state terror serves as an alarming contrast to a bizarre normality, but as *only* one detail in a series, it does not suggest the permeation of everyday life by the threat of arrest, imprisonment, and murder. The detail cannot be generalized sufficiently broadly, so induction fails. And so, too, does irony. Irony in the context of brutality and fear is simply not to Didion's ear an appropriate tone. Didion's irony, typically understatement rather than hyperbole, works by reduction and deflation, which runs in precisely the opposite direction of Didion's desire to produce in her already-distant readers a sense of the everyday horror of El Salvador. There is too much of the everyday in inductive irony and not enough horror. She resorts, therefore, to more direct and personal statements of generality to convey the fact of terror: "I did not forget the sensation of having been in a single in-

stant demoralized, undone, humiliated by fear, which is what I meant when I said that I came to understand in El Salvador the mechanism of terror."[31] If "Slouching towards Bethlehem," an account of contemporary American life, which clearly fills Didion with dread, can function on the power of inductive irony, why doesn't *Salvador*? The problem appears to lie in the scale of feeling.

The psychic injury of terror cannot be adequately communicated to the reader by detail, however concrete, because induction cannot be trusted to properly construct a scale from the specific to the general. We see the boy being herded, guns at his back, in the bright sunshine of an afternoon at the mall; we also see the torn and bloody bodies in concrete, unflinching detail: "These bodies . . . are often broken into unnatural positions, and the faces to which these bodies are attached (when they are attached) are equally unnatural, sometimes unrecognizable as human faces, obliterated by acid or beaten to a mash of misplaced ears and teeth or slashed ear to ear and invaded by insects."[32] Nonetheless, the scale of injury is so extreme and so alien to her readers that she cannot assume the shared context on which irony depends. We find a similar though contrasting problem with induction in an earlier essay, "The Women's Movement." Here it is not that psychic pain is too overwhelming and too pervasive to be transmitted by concrete detail but that pain is too banal and too overstated to warrant the inflation to generality through induction. In "The Women's Movement," Didion will refuse the "inductive leap from personal to political" (*WA*, 114) so as not to escalate minor wounds to systemic injury.

In *The White Album*, the section "Women" contains three essays arranged formally rather than chronologically: a general essay, "The Women's Movement" (1972), followed by a pair of contrasting essays each about a woman artist, "Doris Lessing" (1971) and "Georgia O'Keeffe" (1976). This is not an unusual arrangement for Didion, who organizes her collections so as to produce thematic or topical concentrations (other sections in this volume are called "California Republic" and "Sojourns") as well as internal conversations between the essays. "Women" also works in this way though it is organized more pointedly by the *un*announced subtopic of the section, which is style. Nowhere else in Didion's work does she pay as much attention to the question of writing style as she does in these essays (except those devoted to the topic of writing, like "Why I Write"). In fact, "The Women's Movement" might be said to identify style as feminism's central problem, which the following pair of essays answer with contrasting object lessons. Didion seems to have transposed politics into aesthetics, but only if we misconstrue just how political

and moral style is for Didion. Bad style, or the indifference to style, is not a question of beauty but a logical extension of the politics and morality of writing well.

Didion argues that contemporary feminists want to deny reality, either through a fantasy of weakness or through utopian dreams of refashioning the obdurate realities of adult life, particularly adult sexuality. She sees the women's movement (and its trivialization in the mass media) as offering a "romance" to women about their own weakness. "This ubiquitous construct is everyone's victim but her own" (WA, 115) in movement literature, which features "women too delicate to deal at any level with an overtly heterosexual man," "creatures too 'tender' for the abrasiveness of daily life, too fragile for the streets . . . too 'sensitive' for the difficulties of adult life, women unequipped for reality and grasping at the movement as a rationale for denying that reality" (WA, 116). Constructed by feminists as too weak to confront harsh reality, women are further robbed of their own agency. "She was persecuted by her gynecologist, who made her beg in vain for contraceptives. She particularly needed contraceptives because she was raped on every date, raped by her husband, and raped finally on the abortionist's table" (WA, 115). Didion answers with a seemingly straightforward recourse to personal agency: "To ask the obvious—why she did not get herself another gynecologist, another job, why she did not get out of bed and turn off the television set" (WA, 115). Didion's obvious sarcasm makes mockery of feminists' arguments about systematic oppression in the cultures of medicine, business, or advertising in unusually reductive terms. For Didion, it is merely a question of individual choice rather than broader cultural systems because she refuses this "inductive leap" from the particular to the general, the personal to the political. Didion's refusal of induction rests on her perception of the triviality of the injury. If the wound is not severe enough, there can be no complication of agency, no failure of will. Without an inductive leap, there are no systems, only individuals with varying degrees of self-possession, eager to be relieved of responsibility for their own unhappiness.

When we see the double problem of reality in Didion's complaints about feminism—a dread of reality and a desire to remake it—we are back again on the grounds of style as Didion understands it. Didion makes the odd turn to style—odd because style was not a general concern of the movement especially at this historical moment—because she believes that bad style permits a refusal to deal with painful reality. In comparing contemporary feminists with their forebears, Didion comments: "*I accept the universe*, Margaret Fuller had finally allowed: Shulamith Firestone did not" (WA, 111). This leads her to an extended complaint about feminist style, or the lack thereof, in writing:

"The clumsy torrent of words became a principle, a renunciation of style as unserious. The rhetorical willingness to break eggs became, in practice, only a thrifty capacity for finding the sermon in every stone. Burn literature . . . but of course no books would be burned: the women of this movement were perfectly capable of crafting didactic revisions of whatever apparently intractable material came to hand" (*WA*, 111). She continues: "The idea that fiction has certain irreducible ambiguities seemed never to occur to these women, nor should it have, for fiction is in most ways hostile to ideology" (*WA*, 112). For Didion to turn to style in the center of this essay, to complain about what might appear to be at best secondary considerations of the movement—"the clumsy torrent of words" and the "irreducible ambiguities" of fiction—is to take feminist claims of "seriousness" and shift their terms. If style is "unserious" for feminists, for Didion it is the most serious charge she can make.

Clumsiness, which is mere ineptitude, or the "rhetorical willingness to break eggs,"[33] which is purposeful, represented a means of first misconstruing reality and then imposing the resulting delusion on others. This delusion might lead to authoritarianism or generate undesirable or unworkable plans for the future—that is, utopianism. Delusion seems to Didion so dangerous that she takes as axiomatic that there is an obligation, particularly when it is difficult and painful, to record reality as faithfully and accurately as possible. We can conclude then that Didion's notion of good writing is defined foremost by its lucidity, its clear and accurate representation of an immediate and immediately apprehensible reality. If this sounds familiar by now, it should.

The first of the paired essays on style further develops Didion's aesthetic philosophy. In her discussion of Lessing's novels, we find not only the obligation to reality but an obligation of a particular kind, what I have been calling interpretive reticence. This minimal interpretation is important for two reasons. On the one hand, it assumes that reality requires interpretation. Lessing's "great hunks of raw undigested experience" do not meet this obligation. It also assumes a limit on subjectivity. Didion sees Lessing's progression from her first novel to *The Golden Notebook*, her most feminist novel, as a devolution from a responsible realism to an irresponsible absorption in experience rather than interpretation of it. If in her first novels, "reality was *there*, waiting to be observed," by *The Golden Notebooks*, Lessing had declared this form of realism "false" and "evasive" (*WA*, 124). In her new project, Lessing had failed to maintain the "conventional distance of fiction" (*WA*, 124), presenting instead an "unrelievedly self-conscious . . . author's surrogate" (*WA*, 124) who deposited the contents of her mind directly into her reader's "with deliberate disregard for the nature of the words in between" (*WA*, 125). It is this phrase—"words in between"—that tells us about the obligations of inter-

pretation. There must be distance between writer and experience and between writer and reader, which is provided by the "words in between," that is, the words that make sense of verbs and nouns, that tell of location and orientation, of position and relation. Rather than modifying reality, as an adjective or adverb might, "the words in between" create the logic of relation between things and actions. If we remember Didion's claim in *The Year of Magical Thinking* that she believed "that meaning itself was resident in the rhythms of words and sentences and paragraphs" (*YMT*, 7), then Lessing's "leaden disregard for even the simplest rhythms of language" (*WA*, 119) is a rejection not of grace or beauty but of meaning itself.

That interpretation must be minimal, however, appears in her second complaint about Lessing, which leads to the larger political implications of her argument. Didion describes Lessing as intolerant of other minds. She takes up residence in the mind like the "original hound of heaven" and "holds the mind's other guests in ardent contempt." Lessing is "devoid of any but the most didactic irony" and has an "arrogantly bad ear for dialogue" (*WA*, 119). Because she "does not want to 'write well'" (*WA*, 119), we can conclude that bad writing is monologic, indifferent to other voices and points of view, even the divisions internal to the self produced by ambivalence or ambiguity. By implication, good writing is dialogic and open to competing interpretations; the writer does not colonize the reader's mind but enters into a conversation with it. Evidence is offered forth, but without finality. In contrast to Lessing's "didactic irony," we might imagine Didion offering her own "inductive irony," as she describes it in *Salvador*. Strangely, Lessing's didacticism might seem appropriate to the author of "Why I Write" with its acceptance of, even insistence on, the writer's candid aggression. Is Didion unwilling to encounter this aggression in Lessing's topic or merely in Lessing's style? Didion cannot tell the difference because both content (feminist complaint) and style (clumsy, rhythmless) derive from what she perceives to be self-pity.

Lessing is faulted in two ways: as having too much interpretation (didacticism) and too little ("great hunks of raw undigested experience"). It's difficult to know how to place Lessing's failure as a writer other than to infer what Didion means by writing well. We do know the perils of writing badly, and this is why style has to be a matter of seriousness. Lessing is accused not merely of ineptitude but of being what Didion called "one of the fashionable madmen" in an earlier essay, "On Morality"—that is, one of those who wish to impose their utopian fantasies on the world. And Didion does not mince words about the perniciousness of those madmen. The essay concludes: "That she is scarcely alone in this possession [looking for answers] is what lends her quest its great interest: the impulse to final solutions has been not only Mrs.

Lessing's dilemma but the guiding delusion of her time. It is not an impulse I hold high, but there is something finally very moving about her tenacity" (WA, 125). The contempt for reality, as evidenced and facilitated by bad writing, is a deeply political and moral question for Didion, one that imposes a strenuous burden on writing to capture reality as accurately as possible with as little as possible done to cushion reality's discomforts or injuries. In contrast, unchecked emotional expressivity justifies the lapses in style and provides the authorization for projects of "cosmic reform." That Didion evokes the "final solution" in her conclusion inflates the problem of bad style out of all proportion by aligning it with the worst moral failure of the twentieth century.

What is interesting in the essays, finally, is how Didion departs from her own usual practice in writing them. The section "Women" contains the most polemical essays Didion ever wrote and replaces Didion's customary irony with sarcasm. Inductive irony fails in *Salvador* because the story "would not be illuminated by such details," its terror so overwhelming that it blots out even the irony of the American self-delusions that drive the story. But why is inductive irony inappropriate for the essays on the women's movement? The problem, as Didion names it, is the sheer banality of the problem, a scale of injury so exaggerated as to defy her ironic powers. Irony deflates too little rather than too much. Her answer to this problem of scale is to savage the complaint. Because her sense of outrage is based in a scale of feeling that she has no account of yet, her own scale changes. She has to explain to her readers that feminism's exemplary injuries are absurd and childish. If the inductive detail works on the premise of self-evidence—that is, the ludicrous nature of the example will tell the story of its own absurdity—then Didion clearly does not trust the details to be self-evidently absurd. She either imagines a general form of self-delusion so grand as to defy her intervention, or she herself does not trust her own measurement, all the while claiming that the measurement is only a matter of common sense.

If the Lessing essay further elucidates not only what bad writing is but what its perils are, the Georgia O'Keeffe essay tells us what good writing should look like and offers an alternative to the romance with powerlessness that Didion detects in the women's movement. It's important to note first that by analogy, good writing should look like painting, and painting of a certain kind, perhaps defined as intense personal vision married to the scrupulous rendering of the natural world (impressionistic realism?). We might then think of O'Keeffe as Didion's alter ego. Didion's pithy description of O'Keeffe bears this out: "She is simply hard, a straight shooter, a woman clean of received wisdom and open to what she sees" (WA, 127). These last three charac-

teristics restate in positive fashion (as opposed to inference through the nega-
tive example) Didion's values in good writing: to be "clean of received wisdom
and open to what she sees" is an ideal attitude of perception, in which the
filters of ideology and self-delusion that might block reality are removed so
that detail and specificity of experience may enter; a "straight shooter" implies
the directness of statement, the candidly aggressive syntax of "Why I Write,"
that will offer this specificity to the reader without manipulation for ideologi-
cal persuasion or euphemism that insulate the reader from difficult realities.

"Hardness," however, which is the focus of Didion's short essay, reintro-
duces the moral component of style that Didion sought as she developed her
own writing practice. When Didion happily notes her young daughter's ad-
miration for O'Keeffe's clouds painting in the Art Institute of Chicago, her
happiness is not simply because her daughter is acquiring a taste for art;
rather, it's because she's making the "unconscious but quite basic assumption"
that "every choice one made alone—every word chosen or rejected, every
brush stroke laid or not laid down—betrayed one's character. *Style is charac-
ter*" (*WA*, 127). Quintana, Didion's daughter, is not only expressing her bud-
ding aesthetic sense but developing a moral sense as well. Didion is pleased
"that it was Georgia O'Keeffe's particular style to which she responded: this
was a hard woman who had imposed her 192 square feet of clouds on Chi-
cago" (*WA*, 127). This O'Keeffe essay, written the same year as "Why I Write,"
mandates the aggression and hardness of "imposing" in art. Didion com-
ments that "'Hardness' has not been in our century a quality much admired
in women, nor in the past twenty years has it even been in official favor for
men" (*WA*, 127). Told to paint more flowers because they touch everyone's
heart, O'Keeffe commented that she paints red hills because a "red hill doesn't
touch everyone's heart" (*WA*, 127). Touching hearts is not what "hard" women
do, or what "hard" artists do. Instead, they "impose" their clouds on a city or
their vision on a reader. O'Keeffe's isolated protest, her autonomy of vision,
seem to Didion to constitute an appropriate feminism. "Some women fight
and others do not. Like so many successful guerrillas in the war between the
sexes, Georgia O'Keeffe seems to have been equipped early with an immu-
table sense of who she was and a fairly clear understanding that she would be
required to prove it" (*WA*, 129).

Hardness, it would seem, is not an acquired trait, though it can be culti-
vated. O'Keeffe was "equipped early" for her heroic feminism by her frontier
mentality (though she was born and raised in Wisconsin, Didion appropriates
her for the West). In the essay, Didion by implication calls softness a product
of both the period and of the East Coast. Out in the West, with its virtues of
autonomy and self-reliance, we get the kind of feminism Didion can admire.

It's a commitment to reality rather than community, a willingness to be bold and to be accurate even when these qualities will not touch the heart or will touch it too painfully. It will take Didion another twenty years to reevaluate this hardness, to rethink her romance with the West, and, with it, to rethink her devotion to the hardness of style and the hardness of the heart.

## Morality and Grief

Didion is the only one among the women in this book to publicly examine and reevaluate her relationship to hardness, both moral and aesthetic. The best way to track her change of heart is through reference to the Donner Party, the most frequently recurring anecdote in the body of her work. The story of the Donner Party, one of the tragedies of the westward migration, is part of both California lore and Didion family history. Left in a record of diaries and letters from which Didion often draws, the Donner Party's battle with starvation and the elements, their resort to cannibalism, and the human toll the expedition exacted left a lasting impression on her. Told and retold throughout her youth, the story becomes an object lesson in Didion's own work in much the same way. Her earliest mention of the Donner Party comes in Didion's first novel, *Run River* (1963), to which we will return by way of one of her most recent works of nonfiction, *Where I Was From* (2003). It also appears as a defining episode in "On Morality" (1965) and "Girl of the Golden West" (1982). In *Run River*, Didion uses the Donner Party, without offering a word of explanation, to elaborate the character of Martha, who, though a smart, capable, and athletic teenager, becomes besotted with her brother, falls apart emotionally and psychologically when she comes to marriage age, and eventually commits suicide. "Donner Party" is one of Martha's favorite imaginary games and, to readers who recognize the reference, a macabre one, which Martha tweaks with a somewhat feminist slant by taking the role of a wife and making herself a tragic heroine. The reference to the Donner Party, especially because it is introduced without explanation, reinforces Martha's embeddedness in California and family history and doubles down on the essentially endogamous nature of Northern California society that Martha's incestuous love for her brother stages. The lessons Didion draws from the Donner Party change as she comes to question the moral legacy of California's mythic past and that of the American West more generally.

In "On Morality," the Donner Party announces what Didion calls her "wagon-train" or "primitive" morality in their breach of a fundamental taboo: eating one's own blood kin. As the essay develops, however, Didion reads this catastrophe as merely the final rupture in a chain of lapsed responsibility,

which proposes a very extreme form of agency as the foundation of moral life and moral responsibility. The Donner Party and the Jayhawkers, who experienced a similar loss of life, but in the desert, were not "killed by the desert heat," "by the mountain winter, by circumstances beyond their control; we were taught instead that they had abdicated their responsibilities, somehow breached their primary loyalties, or they would not have found themselves helpless in the mountain winter or desert summer, would not have given way to acrimony, would not have deserted one another, would not have *failed*" (*STB*, 159). In "On Morality," Didion retells the Donner story to impress upon her readers the lessons of her youth, passing on the instruction from her elders, not about cannibalism, but about agency in its most exalted fantasy. While anyone could argue that the Donner Party suffered from a miscalculation of risk, perhaps even a grievous failure to anticipate foreseeable dangers, Didion leaves no room for faulty or incomplete information, for early or especially harsh winters, that is, for chance. Bad luck is delivered upon those who fail to control their destinies. This lesson remains for her the only morality worthy of the name, the only one that has any but the most "potentially mendacious meaning" (*STB*, 159).

Didion returns to the Donner Party in "Girl of the Golden West" (originally titled "Sentimental Education" in the *New York Review of Books*, where it first appeared) seventeen years later.[34] In her review of the kidnapped heiress Patricia Hearst's memoir, she begins to shift her interpretation of its moral lesson from "total control" (her phrase from her UCLA lecture) to the management of loss and pain. Two things become significant: the "sloughing" of the past and the refusal to feel anything about that loss. In this essay, she juxtaposes two children of the West, one a survivor of the Donner Party and the other, Patricia Hearst. The child writing in the aftermath of the Donner tragedy tells her own version of its moral lesson: "Don't let this letter dishearten anybody, never take no cutoffs and hurry along as fast as you can."[35] Didion hears this message echoed in Hearst's remarkable conversion to the Symbionese Liberation Army after her capture and rape. In her memoir, Hearst repeats the mantra she intoned to herself during her captivity: "Don't worry about it . . . don't examine your feelings. Never examine your feelings. They're no help at all."[36] Didion interprets Hearst's capitulation to her captors not in the psychiatric terms that are offered at trial but instead as yet another example of the ingrained frontier mentality of California. Patricia Hearst "had cut her losses and headed west."[37] In this account, the Donner legacy has become illustrative of the Californian preference for the banishment of feeling, which is a coping mechanism that provides forward movement, no matter

the cost. Didion observes this failure to count costs neutrally. It's simply an explanation for how, and to a more limited degree, why heiress Patty Hearst threw her lot in with terrorists.

The value of cutting one's losses and heading west, however ambivalently held in the first three decades of Didion's work, is reassessed and provides the fulcrum of reversal in *Where I Was From* in 2003. Part literary criticism, part social analysis, part history, part family memoir, *Where I Was From* takes aim at two self-delusions, one about personal autonomy (in light of the federal government's massive subsidy of the Californian economy) and the other about community (that Californians take care of their own). She even rereads her own novel *Run River* to indict its nostalgia and unthinking recapitulation of the myths of California, its self-delusions and self-aggrandizements. She convicts herself of both believing the myth of California and being one of its purveyors. It is part of the larger project of self-*dis*illusion for Didion to admonish and to correct herself so publicly.

Didion returns to precisely the same spot she covers in "Girl of the Golden West," though now with a more critical eye, concluding this chapter of self-reversal with the conjunction of Patty Hearst and the Donner Party. At the conclusion of part 3, Didion says:

> *Remember,* Virginia Reed had warned attentive California children, we who had been trained since virtual infancy in the horrors she had survived, *never take no cutoffs and hurry along as fast as you can.* Once on a drive to Lake Tahoe I found myself impelled to instruct my brother's small children in the dread lesson of the Donner Party, just in case he had thought to spare them. "Don't worry about it," another attentive California child, Patricia Hearst, recalled having told herself during the time she was locked in a closet by her kidnappers. "Don't examine your feelings. Never examine your feelings—they're no help at all."[38]

In this final context, we see the moral lesson of the Donner Party as a failed model for the management of loss. This management, which is the failure to examine loss or the feelings it generates, permits abandonment to become a way of life. It is typical of Didion to leave the didacticism of her message to the details. She leaves implicit in the line about her own transmission of the lesson that the compulsion to repeat the past has to be questioned, if not ended. Didion has discovered that in her tough-minded, unsentimental, and undeluded moralism, she had cowered from painful feeling and recast herself in the guise of stalwart realist. She was no better than the most deluded of her subjects.

It should not now surprise us that Didion anoints Emily Post's 1922 etiquette manual as not only the most practical but the most insightful book on the subject of grief in *The Year of Magical Thinking*. In her review of the literature, an information-gathering exercise she performs to gain control of her grief, Didion notes that Post's book precedes the disappearance of death from everyday life in American society (and more generally in America and Europe), which social historians date to the 1930s.[39] It might seem predictable that Didion's satisfaction with the etiquette manual stems from its historical place: Didion had throughout her work claimed an allegiance to her mother's and grandmother's generation, to any, that is, but her own softer, less realist one. In the time when death was a part of everyday life and susceptible to the rituals and duties of ordinary social congress, it was faced head on, not hidden or euphemized away. But nostalgia or a fantasy connection to a mythic past does not tell the whole story. The reason "it spoke to [her] directly" (*YMT*, 59) was its respect for specificity and emotional distance.

Didion admires "this tone, one of unfailing specificity," with its "emphasis on the practical" (*YMT*, 58). Concrete practicality relieves those who are a party to grief of uncertainty by its minute legislation of correct action: where to sit in church, what to bring to the home of the survivors. Specificity in this case *is* a social ethics, a set of concrete behaviors (not abstract maxims that can be interpreted variably) toward others that demonstrate "competency" and "sensitivity" in the aftermath of death (*YMT*, 61). Given Didion's career-long preference for specificity, particularity, concreteness, and lucidity, the etiquette book's appeal transcends its historical place, even if that place also appeals to Didion more than her own historical moment. The area in which Didion most admires Emily Post's insight lies in her appreciation of the physiology of the griever, the somatic responses to loss in, for instance, the lack of appetite or increased agitation. Because the book respects this physical manifestation of grief, it provides a proper guide for those attending to the grieving. The most important among these guides is to protect the bereaved, a person "under shock of genuine affliction," from "all over-emotional people, no matter how near or dear" (*YMT*, 57). Those who wish to attend to the deceased's intimates know that you might bring a ham, but "you do not wail or keen or in any other way demand the attention of the family" (*YMT*, 61). Other people's emotions are thereby properly bounded and contained, thus providing a space around the grieving, a distance from the contamination of other people's emotions. There is no suggestion here that emotions might be voluntarily shared. The problem remains in Didion's own work to chart the expressive latitude of the griever. That is, she must finally answer "the question of self-pity."

I began with the first four lines of Didion's memoir: "Life changes fast / Life changes in the instant / You sit down to dinner and life as you know it ends / The question of self-pity." Didion uses these lines as a leitmotif in the book, repeating one or more of the four throughout the memoir, each return marking out her relationship to self-pity as she cycles through a year of grief. "The question of self-pity" returns a third of the way through to remind us of "how early the question of self-pity entered the picture" (*YMT*, 77) and again two-thirds of the way through as she begins to reassess, grudgingly as it turns out, her own relationship to this question. She remarks:

> I realized that my impression of myself had been of someone who could look for, and find, the upside in any situation. I had believed in the logic of popular songs. . . . It occurs to me now that these were not even the songs of my generation. They were the songs, and the logic, of the generation or two that preceded my own. . . . It also occurs to me, not an original thought but novel to me, that the logic of those earlier songs was based on self-pity. The singer of the song about looking for the silver lining believes that clouds have come her way. The singer of the song about walking on through the storm assumes that the storm could otherwise take her down. (*YMT*, 169)

Like the Emily Post manual that reminds her of her mother, the popular songs that Didion "believed in" were from a generation or two before her own. Her reading of these songs is strained, however, which shows just how degrading self-pity remains. Seeing optimism as self-pity requires that the obstacles— clouds or storms—be interpreted away. Because the singer only "believes" clouds have come her way or that the storm is powerful enough to "take her down," Didion suggests that the songs' insistent optimism props up a speaker too fragile to face difficulties that are not particularly arduous in themselves. The two songs, which both come from popular musicals, might be sentimental because the form of the musical guarantees that problems are resolved, but the songs themselves depict troubles that do not seem insignificant nor do they suggest the fragility of the singers. In the first case, Didion refers to Jerome Kern's "Look for the Silver Lining," made popular in the 1920 musical *Sally*. The heroine, a young girl who washes dishes in the Alley Inn for a living, perseveres through the mounds of dishes day after day by looking for the silver lining. The boy who encourages her in this practice does not suggest that it is anything but drudgery to wash dishes, but he wants the girl to imagine an end to her troubles. In the second case, though in a darker musical, walking through the storm alludes to Rodgers and Hammerstein's song from the 1945 *Carousel*, "You'll Never Walk Alone," sung when the heroine,

a pregnant mill worker without a job, learns that her lover has killed himself rather than be caught during a bank robbery. That losing a loved one and being left alone, jobless, and pregnant might threaten to take one down does not seem implausible. Perhaps Didion implicitly assumes that, like herself, the singers know they are in a musical and that everything will turn out well. But believing everything always turns out well would be a form of self-delusion even Didion could not ordinarily stomach. Didion has not changed her mind about self-pity—it remains a degraded outlook—but she has begun to understand herself as susceptible to it, seduced by it in certain guises. Like her generational self-placement in the 1960s and 1970s, Didion once again shows her allegiance to an earlier generation, but now suggests that this identification follows less from heroic stoicism than emotional self-indulgence disguised as stoicism.[40] This repositioning does not, however, change the meaning of self-pity.

In the last return of "the question of self-pity" toward the conclusion of the work, Didion makes her strongest reassessment of the propriety and the morality of attending to feelings of loss. While she is certain that her own youthful scorn of self-pity was rather easily held,[41] her more dramatic recalculation comes with the emotion itself. First she describes the collective horror of self-pity, our "abhorrence" of it conveyed in the synonyms for the word: "*feeling sorry for oneself*," "*thumb-sucking*," "*boo hoo poor me*," "*indulge*," "*wallow*" (*YMT*, 192–93). Note that these words convey childishness and the satisfactions of grief. Didion concludes: "Self-pity remains both the most common and the most universally reviled of our character defects, its pestilential destructiveness accepted as given" (*YMT*, 193). This description is so exaggerated—most universally reviled? pestilential?—it suggests the extent of Didion's personal revulsion. But the final section also wants to reclaim, perhaps even redeem, self-pity. The bereaved, she argues, have "urgent" "reasons" and "needs" to attend to their own emotions, not least of which is their sudden loneliness; they literally have nothing but themselves to focus on. But finally, Didion makes her peace, suggesting that the ideal of avoiding self-pity is impossible, and stoicism is a self-delusion that comforts us. "We are not idealized wild things. We are imperfect mortal beings, aware of that mortality even as we push it away, failed by our very complication, so wired that when we mourn our losses we also mourn, for better or for worse, ourselves. As we were. As we are no longer. As we will one day not be at all" (*YMT*, 198). Didion has finally been able to attend to her own emotions of loss, not in an outpouring of grief, a "wail" or "keen," but in an allowance for emotional self-reflection.

## Conclusion: Into the Blue

There comes a last reiteration of the Donner Party / Patty Hearst story toward the end of Didion's recent work *Blue Nights* (2011), a memoir of her daughter's death. As Didion walks to the bench in Central Park with its plaque memorializing Quintana, she ripples through the overlapping memories of the toddler Quintana giving her books, Quintana lying in the ICU, teenaged Quintana wanting to be "in the ground," Quintana dying. Didion remembers how her daughter explained her coping mechanisms when she was faced with her "revised circumstances" (the severe impairment of her body after her first hospitalization and subsequent cerebral hemorrhage, which landed her back in the ICU, though not for the last time):

> She did not want to talk about those revised circumstances.
> She wanted to believe that if she did not "dwell" on them she would wake one morning and find them corrected.
> "Like when someone dies," she once said by way of explaining her approach, "don't dwell on it."[42]

"Don't dwell on it." The sentence has a double effect here that follows from the conclusion of *The Year of Magical Thinking*, Didion's rethinking of stoicism and hardness. On the one hand, Quintana's denial represents an ordinary response to life-altering illness, but one that a younger Didion might have felt obliged to correct. On the other, it reminds us of Didion's own self-fashioning. A longtime reader of Didion can't help but hear the exhortations of those two paradigmatically Californian women: Virginia Reed of the Donner Party and Patty Hearst of the Symbionese Liberation Army. "Like when somebody dies, don't dwell on it" sounds like "Never take no cutoffs and hurry along as fast as you can" and "Don't examine your feelings. Never examine your feelings—they're no help at all." Much to Didion's evident dismay, Quintana had followed their advice and absorbed her mother's lessons about self-pity.

Nonetheless, Didion has discarded this lesson in this book without acknowledging it. As in *The Year of Magical Thinking*, she gestures toward an indictment of self-pity—there is a chapter on whining and an opening invocation of sentimentality—but neither of these injunctions complicates or arrests the drive toward a direct expression of feeling that shapes both the story and the style of telling it. Didion exhorts herself to be direct; frequently addresses the reader and constructs a conversational style; talks about her writing process and its difficulties; questions and revises herself ("was I the problem?"); expresses her grief and reveals her sense of humiliating frailty.

Allowing herself self-pity—or the less pejorative emotional self-reflection—
has won her the ability, or imposed the requirement, to change her style. But
being direct for Didion means abandoning style, not finding a new one, as we
might have guessed. She wonders:

> What if this absence of style that I welcomed at one point—the directness I
> encouraged, even cultivated—what if this absence of style has now taken on a
> pernicious life of its own?
>
> What if my new inability to summon the right word, the apt thought,
> the connection that enables the words to make sense, the rhythm, the music
> itself—
>
> What if this new inability is systemic?
>
> What if I can never again locate the words that work?[43]

Naturally, reading the book we have in our hands, we must know that her
capacity to find the right words has not left her permanently. But what if the
real question is not "can I locate the words or the rhythms," but "do I want
to?" What would she be giving up other than style? I've equated her style with
her morality and her personal management of feeling and argued that the two
constitute one another: emotional hardness is both the source and the out-
come of moral conduct. If style, emotional hardness, and morality form the
three legs of Didion's stool, what happens when one of those legs is broken?

Didion will dwell on Quintana's not dwelling, repeating the line four times
in the next four chapters, ending with it three times, which gives it heightened
resonance. Quintana's words become the foil that Didion can write against,
which is, in fact, her younger self, as she, Didion, "dwells on it." Remarkable
in Quintana's use of a phrase so reminiscent of a motif in Didion's work is
that Didion does not seem to recognize it as her own guiding philosophy.
Perhaps this failure of recognition *is* "not dwelling on it." Or perhaps in light
of her immovable grief, she can't "hurry along." She can move: several of the
chapters following Quintana's line are about momentum, which is movement,
but it's clearly movement for its own sake. And then, ill, her momentum is
arrested. Didion is not going anywhere. And in fact, the memoir predicts
that she never will. Entwined with Quintana's narrative is that of Didion's
herself—remorseful mother, grieving mother, an aging and frail woman, in
the dyadic form of autobiography. It predicts that without her style and emo-
tional hardness, Didion will dwell on it for the rest of her life.

# Acknowledgments

This book has taken shape over a long period of time, in many different versions, and with the support and insight of many readers and listeners. I am grateful, not just at this moment of completion but every single day, for the colleagues, friends, and students at the University of Chicago who make my life and made this work better. I especially want to thank my friends Lauren Berlant, Bill Brown, and Jim Chandler in the Department of English for their conversation and careful reading; my writing group in its different forms over the years: Danielle Allen, Leela Gandhi, Jackie Goldsby, Sandra MacPherson, William Mazzarella, Danilynne Rutherford, and, most of all, David Levine, who read so many, many drafts; and my friends Eric Santner and Jim Sparrow, who have given me excellent advice and support at key moments. I am always grateful for the conversations with my brilliant PhD students and feel a special debt to the undergraduates in my Tough Broads course. The Franke Institute provided a year of support and intellectual companionship. My dean, Martha Roth, and provost, Thomas Rosenbaum, backstopped a leave to give me extra time for the book. I'm very grateful for their support and for the subvention provided by the Humanities Visiting Committee for the production of this book.

The Post45 Collective has provided analytical pressure, bibliography, and entertainment for more than ten years. I can't imagine having written this without our yearly colloquium and ongoing conversations. Many thanks to J. D. Connor, Florence Dore, Mary Esteve, Andy Hoberek, Amy Hungerford, Sean McCann, Deak Nabers, and Michael Szalay.

My thanks to colleagues at other institutions: Washington University; University of British Columbia and Simon Fraser Affect Studies Group; Yale University; the English Institute; Texas A&M's Glasscock Center for the Hu-

manities; the Interdisciplinary Humanities Center at the University of California, Santa Barbara; Harvard's Department of English; and especially my hosts Dan Grausam, Adam Frank, Amy Hungerford, Victoria Rosner, Louis Menand, David Alworth, and Susan Derwin. Thanks for the opportunity to share ideas and conversation.

I am forever grateful to my friend and mentor Nancy K. Miller, who always has been and always will be in my corner.

At the Press, Alan Thomas, thank you for your faith in the manuscript over a very long time. I wish to thank the two anonymous readers, who saw things I could not and made the book better for it. Hannah Hayes was invaluable in preparing the manuscript. I would have fallen apart without her help.

Last, I want to thank my family. Adrienne, since we have only one brain left for the two of us, thank you for letting me use it whenever I need it. Theo and Nika, you make every day an adventure. This book is for you with all my love.

Early versions of chapters 2 and 3, "Hannah Arendt: Irony and Atrocity" and "Mary McCarthy: The Aesthetic of the Fact," were published as "Suffering and Thinking: The Scandal of Tone in *Eichmann in Jerusalem*" in *Compassion: The Culture and Politics of an Emotion*, edited by Lauren Berlant (New York: Routledge, 2004), and "The Virtues of Heartlessness: Mary McCarthy, Hannah Arendt, and the Anesthetics of Empathy," *American Literary History* 18, no. 1 (Spring 2006): 86–101. My sincere gratitude to the Diane Arbus Estate and especially Doon Arbus for reading and commenting on chapter 5 and for her generous permission to reprint seven photographs.

# *Notes*

## Introduction

1. See Mary Chapman and Glenn Hendler, eds., *Sentimental Men: Masculinity and the Politics of Affect in American Culture* (Berkeley: University of California Press, 1999), for a history of the movement of sentiment and sympathy into the home in the nineteenth century.

2. Julie Ellison, *Cato's Tears and the Making of Anglo-American Emotion* (Chicago: University of Chicago Press, 1999), 10.

3. Tania Modleski, "Clint Eastwood and Male Weepies," *American Literary History* 22, no. 1 (Spring 2009): 136.

4. See Adam Potkay's "Contested Emotions: Pity and Gratitude from the Stoics to Swift and Wordsworth," *PMLA* 130, no. 5 (October 2015): 1333.

5. Adam Smith's *Theory of Moral Sentiments* as quoted in Ellison, *Cato's Tears*, 71.

6. See Eve Kosofsky Sedgwick's *The Epistemology of the Closet* (Berkeley: University of California Press, 2008); James P. Chandler's *An Archaeology of Sympathy* (Chicago: University of Chicago Press, 2013); and Leonard Cassuto's *Hardboiled Sentimentality: The Secret History of American Crime Stories* (New York: Columbia University Press, 2008).

7. Mary McCarthy, "The Hiroshima *New Yorker*," *politics*, October 1946, 367; and John Hersey, "Hiroshima," *New Yorker*, August 31, 1946.

8. Theodor Adorno, "Cultural Criticism and Society," in *Prisms*, trans. Samuel Weber and Shierry Weber (Cambridge, MA: MIT Press, 1983), 34.

9. Shoshana Felman, *The Juridical Unconscious: Trials and Traumas in the Twentieth Century* (Cambridge, MA: Harvard University Press, 2002), 1.

10. Marianna Torgovnick's book *The War Complex: World War II in Our Time* (Chicago: University of Chicago Press, 2005) offers the first thoroughgoing account of how the war haunted the postwar, which might indeed be the appropriate context for thinking about the emotional extremes that characterize the period. Torgovnick's method—an ethics of identification—strikes me as useful for a great deal of material from the period, but it does not account for the bipolarity of response or the various ways writers attempted to deal directly with the fallout from the war.

11. See Lauren Berlant's "The Subject of True Feeling: Pain, Privacy, and Politics," in *Cultural*

*Pluralism, Identity Politics, and the Law*, ed. Austin Sarat and Thomas Kearns (Ann Arbor: University of Michigan Press, 1999), 49–84; and Wendy Brown's "Wounded Attachments," *Political Theory* 21, no. 3 (August 1999): 390–410.

12. Mark Seltzer, *Serial Killers: Death and Life in America's Wound Culture* (New York: Routledge, 1998), 1.

13. Talal Asad, *Formations of the Secular: Christianity, Islam, Modernity* (Palo Alto, CA: Stanford University Press, 2003).

14. Hannah Arendt, *On Revolution* (New York: Penguin Books, 1990), 72.

15. Susan Sontag, "The Third World of Women," *Partisan Review* 40, no. 2 (Spring 1973): 180–206.

16. Michael Taussig, *The Nervous System* (New York: Routledge, 1992), 10.

17. Stephen Best and Sharon Marcus, "Surface Reading: An Introduction," *Representations* 108, no. 1 (Fall 2009): 1–21.

18. Berlant, "Subject of True Feeling."

## Chapter 1

1. Camus had published her collection of essays *Oppression and Liberty* in the midthirties, and *Cahiers du Sud* had published several of her articles in the early 1940s.

2. Simone Weil, "The *Iliad*: A Poem of Force," in *Simone Weil: An Anthology*, ed. Siân Miles (New York: Grove Press, 1986), 162–95.

3. See Carol Brightman, *Writing Dangerously: Mary McCarthy and Her World* (New York: Harcourt, Brace, 1992). For the quotation from McCarthy, see 626, and from MacDonald, 227.

4. Elizabeth Hardwick, *Bartleby in Manhattan and Other Essays* (New York: Random House, 1983).

5. See Gregory Sumner, *Dwight Macdonald and the "politics" Circle* (Ithaca, NY: Cornell University Press, 1996), 193.

6. Hardwick, *Bartleby in Manhattan*, 158.

7. See bibliography for full titles. Fanny Howe also had many poems and essays devoted to Weil.

8. Simone Weil, *Attente de Dieu* (Paris: La Colombe, 1950); and Simone Weil, *La pesanteur et la grâce* (Paris: Plon, 1947).

9. Simone Weil, *L'enracinement: Prélude a une déclaration des devoirs envers l'être humain* (Paris: Gallimard, 1949).

10. Dwight Macdonald said the Revised Standard Version of the Bible was "like taking apart Westminster Abbey to make Disneyland out of the fragments." See Dwight Macdonald, ed., *Masscult and Midcult: Essays against the American Grain* (New York: Random House, 1962), 38.

11. There are a number of excellent biographies of Weil, and the outlines of her life story are nearly always rehearsed in articles on her work. Simone Pétrement, her friend, wrote the first authoritative biography: *Simone Weil: A Life* (New York: Pantheon Books, 1976). David McLellan's *Utopian Pessimist: The Life and Thought of Simone Weil* (New York: Simon & Schuster, 1990) is perhaps now the definitive one. Francine du Plessix Gray's short biography for the Penguin Lives Series, *Simone Weil* (New York: Penguin Group, 2001), has circulated widest. Robert Coles's biographical/analytical book, *Simone Weil: A Modern Pilgrimage* (Woodstock, VT: Skylight Paths, 2001), also deserves mention. Sylvie Courtine-Denamy's *Three Women in Dark Times*, trans. G. M. Goshgarian (Ithaca, NY: Cornell University Press, 2000), treats her work and life in the

context of two other figures, Edith Stein and Hannah Arendt. None disagree on the basic outlines of Weil's career, but no one has looked at the posthumous reception history of her work. Sisela Bok has written an article on Weil's legacy but treats only a small number of important readers of her work. See Sisela Bok, "No One to Receive It? Simone Weil's Unforeseen Legacy," *Common Knowledge* 12, no. 2 (Spring 2006): 252–60.

12. The split between radical and mystic is more an artifact of publishing history and academic taste than a fact of her work. Françoise Meltzer makes a strong case for the paradoxical continuity of her thought in "The Hands of Simone Weil," *Critical Inquiry* 27, no. 4 (Summer 2001): 611–28.

13. David Castronovo's book *Beyond the Gray Flannel Suit: Books from the 1950s That Made American Culture* (New York: Bloomsbury Academic, 2004) develops from this sort of account. In his summary, the protagonist of *The Man in the Gray Flannel Suit* is paradigmatic not as a man of emotional resilience in the face of war trauma but as a man who "wondered why he should get so scared in *peacetime*" (11, emphasis mine). Castronovo's answer—that "the late 1940s and 1950s produced a remarkable number of new things to worry about" (11), most anxiously, Communist spies and atomic annihilation—places us back into familiar territory.

14. Elaine Tyler May, *Homeward Bound: American Families in the Cold War Era* (New York: Basic Books, 1988).

15. Robert Wuthnow, *After Heaven: Spirituality in America since the 1950s* (Berkeley: University of California Press, 2000).

16. See Robert Ellwood, *The Fifties Spiritual Marketplace* (New Brunswick, NJ: Rutgers University Press, 1997).

17. See ibid., 11–13. But the Christian realists, however pessimistic, were not tragic thinkers, as I explain later in the chapter.

18. Leslie Fiedler, introduction to *Waiting for God*, by Simone Weil (New York: G. P. Putnam & Sons, 2000), vii.

19. Leslie Fiedler, "Simone Weil: Prophet Out of Israel; A Saint of the Absurd," *Commentary* 12 (January 1, 1951): 38–46.

20. Robert Barrat, "Simone Weil," *Commonweal* 24 ( March 1951): 585–87.

21. John Cogley, "Sister to All Sufferers," review of *Waiting for God*, by Simone Weil, *New York Times*, September 16, 1951, Sunday Book Review. John Cogley was on the editorial staff of *Commonweal*.

22. Anne Fremantle, "Soul in Search of Salvation," *New York Times*, December 16, 1956, Sunday Book Review.

23. The first comment was made by Robert Barrat ("Simone Weil"); the second, by John Cogley ("Sister to All Sufferers"). Fremantle ("Soul in Search of Salvation") called her "ugly, unwell, alien."

24. Cold War tensions appear in the occasional attempt to mock Weil's dedication to suspiciously Communist causes like the labor movement. Weil engaged with Marxist theory and Communist political groups on many levels, but she could hardly be considered a Marxist, much less a Communist, so deep was her criticism and so violent her hatred of the Soviet experiment with it, which she considered totalitarian. This contributed to her heroism in the eyes of ex-Communists turned Cold War liberals like Fiedler. Later reviews in the 1950s were increasingly more sympathetic and admiring.

25. William Barret, "Mlle. Weil's Question," review of *Letters to a Priest*, by Simone Weil, *New York Times*, March 14, 1954, Sunday Book Review.

26. Isaac Rosenfeld, "Simone Weil as Saint," review of *Waiting for God*, by Simone Weil, *Partisan Review* 18, no. 6 (November/December 1951): 712–15.

27. Fiedler, introduction to Weil, *Waiting for God*, xvii.

28. Susan Sontag, *Against Interpretation and Other Essays* (New York: Farrar, Straus & Giroux, 1966), 49–50.

29. Chiaromonte had a deep friendship with Albert Camus, one that blossomed as Chiaromonte awaited transport to the United States in Marseille. This was the height of Weil's late production and when the *Iliad* essay was published in *Cahiers du Sud*. Chiaromonte and Camus shared a great deal philosophically and politically, not least their admiration for Weil. See Elizabeth Hawes, *Camus, a Romance* (New York: Grove Press, 2009).

30. Nicola Chiaromonte, *The Worm of Consciousness and Other Essays* (New York: Harcourt Brace Jovanovich, 1976), 184–86.

31. Chiaromonte is quoting Weil, "The *Iliad*: A Poem of Force."

32. Norman Vincent Peale, *The Power of Positive Thinking* (New York: Simon & Schuster / Fireside, 2003), 3, 121.

33. Simone Weil, *Gravity and Grace* (Lincoln: University of Nebraska Press, 1997), 53; hereafter cited in text as *GG* followed by the page number.

34. In *Pursuing Privacy in Cold War America* (New York: Columbia University Press, 2002), I call this a "topological crisis"—a widespread anxiety about the boundaries of the human body, the nation, and the mind, which were figured everywhere in Cold War discourse as containers with leaky membranes. Timothy Melley has called this "agency panic" in *Empire of Conspiracy: The Culture of Paranoia in Cold War America* (Ithaca, NY: Cornell University Press, 2000).

35. There are so many books and articles on the Cold War with the word "containment" in the title that they are impossible to list. I would note the early employment of this term in the cultural field in Alan Nadel's *Containment Culture: American Narratives, Postmodernism, and the Atomic Age* (Durham, NC: Duke University Press, 1995).

36. Amanda Anderson has aptly defined midcentury liberalism as "bleak," identifying some of its key figures, Lionel Trilling most conspicuously, as "marked by a chastened rationalism and a caution against progressive optimism," which she argues forms a central but unrecognized component of the liberal tradition. "Bleak" sits adjacent to Weil's more tragic sensibility. See "Postwar Aesthetics: The Case of Trilling and Adorno," *Critical Inquiry* 40, no. 4 (Summer 2014): 421.

37. There was also a surge in adaptations of Greek tragedy and perhaps something like new forms of tragedy—Arthur Miller would be doing one kind and Samuel Beckett another. Samuel Moyn points out the conversation among German classicists who looked to the Greeks and Greek tragedy as a way of imagining a tradition of human rights. See Moyn, "The Universal Declaration of Human Rights of 1948 in the History of Cosmopolitanism" (lecture presented at the Sawyer Seminar "Around 1948," University of Chicago, November 29, 2011). At the end of Raymond Williams's reissued *Modern Tragedy* (Toronto: Broadview Press, 2006), the Works Cited and Further Reading includes Camus and Steiner, as well as a number of classicists and Shakespearean scholars who wrote on tragedy in the 1950s and 1960s, such as H. D. F. Kitto and G. Wilson Knight.

38. Raymond Williams (*Modern Tragedy*) comes at this question a different way (and he was responding to Arendt in *On Revolution* as well as to Steiner): how do we distinguish what we experience as tragedy and what we know of the tradition of "tragedy," in which only some events and responses to them are deemed tragic? He is referring to ordinary tragedy in ordinary life,

and he is more interested than other critics in connections between the dramatic tradition and the vernacular uses of the term "tragedy."

39. See McLellan, *Utopian Pessimist.*

40. J. P. Little, "Albert Camus, Simone Weil, and Modern Tragedy," *French Studies* 31, no. 1 (January 1977): 48.

41. Rita Felski, introduction to *Rethinking Tragedy,* ed. Rita Felski (Baltimore: Johns Hopkins University Press, 2008).

42. Reinhold Niebuhr, *Beyond Tragedy: Essays on the Christian Interpretation of History* (New York: Scribner, 1937), 155.

43. See Kathleen Sands, "Tragedy, Theology, and Feminism in the Time after Time," in Felski, *Rethinking Tragedy,* 82–103.

44. In, for example, Werner Jaeger's classic work *Early Christianity and Greek Paideia* (Cambridge, MA: Harvard University Press, 1961), there is not one mention of tragedy as a constitutive component of either tradition. Weil was not a classicist, of course; her understanding of both traditions was both learned and typically idiosyncratic. Jaeger's essays on this topic began to be published in the 1930s. My thanks to Sam Moyn, who alerted me to these dates at the Sawyer Seminar "Around 1948" in 2011.

45. Albert Camus, "On The Future of Tragedy," lecture given in Athens in 1955 and published in *Lyrical and Critical Essays,* trans. Ellen Conroy Kennedy, ed. Phillip Thody (New York: Alfred A. Knopf, 1968), 303. Weil's influence can be seen in *The Plague*—the priest in the second half of the novel is a Weil-like figure, and the sermon he gives clearly draws on much of "The Love of God and Affliction."

46. Citations to "The Love of God and Affliction" are taken from *The Simone Weil Reader,* ed. George A. Panichas (Wakefield, RI: Moyer Bell, 1977), hereafter cited in text as *SWR* followed by the page number. *The Simone Weil Reader* has the complete text, whereas *Waiting for God* has only the first half of the essay.

47. Weil wrote many essays, collected in *Intimations of Christianity among the Ancient Greeks* (London: Routledge, 1998), to show the presence of Christian theology centuries before Christ's birth. She also wrote essays and parts of essays devoted to tracing the relationships between Christianity and non-Western religions.

48. George Steiner, *The Death of Tragedy* (New York: Alfred A. Knopf, 1961), 4.

49. Miles, *Simone Weil: An Anthology,* 16.

50. The best account of Weil's concept of decreation, which is enormously complex, is Sharon Cameron's. Cameron states that decreation is "so alien to us that we barely have any concepts for it, so quick are we to find any attempt to eradicate egotism in terms this extreme repellent," in her essay "The Practice of Attention: Simone Weil's Performance of Impersonality," in *Impersonality: Seven Essays* (Chicago: University of Chicago Press, 2007), 110.

51. Talal Asad, *Formations of the Secular: Christianity, Islam, Modernity* (Palo Alto, CA: Stanford University Press, 2003), 67.

52. Elaine Scarry, *The Body in Pain: The Making and Unmaking of the World* (Oxford: Oxford University Press, 1988), 4.

53. McCarthy, for example, typically uses an infinitive construction.

54. Miles, *Simone Weil: An Anthology,* 185.

55. Ibid., 221.

56. Ibid., 222.

57. Simone Weil, *Letter to a Priest* (New York: Penguin Books, 2003), 12.

58. Ibid., 11.

59. This appears in *Intimations of Christianity among the Ancient Greeks*, 18–19.

60. Joan Dargan, *Simone Weil: Thinking Poetically* (Albany: State University of New York Press, 1999).

61. M. K. Ferber, "Simone Weil's *Iliad*," in *Simone Weil—Interpretation of a Life*, ed. George Abbot White (Amherst: University of Massachusetts Press, 1981), 63–64.

62. Italics in quotations are always in the original unless otherwise noted.

63. For a full discussion of the relation of Weil to Marx on the subject of labor, see Robert Sparling's "Theory and Praxis: Simone Weil and Marx on the Dignity of Labor," *Review of Politics* 74, no. 1 (January 2012): 87–107.

64. Dargan, *Simone Weil*.

65. Weil, *Waiting for God*, in *Simone Weil Reader*, 64.

66. In closing the essay, Weil says, "Often, one could weep tears of blood to think how many unfortunates are crushed by affliction without knowing how to make use of it. But, *coolly considered*, this is not a more pitiful waste than the squandering of the world's beauty. The brightness of the stars, the sound of sea-waves, the silence of the hour before dawn—how often do they not offer themselves in vain to men's attention?" (*SWR*, 467, emphasis mine).

67. This is from Barret's "Mlle. Weil's Question."

68. From *The Notebooks of Simone Weil* as quoted in McLellan, *Utopian Pessimist*, 187.

## Chapter 2

1. See Peter Novak, *The Holocaust in American Life* (New York: Mariner Books, 2000), for the now standard account. For a dissenting opinion, see Laurence Baron, "The Holocaust and American Public Memory, 1945–1960," *Holocaust and Genocide Studies* 17, no. 1 (Spring 2003): 62–88.

2. Dan Diner, "Hannah Arendt Reconsidered: On the Banal and the Evil in Her Holocaust Narrative," *New German Critique* 71 (Spring/Summer 1997): 178.

3. See Hans Mommsen's "Hannah Arendt's Interpretation of the Holocaust as a Challenge to Human Existence: The Intellectual Background," in *Hannah Arendt in Jerusalem*, ed. Steven E. Ascheim (Berkeley: University of California Press, 2001), 224–31.

4. Elizabeth Young-Bruehl traces out the debate over *Eichmann in Jerusalem* and comments frequently on Arendt's style but does not speculate as to why Arendt employed the strategies she did. See Elizabeth Young-Bruehl, *Hannah Arendt: For Love of the World* (New Haven, CT: Yale University Press, 1982).

5. Lyndsey Stonebridge's chapter on Arendt's *Eichmann in Jerusalem*, "The Man in the Glass Booth: Hannah Arendt's Irony," provides an excellent alternative to my account of Arendt's irony, arguing that after the Holocaust Arendt feared that "language had run away from historical meaning" (52). See Lyndsey Stonebridge, *The Judicial Imagination: Writing after Nuremburg* (Edinburgh: Edinburgh University Press, 2001), 47–72.

6. All quotations from *The Origins of Totalitarianism* are taken from Hannah Arendt, *Totalitarianism: Part Three of "The Origins of Totalitarianism"* (New York: Harvest Books, 1968), here viii; hereafter cited in text as *OT* followed by the page number.

7. Hannah Arendt, *The Jew as Pariah*, ed. Ron Feldman (New York: Grove Press, 1978).

8. See David Skinner, ed. and trans., *Gershom Scholem: A Life in Letters, 1914–1982* (Cambridge, MA: Harvard University Press, 2002), vi.

9. According to the *New York Times Book Review* editorial comment at the opening of these pages, they had received more than a hundred letters in the month after Musmanno's review, mostly in support of Arendt and critical of the review. The pages themselves include a selection, roughly half in support of *Eichmann in Jerusalem* and half in support of Musmanno's review.

10. Printing this volume of response was unprecedented in the *New York Times Book Review*. The *Book Review* had never (nor has to this date) devoted as much space to one controversy as it did with *Eichmann in Jerusalem*.

11. The response is in the *New Yorker*'s Talk of the Town (July 20, 1963) and does not contain a byline for Shawn, though he did indeed write it.

12. Hannah Arendt, *The Jew as Pariah*, ed. Ron Feldman (New York: Grove Press, 1978), 241; hereafter cited in text as *JP* followed by the page number.

13. See the translation in Skinner, *Gershom Scholem*, 396.

14. Moreover, she claims that "I cannot love myself or anything which I know is part and parcel of my own person," by which she implies a kind of narcissism in the love of a people (*JP*, 247).

15. See Hannah Arendt, *The Life of the Mind*, ed. Mary McCarthy (Orlando, FL: Harcourt, 1978), 73.

16. Musmanno does note tone in reference to various other figures in the trial. For instance, Arendt "deals intemperately" with the lead prosecutor, Gideon Hausner, and "pours scorn" on Israeli prime minister David Ben-Gurion. Michael Musmanno, "Man with an Unspotted Conscience: Adolf Eichmann's Role in the Nazi Mania Is Weighed in Hannah Arendt's New Book," *New York Times*, May 19, 1963, Sunday Book Review, 40–41.

17. Ibid.

18. Hannah Arendt, *On Revolution* (New York: Penguin Books, 1990), 90; hereafter cited in text as *OR* followed by the page number.

19. Hannah Arendt, *Eichmann in Jerusalem: A Report on the Banality of Evil* (New York: Penguin Books, 1994), 25; hereafter cited in text as *EJ* followed by the page number.

20. Grynszpan's unstable son, Herschel, had assassinated a low-level German administrative functionary in Paris on November, 7, 1938, providing the pretext for unleashing the pogroms of Kristallnacht.

21. She recounts one additional story in detail, that of a German soldier, Anton Schmidt, known to many in the courtroom. Schmidt helped the Jewish underground by providing forged papers and military trucks before being executed for that work. Mention of this name produced two minutes of silence in the courtroom as though, she says, "in honor of a man named Anton Schmidt" whose memory produced a "single thought clearly, irrefutably, beyond question—how utterly different everything would be today in this courtroom, in Israel, in Germany, in all of Europe and perhaps all countries of the world, if only more such stories could have been told" (*EJ*, 231). It is not the failure of the court to provide such testimony but the rarity of such stories during the war that is her point.

22. In *The Human Condition* (Chicago: University of Chicago Press, 1998), which Arendt wrote in the mid-1950s, she had already developed a theory of the public world that did not include pain and emotion. Her primary examples of things that should not be shared in public are physical pain and emotion, especially love. Because internal states are not subject to the verifications of plurality, pain and emotion should not be seen and heard, denying the fundamental conditions of publicity—appearance. Moreover, certain things, she claims, cannot bear the light of day, the exposure to many, and one of these is the intensity that comes with intimate feelings. This intensity, she argues, is always a threat to reality (50–51).

23. Margaret Canovan sees *On Revolution* as Arendt's attempt to come to terms with totalitarianism on the left. See the chapter "Morals and Politics in a Post-totalitarian Age," in Margaret Canovan's *Hannah Arendt: A Reinterpretation of Her Political Thought* (Cambridge: Cambridge University Press, 1992), 155–200.

24. *New Yorker*, Talk of the Town, July 20, 1963.

25. *New York Times*, May 19, 1963, sec. 7, 1.

26. See Moshe Zimmerman, "Hannah Arendt, the Early 'Post-Zionist'" (181–93), and Richard Bernstein, "Hannah Arendt's Zionism?" (194–202), in Ascheim, *Hannah Arendt in Jerusalem*. As Bernstein says: "To ask, in an unqualified manner, 'Was Hannah Arendt ever a Zionist and when?' obscures basic issues. We need to make more discriminating judgments. We need to clarify what precisely attracted her to Zionism (especially which version of Zionism, and when this occurred), as well as what repelled her about Zionist ideology and became the target of her stinging criticism" (194–95).

27. Marie Syrkin, "Hannah Arendt: The Clothes of the Empress," *Dissent*, Autumn 1963, 344–52, here 346.

28. Seyla Benhabib, *The Reluctant Modernism of Hannah Arendt* (London: Sage, 1996), 190.

29. Ibid.

30. Note the current mass fascination with psychopathies like serial killing, where an affectless perpetrator motivated by obscure and highly particularized forms of hatred seems to combine the two.

31. Ernest S. Pisko, "Afterword on Eichmann," *Christian Science Monitor*, May 23, 1963.

32. "'Eichmann in Jerusalem'—Can One Know the 'Whole' Truth?," *Newsweek* 61, no. 24, June 17, 1963, 94–95.

33. Note Arendt's *"cura posterior"* in Young-Bruehl, *Hannah Arendt*, 336. Arendt wrote to her close friend Mary McCarthy: "You are the only reader to understand that I wrote this book in a curious euphoria. And that ever since I did it I feel—after twenty years—light hearted about the whole matter. Don't tell anybody: is it not proof positive that I have no 'soul'?" (as quoted in ibid., 337).

34. Moreover, this lack of sympathy is also linked to the similarities between Arendt and her subject. As many critics do, Julia Kristeva reads *Rahel Varnhagen* autobiographically, noting Arendt's especially harsh treatment of her: "Far from empathizing with her heroine, Arendt appears to be settling scores with Rahel, a being held dear, an alter ego that Hannah herself could never be although it threatened her, an alter ego that she dislodged of any compassionate depth with a relentless severity that was as ruthless as it was insightful." Julia Kristeva, *Hannah Arendt*, trans. Ross Guberman (New York: Columbia University Press, 2001), 49.

35. For a more extended discussion of the thinker as conscious pariah, see "The Conscious Pariah as Rebel and Independent Thinker," in Richard Bernstein's *Hannah Arendt and the Jewish Question* (Cambridge, MA: MIT Press, 1996), 14–45.

36. See especially the epilogue to Sylvie Courtine-Denamy's *Three Women in Dark Times: Edith Stein, Hannah Arendt, Simone Weil*, trans. G. M. Goshgarian (Ithaca, NY: Cornell University Press, 2000), 202–22, for an extended discussion of this attempt to reconcile with reality.

37. Hannah Arendt, *The Portable Hannah Arendt* (New York: Penguin Books, 2000), 54; hereafter cited in text as *PHA* followed by the page number.

38. For Arendt, to believe seriously and even literally in ideology, which she calls "harmless" and "arbitrary" when merely opinion, represents contempt for reality. Once this ideology becomes a serious explanation of the world, it forms the "nuclei of logical systems" that reshape

the world for the sake of consistency. It is the systematic nature of supersense that most worries her because what does not fit or threatens to unsettle it will eventually be destroyed for the sake of consistency. Supersense is both the initial premise and, more importantly, the logical system that derives consequences from that premise. Her example: "if the inmates are vermin, it is logical they should be killed with poison gas" (*OT*, 155–56).

39. See chapter 1 on Weil and affliction.

40. Bernstein, *Hannah Arendt and the Jewish Question*, 11.

41. This lecture series and other unpublished writings appeared in *Responsibility and Judgment*, ed. Jerome Kohn (New York: Schocken Books, 2003); hereafter cited in text as *RJ* followed by the page number.

42. See Norman Podhoretz, "Hannah Arendt on Eichmann: A Study in the Perversity of Brilliance," *Commentary* 36 (September 1, 1963): 201–8, for an example.

43. From *American Power and the New Mandarin*, as quoted in Hannah Arendt, *On Violence* (Orlando, FL: Harcourt Brace Jovanovich, 1970), 64; hereafter cited in text as *OV* followed by the page number.

44. Hannah Arendt, *The Life of the Mind*, ed. Mary McCarthy (Orlando, FL: Harcourt, 1978), 70; hereafter cited in text as *LOTM* followed by the page number.

## Chapter 3

1. This account is taken from Carol Brightman's biography of Mary McCarthy: *Writing Dangerously: Mary McCarthy and Her World* (New York: Harcourt, Brace, 1992), 299.

2. Brock Brower, "Mary McCarthyism," in *Conversations with Mary McCarthy*, ed. Carol Gelderman (Jackson: University Press of Mississippi, 1991), 43.

3. Mary McCarthy, *Between Friends: The Correspondence of Hannah Arendt and Mary McCarthy, 1949–1975*, ed. Carol Brightman (New York: Harvest Books, 1996), xxx.

4. Mary McCarthy, *Occasional Prose* (New York: Harcourt Brace Jovanovich, 1985), 10; hereafter cited in text as *OP* followed by the page number.

5. Hannah Arendt, "Reflections on Little Rock," *Dissent* 6, no. 1 (1959): 45–56.

6. Hannah Arendt, *The Jew as Pariah*, ed. Ron Feldman (New York: Grove Press, 1978), 247.

7. For a good summary, see Carol Gelderman's introduction to *Conversations with Mary McCarthy*, and Edwin Newman's television interview, the transcript of which is collected in the same volume (Gelderman, *Conversations*, 69).

8. Hannah Arendt, *Men in Dark Times* (New York: Harcourt, Brace & World, 1968), 25, 24. This and later quotations from *Men in Dark Times* are taken from the address she delivered on acceptance of the Lessing Prize: "On Humanity in Dark Times: Thoughts about Lessing," in *Men in Dark Times*, 3–32.

9. Hannah Arendt, *On Revolution* (New York: Penguin Books, 1990), 88, 89.

10. Arendt, *Jew as Pariah*, 246–47.

11. Mary McCarthy, *On the Contrary: Articles of Belief, 1946–1961* (New York: Farrar, Straus & Cudahy, 1961), 75–105; hereafter cited in text as *OTC* followed by the page number.

12. Arendt, *Men in Dark Times*, 13–14.

13. Ibid., 13.

14. McCarthy, *Between Friends*, 23.

15. Ibid., 24.

16. McCarthy builds her indictment of American self-delusion in Vietnam by describing in

painful detail the mirroring of homogeneous groups in *Viet Nam* (New York: Harcourt, Brace & World, 1967) and *Hanoi* (New York: Harcourt, Brace & World, 1967). Arendt seems to have gotten many of her ideas on image-making and publicity in Vietnam from McCarthy's reports. See Hannah Arendt, "Home to Roost: A Bicentennial Address," in *Responsibility and Judgment*, ed. Jerome Kohn (New York: Schocken Books, 2003), 257–75.

17. Several things have contributed to overlooking McCarthy's careful construction of a fact-based aesthetic. For one, her personal daring, both sexual and rhetorical, so troubled and mesmerized the circle of New York Intellectuals in which she traveled that it has become legend. When this often-caricatured version of McCarthy has not been the default explanation of her work, psychological analyses of McCarthy have offered alternative readings. In other words, her candor has been seen as her best and most attention-getting weapon. Or it has been explained as what Elizabeth Hardwick has called her "Jesuitical morality." See Elizabeth Hardwick, foreword to *Intellectual Memoirs: New York, 1936–1938*, by Mary McCarthy (New York: Harcourt Brace Jovanovich, 1992), vii–xxii.

18. Susan Buck-Morss, "Aesthetics and Anaesthetics: Walter Benjamin's Artwork Essay Reconsidered," *October* 62 (Fall 1992): 5.

19. Philip Roth published a now quite well-known essay in *Commentary* a year later lamenting that "the American writer in the middle of the twentieth century has his hands full in trying to understand, and then describe, and then make *credible* much of the American reality. It stupefies, it sickens, it infuriates, and finally it is even a kind of embarrassment to one's own meager imagination." Philip Roth, "Writing American Fiction," *Commentary* 31, no. 3 (March 1961): 224. He, like McCarthy, found the contemporary novelist retreating into something like a dream world. "What I have tried to point out is that the sheer fact of self, the vision of self as inviolable, powerful, and nervy, self as the only real thing in an unreal environment, that that vision has given to some writers joy, solace, and muscle. . . . However, when survival itself becomes one's *raison d'etre*, when one cannot choose but be ascetic, when the self can only be celebrated as it is excluded from society . . . we then, I think, do not have much reason to be cheery" (233).

20. Prospectus for *Critic* magazine (1952), p. 7, box 174, folder 5, Mary McCarthy Papers, Archives and Special Collections, Vassar College Library (hereafter Mary McCarthy Papers).

21. Ibid., p. 6.

22. Henry Luce dominated the magazine market in the midcentury. By 1952 Luce published *Time, Life, Fortune*, and *House and Home*; two years later, he purchased *Sports Illustrated*. He also produced *The March of Time* weekly newsreel.

23. Prospectus for *Critic* magazine (1952), p. 8, box 174, folder 5, Mary McCarthy Papers.

24. Ibid., p. 10. In this comment, McCarthy prefigures Arendt's dismissal of "the tact of the heart" in her exchange with Gershom Sholem over her *Eichmann in Jerusalem*.

25. Mary McCarthy, *The Company She Keeps* (New York: Harvest Books, 1970), 168; hereafter cited in text as *CSK* followed by the page number.

26. "I had to admit that if I was not fearful, I was at least uncomfortable in the supposition that anybody, anybody whatever, could think of me, precious me, as a Communist. A remoter possibility was, of course, that back there my departure was being ascribed to Jewishness, and this too annoyed me. I am in fact a quarter Jewish, and though I did not 'hate' the idea of being taken for a Jew, I did not precisely like it, particularly under these circumstances" (*OTC*, 61).

27. BBC broadcast on realist playwrights, p. 4, box 18, folder 8, Mary McCarthy Papers.

28. Mary McCarthy, *Writing on the Wall and Other Literary Essays* (New York: Harcourt Brace Jovanovich, 1971), 87.

29. Ibid., 93.

30. Ibid., 94.

31. Arendt, *Men in Dark Times*, 7–8.

32. This first appeared in the *New York Review of Books* on May 12, 1983.

33. McCarthy's sense that aesthetic education was a preparation for citizenship was widely held among the New York Intellectuals, though the art forms or aesthetic practice each found most salutary differed. Dwight Macdonald argued, for instance, specifically for the benefits of aesthetic difficulty like that of modernism to train the reader's resistance to platitude, propaganda, and sentimentality. See Dwight Macdonald, ed., *Masscult and Midcult: Essays against the American Grain* (New York: Random House, 1962). Tobin Siebers makes this argument about the New Critics in *Cold War Criticism and the Politics of Skepticism* (New York: Oxford University Press, 1993).

34. As McCarthy said of *Stones of Florence*, "The reason I enjoyed doing those books on Italy . . . was that I was writing *in my own voice*" (Gelderman, *Conversations*, 26, emphasis mine). The ease of writing she enjoyed with this book, writing in her own voice, was not only the difference from writing a novel ("the technical difficulties" of "feigning an alien consciousness" [Gelderman, *Conversations*, 26]). There's much to be said about voice and point of view in McCarthy's own work and in her sense of the possibilities or, more accurately, the narrowing of possibilities in the novel after Henry James and after modernism. Not just the problem of inhabiting another character's voice in first-person narration but even limited omniscience or free indirect discourse required forms of ventriloquism that McCarthy did not like or feel completely competent to pull off. It's partly a question of aesthetic taste, partly a question of talent, and, I think, partly a question of McCarthy's own factualism, her need for a certain kind of frankness or honesty, that caused her to bemoan the rise of perspectivalism.

35. Gelderman, *Conversations*, 28. Brightman argues that *Stones of Florence* and *Memories of a Catholic Girlhood* mark a breakthrough in McCarthy's writing. She found herself more confident and ready to take on more ambitious projects as she broke loose of the intellectual circle of her formative years (Brightman, *Writing Dangerously*, 411).

36. Mary McCarthy, *The Stones of Florence* (New York: Harcourt Brace Jovanovich, 1959), 74; hereafter cited in text as *SOF* followed by the page number.

37. Hardwick, foreword to McCarthy, *Intellectual Memoirs*, xix.

38. Brightman, *Writing Dangerously*.

### Chapter 4

1. Norman Podhoretz, *Making It* (New York: HarperCollins, 1980), 154.

2. I thank Nancy Miller for this reference. Carolyn Heilbrun, "Speaking of Susan Sontag," *New York Times*, August 27, 1967, 2, 30.

3. Another slightly different and bitchier version of this story comes from Mary McCarthy. In an interview with Frances Kiernan for her book *Seeing Mary Plain*, Sontag says, "'She's the imitation me,' or 'she's the ersatz me,' Mary McCarthy is reported to have said, though no one has been able to pin down when she said it or to whom. Mary McCarthy was, with the exception of one waspish remark, unfailingly polite and friendly to me" (537). Sontag had taken over McCarthy's theater column for the *Partisan Review*, which probably accounts for the supposed provenance of the remark. However, what's interesting is less McCarthy's saying it than the circulation of a remark as something McCarthy *would* say and the way that circulating it put

the idea out of their own mouths and into McCarthy's. Kiernan reports that Sontag saw this as "troublemaking by the boys," and when she was asked to review McCarthy's *The Group*, she declined (537).

4. Susan Sontag, "Against Interpretation," in *Against Interpretation and Other Essays* (New York: Farrar, Straus & Giroux, 1966), 14. Hereafter the book will be referenced as *AI* and the pages numbers for specific essays will be given in the text.

5. Georg Simmel, "The Metropolis and Mental Life," in *Simmel on Culture: Selected Writings*, ed. David Frisby and Michael Featherstone (London: Sage, 1998), 174-85.

6. Raymond Williams introduced the concept of the "structure of feeling" in *A Preface to Film* (London: Film Drama, 1954) and elaborated it over the course of the next two decades, principally in *Marxism and Literature* (Oxford: Oxford University Press, 1977).

7. From the online *Oxford English Dictionary*, http://www.oed.com. The *Oxford English Dictionary* cites only examples from the twentieth century after its first use in German.

8. Both quotations can be found in David Rieff, *Swimming in a Sea of Death* (New York: Simon & Schuster, 2008), 35, 36.

9. I am really not certain in my own mind how to think about Sontag's journals, the first of which was published in December 2008. Sontag was always reticent, to say the least, to write about her personal life and was *never* reticent about the scourge of biography in contemporary criticism. She once said in an essay collected in *Where the Stress Falls*, her last collection published, "My books aren't me—all of me. And in some ways, I am less than them." Susan Sontag, "Singleness," in *Where the Stress Falls* (New York: Farrar, Straus & Giroux, 2001), 259.

10. Sontag argues that there is a taste in emotional styles as in anything else in "Notes on 'Camp,'" in *AI*, 275-92.

11. See Joyce Carol Oates, "Adventures in Abandonment," review of *Jean Stafford: A Biography*, by David Roberts, *New York Times*, August 28, 1988, Sunday Book Review. James Atlas later that year reminded readers of Freud's use of the term ("Freud's Pathology," *New York Times Magazine*, December 18, 1988). According to Atlas, in Freud's use, "pathography" clearly has the same disparaging quality that Oates wants to convey, though Freud defended the genre. The term was first coined in 1848 in German, but it acquired its negative connotation as soon as it migrated from the scientific to the literary in the twentieth century.

12. In Sontag's numerous interviews in the 1970s following the appearance of *Illness as Metaphor* and *On Photography*, she frequently comments on the urgency of her writing on cancer as a result of her own experience. She does not, however, talk about that experience.

13. Nixon's ambitious domestic program of 1971 included universal health care as well.

14. Richard M. Nixon, "State of the Union Address," American Presidency Project, http://www.presidency.ucsb.edu.

15. "Statement about Conversion of Facilities at Fort Detrick, Maryland, to a Center for Cancer Research," October 18, 1971, American Presidency Project, http://www.presidency.ucsb.edu/ws/?pid=3194.

16. This would be a little over nine billion in 2015 dollars, according to http://www.usinflationcalculator.com.

17. Susan Sontag, *Illness as Metaphor* (New York: Farrar, Straus & Giroux, 1978), 23, 67; hereafter cited in text as *IAM* followed by the page number.

18. Constance Holden, "Cancer and the Mind: How Are They Connected?," *Science* 200 (June 1978): 1363-69.

NOTES TO PAGES 102-106

19. Sontag is evidently paraphrasing Reich because, though the terms she uses are all Reich's, this actual (and more eloquent) phrasing does not appear in his work.

20. *Time* magazine has several articles referencing Reich and the orgone box. After his death in 1957, another article appeared, on January 24, 1964, "Morals: Second Sexual Revolution," which begins with the orgone box. Next, his name is mentioned in a May 25, 1970, article on Masters and Johnson and sex therapy, "Repairing the Conjugal Bed." A book review of Orson Bean's account of his Reichian therapy, *Me and the Orgone: The True Story of One Man's Sexual Awakening* (Robbinsdale, MN: Fawcett Crest, 1971), appeared in 1971. Also in 1971, a documentary—a biopic on Reich's life by Yugoslav filmmaker Dušan Makavejev—was reviewed; and in 1973 a book by the author's son, Peter Reich, was reviewed.

21. Mildred Brady, "The Strange Case of Wilhelm Reich," *New Republic*, May 26, 1947, 20-23.

22. Reich's theory of cancer is essentially a theory of its sexual, not emotional, origin.

23. Susan Sontag, "Psychoanalysis and Norman O. Brown's *Life against Death*," in *AI*, 259.

24. "The Pornographic Imagination" is also collected in an anthology along with essays by George Steiner, Paul Goodman, William Phillips, Anthony Burgess, and Kenneth Tynan, among others, all previously published between 1961 and 1969. See Douglas A. Hughes, ed., *Perspectives on Pornography* (New York: St. Martin's Press, 1970). The page numbers in my citations refer to Susan Sontag, *Styles of Radical Will* (New York: Farrar, Straus & Giroux, 1969), hereafter cited in text as *SRW* followed by the page number.

25. See Carl Rollyson and Lisa Paddock, *Susan Sontag: The Making of an Icon* (New York: W. W. Norton, 2000), 176.

26. Susan Sontag, *On Photography* (New York: Picador, 1973), 32; hereafter cited in text as *OPS* followed by the page number.

27. From the *New York Review of Books* article "Freak Show," November 15, 1973: "Preceded (in most of the spectators' awareness) by Warholiana, gay lib, drag rock, Tod Browning revivals, the freak parades of Fellini and Alejandro Jodorowsky, R. Crumb comics, and the grotesqueries of the neighborhood porn films, Arbus's photographs are practically the art of everyday life." Sontag calls this, in *On Photography*, the sensibility of the sixties: "More typically, it is the sensibility of someone educated and middle class who came of age between 1945 and 1955—a sensibility that was to flourish precisely in the 1960s" (43).

28. See Vicki Goldberg, *The Power of Photography: How Photography Changed Our Lives* (New York: Abbeville, 1991); Barbie Zelizer, *Remembering to Forget: Holocaust Memory through the Camera's Eye* (Chicago: University of Chicago Press, 1998); Susan Moeller, *Shooting War: Photography and the American Experience of Combat* (New York: Basic Books, 1989); Lili Bezner, *Photography and Politics in America: From the New Deal to the Cold War* (Baltimore: Johns Hopkins University Press, 1999); Amy Schlegel, "My Lai: 'We Lie, They Die'; or, A Small History of an Atrocious Photograph," *Third Text*, no. 31 (Summer 1995): 47-65; and Fred Ritchin, "The Photography of Conflict," *Aperture* 97 (Winter 1984): 22-27. Their accounts vary: Goldberg sees television's competition with still photography as a reason for the photograph's waning influence. Zelizer sees the Holocaust atrocity photograph as having over decades exhausted the capacity to influence. Moeller, in a complex assessment of the photographers' varied political stances toward the war, the censorship of photographs by the military and the media outlets, and the contrasting political views of the editors who shaped and contextualized the photographs, concludes that war photojournalism "helped" turn the public against the war, but in the end "public discontent that the press fulminated did not extend to a meaningful discontent about anything other

than issues that directly affected Americans in combat" (413). Bezner sees the personalizing of documentary photography during the early Cold War period as a retreat from its social purpose. Schlegel tracks the shifting frames of a photograph's presentation to suggest how powerful the discursive context of viewing is, and Ritchin discusses the ambiguous role of the photojournalist who both glamorizes and indicts the war effort.

29. John Berger, "The Photographs of Agony," in *John Berger Selected Essays*, ed. Geoff Dyer (New York: Pantheon Books, 2001), 279–81.

30. Susan Sontag, *Regarding the Pain of Others* (New York: Picador, 2003), 102.

31. "Feminism and Fascism: An Exchange," *New York Review of Books*, March 20, 1975. This was a response to Rich's critique of Sontag's earlier review, "Fascinating Fascism," published in the same venue on February 6, 1975.

32. Rieff, *Swimming in a Sea of Death*, 35.

33. "A Special Supplement: The Meaning of Vietnam," *New York Review of Books*, June 12, 1975.

34. This interview appeared in Leland Poague, ed., *Conversations with Susan Sontag* (Jackson: University Press of Mississippi, 1995), 186.

35. Ibid., 94.

36. Sontag, *Where the Stress Falls*, 19; and Elizabeth Hardwick, *Sleepless Nights* (New York: New York Review of Books Classics, 1979).

37. Sontag, *Where the Stress Falls*, 259.

38. Ibid., 54, 85; and Adam Zagajewski, *Another Beauty* (New York: Farrar, Straus & Giroux, 2000).

## Chapter 5

1. Harold Hayes, the editor at *Esquire* who commissioned so many of New Journalism's most famous articles, hired Arbus for one of his first efforts upon taking up leadership of the magazine.

2. Diane Arbus, *Family Album*, ed. Anthony W. Lee and John Putz (New Haven, CT: Yale University Press, 2003).

3. Sean O'Hagan makes the case for his breadth of insight and influence in "Was John Szarkowski the Most Influential Person in Twentieth-Century Photography?," *Guardian*, July 20, 2010.

4. "The Question of Belief," in Diane Arbus, *Revelations* (New York: Random House, 2003), 150n; hereafter cited in text as *R* followed by the page number.

5. Susan Sontag, *On Photography* (New York: Picador, 1973), 40.

6. See photographer Joel Meyerowitz on this topic in Colin Westerbeck and Joel Meyerowitz, *Bystander: A History of Street Photography* (New York: Little, Brown, 1994).

7. Sontag, *On Photography*, 20; Stuart Hall, *The Manufacture of News: Social Problems, Deviance and the News Media*, ed. Stanley Cohen and Josh Young (London: Constable, 1973); and Roland Barthes, *Mythologies*, trans. Jonathan Cape (New York: Hill & Wang, 1972).

8. Roland Barthes, *Camera Lucida: Reflections on Photography*, trans. Richard Howard (New York: Hill & Wang, 1981).

9. *Diane Arbus: An Aperture Monograph*, ed. Doon Arbus and Marvin Israel (New York: Aperture, 1972), 1–2; hereafter cited in text as *DAA* followed by the page number.

10. Sontag, *On Photography*, 29.

11. See, e.g., Anne Tucker, *The Woman's Eye* (New York: Alfred A. Knopf, 1973). This story and its speculative conclusion are repeated often in the reviews, as is the quotation. This may have originated in the *Ms. Magazine* piece that Doon wrote in October 1972 after her mother's death.

12. Barthes, *Camera Lucida*, 80; and André Bazin, "The Ontology of the Photographic Image," in *Classic Essays on Photography*, ed. Alan Trachtenberg (New Haven, CT: Leete's Island Books, 1980), 237–44.

13. See also Diana Emery Hulick, "Diane Arbus's Expressive Methods," *History of Photography* 19 (Summer 1995): 107–16; and Diana Emery Hulick, "Diane Arbus's Women and Transvestites: Separate Selves," *History of Photography* 16 (Spring 1992): 34–39. See also Westerbeck and Meyerowitz, *Bystander*.

14. Daniel Belgrad, *The Culture of Spontaneity: Improvisation in the Arts in Postwar America* (Chicago: University of Chicago Press, 1998).

15. Diane Arbus, "The Full Circle," *Infinity*, February 1962, 4–13, 19–21, reprinted from *Harper's Bazaar*, November 1961.

16. Carol Armstrong, "Biology, Destiny, Photography: Difference according to Diane Arbus," *October* 66 (Autumn 1993): 45.

17. Sontag, *On Photography*, 191.

18. Faye Ginsburg has described how the appearance in public of persons with mental disabilities has changed in the past thirty years. Faye Ginsburg, "Enabling Disability: Renarrating Kinship, Reimagining Citizenship," *Public Culture* 13, no. 3 (Fall 2001): 533–56.

19. In his November 27, 1995, review "Unmasked" in the *New Yorker*, Hilton Als says, "But several of these photographs also express great love for and trust in their photographer: not because they were particularly interested in being memorialized by the notorious Diane Arbus but because—for that moment—she was paying attention."

## Chapter 6

1. *Vintage Didion* (New York: Vintage Books, 2004). This isn't a completely representative reader because only the pieces for which Vintage owns copyright are included in the volume.

2. Joan Didion, *The Year of Magical Thinking* (New York: Alfred A. Knopf, 2005), 7–8; hereafter cited in text as *YMT* followed by the page number.

3. She later says: "You see how early the question of self-pity entered the picture" (*YMT*, 77).

4. Self-pity comes up a remarkable number of times in early uncollected essays.

5. This phrase comes from an omnibus review she did of contemporary fiction in the mid-1960s called "Questions about the New Fiction," *National Review*, November 30, 1965, 1100–1102.

6. Joan Didion, *Slouching towards Bethlehem* (New York: Farrar, Straus & Giroux, 1968), 15; hereafter cited in text as *STB* followed by the page number.

7. In an interview in *Joan Didion Essays and Conversations*, ed. Ellen G. Friedman (New York: Persea Books, 1984), she talks about tone, the preface, and doing interviews. In writing the essays, she claims to find a tone that is not hers. The preface, on the other hand, is her, written very quickly (86–87). She also comments on perceptions of her emotional fragility to both own and discount them.

8. See Carol Hult, "Metonymy and Metaphor in Joan Didion: A Personal Grammar of Style," in *The Peirce Seminar Papers*, vol. 3, ed. Michael Shapiro (New York: Peter Lang, 1998), 59–73.

9. Joan Didion, "Alicia and the Underground Press," *Saturday Evening Post*, January 13, 1968, as quoted in Mark Royden Winchell, *Joan Didion* (Boston: Twayne, 1980).

10. Tom Wolfe, *The New Journalism* (New York: Harper & Row, 1973), 31.

11. Joan Didion, *The White Album* (New York: Simon & Schuster, 1979), 13; hereafter cited in text as *WA* followed by the page number.

12. For more about the contagion of feeling, see Adela Pinch, *Strange Fits of Passion: Epistemologies of Emotion, Hume to Austen* (Stanford, CA: Stanford University Press, 1996); and Julie Ellison, *Cato's Tears and the Making of Anglo-American Emotion* (Chicago: University of Chicago Press, 1999).

13. Joan Didion, "Just Folks at a School for Nonviolence," *New York Times Magazine*, February 27, 1966. This later appears in *Slouching toward Bethlehem* as "Where the Kissing Never Stops."

14. Joan Didion, *After Henry* (New York: Simon & Schuster, 1992), 272, 284, 291.

15. If this makes Didion sound like Wendy Brown or Lauren Berlant, it's oddly true that she sees this use of sentiment to mask structural pain in the late 1980s and early 1990s. Obviously, her politics are considerably different from theirs, but there are unexpected overlaps.

16. Didion, *After Henry*, 284.

17. Whether little magazines, mass-market magazines, or literary small-market magazines, everyone who was anyone wrote for them in the sixties because magazines were home to a great deal of literary experimentation. Moreover, unlike today, writers wrote for a variety of magazines of different ideological and political perspectives—Garry Wills wrote for the square *National Review* and the hip *Esquire*, Didion for the middlebrow *Saturday Evening Post* as well as the highbrow *American Scholar*—and readers also consumed magazines across ideological borders.

18. Joan Didion, "Two Up for America," *National Review*, April 9, 1960, 240–41.

19. Mary McCarthy, "The Fact in Fiction," *Partisan Review*, Summer 1960, 438–58; and Philip Roth, "Writing American Fiction," *Commentary* 31, no. 3 (March 1961): 223–33.

20. Didion, "Questions about the New Fiction," 1100.

21. Roth, "Writing American Fiction," 224.

22. Didion, "Questions about the New Fiction," 1101.

23. Digby Diehl, "Chilling Candor of Joan Didion at UCLA," *Los Angeles Times*, May 9, 1971, Q39.

24. Joan Didion, "In Praise of Unhung Wreaths and Love," *Life*, December 1969, 28.

25. For Digby Diehl, the "chilling" aspect of this candor is Didion's affirmation of her own ambition, especially in the context of her roles as wife and mother. To her comment "I'm a wife and a mother but I'm a writer first," he appended her married name "(Mrs. John Gregory Dunne)" and commented, "chilling." Diehl, "Chilling Candor of Joan Didion at UCLA," Q39.

26. See Chris Anderson, *Style as Argument: Contemporary American Nonfiction* (Carbondale: Southern Illinois University Press, 1987), 179.

27. Joan Didion, "Why I Write," *New York Times Magazine*, December 5, 1976, 270, 271.

28. Didion, "Alicia and the Underground Press," 12.

29. Joan Didion, *Salvador* (New York: Simon & Schuster, 1983), 35–36.

30. Dennis Rygiel's "Lexical Parallelism in the Nonfiction of Joan Didion," in *Repetition in Discourse: Interdisciplinary Perspectives*, vol. 1, ed. Barbara Johnstone (Norwood, NJ: Ablex, 1994), 113–27, is an empirical study of this feature of Didion's work. It counts the uses and categorizes them in quite helpful ways.

31. Didion, *Salvador*, 26.

32. Ibid., 16–17.

33. All anti-utopian thinkers, like Arendt, who frequently uses this phrase, will protect the eggs. Being unable to predict the future, morality lies in the immediate. No decisions can be justified by their outcomes because outcomes cannot be known.

34. Joan Didion, "Sentimental Education," *New York Review of Books*, March 18, 1982.

35. Joan Didion, "Girl of the Golden West," in *Vintage Didion*, 10.

36. Ibid.

37. Ibid., 11.

38. Joan Didion, *Where I Was From* (New York: Alfred A. Knopf, 2003), 199.

39. Didion looks to a couple of sources to explain and to date this phenomenon, oddly failing to note the most famous book on the subject, Jessica Mitford's *The American Way of Death* (New York: Simon & Schuster, 1963).

40. This self-reassessment dovetails with that of *Where I Was From*, where Didion acknowledges her participation in a form of self-mythologizing, which was tied to her own family's romantic self-portrait. In *Where I Was From* there is the absolutely brilliant reading of the journals (and other manifestations of the myths of origin) where Didion notes that the tellers cannot possibly have had the perspective that they take up, could not have seen what they testify to— that the myth at some very early point begins to write itself.

41. "I remember being dismissive of, even censorious about, her 'self-pity,' her 'whining,' her 'dwelling on it.' [Caitlin Thomas's] *Leftover Life to Kill* was published in 1957. I was twenty-two years old. Time is the school in which we learn" (*YMT*, 199).

42. Joan Didion, *Blue Nights* (New York: Alfred A. Knopf, 2011), 154–55.

43. Ibid., 110–11.

# Bibliography

## Primary Sources

Arbus, Diane. *Diane Arbus: An Aperture Monograph.* Edited by Doon Arbus and Marvin Israel. New York: Aperture, 1972.

———. *Diane Arbus: Magazine Work.* Edited by Doon Arbus and Marvin Israel. New York: Aperture, 1984.

———. *Family Album.* Edited by Anthony W. Lee and John Putz. New Haven, CT: Yale University Press, 2003.

———. "Full Circle." *Infinity,* February 1962, 4–13, 19–21.

———. *Revelations.* New York: Random House, 2003.

———. *Untitled.* Edited by Doon Arbus and Yolanda Cuomo. New York: Aperture, 1995.

Arendt, Hannah. *Eichmann in Jerusalem: A Report on the Banality of Evil.* New York: Penguin Books, 1994.

———. "Home to Roost: A Bicentennial Address." In *Responsibility and Judgment,* edited by Jerome Kohn, 257–75. New York: Schocken Books, 2003. Originally published in *New York Times,* June 26, 1975.

———. *The Human Condition.* Chicago: University of Chicago Press, 1998.

———. *The Jew as Pariah.* Edited by Ron Feldman. New York: Grove Press, 1978.

———. *The Life of the Mind.* Edited by Mary McCarthy. Orlando, FL: Harcourt, 1978.

———. *Men in Dark Times.* New York: Harcourt, Brace & World, 1968.

———. "On Humanity in Dark Times: Thoughts about Lessing." In *Men in Dark Times,* 3–32. New York: Harcourt, Brace & World, 1968.

———. *On Revolution.* New York: Penguin Books, 1990.

———. *On Violence.* Orlando, FL: Harcourt Brace Jovanovich, 1970.

———. *The Portable Hannah Arendt.* New York: Penguin Books, 2000.

———. "Reflections on Little Rock." *Dissent* 6, no. 1 (1959): 45–56.

———. *Responsibility and Judgment.* Edited by Jerome Kohn. New York: Schocken Books, 2003.

———. "Some Questions of Moral Philosophy." In *Responsibility and Judgment,* edited by Jerome Kohn, 49–146. New York: Schocken Books, 2003.

———. *Totalitarianism: Part Three of "The Origins of Totalitarianism."* New York: Harvest Books, 1968.

Didion, Joan. *After Henry.* New York: Simon & Schuster, 1992.

———. "Alicia and the Underground Press." *Saturday Evening Post,* January 13, 1968, 14.

———. *Blue Nights.* New York: Alfred A. Knopf, 2011.

———. *Democracy.* New York: Vintage Books, 1995.

———. "Doris Lessing." In *The White Album,* 119–25. New York: Simon & Schuster. Originally published in *New York Times,* March 14, 1971, Sunday Book Review.

———. *Joan Didion: Essays and Conversations.* Edited by Ellen G. Friedman. New York: Persea Books, 1984.

———. "Georgia O'Keeffe." In *The White Album,* 126–30. New York: Simon & Schuster, 1979.

———. "In Praise of Unhung Wreaths and Love." *Life,* December 19, 1969, 28.

———. "Questions about the New Fiction." *National Review,* November 30, 1965, 1100–1102.

———. *Run River.* New York: Vintage Books, 1963.

———. *Salvador.* New York: Simon & Schuster, 1983.

———. "Sentimental Education." *New York Review of Books,* March 18, 1982, 3–6.

———. "Sentimental Journeys." In *After Henry,* 253–310. New York: Simon & Schuster, 1992. Originally published in *New York Review of Books,* January 17, 1991.

———. *Slouching towards Bethlehem.* New York: Farrar, Straus & Giroux, 1968.

———. "Two Up for America." *National Review,* April 9, 1960, 240–41.

———. *Vintage Didion.* New York: Vintage Books, 2004.

———. *Where I Was From.* New York: Alfred A. Knopf, 2003.

———. *The White Album.* New York: Simon & Schuster, 1979.

———. "Why I Write." *New York Times Magazine,* December 5, 1976.

———. "The Women's Movement." In *The White Album,* 109–18. New York: Simon & Schuster, 1979. Originally published in *New York Times,* July 30, 1972.

———. *The Year of Magical Thinking.* New York: Alfred A. Knopf, 2005.

McCarthy, Mary. "The American Realist Playwrights." In *On the Contrary: Articles of Belief, 1946–1961,* 293–312. New York: Farrar, Straus & Cudahy, 1961.

———. "Artists in Uniform." In *On the Contrary: Articles of Belief, 1946–1961,* 55–74. New York: Farrar, Straus & Cudahy, 1961. Originally published in *Harper's Magazine,* March 1953.

———. *Between Friends: The Correspondence of Hannah Arendt and Mary McCarthy, 1949–1975.* Edited by Carol Brightman. New York: Harvest Books, 1996.

———. *Cast a Cold Eye.* New York: Harcourt Brace Jovanovich, 1950.

———. *The Company She Keeps.* 1942. New York: Harvest Books, 1970.

———. "The Fact in Fiction." In *On the Contrary: Articles of Belief, 1946–1961,* 249–70. New York: Farrar, Straus & Cudahy, 1961. Originally published in *Partisan Review,* Summer 1960.

———. *The Group.* Orlando, FL: Harcourt, 1963.

———. *Hanoi.* New York: Harcourt, Brace & World, 1967.

———. "The Hiroshima *New Yorker.*" *politics* 3, no. 11 (November 1946): 367.

———. *How I Grew.* Orlando, FL: Harcourt, 1987.

———. *Intellectual Memoirs: New York, 1936–1938.* New York: Harcourt Brace Jovanovich, 1992.

———. "The Man in the Brooks Brothers Suit." In *The Company She Keeps,* 79–134. 1942. New York: Harvest Books, 1970.

———. *Memories of a Catholic Girlhood.* Orlando, FL: Harcourt, 1987.

——. "Novel, Tale, Romance." In *Occasional Prose*, 127–54. New York: Harcourt Brace Jovanovich, 1985.

——. *Occasional Prose*. New York: Harcourt Brace Jovanovich, 1985.

——. *On the Contrary: Articles of Belief, 1946–1961*. New York: Farrar, Straus & Cudahy, 1961.

——. Papers. Archives and Special Collections, Vassar College Library.

——. "The Portrait of the Intellectual as a Yale Man." In *The Company She Keeps*, 79–134. 1942. New York: Harvest Books, 1970.

——. "Settling the Colonel's Hash." In *On the Contrary: Articles of Belief, 1946–1961*, 225–41. New York: Farrar, Straus & Cudahy, 1961.

——. *Stones of Florence*. New York: Harcourt Brace Jovanovich, 1959.

——. *Venice Observed*. Orlando, FL: Harcourt, 1963.

——. *Viet Nam*. New York: Harcourt, Brace & World, 1967.

——. *Writing on the Wall and Other Literary Essays*. New York: Harcourt Brace Jovanovich, 1971.

Sontag, Susan. *Against Interpretation and Other Essays*. New York: Farrar, Straus & Giroux, 1966.

——. "Fascinating Fascism." *New York Review of Books*, February 6, 1975.

——. *Illness as Metaphor*. New York: Farrar, Straus & Giroux, 1978.

——. "The Meaning of Viet Nam." Special supplement of *New York Review of Books*, June 12, 1975.

——. "One Culture and the New Sensibility." In *Against Interpretation and Other Essays*, 293–304. New York: Picador, 1966.

——. *On Photography*. New York: Picador, 1973.

—— "The Pornographic Imagination." In *Styles of Radical Will*, 35–73. New York: Farrar, Straus & Giroux, 1969. Originally published in *Partisan Review*, Spring 1967.

——. *Regarding the Pain of Others*. New York: Picador, 2003.

——. "Singleness." In *Where the Stress Falls*, 259–62. New York: Farrar, Straus & Giroux, 2001.

——. "The Spiritual Style in the Films of Robert Bresson." In *Against Interpretation and Other Essays*, 177–95. New York: Picador, 1966.

——. *Styles of Radical Will*. New York: Farrar, Straus & Giroux, 1969.

——. "The Third World of Women." *Partisan Review* 40, no. 2 (Spring 1973): 180–206.

—— "Trip to Hanoi." In *Styles of Radical Will*, 205–74. New York: Farrar, Straus & Giroux, 1969. Originally published in *Esquire Magazine*, December 1968.

——. *Where the Stress Falls*. New York: Farrar, Straus & Giroux, 2001.

Weil, Simone. "Factory Work." In *The Simone Weil* Reader, edited by George A. Panichas, 53–72. Wakefield, RI: Moyer Bell, 1977.

——. *Gravity and Grace*. Lincoln: University of Nebraska Press, 1997. Originally published as *La pesanteur et la grâce* (Paris: Librairie Plon, 1947).

——. "Human Personality." In *The Simone Weil Reader*, edited by George A. Panichas, 313–39. Wakefield, RI: Moyer Bell, 1977.

——. "The *Iliad*: A Poem of Force." In *Simone Weil: An Anthology*, edited by Siân Miles, 162–95. New York: Grove Press, 1986. Originally published in *Les cahiers du Sud* 19, no. 230 (December 1940): 561–74; and 20, no. 231 (January 1941): 21–34.

——. *Intimations of Christianity among the Ancient Greeks*. London: Routledge, 1998. Compiled of chapters originally found in *La source grecque* (Paris: Librairie Gallimard, 1952) and *Les intuitions pre-chrétienne* (Paris: La Colombe, 1951).

———. "L'amour de Dieu et le malheur" [The love of God and affliction]. In *The Simone Weil Reader*, edited by George A. Panichas, 439–68. Wakefield, RI: Moyer Bell, 1977.

———. *Letter to a Priest*. New York: Penguin Books, 2003. Originally published as *Lettre a un religieux* (Paris: Gallimard, 1951).

———. *The Need for Roots: Prelude to a Declaration of Duties toward Mankind*. Translated by Arthur Wills. With a preface by T. S. Eliot. Boston: Beacon Press, 1955. Originally published as *L'enracinement: Prélude a une déclaration des devoirs envers l'être humain* (Paris: Gallimard, 1949).

———. *The Notebooks of Simone Weil*. Translated by Arthur Wills. London: Routledge, 2004. Originally published as *Cahiers I* (Paris: Librairie Plon, 1970), *Cahiers II* (Paris: Librairie Plon, 1972), and *Cahiers III* (Paris: Librairie Plon, 1974).

———. *Oppression and Liberty*. New York: Routledge Classics, 2001. Originally published as *Oppression et liberté* (Paris: Gallimard, 1955).

———. *The Simone Weil Reader*. Edited by George A. Panichas. Wakefield, RI: Moyer Bell, 1977.

———. *Waiting for God*. New York: G. P. Putnam's Sons, 1951. Originally published as *Attente de Dieu* (Paris: La Colombe, 1950).

### Secondary Sources

Abel, Lionel. *Metatheater*. New York: Hill & Wang, 1963.

Als, Hilton. "*Unmasked*: A Different Kind of Collection from Diane Arbus." *New Yorker*, November 27, 1995.

Anderson, Amanda. "Postwar Aesthetics: The Case of Trilling and Adorno." *Critical Inquiry* 40, no. 4 (Summer 2014): 418–38.

Anderson, Chris. *Style as Argument: Contemporary American Nonfiction*. Carbondale: Southern Illinois University Press, 1987.

Armstrong, Carol. "Biology, Destiny, Photography: Difference according to Diane Arbus." *October* 66 (Autumn 1993): 28–54.

Asad, Talal. *Formations of the Secular: Christianity, Islam, Modernity*. Palo Alto, CA: Stanford University Press, 2003.

Ascheim, Steven E., ed. *Hannah Arendt in Jerusalem*. Berkeley: University of California Press, 2001.

Atlas, James. "Freud's Pathology." *New York Times Magazine*, December 18, 1988.

Baron, Laurence. "The Holocaust and American Public Memory, 1945–1960." *Holocaust and Genocide Studies* 17, no. 1 (Spring 2003): 62–88.

Barrat, Robert. "Simone Weil." *Commonweal* 53, no. 24 (March 1951): 585–87.

Barret, William. "Mlle. Weil's Question." Review of *Letters to a Priest*, by Simone Weil. *New York Times*, March 14, 1954, Sunday Book Review.

Barthes, Roland. *Camera Lucida: Reflections on Photography*. Translated by Richard Howard. New York: Hill & Wang, 1981.

———. *Mythologies*. Translated by Jonathan Cape. New York: Hill & Wang, 1972.

Bazin, André. "The Ontology of the Photographic Image." In *Classic Essays on Photography*, edited by Alan Trachtenberg, 237–44. New Haven, CT: Leete's Island Books, 1980.

Bean, Orson. *Me and the Orgone: The Story of One Man's Sexual Awakening*. Robbinsdale, MN: Fawcett Crest, 1971.

Belgrad, Daniel. *The Culture of Spontaneity: Improvisation in the Arts in Postwar America.* Chicago: University of Chicago Press, 1998.

Benhabib, Seyla. *The Reluctant Modernism of Hannah Arendt.* London: Sage, 1996.

Berger, John. *About Looking.* New York: Pantheon Books, 1980.

———. "The Photographs of Agony." In *John Berger Selected Essays,* edited by Geoff Dyer, 279–81. New York: Pantheon Books, 2001.

———. "The Uses of Photography." In *About Looking,* 52–70. New York: Pantheon Books, 1980.

Berlant, Lauren. "The Subject of True Feeling: Pain, Privacy, and Politics." In *Cultural Pluralism, Identity Politics, and the Law,* edited by Austin Sarat and Thomas Kearns, 49–84. Ann Arbor: University of Michigan Press, 1999.

Bernstein, Richard. "The Conscious Pariah as Rebel and Independent Thinker." In *Hannah Arendt and the Jewish Question,* 14–45. Cambridge, MA: MIT Press, 1996.

———. "Hannah Arendt's Zionism?" In *Hannah Arendt in Jerusalem,* edited by Steven E. Ascheim, 194–202. Berkeley: University of California Press, 2001.

Best, Stephen, and Sharon Marcus. "Surface Reading: An Introduction." *Representations* 108, no. 1 (Fall 2009): 1–21.

Bezner, Lili. *Photography and Politics in America: From the New Deal to the Cold War.* Baltimore: Johns Hopkins University Press, 1999.

Bok, Sisela. "No One to Receive It? Simone Weil's Unforeseen Legacy." *Common Knowledge* 12, no. 2 (Spring 2006): 252–60.

Brady, Mildred. "The Strange Case of Wilhelm Reich." *New Republic,* May 26, 1947, 20–23.

Brightman, Carol. *Between Friends: The Correspondence of Hannah Arendt and Mary McCarthy, 1949–1975.* New York: Harvest Books, 1996.

———. *Writing Dangerously: Mary McCarthy and Her World.* New York: Harcourt, Brace, 1992.

Brower, Brock. "Mary McCarthyism." In *Conversations with Mary McCarthy,* edited by Carol Gelderman. Jackson: University Press of Mississippi, 1991. Originally published in *Esquire,* July 1962, 62–67.

Brown, Wendy. "Wounded Attachments." *Political Theory* 21, no. 3 (August 1999): 390–410.

Bruce, Lenny. "The Jews." In *The Essential Lenny Bruce: His Original Unexpurgated Satirical Routines,* edited by John Cohen, 50. Frogmore, UK: Panther Books, 1975.

Buck-Morss, Susan. "Aesthetics and Anaesthetics: Walter Benjamin's Artwork Essay Reconsidered." *October* 62 (Fall 1992): 3–41.

Cameron, Sharon. *Impersonality: Seven Essays.* Chicago: University of Chicago Press, 2007.

Camus, Albert. "On the Future of Tragedy." Lecture given in Athens in 1955. In *Lyrical and Critical Essays,* translated by Ellen Conroy Kennedy, edited by Phillip Thody, 295–310. New York: Alfred A. Knopf, 1968.

Canovan, Margaret. *Hannah Arendt: A Reinterpretation of Her Political Thought.* Cambridge: Cambridge University Press, 1992.

Capa, Cornell. *The Concerned Photographer.* New York: Grossman, 1968.

Carson, Anne. *Decreation.* New York: Vintage Books, 2005.

Cassuto, Leonard. *Hardboiled Sentimentality: The Secret History of American Crime Stories.* New York: Columbia University Press, 2008.

Castronovo, David. *Beyond the Gray Flannel Suit: Books from the 1950s That Made American Culture.* New York: Bloomsbury Academic, 2004.

Chandler, James. *The Archaeology of Sympathy.* Chicago: University of Chicago Press, 2013.

Chapman, Mary, and Glenn Hendler, eds. *Sentimental Men: Masculinity and the Politics of Affect in American Culture.* Berkeley: University of California Press, 1999.

Chiaromonte, Nicola. *The Paradox of History: Stendhal, Tolstoy, Pasternak, and Others.* Philadelphia: University of Pennsylvania Press, 1985.

———. *The Worm of Consciousness and Other Essays.* New York: Harcourt Brace Jovanovich, 1976.

Cogley, John. "Sister to All Sufferers." Review of *Waiting for God*, by Simone Weil. *New York Times*, September 16, 1951, Sunday Book Review.

Coles, Robert. *Simone Weil: A Modern Pilgrimage.* Woodstock, VT: Skylight Paths, 2001.

Copeland, Roger. "The Habits of Consciousness." In *Conversations with Susan Sontag*, edited by Leland Poague, 183–91. Jackson: University Press of Mississippi, 1995.

Courtine-Denamy, Sylvie. *Three Women in Dark Times: Edith Stein, Hannah Arendt, Simone Weil.* Translated by G. M. Goshgarian. Ithaca, NY: Cornell University Press, 2000.

Dargan, Joan. *Simone Weil: Thinking Poetically.* Albany: State University of New York Press, 1999.

Diehl, Digby. "Chilling Candor of Joan Didion at UCLA." *Los Angeles Times*, May 9, 1971, 389.

Diner, Dan. "Hannah Arendt Reconsidered: On the Banal and the Evil in Her Holocaust Narrative." *New German Critique* 71 (Spring/Summer 1997): 178.

Domenach, Jean-Marie. *Le retour du tragique.* Paris: Seuil, 1963.

Ellison, Julie. *Cato's Tears and the Making of Anglo-American Emotion.* Chicago: University of Chicago Press, 1999.

Ellwood, Robert. *The Fifties Spiritual Marketplace.* New Brunswick, NJ: Rutgers University Press, 1997.

Evans, Walker. "Lyric Documentary." Lecture presented at Yale University, March 11, 1964.

Felman, Shoshana. *The Juridical Unconscious: Trials and Traumas in the Twentieth Century.* Cambridge, MA: Harvard University Press, 2002.

Felski, Rita, ed. *Rethinking Tragedy.* Baltimore: Johns Hopkins University Press, 2008.

Ferber, M. K. "Simone Weil's *Iliad*." In *Simone Weil—Interpretation of a Life*, edited by George Abbot White, 63–64. Amherst: University of Massachusetts Press, 1981.

Fiedler, Leslie. Introduction to *Waiting for God*, by Simone Weil, vii–xxxiv. New York: G. P. Putnam & Sons, 2000.

———. "Simone Weil: Prophet Out of Israel; A Saint of the Absurd." *Commentary* 1 (January 1951): 38–46.

Fremantle, Anne. "Soul in Search of Salvation." *New York Times*, December 16, 1956, Sunday Book Review.

Gelderman, Carol, ed. *Conversations with Mary McCarthy.* Jackson: University Press of Mississippi, 1991.

Ginsburg, Faye. "Enabling Disability: Renarrating Kinship, Reimagining Citizenship." *Public Culture* 13, no. 3 (Fall 2001): 533–56.

Goldberg, Vicki. *The Power of Photography: How Photography Changed Our Lives.* New York: Abbeville, 1991.

Graham, Jorie. *Overlord.* New York: HarperCollins, 2005.

Gray, Francine du Plessix. *Simone Weil.* New York: Penguin Group, 2001.

Hall, Stuart. *The Manufacture of News: Social Problems, Deviance and the News Media.* Edited by Stanley Cohen and Josh Young. London: Constable, 1973.

Hardwick, Elizabeth. *Bartleby in Manhattan and Other Essays.* New York: Random House, 1983.

———. Foreword to *Intellectual Memoirs: New York, 1936–1938*, by Mary McCarthy, vii–xxii. New York: Harcourt Brace Jovanovich, 1992.

————. *Sleepless Nights.* New York: New York Review of Books Classics, 1979.

————. "Sylvia Plath." In *Seduction and Betrayal: Women and Literature*, 104–24. New York: Random House, 1974.

Hawes, Elizabeth. *Camus, a Romance.* New York: Grove Press, 2009.

Heilbrun, Carolyn. "Speaking of Susan Sontag." *New York Times*, August 27, 1967, 2, 30.

Holden, Constance. "Cancer and the Mind: How Are They Connected?" *Science* 200, no. 4348 (June 1978): 1363–69.

Hughes, Douglas A., ed. *Perspectives on Pornography.* New York: St. Martin's Press, 1970.

Hulick, Diana Emery. "Diane Arbus's Expressive Methods." *History of Photography* 19, no. 2 (Summer 1995): 107–16.

————. "Diane Arbus's Women and Transvestites: Separate Selves." *History of Photography* 16, no. 1 (Spring 1992): 34–39.

Hult, Carol. "Metonymy and Metaphor in Joan Didion: A Personal Grammar of Style." In *The Peirce Seminar Papers*, vol. 3, edited by Michael Shapiro, 59–73. New York: Peter Lang, 1998.

Jaeger, Werner. *Early Christianity and Greek Paideia.* Cambridge, MA: Harvard University Press, 1961.

Kiernan, Frances. *Seeing Mary Plain.* New York: W. W. Norton, 2002.

Kristeva, Julia. *Hannah Arendt.* Translated by Ross Guberman. New York: Columbia University Press, 2001.

Little, J. P. "Albert Camus, Simone Weil, and Modern Tragedy." *French Studies* 31, no. 1 (January 1977): 42–51.

Macdonald, Dwight, ed. *Masscult and Midcult: Essays against the American Grain.* New York: Random House, 1962.

May, Elaine Tyler. *Homeward Bound: American Families in the Cold War Era.* New York: Basic Books, 1988.

McLellan, David. *Utopian Pessimist: The Life and Thought of Simone Weil.* New York: Simon & Schuster, 1990.

Melley, Timothy. *Empire of Conspiracy: The Culture of Paranoia in Cold War America.* Ithaca, NY: Cornell University Press, 2000.

Meltzer, Françoise. "The Hands of Simone Weil." *Critical Inquiry* 27, no. 4 (Summer 2001): 611–28.

Miles, Siân, ed. *Simone Weil: An Anthology.* New York: Grove Press, 1986.

Miller, Arthur. "Tragedy and the Common Man." *New York Times*, February 17, 1949.

Mitford, Jessica. *The American Way of Death.* New York: Simon & Schuster, 1963.

Modleski, Tania. "Clint Eastwood and Male Weepies." *American Literary History* 22, no. 1 (Spring 2009): 136–58.

Moeller, Susan. *Shooting War: Photography and the American Experience of Combat.* New York: Basic Books, 1989.

Mommsen, Hans. "Hannah Arendt's Interpretation of the Holocaust as a Challenge to Human Existence: The Intellectual Background." In *Hannah Arendt in Jerusalem*, edited by Steven E. Ascheim, 224–31. Berkeley: University of California Press, 2001.

Moyn, Sam. "The Universal Declaration of Human Rights of 1948 in the History of Cosmopolitanism." Lecture presented at the Sawyer Seminar "Around 1948," University of Chicago, November 29, 2011.

Musmanno, Michael. "Man with an Unspotted Conscience: Adolph Eichmann's Role in the Nazi Mania Is Weighed in Hannah Arendt's New Book." *New York Times*, May 19, 1963, Sunday Book Review, 40–41.

Nadal, Alan. *Containment Culture: American Narratives, Postmodernism, and the Atomic Age.* Durham, NC: Duke University Press, 1995.

Nelson, Deborah. *Pursuing Privacy in Cold War America.* New York: Columbia University Press, 2002.

Niebuhr, Reinhold. *Beyond Tragedy: Essays on the Christian Interpretation of History.* New York: Scribner, 1937.

Nixon, Richard M. "Statement about Conversion of Facilities at Fort Detrick, Maryland, to a Center for Cancer Research." October 18, 1971. http://www.presidency.ucsb.edu/ws/?pid =3194.

———. "State of the Union Address." American Presidency Project. http://www.presidency .ucsb.edu/.

Novak, Peter. *The Holocaust in American Life.* New York: Mariner Books, 2000.

Oates, Joyce Carol. "Adventures in Abandonment." Review of *Jean Stafford: A Biography,* by David Roberts. *New York Times,* August 28, 1988, Sunday Book Review, 3, 33.

Peale, Norman Vincent. *The Power of Positive Thinking.* New York: Simon & Schuster/Fireside, 2003.

Pétrement, Simone. *Simone Weil: A Life.* New York: Pantheon Books, 1976.

Pinch, Adela. *Strange Fits of Passion: Epistemologies of Emotion, Hume to Austen.* Stanford, CA: Stanford University Press, 1996.

Poague, Leland, ed. *Conversations with Susan Sontag.* Jackson: University Press of Mississippi, 1995.

Podhoretz, Norman. "Hannah Arendt on Eichmann: A Study in the Perversity of Brilliance." *Commentary* 36 (September 1, 1963): 201–8.

———. *Making It.* New York: HarperCollins, 1980.

Potkay, Adam. "Contested Emotions: Pity and Gratitude from the Stoics to Swift and Wordsworth." *PMLA* 130, no. 5 (October 2015): 1332–46.

Reich, Wilhelm. *The Cancer Biopathy.* New York: Farrar, Straus & Giroux, 1973.

Reiff, David. *Swimming in a Sea of Death.* New York: Simon & Schuster, 2008.

Ritchin, Fred. "The Photography of Conflict." *Aperture* 97 (Winter 1984): 22–27.

Rollyson, Carl, and Lisa Paddock. *Susan Sontag: The Making of an Icon.* New York: W. W. Norton, 2000.

Rosenfeld, Isaac. "Simone Weil as Saint." Review of *Waiting for God,* by Simone Weil. *Partisan Review* 18, no. 6 (November/December 1951): 712–15.

Roth, Philip. "Writing American Fiction." *Commentary* 31, no. 3 (March 1961): 223–33.

Rygiel, Dennis. "Lexical Parallelism in the Nonfiction of Joan Didion." In *Repetition in Discourse: Interdisciplinary Perspectives,* vol. 1, edited by Barbara Johnstone, 113–27. Norwood, NJ: Ablex, 1994.

Sands, Kathleen. "Tragedy, Theology, and Feminism in the Time after Time." In *Rethinking Tragedy,* edited by Rita Felski, 82–103. Baltimore: Johns Hopkins University Press, 2008.

Scarry, Elaine. *The Body in Pain: The Making and Unmaking of the World.* Oxford: Oxford University Press, 1988.

Schlegel, Amy. "My Lai: 'We Lie, They Die'; or, A Small History of an Atrocious Photograph." *Third Text* 31 (Summer 1995): 47–65.

Sedgwick, Eve Kosofsky. *The Epistemology of the Closet.* Berkeley: University of California Press, 2008.

Seltzer, Mark. *Serial Killers: Death and Life in America's Wound Culture*. New York: Routledge, 1998.

Siebers, Tobin. *Cold War Criticism and the Politics of Skepticism*. New York: Oxford University Press, 1993.

Simmel, Georg. "The Metropolis and Mental Life." In *Simmel on Culture: Selected Writings*, edited by David Frisby and Michael Featherstone, 174–85. London: Sage, 1998.

Skinner, David, ed. and trans. *Gershom Scholem: A Life in Letters, 1914–1982*. Cambridge, MA: Harvard University Press, 2002.

Sparling, Robert. "Theory and Praxis: Simone Weil and Marx on the Dignity of Labor." *Review of Politics* 74, no. 1 (January 2012): 87–107.

Spiegelman, Art. *The Complete Maus*. New York: Pantheon Books, 1996.

Steiner, George. *The Death of Tragedy*. New York: Alfred A. Knopf, 1961.

Stonebridge, Lyndsey. *The Judicial Imagination: Writing after Nuremburg*. Edinburgh: Edinburgh University Press, 2001.

Strickland, Stephanie. *The Red Virgin: A Poem of Simone Weil*. Madison: University of Wisconsin Press, 1993.

Sumner, Gregory. *Dwight Macdonald and the "politics" Circle*. Ithaca, NY: Cornell University Press, 1996.

Syrkin, Marie. "Hannah Arendt: The Clothes of the Empress." *Dissent*, Autumn 1963, 344–52.

Taussig, Michael. *The Nervous System*. New York: Routledge, 1992.

Thibon, Gustave. Introduction to *Gravity and Grace*, by Simone Weil, 3–43. New York: Putnam, 1952.

Torgovnick, Marianna. *The War Complex: World War II in Our Time*. Chicago: University of Chicago Press, 2005.

Tucker, Anne. *The Woman's Eye*. New York: Alfred A. Knopf, 1973.

Westerbeck, Colin, and Joel Meyerowitz. *Bystander: A History of Street Photography*. New York: Little, Brown, 1994.

White, George Abbot, ed. *Simone Weil—Interpretation of a Life*. Amherst: University of Massachusetts Press, 1981.

Williams, Raymond. *Keywords: A Vocabulary of Culture and Society*. Oxford: Oxford University Press, 1976.

———. *Marxism and Literature*. Oxford: Oxford University Press, 1977.

———. *Modern Tragedy*. Toronto: Broadview Press, 2006.

Williams, Raymond, and Michael Orrom. *A Preface to Film*. London: Film Drama, 1954.

Winchell, Mark Royden. *Joan Didion*. Boston: Twayne, 1980.

Wolfe, Tom. *The New Journalism*. New York: Harper & Row, 1973.

Wuthnow, Robert. *After Heaven: Spirituality in America since the 1950s*. Berkeley: University of California Press, 2000.

Young-Bruehl, Elizabeth. *Hannah Arendt: For Love of the World*. New Haven, CT: Yale University Press, 1982.

Zagajewski, Adam. *Another Beauty*. New York: Farrar, Straus & Giroux, 2000.

Zelizer, Barbie. *Remembering to Forget: Holocaust Memory through the Camera's Eye*. Chicago: University of Chicago Press, 1998.

Zimmerman, Moshe. "Hannah Arendt, the Early "Post-Zionist." In *Hannah Arendt in Jerusalem*, edited by Steven E. Ascheim, 181–93. Berkeley: University of California Press, 2001.

# Index

Page numbers in italics refer to illustrations.